ABSTRACTIONIST AESTHETICS

NYU SERIES IN SOCIAL AND CULTURAL ANALYSIS

GENERAL EDITOR: PHILLIP BRIAN HARPER

Nice Work If You Can Get It: Life and Labor in Precarious Times
Andrew Ross

City Folk: English Country Dance and the Politics of the Folk in Modern America
Daniel J. Walkowitz

Toilet: Public Restrooms and the Politics of Sharing
Edited by Harvey Molotch and Laura Norén

Unhitched: Love, Marriage, and Family Values from West Hollywood to Western China
Judith Stacey

The Sun Never Sets: South Asian Migrants in an Age of U.S. Power
Edited by Vivek Bald, Miabi Chatterji, Sujani Reddy, and Manu Vimalassery

Chronic Youth: Disability, Sexuality, and U.S. Media Cultures of Rehabilitation
Julie Passanante Elman

Abstractionist Aesthetics: Artistic Form and Social Critique in African American Culture
Phillip Brian Harper

ABSTRACTIONIST AESTHETICS

Artistic Form and Social Critique
in African American Culture

PHILLIP BRIAN HARPER

NEW YORK UNIVERSITY PRESS

NEW YORK AND LONDON

NEW YORK UNIVERSITY PRESS
New York and London
www.nyupress.org

"(What Did I Do to Be So) Black and Blue," music by Thomas "Fats" Waller and Harry Brooks, words by Andy Razaf. Copyright © 1929 (Renewed) EMI Mills Music, Inc., Chappell & Co., Inc., and Razaf Music Co. All Rights Reserved. Selected lyrics used by permission of Alfred Publishing Co., Inc., and Bienstock Publishing Company on behalf of Redwood Music Ltd.

"This Is Just to Say," by William Carlos Williams, from *Collected Poems: Volume I, 1909–1939.* Copyright © 1938 by New Directions Publishing Corp. Reprinted by permission of New Directions Publishing Corp. and Carcanet Press Ltd.

"The Colonel," by Carolyn Forché, from *The Country between Us.* Copyright © 1981 by Carolyn Forché. Previously published by Women's International Resource Exchange. Reprinted by permission of HarperCollins Publishers and Carolyn Forché.

References to Internet websites (URLs) were accurate at the time of writing. Neither the author nor New York University Press is responsible for URLs that may have expired or changed since the manuscript was prepared.

LIBRARY OF CONGRESS CATALOGING-IN-PUBLICATION DATA
Harper, Phillip Brian.
Abstractionist aesthetics : artistic form and social critique in African American culture / Phillip Brian Harper.
 pages cm
Includes bibliographical references and index.
ISBN 978-1-4798-6543-7 (cl : alk. paper) — ISBN 978-1-4798-1836-5 (pb : alk. paper)
1. African American aesthetics. 2. Abstraction. 3. African American arts—Themes, motives. I. Title.
BH221.U53H37 2015
305.896'073—dc23 2015021344

Book design and composition by Nicole Hayward

New York University Press books are printed on acid-free paper, and their binding materials are chosen for strength and durability.

We strive to use environmentally responsible suppliers and materials to the greatest extent possible in publishing our books.

Manufactured in the United States of America

10 9 8 7 6 5 4 3 2 1

Also available as an ebook

For Henry Louis Gates, Jr., who set me thinking;
and for Thom Freedman, who keeps me going

Contents

Introduction: Against Positive Images / 1

1 Black Personhood in the Maw of Abstraction / 17

2 Historical Cadence and the Nitty-Gritty Effect / 69

3 Telling It Slant / 117

Coda: The Literary Advantage / 161

Acknowledgments / *181*

Notes / *185*

Bibliography / *237*

Index / *263*

About the Author / *280*

Introduction

Against Positive Images

If art reflects life it does so with special mirrors.

—BERTOLT BRECHT

Abstractionist Aesthetics is a theoretical polemic concerned with the critical potential of African American expressive culture. It is premised on the widely accepted (if debatable) notion that such culture consists in works and practices that both originate among and in some way represent the experiences of African American people while also illuminating and appraising the racial-political context in which those experiences occur.[1] Conceived in this way, African American culture effectively *compels* polemic, in that it forces the perennially contestable question of how best to make a racial-political stand; and indeed, this book is preceded by a succession of similarly argumentative tracts issued over the past century or so. For the most part, these call for a socially engaged black art whose manifestation as such, they contend, necessitates an organic connection between the individual artist and the "community." Alternatively—sometimes simultaneously—they repudiate such prescriptions, enjoining black artists to pursue whatever aesthetic paths they choose, heedless of "pleas[ing] either white people or black," itself a political move.[2] The urgency of these competing directives has of course varied with the historical winds, but their mere existence indicates the peculiar effects of African American

culture's having been conceived at all as a political project, a primary one of which is that any given work—not to mention the artist who produced it—is always liable to be deemed not properly black.

Such judgment lies far afield of my interests here, and I am by the same token much less concerned with dictating modes of aesthetic practice (though I do indeed *champion* one that I believe has gone underappreciated) than with influencing current norms of aesthetic reception. For all that these norms presuppose the social-critical function of African American culture just sketched, as I believe they unquestionably do, they also generally assume that that function is best served by a type of realist aesthetics that casts racial blackness in overridingly "positive" terms.[3] Superficially connoting modes of depiction that are properly race-proud and -affirmative, such positivity more fundamentally entails an empiricist demand that racialized representations perceptibly mirror real-world phenomena, however favorable—or not—any particular portrayal may seem.[4] While there are arguably good historical reasons for its prevalence, to the extent that this positivist ethic restricts the scope of artistic practice, the realism that it underwrites emerges as a central problem within African American aesthetics. This book accordingly argues for the displacement of realism as a primary stake in African American cultural engagement, and asserts the critical utility of an alternative aesthetic mode that it characterizes as *abstractionism*.

Abstractionism as theorized in this volume entails the resolute awareness that even the most realistic representation is precisely a *representation*, and that as such it necessarily exists at a distance from the social reality it is conventionally understood to reflect. In other words, abstractionist aesthetics crucially recognizes that any artwork whatsoever is definitionally *abstract* in relation to the world in which it emerges, regardless of whether or not it features the nonreferentiality typically understood to constitute aesthetic *abstraction* per se. An *abstractionist artwork*, by extension, is one that *emphasizes* its own distance from reality by calling attention to its constructed or artificial character—even if it also enacts real-world reference—rather than striving to dissemble that constructedness in the service of the maximum verisimilitude so highly prized within the real-

ist framework just sketched. In thus disrupting the easy correspondence between itself and its evident referent, the abstractionist work invites us to question the "naturalness" not only of the aesthetic representation but also of the social facts to which it alludes, thereby opening them to active and potentially salutary revision.

This proposition that art might operate in a denaturalizing and reformative fashion is by no means novel. Indeed, it recapitulates almost exactly Bertolt Brecht's claims regarding the function of the *alienation effect* within what Brecht conceived as "non-Aristotelian drama."[5] Substantially coinciding with—and arguably directly deriving from—Victor Shklovsky's seemingly less political concept of literary *defamiliarization*, theatrical alienation effect, according to Brecht, entails "taking the human social incidents to be portrayed and labelling them as something striking, something that calls for explanation, is not to be taken for granted, not just natural. The object of this 'effect' is to allow the spectator to criticize constructively from a social point of view."[6] Above all, Brecht is concerned that social facts be recognized as specifically *historical* phenomena that are accordingly subject to progressive change, and he therefore argues against the attempt to generate audience empathy that he maintains characterizes conventional "dramatic theatre" as against non-Aristotelian "epic theatre," since empathy implicates inertial passivity rather than engendering active social engagement.[7] He clarifies this point by positing that the spectator of dramatic theater typically responds to the presentation of a socially subjugated character by thinking, "Yes, I have felt like that too — Just like me — It's only natural — It'll never change — The sufferings of this man appal me, because they are inescapable"; the spectator of non-Aristotelian "epic theatre," on the other hand, says, "I'd never have thought it — That's not the way — That's extraordinary, hardly believable — It's got to stop — The sufferings of this man appal me, because they are unnecessary."[8] Brecht thus affirms the social-revisionary potential of theatrical alienation while also tracing the latter specifically to the theatrical work's emphatic assertion of its own fictive character—the

abstractionism I described earlier: as he puts it in his discussion of non-Aristotelian theater's dissolution of the "fourth wall," "the audience can no longer have the illusion of being the unseen spectator at an event which is really taking place" but instead must recognize both the contrived quality of the production and the centrality of that quality to the performance's social-critical effect.[9]

The mere assertion of a theoretical claim does not, however, equal the universal acknowledgment of its validity, and African Americanist cultural commentary has not betrayed a thoroughgoing commitment to the line of Brechtian thought just outlined.[10] There is arguably very good reason for this, inasmuch as the principle of abstraction that necessarily founds abstraction*ism* has routinely been marshaled *against* black persons and populations within the American context (as throughout the West), in both cultural and social-political terms. With respect to the former, abstraction has largely comprised a mode of genericization whereby the specificity of African American historical experience—and that of other minoritized populations too, for that matter—has been precluded from the representational field, and its value and significance thereby tacitly rejected. Social-politically, of course, by the late eighteenth century abstraction constituted the cognitive mechanism by which persons of African descent were conceived as enslaveable entities and commodity objects, and yet paradoxically denied the condition of disinterested personhood on which U.S.-governmental recognition has been based. While I elaborate the foregoing points—and thus explain what strikes me as a wholly comprehensible resistance to aesthetic and cognitive abstraction within African American culture—at full length in chapter 1 of this book, I am clearly much more concerned with discovering how and in what contexts of African American cultural production aesthetic abstractionism might be most profitably forwarded at the present juncture, since I remain convinced that it *can* in fact have the progressive critical effect that I have indicated.

That I am not entirely alone in this conviction was demonstrated by a cultural controversy that preoccupied residents of Indianapolis for the better

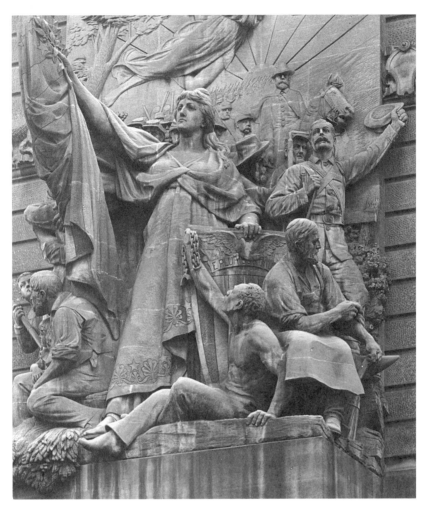

1 Bruno Schmitz, State Soldiers and Sailors Monument, 1888–1902 (detail of west
 face, sculpted by Rudolph Schwarz). Indiana limestone, total height, 284 ft., 6 in.
 Monument Circle, Indianapolis, IN.

part of two years before finally culminating in December 2011. At issue was
the design for a proposed public sculpture that adopted as its central ele-
ment the shirtless and unshod black masculine figure featured in that city's
1902 State Soldiers and Sailors Monument, where, seated at the feet of a
personified Liberty and holding aloft a loosed chain and broken shackle, it
evokes the slave's emancipation (fig. 1). In his rendering of the envisioned

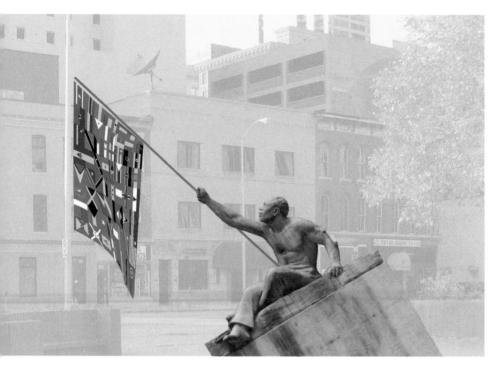

2 Fred Wilson, rendering for *E Pluribus Unum*, 2011. Copyright © Fred Wilson. Photograph courtesy the artist and Pace Gallery.

piece, *E Pluribus Unum*, which was commissioned by the Central Indiana Community Foundation (CICF) for installation along the newly developed Indianapolis Cultural Trail, the New York City–based conceptual artist Fred Wilson replaced the chain and shackle with a flag of his own design meant to represent the contemporary African diaspora, and hence to signal blacks' social and political progress since the nineteenth century. More than this, though, Wilson emphasized his intention to reorient the sculptural figure so that "he is no longer looking up at someone": "I'm shifting him so that he's moving forward . . . , in . . . a more advancing position, a more active position" (fig. 2).[11] Not only would the resultant piece depict an "upright, empowered, twenty-first-century person of color," as Wilson was reported to have said, but by at once recalling and revising the figure that appears in the Soldiers and Sailors Monument, the new work would elicit crucial questions on the part of its viewers—to wit: if the 1902 sculpture is "the only symbol for African American Indianapolis" among

the numerous public memorials on display in the locality (as none of the others represented any black people at all), then "what does that say about the city at that moment" when the monument was erected, "and what does that say about the city at this moment if it still is the only image?"—"why *are* there no other images of African Americans in monument form?"[12] Ideally, Wilson intimated, his work would indeed spur the creation of additional African American memorial sculptures, which would most properly be produced by people who, unlike himself, were members of the Indianapolis community ("When I do projects," he told an Indianapolis audience, "it's about making . . . questions visible, for *others* to answer—especially since I'm an outsider")—and which, "if they were to be done, . . . should be done at the Statehouse and other locations," Wilson having rejected the monument-rich capitol grounds as a site for *E Pluribus Unum* itself, since as he insisted, his own work was "not a monument."[13]

By this account, it is easy to understand Wilson's project in terms of the aesthetic abstractionism described earlier. For one thing, the sequence of critical reflection and motivated action that for Brecht arose from theatrical alienation is exactly what Wilson suggested would ensue among viewers of *E Pluribus Unum*, with the initial inquiry as to why Indianapolis boasts "no other images of African Americans in monument form" eventuating precisely in the creation of additional such images. Further, though, Wilson envisioned those responses as being precipitated specifically by his sculpture's metarepresentational quality—the fact that it would reproduce and thus directly reference another, preexistent artwork rather than immediately lived experience, and indeed would be able to comment critically on the significance of that earlier work only because its featured human figure had itself been "abstracted" from the context provided by the original piece.[14] It is in this insistent distancing of itself from the real-world phenomena that it would have just as insistently (if indirectly) referenced that Wilson's proposed work exemplified—and indeed epitomized—the abstractionism I described earlier.

In the event, however, *E Pluribus Unum*'s aesthetic abstractionism did not fully "take" among members of Indianapolis's African American community, many of whom contended that its appropriated sculptural figure

constituted a "negative" black image simply by evoking blacks' past en-slavement, and thus urged that the project be canceled.[15] Convinced that Wilson's comparatively "upright" rendering was still not upright *enough*, in any sense of the word (one group called for a figure that would be not only more fully *erect* but also more fully *clothed*, "like all of the scores of images around the city that depict men who are empowered"), these critics also put the lie to Wilson's suggestion that viewers of his sculpture would inevitably regard it as primarily a comment on the Soldiers and Sailors Monument, given what he insisted would have to be its close physi-cal proximity to the latter.[16] They were, after all, completely aware that *E Pluribus Unum*'s figural element was lifted from the earlier work, and yet they saw it as simply a reduplication of the Monument's imagery, rather than as a critique of the circumstances that imagery connotes. Hence the group Citizens Against Slave Image (CASI) vigorously resisted "the plans to recreate *another slave monument* as our city's only testimony to African American life and achievement," arguing that "one slave image in India-napolis' public space is enough."[17]

Ultimately, after a series of community meetings in which 90 percent of the attendees voiced opposition to Wilson's design, the boards of the CICF and the Indianapolis Cultural Trail voted unanimously to terminate the project.[18] Of greater analytical consequence than this outcome, however, is the fact that the sculpture's opponents consistently disregarded a feature of the work that Wilson himself regularly emphasized—namely, the black-diasporan flag—in favor of the human figure whose ambiguous signifi-cance thereby became the flashpoint for the controversy.[19] No less than that figure's relatively erect posture, the flag too was meant to signal blacks' putative advancement since the demise of chattel slavery (via its clear allu-sions to contemporary black-national sovereignty), and yet it goes entirely unmentioned in the recorded comments of the sculpture's critics. The rea-son for this is not especially mysterious, and if the *E Pluribus Unum* con-troversy itself suggests the relevance of this study even at a juncture when one had thought that worry over positive black images was a thing of the past, the fate of Wilson's flag within the debate hints at the limitations of realist aesthetics that I intimated earlier, especially as they obtain within

visual representation. The problem, simply put, is that however power-ful *E Pluribus Unum*'s techniques of abstractionist distantiation, they are no match for the figural verisimilitude that the sculpture would also have featured, having adopted it wholesale from the Soldiers and Sailors Monu-ment itself. Of course, the primary purpose of that adoption, as Wilson made clear, was for *E Pluribus Unum* to recall and comment on the import of that very monument, but because by way of doing so it would have also minutely approximated the form of a real-life slavery-era black man, its reference in this regard inevitably emerged as the focal point of the piece, wholly subordinating both the allusion to the monument and the symbolism of the flag. That done, the figure immediately became sub-ject to the assessment of moral propriety that I have suggested is so often elicited by realist racial depiction, evident in critics' determination that it constituted a "negative" black image. At the same time, though, if such as-sessment is completely irrelevant—and, indeed, antithetical—to *E Pluribus Unum*'s critical objective, the figural verisimilitude that precipitated it is also the chief means by which the sculpture would have registered its own racial-political investment—and thus *furthered* its critical objective—as the blackness whose significance the work was meant to interrogate is in-dicated much more forcefully by the physiognomy and deportment of the figure than by the complex iconography of the flag, however ingenious Wilson's design for the latter.[20]

E Pluribus Unum thus exemplifies a conundrum that must necessarily be negotiated by any artwork that aspires to effective African Americanist abstractionism—specifically, how can a work clearly enough ground itself in the real-world racial order as to register as *black* while at the same time clearly enough *dissociating* itself from lived reality as to register as produc-tively *abstractionist*? In addition to reviewing African Americans' fraught history with abstractive principles, chapter 1 argues that works of visual art are especially ill equipped to resolve this dilemma, partly because the visual realm is a classic focus of worry over proper—and hence properly *realist*—black-racial representation, and partly because visual abstractionism is

in any case especially susceptible to realist recuperation. The chapter's primary exhibit in this regard is a controversy that predated the *E Pluribus Unum* debate by a dozen years or so, in which large-scale silhouette installations by Kara Walker were likewise condemned for presenting "negative" depictions of black people. In my own estimation, Walker's imagery is so clearly abstractionist (which is to say emphatically stylized and thus indisputably nonrealist) as to make questions about its "negativity" wholly irrelevant. If that abstractionism nevertheless failed to impress itself on Walker's critical viewers (as it quite evidently did), this, I contend, indicates not only continued African American concern with appropriate black-racial portrayal but also the degree to which abstractionist visual representation per se had become wholly naturalized—and hence largely imperceptible to spectators—by the last decades of the twentieth century. In other words, no less than the social facts whose revisability we seek to disclose, aesthetic abstractionism's critical efficacy is itself a historical phenomenon that does not necessarily obtain in every time and circumstance.[21] Indeed, I argue, precisely because Western viewers have by this point assimilated all manner of cognitively discrepant—or *abstractionist*—visual display to the norms of everyday—or *realist*—perception, visual art is today one of the *least* likely contexts in which abstractionism might gain the critical traction it is theoretically capable of achieving.

If we thus disallow contemporary visual representation as a domain in which abstractionist aesthetics can be expected to operate effectively, we might on the contrary imagine that African American music offers an optimum site for abstractionism-driven critique. Music is, after all, held to constitute the quintessence of black culture while at the same time being generally conceived as the epitome of aesthetic abstraction, since it appears fundamentally nonreferential and hence wholly "autonomous" in relation to the world beyond itself.[22] Of course, its presumed supreme abstractness relative to the social surround may well *preclude* music from attaining to an abstractionist function, insofar as the latter depends on an artwork's clearly evoking lived social reality even as it registers its unbridgeable distance from that reality. On the other hand, though, for music to be understood as "African American" to begin with is for it *necessar-*

ily to be understood as in some way signifying social phenomena—most specifically, black racial identity and its complex import—and thus for it not to be received as *abstract* at all. That signification is accomplished not through explicit *reference* (for music as such is indeed resolutely nonreferential) but through what we might call genetic *expression*, in that any given musical instance attains to "blackness" specifically by featuring characteristics of an indigenous African musical practice whose "tradition" it is understood to continue. It is thus by being conceived as an element in a historical sequence that music manifests as African American—a fact that explains the seeming paradox whereby music can be understood as at once fundamentally abstract (and so wholly unimplicated in social signification) and yet eminently admissive of racial blackness (and thereby fully *liable* to social signification), inasmuch as when we apprehend music as *black* we are apprehending it not in its phenomenal modality *qua* music but in its specifically *historical-narrative* function.

This point is the burden of chapter 2, and in addition to rendering music marginal to this study's primary concerns (notwithstanding its accustomed centrality within African Americanist discussion), it sets the stage for the book's ultimate argument. Having been established as a presentational mode whose cognitive import contrasts with that of aesthetic abstraction, *narrative* accordingly emerges as a prime context in which abstractionist alienation effect might register with optimum force. This emergence in turn suggests that *literature* is the domain in which abstractionism can gain maximum critical purchase at present, given that it comprises the *locus classicus* for narrative function. This is to say not only that literature is a principal means for offering up the stories that we take to constitute narrative "content" but also that it presents those stories in a medium—language—that itself implicates a narrative *logic*. Consisting in regularized syntactical formulations that convey intelligence only insofar as they are properly apprehended over the course of time, linguistic productions in their very structure entail a principle of narrative signification whereby meaning derives through temporal elaboration and sequential development. Any disruption to such narrative progression—or to the syntactical flow on which it depends—thus potentially works to denatu-

ralize both the linguistic production in which a given story is recounted and that story itself, in the manner outlined by Brecht in the passages quoted earlier. The potential in this regard is especially great, of course, when there is minimal expectation that such disruption will occur, and while the mobilization of language per se does typically lead us to anticipate unimpeded syntactical flow (since we know that any linguistic instance must indeed conform to certain structural rules if it is to make sense), some kinds of print discourse are in fact "more equal than others" in this respect.

As I note in chapter 3 of the book, of the major genres of English-language literary production generally recognized at present, verse poetry is widely understood to be characterized by syntactic complexity and concomitant semantic difficulty, and this means that it is *not* generally expected to manifest the unencumbered developmental progression discussed earlier, even when it frankly partakes of a narrative mode that would seem to make such progression appropriate. Print prose, by contrast, is largely held to be relatively straightforward and accessible by definition, in keeping with its receivedly workaday character; indeed, it formally implies such directness in the continuous flow of its lines, whereas the deliberate truncation of the poetic verse line itself serves to check poetry's syntactic coherence. Thus prose texts apparently constitute the perfect venue for the social-critical operation of aesthetic abstractionism, in that they seem to extend a promise of easy and transparent communication in light of which none of their cognitively disjunctive features can fail to make an impression, since these evidently violate that very promise. Such disjunctive features (including the attenuated characterization, referential indeterminacy, and rhetorical repetition on which chapter 3 primarily focuses) are the defining elements in what is typically called "experimental" prose, where they persistently thwart the will to aesthetic realism that permeates the African Americanist cultural field.

Ultimately, then, this volume contends not only that aesthetic abstractionism is a potentially vital element within African American expressive culture—nor even simply that literature is the art form in which abstractionist "alienation" can achieve maximum efficacy at this histori-

cal juncture—but, more specifically, that critical abstractionism is most powerfully operative in the sort of nonconventional printed prose works whose renunciation of narrative realism makes them marginal at best within the African Americanist canon. Thus the book is as much an argument for the broadening of our idea of what constitutes African American literature as it is a brief for abstractionist aesthetics and, by extension, the critical utility of literature as such. A short coda posits that while print prose is by no means the only vehicle for narrative expression within the contemporary cultural context (beyond the theatrical performance that Brecht sought to revolutionize, film immediately suggests itself as a prime alternative), its dependence on language still makes it most susceptible to the sort of abstractionist defamiliarization for which I am advocating throughout the volume.

I am hardly the first person to bemoan the hegemony of realism within African American aesthetics, to assert the importance of black literary experimentalism, or to champion the abstractive principles that I contend necessarily inform the latter, even if these remain distinctly peripheral pursuits within African Americanist criticism.[23] Nor am I the first to suggest that it might be precisely through the mobilization of such principles that an artwork affirms its African Americanist commitment, rather than through the mode of positivist depiction alluded to earlier. Indeed, in 1993 Nathaniel Mackey observed that some writers not only tell stories of black social marginalization while at the same time calling into question received conventions for that telling but actually "tell their stories *by* calling such conventions into question."[24] Notwithstanding his reference here to "telling stories," however (terms which he is in any case adopting from his immediate interlocutor)—or the reality that his own most signal literary offering is the multivolume epistolary novel *From a Broken Bottle Traces of Perfume Still Emanate*—Mackey has focused the majority of his indispensable critical analysis not on prose narrative and its variations but on poetry as such, which in most commentary on the subject (by, for instance, Aldon Nielsen, Evie Shockley, and Tony Bolden, in addition to Mackey) appears

as the unexamined default locus of black literary experimentation.[25] Alternatively—or, again, simultaneously—formally innovative black writing in whatever genre is assimilated to a larger radical aesthetic project that manifests (mutatis mutandis but still comprehensively) across multiple forms of artistic practice. Thus, in his own indispensable account, Fred Moten demonstrates how novelistic, verse-poetic, and critical writings (by the likes of Ralph Ellison and Amiri Baraka, among others) join with musical collaborations, spoken-word productions, jazz and soul recordings, and conceptual performance pieces (by such artists as Max Roach, Abbey Lincoln, and Oscar Brown, Jr.; Cecil Taylor; Billie Holiday; Marvin Gaye; and Adrian Piper) in registering a distinctive experiential blackness that is itself "an avant-garde thing."[26]

To the extent that the means of that registration approximate the aesthetic abstractionism that is the focus of this volume, Moten and I are clearly working in concert; but while Moten is concerned to show the wide variety of artistic activity in which a radical black aesthetics is discernible, I am interested in identifying the particular artistic context in which black abstractionist aesthetics is most critically *effective*, which is to say that my objective is more tightly focused than his. As for the centrality of poetry within considerations of black experimental writing, this is no doubt largely due to a pervasive sense that it is poets, more than any other type of writer, who "test the limits of language," as Aldon Nielsen has put it.[27] While this of course might well mean that any writer who tests those limits—through whatever generic form—is by definition a poet, practically speaking it has meant that most of the critical attention garnered by black literary innovation, such as it is, has been accorded specifically to verse.[28] Then, too, insofar as black music is the avowed model for African American literary experiment—as it certainly has been for Baraka and many of his successors, including some of the commentators cited here—it perhaps stands to reason that such experiment should be sought after primarily in poetry, which clearly shares music's concern with rhythm, phrasing, sound patterning, and the like.[29] To suggest this, however, is both to imply that nonverse literary genres cannot further musically derived projects and to underplay nonmusical sources of black literary innovation,

while to claim poetry as the prime site for linguistic experimentation is potentially to limit the impact of that experimentation by circumscribing it within a realm where it already appears routine. Although I am relatively unconcerned in this volume with the specific impetuses behind any given abstractionist venture, I am very much interested in maximizing the critical effect of abstractionism per se, and it is for this reason that I trace its operation in prose, the ubiquity and seeming transparency of which potentially underwrite precisely that maximization.

A concomitant of *Abstractionist Aesthetics*' polemical character is that the work is also an *essay* in the true sense—a trial inquiry that, in this particular case, moves more or less inductively from point to point as these are suggested by the occasional evidence at hand. The argument overall is thus meant to be associative but not by that token illogical; whether it succeeds in this regard must be determined by the reader. For my part—and notwithstanding my advocacy of abstractionist disruption—I have tried to honor the book's essayistic character by presenting my case in as unitary and unmediated a narrative-expository voice as I could muster. Practically speaking, this means that while I base my claims on a wealth of prior scholarship, I do not in the text explicitly announce my every mobilization of earlier critical work or regularly name the other commentators on whose insights I draw. This strategy is meant to provide for maximum fluidity, and it should not be taken to imply that my account is not informed by the contributions of thinkers from a wide variety of fields. The reader is urged to consult the notes, which are both plentiful and extensive, in order to identify the basis for any assertion that incites curiosity, and to take stock of my extensive intellectual debts. The more immediate and personal of these I am pleased to indicate in the Acknowledgments, which appear at the end of the book.

Black Personhood in the Maw of Abstraction

It may be hard to imagine at this point, but there was a time, during the late 1990s, when the acclaimed visual artist Kara Walker was the target of intense criticism from fellow members of the African American creative community.[1] The problem, according to her antagonists—chief among them the prominent assemblage artist Betye Saar, who registered her opinion in a widely circulated condemnatory letter—was that Walker routinely presented "negative images" of black people; the evidence was scenarios such as we have in figure 3, in which, as one critic declared in 1997, "a bearded white man puts his head between the legs of a naked girl so young that her breasts have not begun to swell"—a characterization meant to substantiate the author's charge that Walker's work overall depicts an inordinate number of "prepubescent black girls being sexually abused or hypersexed."[2] That similar accusations of "negative" portrayal have been made against other African American artists in the ensuing years indicates the ongoing relevance of the issues taken up in this volume.[3] The now relatively distant Walker controversy remains exemplary for my purposes, however, because it renders explicit not only the mode of audience reception that informs all such disapproving responses (and whose cogency I

3 Kara Walker, *Presenting Negro Scenes Drawn upon My Passage through the South and Reconfigured for the Benefit of Enlightened Audiences Wherever Such May Be Found, by Myself, Missus K. E. B. Walker, Colored,* 1997, detail. Cut paper on wall, installation dimensions variable; approximately 144 × 1,860 in. (365.8 × 4,724.4 cm). Copyright © 1997 Kara Walker. Reproduced courtesy Sikkema Jenkins & Co.

would like to query) but also the mode of representational aesthetics that I wish to promote, for the sake of its distinctive social-critical potential.

The reception protocols to which I allude are epitomized in the previously cited observation regarding the depicted female figure's as-yet-undeveloped breasts. On the one hand, this remark registers a commitment to representational realism that appears wholly appropriate insofar as Walker's rendering itself evidently deploys certain visual cues familiar to us from "real life" (i.e., the relative smallness of the figure's breasts) to signal certain facts likewise made conceivable by our knowledge of said life (i.e., the figure's comparative youthfulness), in a manner whose intelligibility similarly derives from our real-world experience. On

the other hand, though, the very grammar of the assertion suggests that its apparently reasonable interpretive realism is being made to further a *literalist* understanding that is much more problematic: specifically, by positing through a negative past-participle formulation that the depicted figure's breasts "have not begun to swell," this account somewhat oddly implies that, eventually, they *will* begin to do so, as though what the artwork presented were not a representational paper cut-out (comprising as it does Walker's signature mode of the excised silhouette) but rather a live human being whose progress through puberty we would be able to discern in her bodily development if only we were at liberty to observe her in the gallery over several years' duration.[4]

The actual infeasibility of this latter proposition attests to the limits of the realist reception protocol that this instance of Walker's work otherwise seems to demand, for it shows up the limits of the pictorial verisimilitude on which the validity of that protocol depends. However closely it might approximate the appearance—and hence conjure the notion—of a preexistent lived reality to which it is thus understood to refer, pictorial depiction nevertheless cannot figure the change over time that is itself a defining feature of that lived reality, and so to that extent is precluded from ever manifesting as fully true to life. Neither a failing to be condemned nor a fault to be corrected, this fact is rather the local instantiation of a general truth about all representational depiction—namely, that it necessarily exists *at a remove from* even those real-world phenomena its resemblance to which is its most notable trait. To put the matter in the terms that I believe are centrally—if tacitly—at issue in such debates about "negative images" as the one under discussion here, let us conceive of this removal as a mode of *abstraction*, understanding the word in its most basic etymological sense to mean simply a state of *withdrawal* from some originary point.[5] One consequence of our thus allowing that every instance of representation is characterized by such a broadly defined condition of abstraction is that we immediately recognize that all art is in this most general sense "abstract," whether it officially circulates under that rubric or not; and to recognize this is merely to remind ourselves that an aesthetic representation is by no means the same thing as the "reality" to which it may seem to refer.[6]

It is of course the characterizations of Walker's work previously cited that suggest to me that we do in fact need to be reminded of this admittedly elementary point, the implication of which is not just that the breasts of Walker's female figure never *will* develop further but, more important, that the criteria by which Walker's depictions are judged to be "negative" are invalid for the modality the work assumes. In other words, it isn't simply that these determinations of negativity are at best highly contingent and at worst wholly subjective, although this is in fact the case. (Couldn't the depiction of "sexual abuse," which anyone who believes in the concept would concur is irredeemably negative, actually encourage viewers to combat the offense within the societies they inhabit, and thus be understood as an effectively "positive" event? Doesn't the very idea of "hypersexuality" presuppose an absolute maximum acceptable level of human sexual interest and activity on which there is in reality no societal agreement, and even the mere existence of which many individuals would dispute?) Rather, it is that the phenomena on which these determinations rest are themselves scarcely manifest in the pictorial domain.

"Sexual abuse," for example, depends by definition on factors of consent that can be clarified only through a review of the circumstances under which it is alleged to occur. It thus must inevitably be a function of context, and *context* must comprise a state of affairs that to some extent preexists and, in any case, evolves in relation to the allegedly abusive activity. Its previously cited incapacity to figure development over time, however—or, for that matter, even to register temporal sequence—renders pictorial depiction incapable of indicating what factors inform the "actions" it represents; and the consequent impossibility of properly assessing context within the pictorial realm disallows any claim that Walker's installations portray what can be unproblematically termed "sexual abuse."[7] "Hypersexuality" is similarly dubious insofar as it entails a putative excess that is apprehended primarily in terms of iterative frequency. Even if a picture might circumvent its basic inability to represent repetitive action and otherwise establish its depicted subject as prodigiously carnal (by presenting her as sexually engaged with multiple persons simultaneously? by portraying her consorting with the first in a queue of individuals, each evidently

awaiting a turn?), its recourse to these stratagems would itself register the representational limits that it thereby managed to evade.[8] For its part, the Walker piece under consideration here does not even attempt such maneuvers, forgoing any effort to convey either the factors in or the implications of the activities it depicts. It thereby acquiesces both to the standard limits on pictorial representation noted earlier and to its own status as precisely an *instance of* such representation, as distinct from the lived reality within which such phenomena as "sexual abuse" actually occur.

Of course, Walker's tableau most certainly bears a *relation* to that lived reality, telegraphing such real-world matters as racial and gender identity through the naturalistic precision of its graphic outline. Indeed, not only does that precision enable the critic cited earlier to charge that Walker has presented a "prepubescent black girl" (fronted, moreover, by "a bearded white man")—and me, conversely and paradoxically, to suggest that she has in fact portrayed a pregnant young black woman whose breast rests lightly on her protruding belly; it also establishes Walker's work in general as an engagement with antebellum southern-U.S. plantation life and, by extension, as a commentary on the continuing melodrama of national black-white race relations.[9] By thus clinching not just the depiction's referential purchase but also its historical import, the exactness of Walker's delineation evidently authorizes a wholly realist account of the work's significance; and if any such account verges into the sort of literalist understanding that I call into question here, this is arguably due simply to the undeniable accomplishment of Walker's representational craft.

While the rendering is distinguished by Walker's characteristic lineal accuracy, however, that precision also informs elements in the scene that actually *mitigate* the latter's evident realism. Slightly toward the foreground of the composition and just to the left of where the two previously discussed figures appear, there sits a large, brimful washtub, a toy sailboat floating on the rightward portion of the bath surface, and the top half of a black child's head—telltale hair plaits and all—emerging through that surface to the left. And beyond the mere incongruity of this image and the

seeming cunnilingus scenario, there is the complete abeyance of realist effect, whereby, for instance, the items that the woman is hanging are not clipped to a line at all but simply festooned in midair, with nothing even to suggest a clothesline except for the placement of the pins themselves. More strikingly still, the farthermost portion of this only-hinted-at wire bears not a standard laundry article but a full-size man, pinned up in a prone position just by the shoulder blades and at the back of the knee, his head aimed rightward and his feet to the left, arms seemingly tied behind his back with a rope or a strip of cloth. He looks to be gazing down at the decrepit fence, random floorboards, and stray vegetation clustered to the left and slightly back of the washtub. His hair hangs off his forehead as lank as that of the other male figure, and this, along with his facial profile, makes him appear white as well. Additionally, he seems to be dressed like the other white figure, in a full suit of clothes, and these latter may account for the anomalous protrusions at the front of his body: it *could* be the loose-hanging tail of his jacket that dangles near his crotch at the underside of his outstretched form; it *might* be his shirt and tie that gather into distinctive folds at his breast—but this is by no means sure, as the contour at his chest looks far too much like the facial profile of yet another white man, and the fin-shaped wedge that tapers to a slightly upturned point at the vicinity of his groin curves far too uniformly to be caused by the haphazard drape of his clothing.

The very uncertainty that they generate confirms that these figural peculiarities—like the bodily levitation also at play in the scene—do not correspond to any conventional human experience, while the discrepancy between the washtub vignette and the apparent sexual situation contravenes the thematic coherence that is a hallmark of realist representation. Thus, beyond the mimetic fidelity to real-world entities that it indisputably seems to achieve, Walker's tableau also presents fantastical or absurd elements that offset that mimeticism's realist significance, making it questionable whether the work overall can sustain the sort of realist interpretation on which the charge of negative portrayal necessarily depends.[10] Indeed, if its figural lifelikeness encourages us to imagine that Walker's work is wholly continuous with the reality it is understood to depict—as

though its silhouette forms were in fact the shadows cast by real-world entities at a particular moment of lived experience—the incongruous aspects of the composition vigorously assert the distinction between reality and representation, firmly installing the work itself within the latter domain. Then, too, inasmuch as certain items in the scene (the washtub, the kneeling man) cast their *own* "shadows," the silhouettes clearly cannot comprise shadows of the phenomenal world at all, but instead manifest as precisely what they are: static, two-dimensional, monochromatically shaded outlines produced through human handicraft.[11] The irrefutably artificial quality of these forms thus registered, their minute verisimilitude does not counter but actually *concerts with* the tableau's compositional dissonances to affirm the work's divergence from the reality it connotes.

In thus showing up its distance from the phenomenal world (to which it might otherwise—and even simultaneously—mimetically refer), an artwork does nothing other than underscore its own fundamentally *abstract* condition in the sense elaborated earlier—a function traditionally understood to be typical of abstract art per se. Indeed, a prominent strain within modernist criticism of the mid-twentieth century famously holds that, in shunning frank representation, abstract art by default (and by definition) takes as its thematic focus the terms and means of its own existence, thereby revealing itself as nothing more than a set of materials intentionally fashioned in a certain way so as to produce a certain effect. Thus geared to impress on audiences not just the simple materiality of the artwork but also what we might call the *mode of its being* as artwork, instances of such practice may with respect to *objective facticity* appear even *less* abstract than works designed to achieve realist verisimilitude, in that they powerfully affirm their undeniable status as substantive entities within the phenomenal realm; they appear as maximally abstract, however, when considered in terms of *representational referentiality*, long a critical touchstone within Western visual aesthetics in a way that the assertion of objective facticity has not been.[12] It is for this latter reason that resolutely nonrepresentational work is understood to *epitomize* the

abstract in art; and, in a corollary to the critical commonplace cited earlier, work thus registering as abstract and evidently attending to the conditions of its own existence rather than to some external referent is understood to be primarily "about" nothing other than itself.[13]

It would obviously be inaccurate and nonsensical to say that Kara Walker's silhouettes are about nothing other than their own status as pictorial renderings, for as we have already remarked, they clearly adapt imagery from a crucial period in U.S. history and so effectively refer to—and are to that extent *about*—that earlier moment and its legacies. This is to say that Walker's work is not fully *abstract* according to the conventional meaning of the term. In unabashedly asserting its artifactual character in the manner we have noted, however, Walker's work does attain to the aesthetic mode that I designate as *abstractionism*, and this significantly complicates the import of its real-world reference, forcing the question of exactly *in what way* the work is "about" the historical phenomena it evidently engages. As is made clear by the tableaux themselves—or, if not, then at least by the foregoing discussion—Walker's work by no means depicts historical reality "as it is," in the form in which it is empirically observed. Nor, for that matter, does it depict life *as it might be*, inasmuch as its figures—however meticulously verisimilar they appear—are presented in the kind of egregiously impossible situations cited earlier. Indeed, if Walker offers images of black people that cannot be taken as "positive," this is not because she has opted to render them "negative," as her critics allege, but because she altogether eschews the mode of *positivist* representation—that is, the committed depiction of that which either objectively does or plausibly might exist—that makes any such judgment possible. Flaunting the deliberate artifice by which it so precisely evokes a particular recognizable historical reality, Walker's work does not so much assert (let alone endorse) the manifest existence of that reality as remind us that it, too, results through human activity and hence is alterable along potentially salutary lines.[14]

This is, of course, entirely in keeping with the Brechtian *alienation* discussed in the introduction, and if Walker's silhouettes thus accord with Brecht's epic theater in similarly redirecting our attention away from

themselves and toward the prospective betterment of our own social reality, they should by that very token be seen as wholly unproblematic instantiations of African American expressive culture, which is traditionally understood to do exactly the same thing, with respect to racial politics in particular.[15] Indeed, even if they neither indicate exactly what should be altered in the historical reality they adduce nor sketch specific scenarios that would characterize a properly meliorated society (both typical strategies in the realist aesthetics that conventionally governs African American cultural practice), in their extraordinary figural intricacy and exactitude Walker's tableaux do assert the power of *human ingenuity per se*—our sheer capacity to engineer both the forms of our aesthetic experience and the conditions of our social existence—and this arguably constitutes them as politically committed works par excellence.[16] To put the matter in more general terms, the aesthetic abstractionism exemplified by Walker's work potentially expands our sense of political possibility, in that it opens unrestricted onto the world at large and invites us to imagine what we might do to transform it.

According to the abstractionist paradigm just sketched, then, an artwork's reference to real-world phenomena makes those phenomena available for critical interrogation, whereas within the type of realist program evinced by Walker's detractors, it evidently affirms their status as immutable givens.[17] Hence, not only do aspects of Walker's work vigorously militate against its being apprehended in these latter terms, as previously noted, but it would seem that abstractionism should comprise the preferred mode for receiving that work among viewers who maintain a customarily African Americanist investment in social critique—and who find distinctly unpleasant the historical reality that Walker cites. Cultural custom is a notoriously overdetermined affair, however, and even if we insist that Walker's silhouettes should compel an abstractionist engagement by virtue of their showcasing their own artificiality, we must also admit that the very abstractive logic that informs them constitutes a practical barrier in this regard, in that it has historically been mobilized to black people's

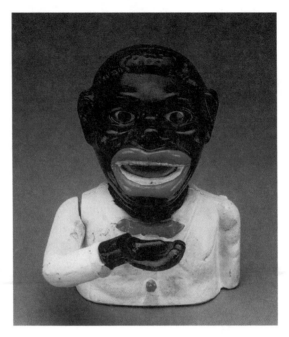

4 "Jolly Nigger" mechanical bank, ca. 1882. Collection
 of Kenneth W. Goings. Reproduced, by permission,
 from Goings, *Mammy and Uncle Mose: Black
 Collectibles and American Stereotyping* (Blooming-
 ton: Indiana University Press, 1994).

detriment, and so has long elicited not sympathetic acquiescence but stud-
ied *resistance* within African American culture.

Walker's tableaux themselves suggest how such detriment has been
furthered by visual means, inasmuch as they recall a long-lived graphic
tradition that similarly combines clearly referential and obviously imag-
ined elements, but whose deployment vis-à-vis black people has entailed
indisputably prejudicial intent. Epitomized in the profusion of explicit
black-derogative imagery that circulated throughout the U.S. in the de-
cades following Reconstruction (see, for example, fig. 4)—the so-called
"nadir" of African American communal experience—the tradition at issue
here is that of figural caricature, which evokes its object precisely by pre-
senting an *exaggerated* (i.e., imaginatively emphasized) rendering of the
latter's supposedly most *distinctive* (i.e., referentially denotative) features,

whether these be specifically physiognomic characteristics or discrete ac-
coutrements widely associated with the represented personage (the green
carnation in Oscar Wilde's lapel or the white gardenia in Billie Holiday's
hair, to name two floral examples).[18] Furthermore, and as the example of
nadir-era black imagery itself indicates, a caricatural referent might be so
broadly conceived as to comprise a whole class of persons, rather than
just the single individual typically evoked in comic celebrity portraiture.[19]

As this summation makes clear, caricature in its practical function bla-
tantly contravenes the abstractionist principles that my earlier account
suggests it should exemplify: while its artful exaggeration so patently di-
verges from realist verisimilitude that viewers are obliged to admit that its
depicted subject doesn't really look "like that," it also paradoxically *con-
firms* for them who that subject "*really is*," thus solidifying that figure's
received social significance rather than unsettling it in the abstractionist
manner outlined earlier.[20] If this implies that visual abstractionism is es-
sentially less sure in its effects than I have intimated is optimally the case
(a point to which I return later in this chapter), it also explains the wary
critical reaction to the Walker tableau discussed here, whose female figure
does indeed present a generically "Negroid" facial profile combined with
the historically resonant delineation of the servant's kerchief, and so very
likely *would* evoke the collectivity of African American women among
viewers of the work. Given that this female figure also seems to be engaged
in sexual activity (and, at the same time, not especially engaged *by* it), the
depiction might further be understood to affirm that collectivity's wan-
tonly lascivious or "hypersexed" character—but only insofar as general-
ized presuppositions along those lines already inform the cultural context
into which the silhouettes emerge. In other words, what late-1990s critics
of Walker's work evidently feared was that, in appearing to draw on ste-
reotypical ideas about African Americans—perhaps especially about Af-
rican American *women*—Walker's representations would serve to confirm
those ideas rather than to combat them, just as earlier black-caricatural
imagery is understood to have done. Their response to the silhouettes
accordingly replicated African Americanist reaction to those derogatory
caricatures, defensively asserting black people's actual dignity and respect-

ability over against the evident distortions promulgated in the visual material. This move was bound to constitute an interpretive mishap, since it is precisely *through* such distortions that Walker's work registers its own racial-political critique, so that to reject them is to miss that critique altogether. Considered with respect to the historical record, though, it is also to repudiate the representational *abstraction* to which black people have routinely been subjected—their prejudicial depiction as other than they "really are"—and is in this regard entirely understandable.

Indeed, if African American cultural history catalogs numerous strategies for thus resisting the effects of abstraction, this is because those very effects are not only plentiful but also insidious, often manifesting so imperceptibly that their pervasiveness is as easily denied as it is deeply felt. Betye Saar has in fact forwarded such resistance in her own artwork, recasting dubious figures such as Aunt Jemima as exemplars of strength and autonomous agency in pieces whose effect, by Saar's account, is to "empower the stereotype" rather than to perpetuate it, as she evidently believed Walker's silhouettes to do (fig. 5).[21] While it may be difficult to distinguish objectively between the two artists' accomplishments in this respect, the more crucial point for our purposes is that Saar claims to have developed her approach as a result of her having since the 1970s actually *collected* vintage black-caricatural knickknacks (now widely traded under the euphemistic rubric of "black Americana"), thereby seeing firsthand "how dangerous" their imagery is.[22] If that danger seems to have been neutralized in Saar's own case, as is evidenced by her retooling the imagery to her purpose, the means by which this was achieved are apparently shared by other commentators, who have similarly cited their immersion in the offensive materials. In a landmark 1994 volume, for example, the folklorist Patricia Turner attests that she "sometimes forget[s] that many people are unsettled and disturbed" by the very items whose racial caricature she herself deems "contemptible," attributing this lapse to her having spent "more than a dozen years . . . collecting, classifying, analyzing, and teaching about" such objects.[23] Likewise, having unequivocally

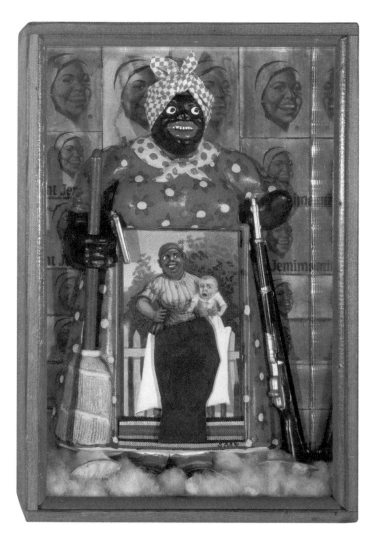

5 Betye Saar (b.1926), *The Liberation of Aunt Jemima*, 1972. Mixed
 media assemblage, 11¾ × 8 × 2¾ in., signed. Collection of University
 of California, Berkeley, Art Museum; purchased with the aid of
 funds from the National Endowment for the Arts (selected by The
 Committee for the Acquisition of Afro-American Art). Courtesy of
 Michael Rosenfeld Gallery, LLC, New York, NY. Photograph by
 Joshua Nefsky.

asserted that the caricatural material "induces the viewer consciously and unconsciously to accept the stereotypes that the objects themselves portray," the historian Kenneth Goings nevertheless proclaims that when he himself considers the stock characters evoked by that portrayal, he "think[s] of them as people"—seeing Aunt Jemima "not as a cook but as a fighter for freedom" and Uncle Mose "not as the faithful butler but as an activist and orator"—his capacity in this regard evidently stemming from his having accumulated "several hundred" instances of that selfsame material.[24]

As Turner's reference to "classifying, analyzing, and teaching" implies, the ability of these commentators to resist what they themselves contend is "black Americana's" prima facie racism apparently derives from their having been able to subject the material to prolonged study, which depends in turn on their having *collected* it in the first place.[25] This stands to reason, inasmuch as any assortment of objects must necessarily be brought under a state of arrested circulation before it can be examined for its overall significance, but it also suggests the subjective enhancement that stems from proprietorship as such, whereby the scope of one's command increases in proportion with the extent of one's holdings.[26] This would account for the prodigious numbers by which our commentators characterize their own acquisitive exertions—not just the "more than a dozen years" Turner spent amassing her collection or the "several hundred items" Goings managed to procure, but also the "many, many things" in the category of "black memorabilia" that the activist, historian, and former legislator Julian Bond attested to owning during a March 1998 roundtable, and the extraordinary quantity of articles to which the literary and cultural critic Henry Louis Gates, Jr., lay claim in 1988 by writing, "*I* have a collection of ten thousand racist visual images of blacks from between 1800 and 1940," the italicization not only suggesting that countless such items must have originally existed if so many are in the possession of a single person as much as a century and a half later, but also underscoring the agential subjectivity that is designated by the pronoun "I" to begin with, whose potency here seems a function of the collection's very extensiveness.[27]

The irony, of course, is that the regime of property through which these commentators manage the threat of black-caricatural abstraction was itself the locus of black people's deleterious *social-political* abstraction in the context of American commodity slavery—that is, their conceptualization in collective terms as a massified source of relatively skilled and fully expropriable labor, and in individual terms as entities more or less interchangeable with one another and fully *ex*changeable for other items held as property.[28] Thus reduced to a lowest-level commonality in which their very humanity was annulled, black people assumed a condition of *abstraction* whose import was wholly negative. Just like the property relation, however—which can now be adopted and mobilized by African Americans themselves—abstraction is neither good nor bad *per se*, its value instead depending on the functions it is made to serve and the perspective from which it is assessed. Indeed, at the very moment that plantation slavery was being consolidated as the foundation of the U.S.-national economy (and leaving aside that from this angle black people's abstraction constituted an absolute boon), abstraction provided the conceptual means whereby certain members of the population saw their own personhood *optimized* rather than negated, with all the benefits that implies.[29]

It is, after all, widely known that citizenship in the early republic was restricted to "white, landowning male[s]," as one influential scholar has succinctly put it, their eligibility in this regard deriving from their understood capacity for the personal disinterestedness necessitated by democratic-republican government.[30] A mode of "popular rule" wherein the people's business is in fact forwarded by delegated agents, the latter system presumes uniformity and equivalence among all recognized citizens such that any one of them could effectively stand in for the others in the halls of state.[31] Such conformity implicates a disavowal of individual interest whose import is as much intellectual as moral, as it bespeaks not only a selfless preferment of the common good but also the valuation of general principles over concrete particulars—a mode of *abstract* reckoning that is understood as the very epitome of rational thought. Their sameness with one another thus predicated on their putatively unique capacity for virtu-

ous reason and securing their fitness for governmental participation, white American yeomen sustained a condition of abstraction that, while approximating the entailments of chattel slavery, actually *enhanced* their social-political subjectivity and so manifested as a thoroughly positive affair.

<p style="text-align:center">▬▪ ▪ ▪</p>

This mode of abstract personhood, which effectively comprises a platonic ideal, can even be said to have its own graphic emblem, conceived by one of the very founders of the republic and promulgated to this day in his autobiography. Having decided to pursue "the bold and arduous Project of arriving at moral Perfection," Benjamin Franklin in 1733 famously devised a repeatable thirteen-week course for "acquir[ing] the *Habitude*" of the thirteen specific "virtues" of which he understood that perfection to consist:

> I made a little Book in which I allotted a Page for each of the Virtues. I rul'd each Page with red Ink so as to have seven Columns, one for each Day of the Week, marking each Column with a Letter for the Day. I cross'd these Columns with thirteen red Lines, marking the Beginning of each Line with the first Letter of one of the Virtues, on which Line & in its proper Column I might mark by a little black Spot every Fault I found upon Examination, to have been committed respecting that Virtue upon that Day.
>
> I determined to give a Week's strict Attention to each of the Virtues successively. Thus in the first Week my great Guard was to avoid every the least Offence against Temperance, leaving the other Virtues to their ordinary Chance, only marking every Evening the Faults of the Day [fig. 6]. Thus if in the first Week I could keep my first Line marked T clear of Spots, I suppos'd the Habit of that Virtue so much strengthen'd and its opposite weaken'd, that I might venture extending my Attention to include the next, and for the following Week keep both Lines clear of Spots. Proceeding thus to the last, I could go thro' a Course compleat in Thirteen Weeks, and four Courses in a Year. . . . So I should have, (I hoped) the encouraging Pleasure of seeing on my Pages the Progress I made in Virtue, by clearing successively my Lines of their Spots, till in the End by a Number of Courses, I should be happy in viewing a clean Book after a thirteen Weeks daily Examination.[32]

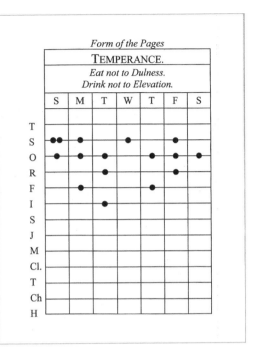

Form of the Pages

TEMPERANCE.						
Eat not to Dulness.						
Drink not to Elevation.						
S	M	T	W	T	F	S

	S	M	T	W	T	F	S
T							
S	●●	●			●	●	
O	●	●	●		●	●	●
R			●		●		
F		●			●		
I				●			
S							
J							
M							
Cl.							
T							
Ch							
H							

Form of the Pages

TEMPERANCE.						
Eat not to Dulness.						
Drink not to Elevation.						
S	M	T	W	T	F	S

	S	M	T	W	T	F	S
T							
S							
O							
R							
F							
I							
S							
J							
M							
Cl.							
T							
Ch							
H							

6 Benjamin Franklin, sample table from the plan for moral perfection, as presented in the *Autobiography*.

7 Emblem of the perfected Franklinian subject.

Notwithstanding his ultimate disappointment on this score (in particular, he discovered himself to be "incorrigible with respect to *Order*," the third of his designated virtues), Franklin does give us a distinct form for the "clean book" he theoretically might have achieved, which figures nothing so much as the perfected Enlightenment subject who would later be posited as the ideal republican citizen (fig. 7)—largely by virtue of its essentially figuring nothing at all.[33] Indeed, taken on its own, without being expressly keyed to any of the various things it might intelligibly denote—whether mimetically (e.g., a tiled floor or a window screen) or suppositionally (e.g., the graphed relation between two sets of data or the perfected Franklinian subject itself)—the *grid* doesn't signify anything except the very principle of abstraction it consequently exemplifies,

disassociated as it is from all the other objective phenomena to which it could possibly refer. Recruited to the project of figuring the moral perfection of the proto-republican citizen, its consummate blend of faultless uniformity and ordered regularity aptly emblematizes not only the noble genericism but also the supreme rationality that citizen was understood to epitomize.[34] By that same token, of course, it also figures the absolute exclusion of blacks (and other non-white-male persons) from the polity, inasmuch as they were considered incapable of either sublimating their particular interests or eradicating their vicious tendencies (both of which were held to be intractable elements of their blackness itself), and deemed wholly devoid of the capacity for reason.[35]

Considered in this way, the ostensibly innocuous grid construct is effectively an avatar of the white-masculine form itself, whose own supposed generic-representative character has made it the archetypal image of everything from the citizen-soldier (fig. 8) to the prospective consumer (fig. 9). Such figurations inevitably inflict a measure of cognitive violence, essentially compelling one to "let this white-masculine form represent all those who died serving the United States in World War I" (or, as the case may be, "all those who might eat hot cereal"), despite the evident fact that not all such individuals are directly referenced by the depiction. Indeed, in acquiescing to such a mandate—necessary if one is to make useful sense of the rendering at hand—one inevitably participates in a self-perpetuating exaltation of white-maleness that is powered by the latter's doubly normative quality: objectively characterizing the numerical plurality of those in the U.S. who enjoy the legitimating effects of wealth, education, and official political clout, white-maleness properly attains to a condition of *statistical predominance* that underwrites its far more specious function as a *standard of valuation* for society members at large.[36] Paradoxically but yet undeniably providing the gauge for his own appraisal, against which everybody else is evaluated too, the white male person is thus destined to appear manifestly excellent in the assessment of social worth that is always tacitly afoot in the culture—all the more so given that his routine function

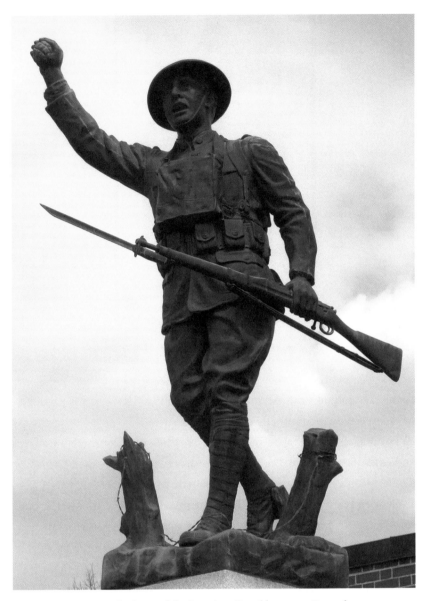

8 E. M. Viquesney, *The Spirit of the American Doughboy*, 1920. Pressed copper, life-size. Located at VFW Post 1308, Alton, IL. Photograph by Beverly Bauser, copyright © 2011 Beverly Bauser. Reproduced, by permission, from the Madison County ILGenWeb website: http://madison.illinoisgenweb.org.

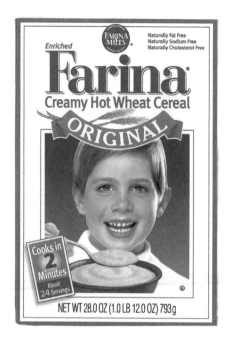

9 Box cover for Farina cereal, ca. 2010,
Farina Mills.

as the representative of personhood as such itself *furthers* his predominance in the sociocultural field.

From a certain perspective, of course, this situation merely updates and extends a classical-European tradition in which the male form was similarly conceived as the epitome of a paradoxically generic perfection. Writing in the first century BCE on the standards to be met in the construction of temples, the Roman engineer and architect Marcus Vitruvius Pollio proclaimed that such edifices must manifest a symmetry akin to the bodily proportions "of a well shaped man" (*hominis bene figurati*).[37] The qualifying phrase clearly indicates that the point of reference here is not any personage taken at random but rather the comparatively rare prime physical specimen, whose ideal relative measurements are detailed at length in the succeeding paragraph of the tract. Subsequently returning to the "harmony" that should characterize "the symmetrical relations of the different parts [of a temple] to the general magnitude of the whole," Vitruvius continues his analogy by stating that, just so,

in the human body the central point is naturally the navel. For if a man be placed flat on his back, with his hands and feet extended, and a pair of compasses centred at his navel, the fingers and toes of his two hands and feet will touch the circumference of a circle described therefrom. And just as the human body yields a circular outline, so too a square figure may be found from it. For if we measure the distance from the soles of the feet to the top of the head, and then apply that measure to the outstretched arms, the breadth will be found to be the same as the height, as in the case of plane surfaces which are perfectly square.[38]

Here, of course, is the pattern for the celebrated "Vitruvian Man," most famously rendered by Leonardo da Vinci (though by no means *only* by him), in a drawing completed around 1490 (fig. 10). Of greatest interest for our immediate purpose, however, is not the specific description of that figure that the foregoing excerpt provides but the unqualified manner in which it registers its assertion. Rather than invoking the "well shaped man" that the earlier paragraph explicitly adduces, this passage instead declares simply that the appropriately arrayed body of "a man"—that is, of *any* man—would describe either a true circle or a "perfect" square. While the discrepancy appears quite minor—and indeed is effectively resolved if we assume that our understanding of the phrase "a man" should be conditioned by the reference to the "well shaped" exemplar that precedes it—the point is precisely the ease with which the treatise paradoxically assimilates the "common" "man" not simply to superlativeness as such (thereby enacting the same process of normative idealization that was queried earlier) but to a superlativeness that it simultaneously figures in terms of the geometrically regular form, since in so doing it decisively casts the latter as the emblem both of perfection itself and of human genericism per se.[39]

Of course, the human excellence propounded in this scheme is "generic" only within certain well-defined limits, inasmuch as elsewhere in the same work Vitruvius claims that, in contrast to African and Indian peoples, on the one hand, and Nordic and Germanic ones, on the other, "the races of Italy are the most perfectly constituted . . . in bodily form and in mental activity to correspond to their valour" and thereby are afforded

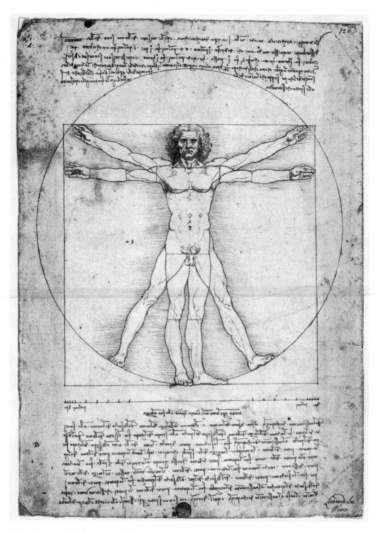

10 Leonardo da Vinci, "Vitruvian Man," ca. 1490.

"the right to command the whole world."[40] By the time the Vitruvian ideal was resuscitated in the Renaissance-era adaptations exemplified by Leonardo's drawing, the advent of modern racial and religious thought would have begun to modify the import of such chauvinism, recasting it in the interest of a broader Christian ideal that was itself exemplified in sacred architectural design (fig. 11), the European-masculine template for which was now fully invested with the grid's own ordered regularity (fig. 12).[41]

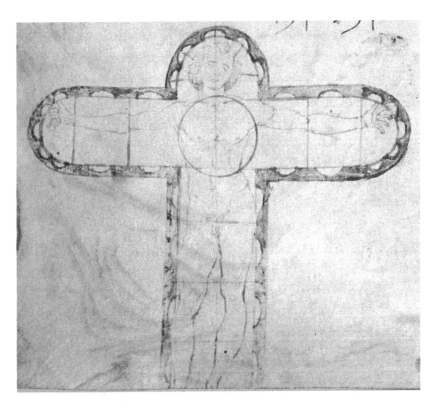

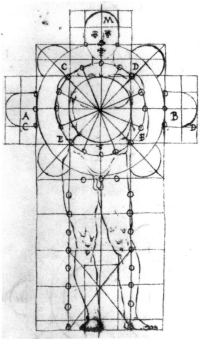

11 Francesco di Giorgio,
 design for cruciform church,
 fifteenth century CE.

12 Francesco di Giorgio, church
 plan overlaying masculine
 figure with grid pattern,
 fifteenth century CE.

Indeed, the latter move perfectly illustrates the circular and self-fulfilling character of white-masculine social and cultural hegemony, in that the grid's geometrical perfection here sublimates a human form that has already been posited as ideal by being adopted as a structural template to begin with. If this is all the more the case in the context of early modern cruciform church design, where the mere mortal is recruited to the attitude iconically assumed by an impassioned Christ, it is worth remembering that that attitude itself was necessitated by the specifically *human* incarnation in which Christ became susceptible to crucifixion in the first place. Early modern church design consequently indexes *both* divine perfection *and* noble humility, and while this makes it difficult to tell whether what is being extolled is the human form in its most exceptionally fine or its most broadly typical manifestation, there is no ambiguity as to that exemplary form's European-masculine character, which partakes of the perfected genericism of the grid itself.

<hr />

To the extent that the grid *has* thus been posited as cognate with the white-masculine figure, both it and the abstraction it connotes might well be expected to elicit suspicion within African American culture, just like the abstractive distortion of racial caricature. Sure enough, in his 1971 verse treatise on "The Nature of the Grid," Michael S. Harper indicts the latter for instantiating a brutally severe Apollonian rationality whose ultimate destructiveness is indiscriminate and total:

> This grid, ideal,
> intersecting squares,
> system, thought,
> western wall,
> migrating phoenix,
> death to all.[42]

In an interview given two years later, Harper is even more explicit, describing a companion poem to the just-cited work as being "essentially . . . about imperialism" and proposing that, within it, the grid represents "dominion

A SECTION OF LAND—640 ACRES.

A rod is 16½ feet.
A chain is 66 feet or 4 rods.
A mile is 320 rods, 80 chains or 5,280 ft.
A square rod is 272¼ square feet.
An acre contains 43,560 square feet.
 " " " *160 square rods.*
 " " *is about 208¾ feet square.*
 " " *is 8 rods wide by 20 rods long,*
 or any two numbers (of rods) whose
 product is 160.
25x125 feet equals .0717 of an acre.

CENTER **OF** **SECTION.**

Sectional Map of a Township with adjoining Sections.

13 Surveying diagram, Land Ordinance of 1785.

over all things. But," he continues, "black people can't function in that particular vision of the grid. They're expendable, they've been annihilated; and not only black people but nonwhites or pagans or Indians or anyone or thing in the way of this particular vision, with its armies, navies, and its technological system."[43]

Hyperbolic though this characterization may seem, it is in fact borne out by the United States' own political-geographical history, with Congress having just two years after the Revolution decreed that unsurveyed land to the north and west of the Ohio River and the Appalachian Mountains should be apportioned into regularized "townships" of six miles square, each one subdivided into thirty-six one-square-mile "sections" (fig. 13).[44] Easily implemented, readily understood, and a boon in the efficient deter-

mination of property lines, the resulting orthogonal schema forestalled a wholly disorderly advance on the land even as it fostered rapid appropriation of the affected regions and thus promoted U.S. identification among settlers who might otherwise have formed alliances with the Spanish localities toward the Pacific coast.[45] At once affirming the authority and extending the aegis of the early-republican government, the rectangular surveying system dictated by the Land Ordinance of 1785 quite evidently furthered national consolidation (implicating what would ultimately amount to a good 75 percent of the continental United States), but only inasmuch as it figured the western territories as both essentially vacant and—consequently—ripe for development.[46]

For the grid powerfully signals nullity in two mutually reinforcing ways: Abstractively devoid of any other clear denotative reference, it pointedly (and exclusively) symbolizes the peculiar *nothingness* of its own representational import. Meanwhile, in its graphic manifestation as alternating spaces and intersecting lines, it looks more than anything else like *emptiness* packaged for easy consumption.[47] The potency of the grid's dual connotation in this regard was crucial to the success of the 1785 Land Ordinance insofar as the territory in question was of course *not* actually vacant, but rather inhabited by any number of native peoples the recognition of which would have belied its availability for European American settlement.[48] Conceptually, then, the township diagram at once cleared the land of occupants and divvied it for allotment, imaging not simple vacancy, even, but vacancy framed, bundled, and primed to receive what would seem the very first foray it had ever sustained.[49]

This effect, whereby the grid actually produces the notional emptiness that it simultaneously orders, is in fact suggested in the very word *plotting*, which in the relevant sense of *land parceling* derives in association with the Middle French *platir*, "to flatten."[50] It is, moreover, strikingly literalized in the laying of rectangular street patterns on lands not naturally fit to support them. Prime cases in point are New York City's Manhattan and Boston's Back Bay (both untouched by the 1785 Land Ordinance's survey protocol), whose topographical irregularities—hills, outcroppings, bays, coves—were literally razed or filled in as necessary in order to provide the

14 Agnes Martin (1912–2004),
untitled, from the portfolio *On
a Clear Day*, 1973. Screenprint,
composition: 8½ × 8½ in. (21.6
× 21.6 cm); sheet: 12⅛ × 12 in.
(30.8 × 30.5 cm). Copyright ©
Estate of Agnes Martin / Artists
Rights Society (ARS), New
York. Gift of the artist and the
publisher, Parasol Press, Ltd.
The Museum of Modern Art,
New York, NY, U.S.A. Digital
Image © The Museum of
Modern Art / Licensed by
SCALA / Art Resource, NY.

even terrain for which the grid plan is best suited and that it effectively pre-
supposes.[51] No more topographically *flat* when they were subjected to the
surveyor's gauge than the continent's westward regions were *vacant* in 1785,
these localities dramatically illustrate in physical-geographical terms the
leveling effect of which the grid is capable in even more obviously social-
political respects, as the history of U.S. territorial expansion makes clear.

If the grid is thus revealed to be a veritable agent of the abstraction it
seems only to emblematize, its function in this regard is evident in the
history of "abstract" art itself, within which domain it is a well-nigh-
ubiquitous presence (fig. 14). Indeed, one prominent critic has attributed
the grid's modernist popularity to the fact that it connotes absolute artis-
tic precedence—tacitly establishing whoever lays it down as the first to
arrive at the site of representation and so ascribing to that person a highly
valued aesthetic originality—by virtue of its resembling the "graph-paper
ground" that is conventionally requisite to visual depiction per se.[52] Mani-
festing as highly potent in its perpetual readiness to signify, the grid on
this view also manifests as wholly benign, since that readiness has not
yet been turned to account in the production of specific—and inevitably
exclusionary—meaning. It thus registers as an effective nonevent even as it

15 Piet Mondrian (1872–1944), *Study of Trees I*, 1912. Black crayon on paper, 68 × 89 cm. Copyright © HCR International. Haags Gemeentemuseum. Photo copyright © DeA Picture Library / Art Resource, NY.

comprises an undeniably crucial occurrence, subduing the abysmal blank chaos of the undifferentiated visual field and presenting it, reconstituted, as fully exploitable possibility.

Art-historically speaking, however, the visual field confronted by modernism was not undifferentiated at all; rather, it was occupied by the representational elements of conventionally figurative work that would effectively be eliminated by the grid itself. This development is aptly characterized in a critical gloss on the movement "from figuration to abstraction" undertaken by one of the grid's pioneering champions within twentieth-century Western art—Piet Mondrian—according to which, in a succession of works produced in 1912 and 1913 (fig. 15, 16, and 17), Mondrian "begins with the object, irregular as it is, and . . . sets about demonstrating all the processes involved in 'reducing' it to a 'grid.'"[53] Notwithstanding the putative primacy within this series of the depicted "object" (i.e., the centralized tree), whose own delineation does essentially structure the latticework into which it ultimately merges, of clearly greater import is the *reduction* whereby that merger is enacted—the progressive attenuation of the central

16 Piet Mondrian (1872–1944), *Study of Trees II*, 1913. Charcoal
and white lead on paper, 66 × 84 cm. Copyright © HCR
International. Haags Gemeentemuseum. Photo copyright ©
DeA Picture Library / Art Resource, NY.

17 Piet Mondrian
(1872–1944), *Tableau
No. 2 / Composition
No. VII*, 1913. Oil on
canvas, 41⅜ × 45 in.
(105.1 × 114.3 cm).
Copyright © HCR
International.
Solomon R. Guggen-
heim Founding
Collection, The
Solomon R. Guggen-
heim Museum. Photo
courtesy the Solomon
R. Guggenheim
Foundation / Art
Resource, NY.

figure until it is effectively obliterated in the grid, which thus issues forth as the focal point of the composition. However that reduction is brought about (and both the "processes" entailed and the operative force behind them are left notably vague in the quoted passage), it is the grid itself that finally assimilates and thus literally *cancels* the figure, in an instance of the "annihilation" that Harper so explicitly addresses.[54]

The foregoing example of course implies that it is merely landscape elements (or, for that matter, wholly inanimate objects) that are absorbed within the modernist grid, but while certain instances of *post*modernist practice seem engineered to remind us that a specifically human import is also embedded there, they are liable as well to recapitulate the vexed racial politics that I have already suggested informs the grid's genericizing function. Exemplary in this regard is Vanessa Beecroft's 1999 performance event *U.S. Navy SEALs* (alternatively known as *VB39*, in keeping with Beecroft's practice of designating each of her performances with her initials and a sequentially assigned number), which was presented at the Museum of Contemporary Art San Diego on June 5 of that year. Comprising sixteen officially attired members of the U.S. Navy's elite Sea, Air, and Land special forces unit arrayed as five three-man columns centered behind a single commander, the work dramatically staged not only military order but also social standardization–cum–visual homogeneity. For if it were not enough that the assemblage manifested a thoroughly masculine aspect (logical and inevitable given the SEALs' exclusively male membership), the gathered personnel were all clothed in immaculate summer service uniforms whose gleaming whiteness at once matched and extended that of the gallery's floor, walls, and ceiling. Hence the elevation and normatization of conventional masculinity (entailing uprightness, impassivity, stoicism, strength) that *VB39* both exposed and enacted was of a piece with the chromatic uniformity it is understood to have presented, with one reviewer going so far as to characterize a documentary photograph of the event as "white-upon-white" (fig. 18).[55] This is an overstatement, of course, inasmuch as the servicemen's apparel itself offers deviations from the dominant white palette, including ribbons, badges, sleeve and breast insignia, officers' shoulder boards, and, among what are evidently enlisted

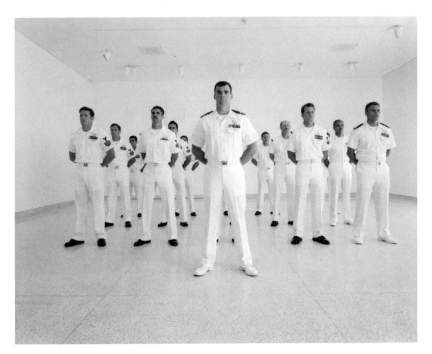

18 Vanessa Beecroft, *VB39, U.S. Navy SEALs*, MCA Museum of Contemporary Art, San Diego, CA, 1999, vb39.290.te. Photograph by Todd Eberle. Copyright © 2015 Vanessa Beecroft. Reproduced by permission of the artist.

men, black dress shoes—and this is to say nothing of the SEALs' own persons, with their invariably rather dark head or facial hair, shadowed if not categorically brown eyes, and generally ruddy but occasionally downright swarthy exposed skin (indeed, two of the men seem to diverge from phenotypical whiteness entirely; see fig. 19). Nevertheless, to the extent that the group overall both assumes a fully regularized grid-like arrangement (no less characteristic of Beecroft's performances than of military assembly itself) and approximates a recognized demographic normativity, the result is a veritable diagram of the generic idealization discussed earlier.[56] Furthermore, in evidently misapprehending the overall disposition of the performance participants ("everything about them is white," he says), the cited commentator testifies to *VB39*'s status as an actual vector of racial-political effect, inasmuch as he betrays an acquiescence to the very racial-normative mission that he understands the piece to have documented.[57]

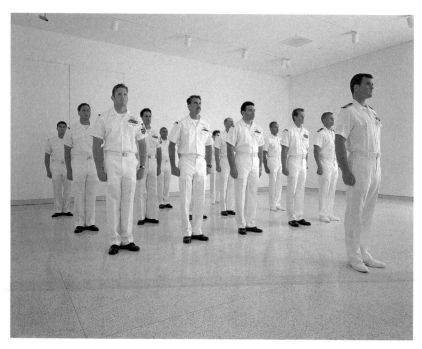

19 Vanessa Beecroft, *VB39, U.S. Navy SEALs*, MCA Museum of Contemporary Art, San Diego, CA, 1999, vb39.293.te. Photograph by Todd Eberle. Copyright © 2015 Vanessa Beecroft. Reproduced by permission of the artist. The fifth man from the left and the fourth one from the right appear to be nonwhite.

Arguably even more symptomatic in this regard is Beecroft's notorious *VB35*, also known as *Show* (or, to be absolutely correct, *—Show*), which was staged in the rotunda of New York City's Guggenheim Museum in April 1998—and which, like the vast majority of the performances executed by Beecroft to that date (and, indeed, long after), featured an entirely female participant cohort. Stationed in a precise coordinate arrangement and bedecked either in ruby-red rhinestone-studded bikinis with matching stiletto mules or in nothing whatever save for white spike-heeled leg-wrap sandals—all provided by Tom Ford, of Gucci—the twenty performers seemed to one observer to "match the pale beige walls of the museum's soaring spiral," and quite understandably so, for their evidently already fair skin had been rendered uniformly pallid through the application of light-toned body makeup designed by the professional cosmetician Pat McGrath (fig. 20).[58] The effect is similar to—but in fact more intense

20 Vanessa Beecroft, *VB35*, —*Show*, Solomon R. Guggenheim Museum, New York, 1998, vb35.079.vb. Photograph by Vanessa Beecroft. Copyright © 2015 Vanessa Beecroft. Reproduced by permission of the artist.

than—that achieved in *VB39*, in that here, rather than serving to *relieve* the scene's predominating whiteness, the performers' bodies themselves *comport with* the surrounding environment and so help to *establish* the prevailing paleness of the compositional field. Hence, even more than in *VB39*, the genericism suggested by the models' regularized formation registers as both essentially *personal* and—to the extent that skin color signals social identity, especially in the U.S. context—fundamentally *racial*. Additionally, though, the social institution that *VB35* indexes bears an import quite different from that of the military culture that inevitably informs *VB39*, as it is founded entirely on a principle of aspiration in which racialized genericism is itself a central stake.

Indeed, if *VB39* at once approximates and yet tentatively retreats from uniform racial whiteness, it thereby reflects not only the compositional pattern of the SEAL teams from which its participants were drawn (no more than 9 percent of whose enlisted men were nonwhite during the late 1990s) but also what the military itself understands as a *problem* with the makeup of its Special Operations Forces overall, as is attested by its having commissioned an official study of "barriers to minority participation" in those forces, which was published in the same year that *VB39* was staged.[59] By contrast, within the realm of fashion modeling from which *VB35* drew its organizational logic—evidenced not only by the estimable pedigree of the costumes but also by the performers' own relative youthfulness, their whip-thin figures, their statuesque bearing, and their projection of what the critic cited earlier called "a certain hauteur"—phenotypic non-whiteness per se is seen as both an aesthetic challenge and a promotional impediment, a view that works to *further* the profession's persistent (and sanctioned) overwhelming whiteness.[60]

Centrally at work in this situation is the fashion industry's governing contention that "a model is a hanger, a blank," as the owner of one management agency was quoted as saying in the mid-1990s.[61] The definition makes sense insofar as the job of a model is to promote the sale of any given garment or accessory by showing it off to best advantage—which is to say, by drawing favorable attention to the marketed item itself, in relation to which the actual model effectively recedes from view. At the same time, though, it also belies the parallel claim, succinctly posited by a different industry professional, that a model's bodily hue constitutes nothing more than "a paint chip" to be deployed along with whatever other prospective compositional elements are at a designer's disposal, since this implies the potential for all the extant skin colors to be worked up to equal aesthetic effect, whereas in reality only one portion of the spectrum has been deemed fully capable of modeling's offsetting function.[62] Ford Models CEO Katie Ford admitted as much when, in 1996, she conceded that that year's fall runways had indeed offered up "a totally blonde season." Characterizing the development as "a trend started by the minimalist designers like Prada and Gucci," Ford went on to explain that, "by using

models who all have the same coloring, they took the identity out of the model. Their goal was to take the attention off the models and put it back on the clothes."[63] Given that mere uniformity of "coloring" is just as easily achieved with models who are *not* blond haired, blue eyed, and pale skinned as with models who are, what really had to have been at issue was a worry (if not an out-and-out *conviction*) that nonwhite models are insufficiently "blank" to constitute appropriately self-effacing "hangers" for the clothes they might be charged with selling—which indeed they are, inasmuch as they fall short of the genericism on which such inconspicuousness depends.[64] This is not to say that the members of any given nonwhite racial cohort cannot be regarded as generic *unto themselves*; on the contrary, and as we have already noted, the entire system of chattel slavery was governed by just such a conception of African-descended blacks. Rather, it is to say that so long as that cohort constitutes a functional minority within the larger society of which it is a part, its members are precluded from the condition of *typicality* that would render them unremarkable in any putatively general setting. Inevitably, then, the consummate visual neutrality against which the fashion industry proposes to set off its wares registers practically as the idealized personal genericism that, in the West—and for the demographic reasons reviewed earlier—only racial whiteness can afford.[65]

This would explain how the suggestion that models should be evacuated of "identity"—or that the performers in *VB35* effectively fade into their surroundings—can be mooted with such blitheness as is evidenced in Ford's remarks, for while it contravenes the ethic of personal "individuality" that supposedly holds sway within the U.S. context, it does so only to *reaffirm* identity in broader and more socially significant terms than are represented by the individual per se. After all, if during the period in question designers largely succeeded in "taking the identity out of the model"—that is, in divesting each one of her distinctive *self*-sameness—this amounted to nothing other than their *asserting* the identity of the *models*—that is, establishing and underscoring their sameness *with one another*.[66] Inasmuch as that sameness consists in a shared racial whiteness that is also societally predominant, its emphasis constitutes the self-

perpetuation of that very predominance—a self-perpetuation that *VB35* additionally figures both in the performers' coordinate positioning (which suggests a potentially infinite network of mutually reinforcing relays between essentially equivalent elements) and in their envelopment within an environmental surround that reflects and so enhances their own "whiteness," thereby approximating a key function of U.S. mass culture in general. Indeed, the catwalk aside, the fashion industry itself most powerfully enacts that function through the much more far-ranging medium of the glossy magazine, a long-standing axiom about which is that newsstand sales decline significantly whenever a nonwhite person is featured in the cover photo.[67] In explaining this perceived phenomenon in 1999, one former magazine editor averred that "the person you put on the cover has to be somebody that readers can aspire to aesthetically": "You want to look at the picture and say, 'I want to look like that.' I'm not saying that couldn't happen if the reader is white and the model is black. But it is more difficult."[68] Clearly evincing the (perhaps not wholly illogical) industry assumption that majority-racial-group readers are the sine qua non of maximized market share, this statement additionally—and more significantly—betrays the imaginative poverty of those readers' supposed aesthetic "aspiration," which evidently depends on their *already* looking like any given cover model, at least with respect to racialized skin color. Readers of color, by contrast—if not entirely precluded from consideration by the seeming negligibility of their bottom-line importance—are in this schema presumed to have no difficulty whatever in aspiring to resemble a white model, whose every appearance on a magazine cover (or in a print layout, or on a billboard, or in a television commercial . . .) thus channels the assumption that anyone who might happen within eyeshot either *is* or surely *would rather be* white, thereby asserting the incomparable value of whiteness in a manner that both derives from and augments its idealized genericism.

Considered from this perspective, such "totally blonde" runway shows as have been mounted by Gucci and Prada do not void their participants of

individual "identity" so much as they sublimate that identity to a hege-monic principle that is the source of those participants' own enhanced social currency. In other words, they function just as does U.S. mass cul-ture as a whole, relative to the white population whose racial image is ubiquitous within it—conceiving that image as so perfectly generic (and, indeed, so generically *perfect*) as to comprise absolutely *everyone's* aspi-rational objective. While *VB35* arguably shows up and comments on this process, it also unavoidably *participates* in it, inasmuch as its primary medium itself bears a ready-made significatory import that exceeds the scope of the artist's control. Given that their conscription within Beecroft's performance does not divest them of the connotations they carry in soci-ety at large, the bodies in *VB35* cannot help but register as generic in their whiteness—and hence as apotheosized in that respect by their similarly pale surroundings—any more than they can refrain from registering as distinctive in their femaleness, and thus as reinforced in that regard by their exaggeratedly feminine styling.[69] The work as a whole thus manifests as no less racial-politically dubious than any of the other abstractive proj-ects reviewed in the foregoing pages.

That Beecroft herself is inclined to disown this fact is suggested by her evident disavowal of the very fleshliness through which her models reg-ister their racial and gender identities, which also imposes physiological limits on their aesthetic function within the performances. Indeed, one reviewer observed that, over *VB35*'s two-and-a-half-hour duration, "the women's Achilles tendons were stretched . . . to their limits; their grid for-mation wobbled and their erect poses altered to relieve the strain on their backs," with some of the participants ultimately either squatting or out-right sitting on the floor (fig. 21).[70] But although Beecroft has attested that she "like[s]" it when her models thus "start to abandon themselves during a performance" (as an interviewer put it to her), she appears not to ap-prehend that surrender in terms of the bodily stress that the reviewer just cited so readily perceived.[71] On the contrary, while Beecroft professes to be "interested in whatever happens during the performance," she admits that this is so *only* once she "accept[s] that the formation is going to break apart" (to quote her directly) and *despite* the fact that those developments

21 Vanessa Beecroft, *VB35, —Show*, Solomon R. Guggenheim Museum, New York, 1998, vb35.354.al. Photograph by Armin Linke. Copyright © 2015 Vanessa Beecroft. Reproduced by permission of the artist.

are bound to be "formally unacceptable," each time making for an event that "begins like a Donald Judd and ends like a Jackson Pollock."[72] Completely disregarding any extracompositional meaning that the performers' bodies might register, and attending instead to each performance's descent from regimented order into random chaos, these statements clearly constitute an attempt by Beecroft to frame her works as purely formal events, thereby recalling Ford's characterization of Gucci's and Prada's all-white runway-show casts as mere—politically innocent—aesthetic constructs. Just like that description, though, Beecroft's efforts in this vein founder insofar as they deny the social-political import inevitably borne by her models' phenotypical traits, notwithstanding her admission of the "racial and psychological" functions served by her compositional attention to skin tone.[73] Indeed, that acknowledgment goes tellingly unelaborated even as Beecroft additionally asserts that she "enhance[s] skin colours for pictorial reasons" and "use[s] colours like in a painting," thereby subordinating "racial and psychological" functions to properly formal ones; and while

22 Vanessa Beecroft, *VB46*, Gagosian Gallery, Los Angeles, CA, 2001, vb46.017.dr. Photograph by Dusan Reljin. Copyright © 2015 Vanessa Beecroft. Reproduced by permission of the artist.

she allows that those colors' "meanings are related to the circumstances" amid which her works emerge, it turns out that the circumstances she has in mind are so narrowly conceived as to exclude the social-historical considerations that imbue various skin colors with their politically charged racial significance.[74] Thus, when for *VB46* Beecroft subjected a group of complexionally "fair" models to full body waxing, painted their skin white, and bleached their hair, it was simply because, as she put it, she "wanted to realize a white monochrome, . . . an invisible picture" within the typical white-box exhibition space of the Gagosian Gallery, Los Angeles, where the event was staged (fig. 22).[75] When, by contrast, for *VB48* she recruited dark-skinned models of African descent, arranged for all but one of them to be fully covered in black matte body makeup, and strapped the entire crew into minute black bikinis designed by Lawrence Steele (and, characteristically, towering Manolo Blahnik sandals), it was, by her own

23 Vanessa Beecroft, *VB48*, Palazzo Ducale, Genoa, Italy, 2001, vb48.721.dr. Photograph by Dusan Reljin. Copyright © 2015 Vanessa Beecroft. Reproduced by permission of the artist.

explanation, only in order to recall the frescoes adorning the interior of the performance venue, Genoa's Palazzo Ducale, and to approximate the "Caravaggio type of illumination" suggested by the site (fig. 23).[76] In other words, however much Beecroft's allusion to circumstantial effects suggests an awareness of the social-contextual factors in aesthetic interpretation, the foregoing accounts betray a sense of those effects that is itself fundamentally formal, and a frame of reference that is steadfastly art historical, ranging from early Baroque to late geometric abstraction—but *not* admitting of the social per se.

As the earlier portions of this discussion have made clear, to thus disavow the social in the name of a putatively disinterested formalism is to court intense African Americanist suspicion, inasmuch as formal abstraction itself has historically played a pivotal role in black people's subjection, which raises well-founded doubts as to whether form—and bodily form

in particular—can *ever* be divested of social-historical import. Unsurprisingly, it was specifically with "the black performance" of *VB48* that this latter question was brought to the fore in regard to Beecroft's work, in that one commentator immediately determined that the piece carried a historical allusion that Beecroft's own formalist account disallows.[77] Reviewing photographs of the show in the *New York Times*, a disgusted Ken Johnson noted the "black women in bikinis," the "bad Afro wigs," and the "black greasepaint" and opined that, "with a palatial, European interior for background, it looks like a parody of a slave auction dreamed up by a twisted art director."[78] Thus we come, if not full circle, then at least back to the scene of the crime. Rendering its performers in the same peculiarly abstractive manner that characterizes such pieces as *VB35*, *VB48* might be said similarly to *comment on* the racial-political dispensation that it thereby indexes. By the same token, however, it also cannot help but *further* the effects of that very dispensation, given that it partakes of the representational regime that factors centrally within the latter; and since it is unable within the prevailing racial-political order to suggest that its models embody a culturally valorized genericism, *VB48* instead seems to replay black women's reduction to a *massified* and *commoditized* genericism within the context of chattel slavery—the classic *betrayal* through abstraction that has haunted African-descended peoples since the advent of the triangular trade. Indeed, to apprehend *VB48* in these terms is arguably to insist on the historical fact of systemic antiblack violence that the piece quite noticeably conjures, but that its reception as simply a reference to Venetian tenebrist painting would itself abstract into imperceptibility. On the other hand, to persist in such an interpretation is potentially to foreclose other ways of understanding the work that might themselves be critically productive, just as detractors of Kara Walker's silhouettes can be said to have done.

I have of course fudged the problem of this seemingly dichotomous situation by invoking a principle of simultaneity, suggesting that Beecroft's work in fact exposes—and even critically comments on—a significant

racial-political problem *even as* it recapitulates that very problem, and the same could just as easily be said of Walker's tableaux. To assert this, though, is merely to acquiesce in the work's evident ambiguity, whereas the social critique with which my argument is concerned depends on that ambiguity's being *resolved* in favor of the work's abstractionist import. The discussion thus far has implied that what is at issue is a simple tension between history and form—between respectful recognition of black people's historical reality and willing assent to an artwork's formal strategies for promoting social change—but this is a false distinction insofar as forms have their *own* histories, which include changes over time in how they are perceived, and hence in the effects of which they are capable. Most relevant for our purposes are changes to the repertoire of visual forms susceptible to realist interpretation, since the latter has constituted a major impediment to the efficacy of abstractionist visual aesthetics. Indeed, owing to precisely such innovations as are exemplified by Mondrian's work, that repertoire expanded dramatically over the course of the twentieth century, making it all but impossible for contemporary viewers to experience anything like the shock and disorientation legendarily suffered by visitors to the infamous "Armory Show" of February 1913, which introduced U.S. audiences to modernist practices in painting, sculpture, and decorative design.[79] Consisting largely in just such abstractionist strategies as characterize Walker's silhouettes, those practices established much of the displayed work as radically disjunct from the real-world phenomena it was conventionally expected to denote, and thus generated grave doubts about its status as "art."[80] Since the early decades of the last century, however, spectators have become thoroughly familiar with the aspects of fragmentation and disarticulation that characterize, say, Marcel Duchamp's *Nude Descending a Staircase, No. 2* (fig. 24), which outraged visitors to the 1913 Armory Show: thanks largely to such factors as the influence of Duchamp's own work, we now know how to "read" such visual features much more effectively than did their earliest viewers, who confronted them without comparable advance preparation. And yet, insofar as our "reading" in this way amounts to our seeing in Duchamp's canvas exactly what its title encourages us to seek, we essentially disavow precisely that

24 Marcel Duchamp (1887–1968), *Nude Descending a Staircase, No. 2*, 1912. Oil on canvas, 57⅞ × 35⅛ in. (147 × 89.2 cm). Copyright © Succession Marcel Duchamp / ADAGP, Paris / Artists Rights Society (ARS), New York 2014.

25 According to the cognitive psychologist Donald
D. Hoffman, certain "innate rules of universal
vision" dictate that we will apprehend this figure
as representing a three-dimensional doughnut-
shaped object, despite its being presented on a
two-dimensional plane with a minimum of
visual cues to indicate spatial depth. Reprinted
from Hoffman, *Visual Intelligence: How We
Create What We See* (New York: Norton, 1998).

which apparently stoked indignation among Armory Show attendees—
that is, the painting's *refusal* to make good on the extended promise of easy
referentiality, and its resultant *critique* of realist reception.[81]

This is exactly the same disavowal enacted by critics of Walker's silhou-
ettes, and while in the heat of the 1997 controversy Henry Louis Gates, Jr.,
designated it a fault of "the visually illiterate," in practical terms it actually
constitutes the very height of sophisticated visual consumption.[82] After all,
if Western culture has assumed an increasingly visual character since the
late nineteenth century (as is agreed across a wide range of disciplines), it
has done so by generating ever more material that is so visually stimula-
tive as to radically challenge human beings' cognitive powers.[83] One way
of responding to that challenge is simply to consider potentially baffling
abstractionist imagery as nothing more than a coded presentation that
can be deciphered along realist lines—a reaction that may well be only
"natural" in that, according to some cognitive neuroscientists and per-
ceptual psychologists, human beings are innately inclined to perceive as
logically realistic visual depictions that are in fact inconclusive or impre-
cise (fig. 25).[84] Innate or not, however, that inclination had never been so
thoroughly and insistently tested among Western populations as it was

26 Package logo for Ginsana
 "All-Natural Energizer," ca.
 2002, Pharmaton Natural
 Health Products, Boeh-
 ringer Ingelheim Pharma-
 ceuticals, Inc.

27 Universal traffic
 warning sign, "Slippery
 When Wet."

once modes of visual representation that were developed during the early twentieth century permeated the extended cultural field, which by the late 1990s comprised not just the realm of "high" art but also such utilitarian spheres as commercial and public-service print advertising, and the ever-expanding domain of cinematic and electronic-media entertainment. If in engaging with these we find it eminently feasible to identify real-world referents for the impressionistic brushstrokes of the consumer product logo or the iconistic graphics of the universal traffic-warning sign (figs. 26 and 27)—or to fashion plausible narrative sequence from the disorder of jump-cut montage—this is because a century's worth of collective experience has both equipped and encouraged us to make realist sense of abstractionist visuals without a second's pause or reflection.[85] Not only is our skill in this regard thus a properly historical phenomenon, but inasmuch as it enables us to navigate the modern visual field with substantially greater aplomb than was achievable by European and North American art viewers of the 1910s, it actually *epitomizes* contemporary visual literacy.

Of course—and this is Gates's real point—that literacy is dubious insofar as it entails our "seeing" *past* visual abstractionism's challenges to knee-jerk realist perception rather than heeding their invitation to question it;

and its general prevalence only compounds the difficulty of forwarding African Americanist critique through visual-abstractionist means. As the foregoing discussion has made clear, abstraction itself has historically been detrimental to black people, both directly and collaterally, constituting them as a dehumanized generality thus eligible for enslavement (among other things) and underwriting an exalted generic national personhood from which they have typically been excluded. It has also been ubiquitous in its operation (hence the wide-ranging and contingent quality of my review in this chapter), informing diverse yet overlapping philosophical, political, cultural, aesthetic, and commercial projects from the early modern period through the present day, always with the questionable ramifications alluded to earlier. Its visual deployment has consequently often met with vigorous African Americanist resistance, whether in the interest of correcting representational distortion or with the aim of merely asserting black social, cultural, and political presence. Whatever its objective, though—and however understandable—that resistance has militated against the efficacy of visual-abstractionist social critique, because it in practice entails strenuously recruiting any given depiction to the protocols of realist reception and accordingly *disallowing* any compositional elements that might compromise the depiction's realist import—precisely those elements on which abstractionist effect depends. If our current cultural-historical dispensation is such that we are inclined at all events to apprehend visual portrayal in realist terms, this only reinforces what is already a signal tendency within African American culture—one that visual representation per se is distinctly ill equipped to counter.

Social-critical abstractionism as I have defined it must necessarily negotiate a delicate relationship between clear real-world reference, on the one hand, and obvious fictive contrivance, on the other, for while the latter is crucial in registering human beings' creative—and hence social-transformative—capacities, it is only through the former that an artwork can indicate exactly what aspects of lived reality should be targeted for change. The relationship at issue here is not one of "balance," insofar as

that word implies equality between two terms; rather, as I said earlier, in order for a work to achieve abstractionist critical effect, any evident ambiguity between its social-realist quality and its artifactual character must be resolved in favor of this last, or else it risks apparently *reaffirming* that which is the object of its critique. That resolution is highly problematic, however, for works whose African Americanist investment is indicated specifically through human figuration, because although figuration is by far the most effective means of visually signaling such an investment, its mimetic-realist significance tends to overpower whatever abstractionist import a given depiction might also bear, as is demonstrated by critical response not only to Walker's silhouettes but also to Fred Wilson's *E Pluribus Unum*, discussed in the introduction. Indeed, even a work that quite evidently "introduces messy racial complications into the otherwise pure modernist grid" promulgated within twentieth-century Western art, as one commentator has characterized a 2001 Lorna Simpson photo/text work as doing (fig. 28), can also be said to engage that grid so subtly as to subordinate it entirely to the function of portraiture, and thus to evacuate it of its abstractionist power.[86] On the other hand, works whose figurative purchase is attenuated enough *not* to eclipse their abstractive import so miniaturize "the swarming thick lips and bug eyes" that thwart their grid-like regularity and thus potentially query the social normativity it connotes (as another critic put it about paintings produced by Ellen Gallagher during the mid-1990s; figs. 29 and 30) that unless they are subject to the most minute inspection, their arguable black-racial import is wholly lost.[87]

This is not to say that contemporary visual imagery can *never* achieve critical abstractionist effect; the foregoing accounts of Simpson's and Gallagher's pieces—not to mention my own assessments of Walker's and Wilson's work—clearly establish that it can. Rather, the point is that, as Walker's and Wilson's critics demonstrate, it cannot *reliably* do so, inasmuch as the manner in which it is received is subject to too many uncontrollable factors, including the predilections of the individual viewer. This situation would of course not obtain if pictorial depiction were capable of setting the terms of its own reception. Under those circumstances, Walker's silhouettes, for instance, might undercut a viewer's inclination to

28 Lorna Simpson, *Untitled (impedimenta)*, 2001. Gelatin prints under semitranspar-
ent Plexiglas with black vinyl lettering in wooden frame, 41 × 61 × 1 in. Courtesy
of the artist and Salon 94, New York.

29 Ellen Gallagher, *Host*, 1996. Oil, pencil, and paper on canvas, 69 × 50 in. (175.3 × 127 cm). Copyright © Ellen Gallagher. Courtesy Gagosian Gallery.

30 Ellen Gallagher, *Bubbel*, 2001. Oil, ink and paper on linen, 120 × 96 in. (304.8 × 243.8cm). Copyright © Ellen Gallagher. Courtesy Gagosian Gallery.

apprehend them in realist terms, by clearly indicating that their natural-istic verisimilitude should be overridden by their abstractionist character. When, as it happens, spectators actually take offense at the tableaux, ex-actly the opposite valuation has occurred, there being no recognized sys-tem of imagerial arrangement to dictate that the silhouettes' abstractionist elements should be given interpretive primacy.[88] In other words, while one can be led to the well of abstractionist visual aesthetics, a visual composi-tion cannot itself compel one to imbibe whatever abstractionist import might be found there. This fact—along with the visual realm's long history as a prime site of African Americanist resistance to abstraction, with its conventionally antiblack import—suggests that visual culture is not the context in which to seek after abstractionism's optimal black-critical im-pact. Exactly where that impact *is* to be looked for is hinted in the forego-ing reference to *systematicity*, but before—or, perhaps more accurately, *by way of*—pursuing the specific system in question, we would do well to consider further the place of abstraction itself within African American culture. For like everything else in the latter domain, this is more complex than it might initially seem.

Historical Cadence and the
Nitty-Gritty Effect

The account in chapter 1 suggests that the African American cultural tradition is indeed one that rightly "abhors all abstraction," as the poet June Jordan bluntly insisted in a 1985 essay.[1] And yet there is a paradox in claims to this effect, often evident in the very terms in which they are put forth. Take, for instance, Michael Harper's litany of the proscriptions entailed by the abstract rationality of the "Apollonian" grid:

> no ritual; no dance;
>
> no song; no spirit;
>
> no man; no mode;
>
> no cosmos; no color;
>
> no birth; no death;
>
> no myth; no totem;
>
> no magic; no peace.[2]

Or, alternatively, consider the proclamation made by the "lady in blue" on behalf of the title constituency of Ntozake Shange's 1977 "choreopoem," *for colored girls who have considered suicide / when the rainbow is enuf*:

we deal wit emotion too much

so why don't we go on ahead & be white then/

& make everythin dry & abstract wit no rhythm & no

reeling for sheer sensual pleasure/ . . .

. . .

. . . / lets think our

way outta feelin/ lets abstract ourselves some families

& maybe tonite/ i'll find a way to make myself

come witout you/ . . .[3]

Evoked through reference to *ritual, dance, song,* and *spirit* in the one instance and to *rhythm* and *reelin'* in the other, racial blackness as conceived here not only comprises the sensuous opposite to European asceticism but inheres in a fundamentally *musical* impulse. However well established this idea of music as the quintessence of black culture might be, though—and it is so firmly entrenched at this juncture as to be axiomatic—it sits uneasily with assertions of that culture's antiabstract character insofar as music itself is conventionally considered the "most abstract" of all the arts. Indeed, this preeminent abstractness is what Walter Pater had in mind when he proclaimed in 1877 that "all art . . . aspires towards the condition of music," meaning that music attains to a state of autonomy by comprising the perfect, irreducible unity of objective ontology and aesthetic effect: the sonic waves in which music has its objective existence are also the means by which it achieves its aesthetic impact, itself necessarily implicating nothing other than sound per se.[4] As distinct from, say, painting (whose properly optical effects are dependent on the materiality of pigment and support) or from literature (which gestures outward from itself through the very language in which it is composed), music is on this conception wholly contained and self-sufficient—*removed*, that is, from everything that lies beyond it, in the manner I have been discussing throughout this volume.[5]

Given the continued wide currency of this view, whose primacy is indicated by its promulgation in even the most abbreviated introductory discussions of Western musical culture, our chief concern here is not whether

the apprehension of music as supremely abstract is objectively accurate and valid, but rather how that presumed abstraction is negotiated and mobilized within the black-derived productions for which it would seem to pose a severe problem, in light of the observations offered up in chapter 1.[6] Thus it must be of crucial interest to us that, according to one prominent commentator, the most impressive instances of African American musical production actually *maximize* their own abstractness, an effect that by this account is the very essence of their achievement. Speaking in the second broadcast episode of Ken Burns's enormously popular television-documentary history of jazz, first aired by PBS in January 2001, the trumpeter and impresario Wynton Marsalis characterizes the early-1920s offerings of Louis Armstrong and King Oliver as "some of the most abstract and sophisticated music that anybody has ever heard, short of Bach," rather cryptically prefiguring violinist and music-performance professor Matt Glaser's more explicit claim, presented later in the same episode, that Armstrong was uniquely able to "spontaneously take a melody and abstract it, . . . [to] remove all the unessentials from this melody and be left with just this pure vision of what the melody could be." It was specifically the "feeling" engendered by this abstraction, Marsalis contends, that led white musicians in Oliver's and Armstrong's audience—who had presumably "been taught their entire lives that nothing of any good can come out of . . . niggers"—to decide, "Man, this is what we want to play like."[7]

In a subsequent series episode focused on the late 1930s, Marsalis discusses what he calls the "musical kinship" that legendarily obtained between the singer Billie Holiday and the tenor saxophonist Lester Young, explaining that

> when you play the music, you enter another world. It's very abstract. Your sense of hearing . . . it's heightened. You're listening to another person, and you're trying to absorb everything about them—their consciousness, what they mean when they're talking to you, what they're feeling like, where you think they're going to go. It's rare for people to really connect. You'd think, because jazz music is about communication and connection, you would have a lot of it, but you don't have that much of it. And you don't have it,

really, on the level of Billie Holiday and Lester Young. Because they both had that same type of burn, that same type of hurt, and the same joy. They expressed it through their swing.[8]

There seem on first impression to be two types of abstraction at issue in these accounts, the one constituting a state of high aesthetic refinement that is to be strongly desired and eagerly aspired to and the other comprising an order of expressivity so rarified as to be practically inaccessible, thereby paradoxically thwarting communication and making human "connection" extremely difficult to achieve. If on further consideration these two conditions appear to be distinguished only by a difference in degree, in that *over*refinement in fact *gives rise to* abstruseness, one of my objectives in this chapter is precisely to consider how black musical culture negotiates the delicate balance between subtle sophistication and incomprehensible obscurity. First, however, so as to avoid obscurity in this discussion itself, we will need to determine exactly how the modes of abstraction to which Marsalis and Glaser allude are manifested in the musical legacies they adduce, and it is to these latter that we will accordingly now turn.

As a New Orleans–bred bandleader working in Chicago, San Francisco, and other locales during the first decades of the twentieth century, Joseph "King" Oliver was a crucial innovator of the collective improvisation that came to define classic "hot jazz" as against the blues, ragtime, and marching band traditions on which it drew and from which it sprang.[9] A primary factor in the richness and originality of the earliest jazz performances, such extemporizing seems to have been at least partly a function of circumstance, inasmuch as black musicians enjoyed access to only a limited variety of instruments with which to forge complex productions, and constraints on formal instruction left many black players of the period unable to read music.[10] Whatever its genealogy, though, this early improvisation is for our purposes most notable for what has been called its "referential" quality[11]—a paradoxical characterization, given that music's

putative abstractness is conventionally understood as tantamount with its essential *non*referentiality, but also a telling one, in that it is precisely *through* its referentiality that King Oliver's music achieves the large measure of abstractness that Wynton Marsalis ascribes to it.

For music is by no means utterly *incapable* of reference; rather, it is merely—albeit severely—*restricted* in its referential capacity by the very autonomy that it is understood to epitomize. Its aesthetic effect being fully congruent with—and hence wholly delimited by—its objective manifestation as sound waves, music is so constrained within its ontological particularity that it can reliably signify only other properly sonic events; its referential purview is thus circumscribed in a way that does not obtain for, say, literary language, which through mechanisms of description, declaration, and relation can readily refer to phenomena that are not themselves linguistic.[12] On the other hand, if music can achieve reference only by imitative approximation, its mimetic potential is much greater than that of, say, visual depiction, which is of an entirely different phenomenal order than the objects to which it might refer.[13] Indeed, no matter how exact the verisimilitude achieved by a visual rendering of any given entity, it obtains only so long as we suspend our awareness of the fundamental ontological difference between the two—of the fact that a painted landscape, for instance, is not *real* in the same way as its depicted object is (though it is of course real in another way, as a painted landscape). By contrast, and precisely because all sonic phenomena achieve their aesthetic effects in the same modality in which they sustain their objective existence, a mimetic musical production can actually *replicate* its sonic referent, and both of them are *real* in exactly the same way—*as sound.*[14]

From this perspective, the more referentiality any musical instance achieves, the more abstract it paradoxically becomes, since it can optimize its mimetic purchase only by engaging the terms and means of its referent's existence, which are also those of its own. It thereby emerges as being primarily "about" itself, in exactly the manner we noted in chapter 1 is considered characteristic of properly abstract art, which is conventionally understood to *eschew* mimetic representation altogether. This would have been especially true in the case of King Oliver's productions, inasmuch as

the referent for any of his bands' improvisations was nothing other than an antecedent element of the performance at hand, which served as the basis for the musicians' unscripted variations.[15] Indeed, notwithstanding music's theoretical capacity for *perfect* mimesis, it is in fact by simultaneously evoking and yet *diverging from* its referent that Oliverian improvisation would have most effectively impressed listeners with music's autonomous power, as it is precisely that discrepancy that would have fixed their attention in the first place, attuning it to the peculiar aesthetic efficacy of music as such.[16]

Thus the paradoxical abstraction of musical referentiality—whereby the art form pointedly engages the terms and means of its own existence—is essentially heightened through the methods of improvisation pioneered by King Oliver and by Louis Armstrong, who played in Oliver's band during the early 1920s.[17] Brought through intensified self-reference to a surpassing degree of insular autonomy, music by that very same token accedes to a state of supreme self-presence and well nigh concrete actuality—the aesthetic preeminence implied in the Paterian suggestion that all art seeks after the musical condition. On this account, improvisation augments the already incomparably great value of music per se, and it is thus understandable that this manner of playing should have won Oliver and Armstrong the admiration and esteem of numerous other musicians—including white ones—who had the opportunity to hear them perform together between 1922 and 1924.[18]

Armstrong was soon to extend and complicate the process of musical exaltation described earlier by engineering the focal shift in jazz improvisation from the collective to the solo format.[19] In the meantime, however, another signature feature in the performance repertoire of King Oliver factored in the latter musician's ability to turn musical referentiality to supreme abstractionist purport—even when the referential antecedent evidently lay beyond the realm of musicality per se. Known as much for his distinctive use of mutes and other timbre modifiers in his cornet playing as for his fostering of collective improvisational embellishment, Oliver helped

to establish the resultant class of sounds as a defining element within New Orleans–style jazz, thereby furthering the apparently incongruous situation in which intensified reference actually enhances musical autonomy. As musicians who attended performances by Oliver in Chicago around 1923 reputedly put it, "he could literally converse with his fellow bandsmen by means of his cornet and mute."[20]

It is not especially remarkable for any given post-classic-era jazz performance to conjure the sense of a verbal conversation, especially when it entails the alternating contributions of two different musicians.[21] The key point about the characterization of Oliver's playing in these terms, though, is that it traces the conversational impression not simply to the performative exchange that seemingly went forward between Oliver and his band members but, more specifically, to Oliver's unilateral deployment of particular instrumental apparatuses—namely, his cornet and mute. Indeed, the account cited in the preceding paragraph indicates not just that Oliver and his bandmates together achieved the semblance of verbal dialogue, but that Oliver himself ostensibly communicated with the other players by means of his "talking trumpet." Comprising a sound akin to a modulated wail merged with a refined duck call, the talking-trumpet effect is produced by the use of the cup mute—essentially a straight-sided round cone whose wide end is topped with an inverted cup that can virtually close off the entire horn bell; and, as is suggested by the reference to "talk" in the descriptive term, it closely approximates to human vocalization per se.[22] (Because Oliver's recorded oeuvre is both relatively limited and notoriously difficult to parse, there is disagreement among critics about whether the archive contains any instances of his talking-trumpet playing. Depending on the source, the nearest example appears either on the 1926 track "Wa Wa Wa" or on the 1931 "Sugar Blues" recording.)[23]

Even more than for the talking trumpet, though, Oliver became famous for the so-called wa-wa effect, which he generally produced by fitting the bell of his horn with a plunger mute (an inverted rubber cup frequently taken from an actual drain plunger) but which by the early 1920s was more easily achieved by use of the Harmon mute (a hollow metal insert with an adjustable hole at its far end).[24] Conjuring vocal expression no less than

does the talking trumpet, the wa-wa effect implicates variations in volume and sound proximity as well as in timbre, thereby suggesting nothing so much as a blues aria filtered through a slide whistle. Particularly popular and influential in this regard was Oliver's solo on "Dipper Mouth Blues," recorded in 1923 with the legendary Creole Jazz Band lineup that included Armstrong on second cornet.[25]

While in approximating verbal conversation or even the human voice itself these talking-trumpet and wa-wa effects potentially extended the sonic referentiality of Oliver's playing beyond the realm of music proper, they arguably enhanced the autonomous self-presence of music per se at least as much as did the recognizably intramusical reference of improvisational performance. Obviously consisting in the purposeful modification of the sounds that would normally issue from the instrument, wa-wa and talking-trumpet effects cannot help but foreground the deliberate manipulation through which they are clearly achieved. In so doing, they appear to indicate the eminent malleability of music as such, with that evident plasticity in turn implying music's effective solidity and substantiality. The powerful assertion of its concrete actuality that music thus achieves in these circumstances establishes it as supremely abstract in precisely the terms discussed in chapter 1, highlighting (rather than dissembling) its status as a set of manipulable elements intentionally worked upon in a certain fashion, even as those elements are deployed to refer to phenomena beyond the domain of music strictly conceived. By insistently demonstrating music's objective facticity and thereby implying its aesthetic preeminence, then, Oliver's distinctive mute work, no less than his thematic improvisation, would seem to have recommended his playing to the other practitioners who heard him perform during the early 1920s.

For his part in this particular project, Louis Armstrong not only extended the typical improvisational line and thereby established the solo as a signal feature of modern jazz;[26] he also incorporated maximal inflection into what was otherwise the comparatively steady two-beat rhythmical pattern of early New Orleans–style "Dixieland" music.[27] The accentual

power of Armstrong's solos can be heard as early as 1923 in the recording of "Chimes Blues" made by Oliver's Creole Jazz Band; and on the 1927 recording of "Struttin' with Some Barbecue"—which he made with his own group, the Hot Five, formed in 1925—Armstrong both lays down the central feature of the performance (in the form of his lengthy elaboration on the composition's melodic line) and invests the whole production with a theretofore unwonted degree of "swing" through his propulsive accentuation of the beat, forging the vigorous rhythm that was to become a defining jazz characteristic.[28]

These effects are furthered in subsequent recordings that Armstrong made with various personnel, in which the solo horn player issues forth as the indisputable focal point of the production, marking it with both an identifiable timbre and a distinctive cadence, whether in the stately and melancholic "West End Blues," recorded by the Hot Five in June 1928, or in the energetic, up-tempo "Weather Bird," recorded in December of that same year and released under Armstrong's name alone as a "trumpet solo with piano acc[ompaniment] by Earl Hines."[29] In these instances—generally seen as having inaugurated Armstrong's solo stardom—the sonically registered autonomy of musical generation is joined with and bolstered by the singular genius of the individual *auteur*, who somewhat paradoxically now manifests as the authorizing sponsor of music's supremely abstracted condition.[30] Within this scenario, then, the abstractness that music epitomizes redounds to the self-actualizing potency of the musician who discloses it, and thereby emerges as a contributing factor in the assertion of artistic subjectivity. Thus, if Armstrong's 1920s performances exemplified what other contemporary musicians "want[ed] to play like" (as Wynton Marsalis puts it), this must have been because those musicians wished similarly to appear not simply as the engineers of ensemble testimony to music's self-sufficiency (in the manner of King Oliver) but as the effective *engines* of musical self-sufficiency per se, and hence as themselves the very essence of creativity.

In Matt Glaser's judgment, Armstrong's special manifestation of such essential creativity inhered in his exercise of what we might call "distillative" abstraction, which, as distinct from the process of aesthetic substantialization sketched earlier, entails "remov[ing] all the unessentials from [a] melody" so as to arrive at a "pure vision" of it. While Glaser elsewhere in his interview suggests that Armstrong's performance on the live 1933 concert recording of "Dinah" "is a perfect example of this abstraction," for the sake of the present consideration a more useful—because more readily discernible—instance is presented in Armstrong's 1931 recording of the Hoagy Carmichael / Sidney Arodin standard, "Lazy River," Glaser's description of which makes utterly clear what he understands to be at stake in musical abstraction.[31]

Focusing, notably, on the singing rather than on the trumpet playing that Armstrong provides on this recording, Glaser characterizes Armstrong's performance by explicitly contrasting it with that of the other musicians on the track. First, Glaser says,

> the saxophones come in playing the melody, really corny. . . . They're playing the melody in a very stiff, old-fashioned kind of way. And then Louis comes in to show them a new way to play melody. Articulated, completely free rhythmically, boiled down to one note, abstracted. Free, no time. All one note—he's boiled down this complex melody to its essential impulse.[32]

For Glaser, then, as we have already gleaned from the comments cited earlier, musical abstraction as exemplified by Louis Armstrong consists in Armstrong's "boiling down [a] complex melody to its essential impulse"; further, though—and most crucial for the present discussion—that "essential impulse" comprises only so many notes as are absolutely necessary to render the melody intelligible in performance, reputedly totaling no more than one in the exemplary instance of Armstrong's solo virtuosity to which Glaser refers in his remarks.

Sure enough, whereas the original sheet music for "Lazy River" prescribes a melodic line plotted among thirteen distinct notes—four of these at varying pitches—played over the course of the first six four-beat measures (fig. 31), Armstrong executes his vocal by hitting nothing but

31 The opening eight measures of "Lazy River," from *The Best Years of Our Lives*, words and music by Hoagy Carmichael and Sidney Arodin. Copyright © 1931 by Peermusic III, Ltd. Copyright renewed. This arrangement copyright © 2014 by Peermusic III, Ltd. International copyright secured. All rights reserved. Reprinted by permission of Hal Leonard Corporation and Music Sales Limited.

the same midrange B note for nearly twenty-two of those twenty-four beats, dipping briefly to an E for only half a beat—about the duration of an eighth note—at the very end of the fourth bar, and lilting upward just slightly to a D note on the twenty-first and twenty-second beats before returning again to his standard B at the very end of the sixth measure. By

the same token, he rounds out the first verse of the song—which culminates in the seventh and eighth measures—by repeatedly hitting a single G note throughout the entire lyrical phrase ("throw away your troubles, dream a dream with me"), modifying this approach only in the improvised repetition of the last verbal clause, which again presents a slight upturn in pitch by incorporating two B-flats and an A at the very end of the measure.[33] (Indeed, Glaser's contention that Armstrong reduces the melody to its "essential impulse" seems quite apt, in that given the lack of tonal differentiation in his vocal performance, Armstrong registers a sense of the song's melody less through the specific character of the notes he hits than through the pattern of rhythmic pulsation he establishes.)

This type of musical minimalism—the paring down of the melodic line to the bare essence of a single note—is discovered by Glaser to be at work as well in Armstrong's trumpet playing on the 1931 recording of "Chinatown, My Chinatown" made by Louis Armstrong and His Orchestra, and his discussion of that piece significantly reprises and yet modifies the terms by which he characterizes Armstrong's singing on "Lazy River."[34] Offering his assessment as the recording plays in the background, Glaser once again begins by describing the playing of the other band members before characterizing Armstrong's entry into the instrumental fray:

So they're, they're playing fast, it sounds like they're nervous, it sounds like they're having a hard time coping with this fast tempo. The hectic nature of the modern world, . . . the temporal nature of the modern world, but [Armstrong's] ready and now there's gonna be no time when he comes in suddenly, just one note. [At this point, just about one minute and thirty-seven seconds into the recording, Armstrong begins his trumpet solo, sounding the same moderately long B-flat note twice in succession before proceeding with his melodic elaboration, the singular clarity of which sets it noticeably apart from the relative cacophony of the orchestral accompaniment.] Free. Completely relaxed. Floating above this. It sounds like an aria. . . . So this is a new way to experience the modern world in all of its hectic movement. It's like the platonic world has entered for a moment into the modern world.[35]

Especially noteworthy in these remarks is Glaser's characterization of Armstrong's playing as "free." Whereas in the "Lazy River" discussion this designation worked in an appositive manner to clarify the meaning of the word "abstracted" (Armstrong's singing on that record, Glaser says, is "boiled down to one note, abstracted. Free"), here that other term is not explicitly adduced at all; rather, Armstrong's instrumental offering is described simply as comprising "just one note. Free." Thus, when considered alongside its invocation in Glaser's commentary on "Lazy River," the word free in this instance seems effectively to assimilate the significance of "abstracted" and to substitute for it in a synonymic fashion, while abstractedness itself thereby manifests as nothing other than freedom per se.

That the freedom at issue should indeed be understood as absolute is indicated by another of Glaser's propositions about the two recordings—namely, that Armstrong's performance on each of them somehow engages "no time." Rendered most intelligible when it is contrasted with "the temporal nature of the modern world" in the commentary on "Chinatown, My Chinatown," this condition of timelessness is itself set forth by Glaser in an appositive formulation that establishes it as a function of Armstrong's minimalist performance: "there's gonna be no time when he comes in suddenly, just one note." In this account, it is not simply that Armstrong's playing is not *subject to* time. Rather, the suspension of time itself directly *derives from* Armstrong's sustaining—whether through repetition or through sheer duration—"just one note"; and it constitutes an escape from the temporality of modern life that amounts to a release from all other practical constraints as well—our accession, however fleeting, to the realm of pure "platonic" ideal. Hence, through the processes of reduction that Glaser identifies with abstraction per se, Louis Armstrong brings music to a state of absolute disengagement from all other worldly phenomena and thus to the same condition of supreme autonomy to which it might alternatively—and *simultaneously*—be led through the processes of substantialization I have already described, whereby improvisatory performance and muted horn playing register the self-sufficient facticity of music as such.

The foregoing observations allow us to comprehend the import of Armstrong's contributions in the modernist terms elaborated in the previous chapter. If jazz improvisation as I have described it registers the preeminently abstract character of music—its incontrovertible objective actuality and its self-contained detachment from all external phenomena—it thereby accomplishes for music per se what the modernist grid accomplishes with respect to any visual production in which it is featured, instancing a condition of elemental primacy that figures as absolute aesthetic precedence.[36] On this reading, then, Louis Armstrong's unchallenged priority in solo improvisation would establish Armstrong himself as the avatar of modern musical originality, while *any* musician who staked a reputable improvisatory claim would appear as a generative source of the aesthetic essence discovered within the improvisational instant.

However much this account clarifies why such abstractness as is epitomized in music should be positively esteemed in the critical commentary—and why musicians themselves should seek to disclose it in the manner exemplified by Louis Armstrong—it nevertheless illuminates little beyond prevailing conceptions of jazz aesthetics, on the one hand, and the powerful impetuses of individual ego, on the other. That there must be more—and more of a specifically *social-collective* significance—to jazz music is indicated by the widely held understanding that it implicates an intense racial politics, reflected, for instance, in Wynton Marsalis's suggestion that white musicians were mightily surprised to find that anything "of any good [could] come out of . . . niggers." The question is whether that collective significance is itself related to the condition of abstraction discovered within the most exemplary jazz performances and, if so, how. In pursuing this crucial concern, we must inevitably turn to the ominous flip side of musical abstraction's proclaimed desirability—namely, the threat that Marsalis implies abstraction poses to comprehension and human "connection." First, however, it will be useful for us to consider one additional commentary regarding the vicissitudes of time within Louis Armstrong's signal performances.

In the prologue to his 1952 masterwork, *Invisible Man*, Ralph Ellison offers a now-classic discussion of Armstrong's recording of "(What Did I Do to Be So) Black and Blue," which his unnamed title character associates with the condition of "invisibility" that he suggests both he and Armstrong suffer:

> Invisibility, let me explain, gives one a slightly different sense of time, you're never quite on the beat. Sometimes you're ahead and sometimes behind. Instead of the swift and imperceptible flowing of time, you are aware of its nodes, those points where time stands still or from which it leaps ahead. And you slip into the breaks and look around. That's what you hear vaguely in Louis' music.[37]

Just as Matt Glaser remarks the suspension of time that Armstrong seemingly brings about through his music, so too does Ellison, via his protagonist, propose that Armstrong's music makes one aware not of the temporal flow that characterizes quotidian modern life, but of the static "nodes" in relation to which that flow is normally—if unwittingly—registered. Attributing this effect to being "sometimes . . . ahead [of] and sometimes behind" a given rhythmic production's standard beat, the Invisible Man suggests that such temporal suspension can derive as easily from syncopation as from the tonal singularity that Glaser emphasizes, with his repeated references to Armstrong's distilling a melody to "just one note." Be this as it may, however, what is most noteworthy for our purposes is the fact that Ellison implicates Armstrong's music in a phenomenon that would seem to stand in stark opposition both to the timelessness claimed for that music itself and to the resolute abstractness that we have identified with music per se.

Recalling that once, under the influence of marijuana, he found himself hearing Armstrong's music "not only in time, but in space as well," the Invisible Man goes on to relate his having "descended, like Dante, into its depths," where he was subjected to a number of more or less nightmarish hallucinatory phenomena, including the "black is, black ain't" sermon for which (among other things) the novel is famous. Eventually, he says,

I came out of it, ascending hastily from this underworld of sound to hear Louis Armstrong innocently asking,

> *What did I do*
> *To be so black*
> *And blue?*[38]

This refrain assumes a pivotal function in *Invisible Man*, in that the protagonist turns the question on himself at the very end of the prologue, wondering rhetorically, "But what did *I* do to be so blue?" and then beseeching his reader, "Bear with me," thereby providing the immediate transition to the novel's first main chapter and introducing the comprehensive answer to this question that is the remainder of the text.[39] As a specifically discursive elaboration that effectively establishes the Invisible Man's own peculiar disaffection as the topical referent of "Black and Blue," that answer is of a piece both with the discussion of Armstrong's recording that is presented in Ken Burns's *Jazz* program and with an aspect of the song itself. Outlining the professional activities that Armstrong undertook in 1929, the voice-over narration in episode 4 of *Jazz* informs us that "among the Broadway tunes he recorded that year was Fats Waller's 'Black and Blue,' originally written for [the all-black musical revue] *Hot Chocolates* as a complaint by a dark-skinned woman about her man's preference for lighter-skinned rivals. Armstrong transformed it . . . into a song about being black in a world run by whites."[40]

This is true enough, and the mechanism of that transformation was itself fairly simple. Armstrong deleted from his vocal rendition the initial verse that in Andy Razaf's original lyrics establishes the scenario of intraracial color conflict:

> Out in the street, shufflin' feet,
> Couples passin' two by two,
> While here am I, left high and dry,
> Black, and 'cause I'm black I'm blue.
> Browns and yellers all have fellers[,]
> Gentlemen prefer them light,
> Wish I could fade, can't make the grade,
> Nothin' but dark days in sight[41]

Absent this contextualizing setup, the singer's lamenting, "I'm white inside, but that don't help my case / 'Cause I can't hide what is in my face," amounts to his asserting the probity and rectitude that a white-dominated society refuses to credit to persons of African descent, rather than his staking a claim for the intimate love that his dark skin precludes him from attaining.[42] Thus, notwithstanding the unsettling rhetoric of moral "whiteness" that is central within these lines, it is apparent that by modifying the lyric Armstrong has indeed "transformed" the song from being about one thing (the social and sexual politics of skin-color difference within black communities) to being about another (the injustices visited on black populations under conditions of white supremacy and societal racism) in just the same way that Ellison frames it as being about the Invisible Man's own psycho-social state.

But of course, given that in its supreme abstraction music as such is necessarily "about" nothing other than its own phenomenal modality, it is *only* by virtue of its discursive component that the song can register an extramusical topical focus, and comparatively pithy though it is, Armstrong's lyrical rendering does this in the same way as does Ellison's novel: by offering up a particular *story* that elucidates the factors in the narrator's "black and blue" condition, all of which derive in the realm of lived U.S. racial politics during the first half of the twentieth century.[43] Thus, if Armstrong's recorded rendition of "Black and Blue" clearly registers a historically specific social significance and consequently manifests as the veritable *negation* of timelessness and abstraction (even as Ellison's protagonist, like Glaser in discussing "Chinatown, My Chinatown," suggests that it *epitomizes* these states), this is so only to the extent that it manifests not as music per se but as something else—namely, *narrative discourse*. Seemingly merely auxiliary to the musical composition proper, narrative discourse here actually demonstrates its signal capacity to incorporate such nondiscursive phenomena within itself, assimilating them in the service of a story that offsets whatever quality of abstraction they otherwise might bear, and thereby establishing narrative per se as abstraction's effective antithesis.[44] This fact helps us to answer the question that is still pending from my initial consideration of Wynton Marsalis's remarks:

by what means can we manage and overcome what we might call musical abstraction's antisocial character—the danger it poses to the human "connection" that Marsalis suggests is central to jazz itself?

Marsalis begs this very question by claiming in the first place that "jazz music is about communication and connection," inasmuch as he has also claimed that it constituted the height of aesthetic abstraction during the first half of the twentieth century. Indeed, by suggesting that jazz "is about" communion among individuals and groups, Marsalis is imputing to the music the same sort of externalized social significance that Louis Armstrong and Ralph Ellison engineer on behalf of "Black and Blue," albeit in slightly ambiguous terms. We might, for instance, imagine that jazz "is about" such communion in its effectively *engendering* the latter—in its bringing people together, whether virtually, through their shared enjoyment of the music, or literally, in common physical space.[45] On the other hand, though, Marsalis insists that, within the jazz milieu, "you don't have that much" of the sort of communication he invokes, which suggests that he has in mind something that is a great deal rarer than the instances of music-centered socialization alluded to here.

Indeed, in noting the overall infrequency of "connection" within the jazz setting, Marsalis is remarking specifically on relations *between musicians*, as distinct from the lay listeners who might form an appreciative fan cohort, and he is citing a mode of communication that is wholly aural in character: "When you play the music," he says, "your sense of hearing . . . it's heightened. You're listening to another person and you're trying to absorb everything about them—their consciousness, what they mean when they're talking to you, what they're feeling like, where you think they're going to go." Considering that it is the interpersonal knowledge achieved through attentive listening that constitutes the connection Marsalis describes, jazz music in this regard does in fact engender communion, but only among the musicians themselves, and only when their sensitized hearing gives them purchase on the "consciousness" of their fellow play-

ers adequate to determining where the latter are "going to go" within the performance at hand.

If, as Marsalis contends, this seldom occurs, the trouble would seem to stem from the perdurable particularity of each individual musician, which is liable to thwart the performers' requisite attempts "to absorb everything about" their colleagues. The difficulty of thus plumbing a peer subjectivity through heightened aural attention suggests that the very specificity that constitutes the abstract character of music per se potentially renders inscrutable any given instance of musical execution: the autonomy that in positive terms registers as music's self-sufficiency and independence can in negative terms register as insularity and inaccessibility. Under these circumstances, the singular sensibility of the musical artist appears less as compelling individual genius than as incomprehensible idiosyncrasy. The rare moments when musicians do achieve mutual understanding form the occasions when jazz does in fact engender deep "communication," epitomized by the connection obtaining "on the level of Billie Holiday and Lester Young."

At the same time, though, we are cognizant of that connection only because it is itself discernible in the music that Holiday and Young produced together, where, as Marsalis puts it, they "*expressed* . . . through their swing" "that same type of burn, that same type of hurt, and the same joy," their shared experience of which evidently founded their connection in the first place. Holiday and Young's music thus "is about" communication and connection in the sense of *indicating* the latter—disclosing them to listeners just as Louis Armstrong's recording of "Black and Blue" discloses the experience of "being black in a world run by whites." As we have already noted, however, Armstrong's rendition of that song achieves its topical significance not in its specifically musical aspect but rather in the discursive elaboration provided for by the lyrics. In Holiday and Young's case, by contrast, the music itself bespeaks the matter of human connection, turning the peculiarities of the artists' performance to expressive effect in such a way that, paradoxically, these too are recruited to the function of narrative discourse.

By the time Billie Holiday and Lester Young's collaboration reached its height, during the late 1930s and early 1940s, Young had already set himself apart from other tenor-sax players through the relative lightness and delicacy of his tone and the relaxedness of his rhythm, as compared with the deep richness and regular phrasing that had been made conventional during the 1930s, especially by Coleman Hawkins. Indeed, Young is credited with revolutionizing jazz musicians' approach to the solo by extending his phrasal line to various lengths for optimal melodic effect, sliding smoothly from one note to the next for a seamless glissando, and favoring a slow, spare, minimalist vibrato over the faster, broader, and more pronounced tremor then current among sax players.[46] These peculiarities of Young's playing comported neatly with Holiday's vocal style, which itself featured both the contraction and the expansion of the melodic phrase in tense relation to the main beat, plus a finely attenuated tone occasionally admitting of slippages in pitch or clarity.[47]

These characteristics are discernible in the classic 1939 recording of George and Ira Gershwin's "The Man I Love," in which Holiday alternately extends and compresses the phrasing in the opening verse so as to introduce a slight but noticeable temporal discrepancy between the primary clauses of the initial two lines.[48] In her rendering of the first line— "Someday he'll come along, the man I love"—Holiday stretches the final syllable of "along" so that its duration almost exactly matches that of "love" in the immediately succeeding clause, although the published composition presents the latter syllable as a half note and the earlier one as only a quarter note. By contrast, in her singing of the subsequent line—"And he'll be big and strong, the man I love"—she clips her delivery of "strong" so that it registers more like the five eighth notes that precede it in the measure (matching the five syllables leading up to "strong") than as the quarter note dictated by the score, which indeed presents the two clauses in question as musically identical (fig. 32). Consequently, in Holiday's vocal rendition, the phrase "Someday he'll come along" lasts nearly half a second longer—for a nearly 17 percent lengthier duration—than "And he'll be big and strong," thereby conveying a sense of pining languor that is immediately mitigated by the somewhat more chopped and staccato delivery

Andantino semplice

Some day he'll come a-long, the man I love; and he'll be big and strong, the man I love

32 The initial four bars of the vocal line for "The Man I Love," from *Strike Up the
 Band*, music and lyrics by George Gershwin and Ira Gershwin. Copyright © 1924
 (Renewed) WB Music Corp. All rights reserved. Reprinted by permission of
 Alfred Publishing Co., Inc.

characterizing the succeeding three bars, which rather suggests an anxious
hopefulness. In the meantime, the beat laid down by the rhythm section
proceeds at a regular 4/4 rate, constituting an effectively stable ground
above which Holiday's vocal makes its relatively independent advance, in
loose but controlled tension with the bass line.

Similarly, over the course of his sixteen-bar sax solo—which contin-
ues for about forty-five seconds on the recording—Young incrementally
increases the speed of his playing so that, by the final half of his run, he is
producing over one more note per second than he is during the first sec-
tion of the passage. Those initial four measures comprise a series of vari-
ously lengthy tones—apprehensible as a set of intermixed quarter, eighth,
sixteenth, and even thirty-second notes—that glide lightly and smoothly
over and around the regularly sustained beat, while the subsequent two
bars intermingle quarter and eighth notes in such a proportion as to
maintain the same average pace as the preceding measures, in addition to
sounding at a slightly lower volume than the opening section. The overall
effect is one of effortlessness, ease, and relaxation.

Things pick up, however, in the remaining two bars of the second sec-
tion, which present a preponderance of eighth and sixteenth notes as
compared to the quarter notes that are in fuller evidence in the earlier
measures, thereby setting the stage for the even greater proliferation of
notes—and the accordingly more accelerated playing—that occurs in the
final two sections of the solo. Hence, relative to the introductory bars, the
latter portion of Young's solo manifests a compression comparable to that
marking the second line of the opening verse in Holiday's vocal rendi-

33 Transcription of Lester Young's tenor saxophone solo on "The Man I Love," recorded December 13, 1939, by Billie Holiday and Her Orchestra (Vocalion/OKeh 5377). Transcription prepared by Charles McNeal, copyright © 2015 by Charles McNeal. Published by permission.

tion. This contractive effect is enhanced, moreover, through the peculiar scheme of emphasis that obtains in the second half of the solo, which derives jointly from the distribution of notes in key passages and the variations in volume within the last eight bars of the instrumental break. The third section in particular intensifies a general pattern carried over from the first two sections, concentrating the short, rapidly played notes that constitute Young's trademark glissandi within the latter half of each bar, while the first two beats of each measure implicate fewer notes of longer duration—or, in the ninth and eleventh solo bars, actual rests of a quarter and an eighth measure, respectively (see fig. 33 for a complete transcription of the solo). Alternatively, when the notes are more evenly distributed throughout the bar (as they are in the fourth section), the first portion of the measure is often played more softly than the latter part, making for a

fluctuation in volume that accords with the alterations in velocity evident in the other instance. In either case, each measure presents a moment of tonal intensification following on an interval of relative quiescence, and the resulting effect of continual ebb and swell correlates with the interchange of phrasal compression and expansion that characterizes Holiday's vocal delivery. Finally, the clarity of tone that generally distinguishes that delivery is offset and accentuated by the slight but perceptible graininess that periodically informs it (particularly as Holiday closes off each phrase), much as the velvety lilt of Young's solo is occasionally punctuated by the low waver of his characteristic long vibrato. Thus the complementarity of Holiday's and Young's rhythmic styles is evidently matched by the parallelism of their modifications to timbre, with their partnership consequently appearing as especially apt and felicitous.

As we have seen, Marsalis characterizes Holiday and Young's musical concord in terms of their shared "swing," and this makes sense insofar as *swing* consists in precisely such distinctive rhythmic impetus as the two musicians achieve through their peculiar adjustments in phrasing, which our review of "The Man I Love" suggests are indeed congruent.[49] Further, though, beyond merely claiming that Holiday and Young together offer the same swing, Marsalis also declares that this common swing itself evinces attributes that Holiday and Young additionally share—namely, specific modes of "burn," "hurt," and "joy" that apparently both ally them with each other and set them apart from everyone else. Manifesting initially as qualities of each performer's musical execution that only the other can fully discern (in what Marsalis contends are comparatively rare moments of musician-to-musician communion), these recognizedly common experiences provide the basis for the duo's studious collaboration, which in turn makes third-party audiences cognizant not just of the pair's intense connection but also of the affective states that found it, since as Marsalis puts it, these are powerfully "expressed" through the music. Thus Holiday and Young's "kinship" is not just "musical," as Marsalis would have it. Rather, it comprises most fundamentally a *sympathy of feeling* understood

to subtend and secure the two musicians' evident *compatibility in sound*. In this regard, then, that sonic compatibility signals the existence of the affective sympathy, but only because the latter *enables* the sonic compatibility in the first place, underwriting the unusually efficacious "communication" between Young and Holiday that both generates and consists in the conformity of their musical practices.

Thus, no less than Armstrong's "Black and Blue," with its testament to "being black in a world run by whites," Holiday and Young's collaboration is also "about" extramusical concerns—that is, the very emotional conditions it is understood to "express." Moreover, while that expression is effected through specifically musical means—that is, a unique rhythmic swing—as distinct from the narrative-discursive ones at work in Armstrong's recording (the singer's explicit complaint that racist attitudes blind observers to his honorable character), it nevertheless partakes of the same logic that informs narrative discourse itself. Understood to denote a set of affective conditions that the musicians share, Holiday and Young's swing constitutes the end term in a chain of causation whereby a presumed objective experience (say, rough or inconsiderate treatment) gives rise to an affective state (e.g., "hurt"), which in turn contributes to the peculiarities of musical execution.[50] Such relations of consequentiality are in fact the *essence* of narrative, the fundamental function of which, after all, is to account for a set of events in terms of both the order of their occurrence and the nature of the connection between them.[51] From this perspective, then, not only is the abstract character of any given musical instance mitigated by the latter's achievement of expressive reference, but such reference is just as much a *narrative function* as is the recognizable (if minimal) *story* that counters the musical abstractness of Armstrong's "Black and Blue."

This fact is significant precisely inasmuch as some manner of consequentialist expression—and hence of narrative—inevitably informs *any* musical instance. To be sure, such inevitability is not at work in the example of *affective* expression on which we have focused thus far: because a musical performance can convey a sense of "burn," "hurt," or "joy" even if the musicians themselves have never experienced those feelings—and *only* if a listener conceives aspects of the performance as symbolically

betokening those feelings—the narrative import I have ascribed to Holiday and Young's musical expression is of a wholly contingent character.[52] Consider, though, the suggestion made in one critical account that, by the late 1940s, Billie Holiday's voice had "coarsened through age and mistreatment."[53] Here the vocal quality of "coarseness" is posited as the consequence not of particular *affective* experiences, but of a specifically *physical* phenomenon—deterioration of the vocal cords—wrought by bodily senescence and stress. Although it is perfectly possible for a person who has *not* suffered such deterioration to sing in a "coarse" voice, the more crucial point is that physical wear and tear definitely *will* manifest in a roughened vocal texture, in which case the coarse voice sustains not merely a *symbolic* but an *indexical* connection to the experiential conditions of age and injury—that is, it materially correlates with and so directly evidences those same conditions.[54] Hence the consequentiality informing this situation is substantially more certain than that characterizing affective expression, since it is objectively true that vocal coarseness issues from the degeneration of the vocal cords, which in turn results from the experiential factors of age and physical strain, a "story" about which is thus compacted in the coarse vocalization itself.

Just as such coarse vocalization issues from a damaged anatomy, so too do *all* sonic events—including all manifest aspects of music—have to come from *somewhere*, with that *somewhere* consisting in the material circumstances of their production. On this account, any given musical instance inevitably assumes an indexical function by which it signifies— refers to and so "is about"—the material factors from which it has arisen, whether these be the musician's own physical state at the time of the performance or, more significantly, the prevailing social arrangements that have dictated the mode of the musical production itself. When those social factors are the same ones that have constituted the very people for whom the music in question is a recognized cultural legacy, then the music also effectively references that people, condensing genealogical information about the group that is in turn necessarily *adduced as* narrative whenever the cultural heritage is invoked. It is precisely this dual phenomenon that Amiri Baraka (still writing as LeRoi Jones) at once attests and enacts in his

famous, pithy assertion that the music that blacks have produced since arriving on American shores comprises "our history," where "history" names the particular narrative mode that is at work in such conceptions of cultural tradition.[55] In other words, however intrinsically abstract any musical instance—say, a cornet solo by King Oliver or Louis Armstrong—it registers as specifically *African American* only by means of a decidedly *non*abstract historical narrative that traces the music's genealogy in that of African Americans themselves.[56]

Such a narrative would of course recount the arrival of indigenous Africans on American soil and, more specifically, within the regions that ultimately became the United States. Remarking the conditions under which that arrival occurred and the means by which it was effected, this narrative would further review the various situations confronted by the developing collectivity in its ongoing engagement with the larger culture, salient among them the severe curtailment on educational opportunity generally suffered by black people both during and after the slavery era, touched on earlier. This restriction applied not only to training in mathematics and literacy, commonly understood to form the basis of modern education (with constraints on the latter figuring especially prominently in received accounts of slavery's detrimental effects), but also to the acquisition of such skills as were required for participation in recognized cultural pursuits, including various modes of musical production.[57] To say this is not, of course, to say that blacks did not make music from their first arrival on American shores. Rather, it is simply to acknowledge that practical limits on black people's access to instruments and to formal musical instruction obtained not only during the early twentieth century when jazz was developing (as we have already remarked) but also throughout the colonial, early-national, and antebellum periods. Indeed, considering the northern colonial context specifically, one authoritative historian of African American music pointedly and aptly wonders "how the slaves, lacking personal possessions and control of their time, developed instrumental skills," postulating that

under the circumstances . . . , the musical instruments favored by the slaves would have had to fulfill three conditions: first, the instruments had to offer a minimum of technical difficulties in the learning process, so that they could be learned with little or no professional help; second, the instruments had to be easily available and so easily handled that the slaves could carry them around and practice them at odd times of the day or night, whenever there were a few extra minutes to spare; third, the instruments had to be useful, so that once the slaves had learned to play them they would have opportunities to perform for others.[58]

Between such inferences and the scant available hard evidence, this commentator is led to conclude that a sizable number of slaves had to have constructed their own instruments from what materials they could obtain, even as some were apparently furnished with a few different kinds of instruments by slaveholders themselves.[59] Thus, while black drummers and fifers helped staff military bands during the Revolution and the War of 1812 (with the latter conflict evidently also giving rise to black brass players), it would seem that the instruments most prevalent among black slave populations throughout the eighteenth and nineteenth centuries were the flute, the banjo, and the fiddle, with a number of homemade percussion instruments undoubtedly filling out this roster.[60] In antebellum urban centers—certainly those in the North, with its more relaxed racial dispensation, but also such southern localities as New Orleans, Baltimore, and Charleston—a wider variety of instruments was made available to black practitioners in contexts including churches, theaters, concert halls, and ballrooms, especially given that by the earliest decades of the nineteenth century it had long been customary for black musicians to provide dance music at social gatherings for whites, even on plantations in the South.[61] Thus the record attests to some playing by blacks of the panoply of bowed string instruments, brass and woodwinds, and percussion, along with piano, although the institutional structures through which such activity was forwarded would have remained under the ultimate authority of whites.[62]

As for instruction, clearly some individuals who were transported from Africa brought with them estimable musical skills that they passed along

to other black people in America, necessarily adapting their practice to the unfamiliar objects they encountered in the new setting. Additionally, however, even prior to the expansion of institutionalized entertainment in the United States during the nineteenth century, there were instances in which blacks were afforded training in European-derived instruments by professionals or by accomplished amateurs, white or black, although such lessons obviously could not have been pursued at will by enslaved persons and in any event would have been tightly regulated in the slaveholding states during the antebellum period.[63]

Notwithstanding the sketchiness of the foregoing account and the relative marginality of the hardships it describes (as contrasted with the more flagrantly brutal aspects of black life within eighteenth- and nineteenth-century North America), those hardships themselves are in some measure constitutive factors in black American societal formation, inasmuch as they help to establish the very parameters of the group. That is, if asked to describe the slavery-era demographic cohort that was eventually to give rise to the people now known as African Americans, we might say that, among many other things (such as its consisting of more or less dark-skinned individuals of varying degrees of African ancestry), it was a class of persons whose access to musical instruments and professional musical training was generally limited—either directly controlled by the societally dominant population characterized as "white" or indirectly curtailed through systematic means developed to serve the interests of that dominant group. This constraint, along with the various other conditions experienced by the contingent as a whole, would necessarily have helped to define the very character of the people in question, such that problematized access to formal musical activity effectively became part of that people's "identity." By the same token, of course, the restrictions on access to musical instruments and to formal training would also have necessarily shaped the music emanating from the group, dictating, for instance, the general predominance within black-produced music of the fiddle and the homemade banjo—or of rhythms generated with makeshift percussions, since proper drums were largely prohibited among enslaved blacks in the antebellum deep South.[64] More positively, the music would also have been

informed by elements of indigenous practice retained by transplanted West Africans and their descendants, prominent among them antiphonal "call-and-response" performance customs and multimetric beat patterns or polyrhythms.[65] Given that recollection of and skill in these musical traditions were among the precious few personal effects the captives were allowed to bring along from Africa (because they did not manifest as material possessions), they were understandably crucial to the solidification of black community within the American setting, which went forward largely through the group's musical enactments themselves.[66]

Inasmuch as the conditions cited here at once help to establish African-derived persons in America as a recognizable collectivity and inform the character of the music generated by the group, then on the principle sketched earlier, the music itself in turn *bespeaks* the racial history in which those conditions are a defining factor: that is, the sheer salience of antiphony and polyrhythms or the prevalence of the banjo within certain musical forms effectively *attests* the African origins of both the music and its producers, in addition to implying the source population's removal to America and the experiences subsequently shared by black people in that context.[67] At the same time, if the historical circumstances delineated in the foregoing narrative are thus "expressed" in any musical instance received as *African American*, then so too does that music at once condense and extend that very narrative, which indeed is telegraphed in such de facto synonyms for "black music" as *rhythm-and-blues*, *soul*, *hip-hop*, and *jazz* itself.[68]

Most significant for our purposes, however, are those musical instances that do not obviously bear out the racial-historical import imputed to them through the application of such labels, as their seeming failure in this regard forces us explicitly to recount that import in order to claim the music as black, thereby disclosing the narrative principle on which the very concept of African American culture depends. Consider, for example, the pioneering "free jazz" works produced during the late 1950s and early 1960s by the pianist Cecil Taylor—notable precisely because their references, as Amiri Baraka acknowledged in 1966, are "determinedly Western

and modern, contemporary in the most Western sense."[69] Avowing that "one hears Europe and the influence of French poets on America and the world of 'pure art' in Cecil's total approach to his playing," Baraka frankly concedes that "Cecil's is perhaps the most European sounding of the New Music," while insisting that, nevertheless, "his music is moving because he is still Black, still has imposed an emotional sensibility on the music that knows of actual beauty beyond 'what is given.'"[70]

While it is not clear from this passage—or, for that matter, from the essay as a whole—what constitutes the "emotional sensibility" that Baraka suggests founds Taylor's musical blackness, some commentary that Baraka offers in a 1962 album review hints strongly at how he conceives this attribute. Focusing on the 1960 release *The World of Cecil Taylor*, Baraka makes three key observations.[71] First, citing Taylor's rendition of "This Nearly Was Mine," from the Rodgers and Hammerstein musical *South Pacific*, Baraka says Taylor "almost completely rearranges the melodic, harmonic and rhythmic devices of the tune and succeeds in making a music that is so personal and intimate as to give one the feeling that the original 'This' never really existed." Moreover, he adds, Taylor has transformed this same piece into "a subtle but genuinely bluesy blues," incorporating a "'blue' insistence" that is "one of accretion rather than immediate overstatement." Finally, Baraka finds that, on various other tracks from the album (as well as on "Of What," from the 1959 release *Looking Ahead!*), Taylor "seems to get the rhythm right up in the melodic surface of his music," "insert[ing] . . . the rhythmic pulse of the music directly into the melody."[72]

Sketchy as these assessments are, they seem reasonable enough when considered alongside the music itself. In his recording of "This Nearly Was Mine," for instance, Taylor does indeed radically rework the original melody so that it is scarcely recognizable even in its first refrain iteration, which one might expect to lay a familiar foundation for variations to come. For one thing, Taylor's rendering of this four-section segment of the composition is quite a bit longer in absolute terms than is the corresponding portion of Ezio Pinza's vocal interpretation on the 1949 Broadway cast recording, extending to fully twice the latter's duration of twenty-two seconds.[73] This is partly because Taylor intersperses among the scripted tones

34 From the vocal refrain of "This Nearly Was Mine," from *South Pacific*, lyrics by
Oscar Hammerstein II, music by Richard Rodgers. Copyright © 1949 by Richard
Rodgers and Oscar Hammerstein II. Copyright renewed. This arrangement
copyright © 2014 by Williamson Music, a Division of Rodgers & Hammerstein:
an Imagem Company, owner of publication and allied rights throughout the
world. International copyright secured. All rights reserved. Reprinted by
permission of Hal Leonard Corporation.

a sizable number of extraneous improvised notes, thereby disrupting the
continuity of the prescribed melodic line. The initial section of that line,
presenting one central D note both preceded and followed by two E-flats,
immediately gives way in the score to a second section comprising two B-
flats succeeded by an A, two more B-flats, an E-flat, and an A-flat (fig. 34).

35 The first four sections of the melody from "This Nearly Was Mine," as played by Cecil Taylor. The markings here indicate only pitch and not note value. Black notes are from the Rodgers and Hammerstein score; red notes signal Taylor's additions.

On his recording, Taylor introduces between these two passages what amounts to an entire new five-note measure, consisting of an A and two successive iterations of a D–E-flat sequence. While on the one hand this sequence echoes and thus supports the melody's opening section, its very intrusion into the melody line—coupled with its being pitched a full octave higher than the first melodic section—renders it more contrapuntal than complementary, and as such it offsets and displaces the composed melody within Taylor's recording.

This effect intensifies through the end of the refrain, as Taylor incorporates a gratuitous B-flat between the final E-flat and A-flat of the second scripted section, inserts yet another wholly novel seven-note phrase between the second and third sections of the scored melody, and intermixes various discrepant tones among the prescribed notes of the fourth section (whose indicated pitches and pattern exactly replicate those of the opening refrain section)—thereby not so much completing the notated passage as making it dissolve into a larger musical entity of Taylor's own design. Indeed, Taylor's version of this section greatly expands the tonal range of the song, incorporating notes pitched a full two octaves above or below the scripted melodic line (an E-flat and a highly distorted, cacophonic D,

respectively), which supplement the array of unauthorized bass-register notes that Taylor has already begun to introduce by the second of the two improvised sections mentioned earlier (fig. 35).

Thus Taylor clearly does "rearrange" Richard Rodgers's melody, as Baraka observes—largely by infusing it throughout with notes not represented in the score, but also by effecting the rhythmic modifications that Baraka additionally discovers in the 1960 recording. After all, even should a set of played notes comprise the exact sequence of pitches dictated by a score, it will not necessarily register for listeners as the *melody* indicated by that score if it diverges from the prescribed metrical scheme. Written in 3/4 waltz time, the Rodgers and Hammerstein composition calls for the first melodic section of "This Nearly Was Mine" (the E-flat–E-flat–D–E-flat–E-flat succession described earlier) to be played essentially as one three-beat-long note followed by three notes of one beat each and, finally, one note held for six beats, so that the full series of pulses can be characterized as long–short–short–short–double-long. While sounding the same five tones, though, Taylor presents them in a durational pattern that amounts roughly to short–double-long–long–short–double-long, holding the first note for about 0.7 seconds, the second for 1.9, the third for 1.2, the fourth for 0.7, and the fifth for 1.8 seconds. Such reorganization of the prescribed stresses—which continues throughout the section—makes it very difficult to discern the composed melody in Taylor's rendering of the piece, even in those passages where the scored melodic line is not disrupted through the introduction of improvised tones.

It is, in fact, virtually impossible to discern even a regular *meter* in the portion of Taylor's performance discussed thus far, since throughout the first minute and fifty seconds of the recording the contribution of the rhythm section is so subdued and attenuated as to be scarcely audible, let alone apprehensible in terms of a standardized beat. Consisting here solely of Buell Neidlinger's subtle and sporadic bass playing, that contribution appears during the initial refrain passage as a series of about thirty low tones plucked at seemingly random intervals (ranging from 0.2 to nearly

4.5 seconds long) and not so much providing a foundation for the melody line as echoing the irregular rhythms laid down by Taylor in his idiosyncratic interpretation of that melody on the keyboard. Indeed, in Taylor's rendering, the first four scripted refrain sections achieve four different temporal spans, extending from 6 to well over 11 seconds—and this is to leave aside the two newly improvised bars mentioned earlier. Pinza, by contrast, reliably allots about 5.75 seconds to each measured section of the piece, holding a steady 124 beats per minute for the duration of the song.

The pacing on Taylor's recording becomes more regularized once the drummer Dennis Charles joins in the performance, almost two minutes after it has begun (Taylor's rendition of the song runs to nearly eleven minutes, total, as compared with about three and a half minutes for the original Broadway cast version). From that point through the next eight and a half minutes or so, it is possible to discern the 3/4 beat indicated by the Rodgers and Hammerstein score, as it is fairly constantly maintained by Charles and Neidlinger together until about the last forty-five seconds of the track (albeit at a rather slower tempo than is in evidence in the cast recording, averaging only about ninety-eight beats per minute). Taylor himself adheres to this meter only intermittently, however—occasionally subdividing it by investing a single quarter-measure beat with multiple eighth or sixteenth notes and, much more significantly, periodically playing *in between* the established beats for lengthy stretches during the middle of the performance, often in no discernible rhythmic pattern. Both these aspects of Taylor's playing are nicely exemplified in a thirty-five-second span that begins about three and a half minutes into the recording, but for our purposes they appear most usefully in a twenty-second improvisatory turn that begins around minute seven and a half, during which Neidlinger establishes a "walking" bass line (as he does periodically throughout the recording) by playing evenly on just about every beat for the last few measures of the passage. At the end of this run, both Taylor and his rhythm section recur once again to their composed parts, with Neidlinger now stressing just one of the three beats contained in each bar and Taylor taking up the first section of the scripted bridge, comprising the note sequence A-flat–G–A-flat–E-flat–D-flat–C. The musicians all ef-

36 First bridge section of "This Nearly Was Mine," with Cecil
Taylor's one-note modification indicated in red.

fect this recurrence in such a way, however, that the downbeat now falls
on the second rather than the first beat of each measure as gauged from
the beginning of the recorded melody line. Additionally, Taylor inserts a
second D-flat just before the final C of the scored section (fig. 36), and this
small embellishment effectively sets him up to work a further rhythmic
change during the roughly six measures of improvisation that immediately
follow his playing of that section.

The third of those six measures introduces what appears to be Taylor's
modification of the scored piano part (as distinct from the vocal line),
offering up the repeated E-flats that effectively anchor the chord progres-
sion for the first bridge section—followed by an apparently anomalous
F-sharp—before proceeding with the half-step-by-half-step ascent up the
keyboard from A-flat to D that rounds out the run. More important than
any notated basis for this turn of Taylor's, though, is the fact that it com-
mences on the *third* beat of its initial measure, whereas Neidlinger and
Charles persist in stressing what is technically the second beat of each
bar—and Taylor continues playing in this rhythmic pattern when he re-
prises the first melodic bridge section immediately after the aforemen-
tioned ascent.

The rhythmic discrepancy between the lead part and the accompani-
ment at this point produces a distinctly syncopated beat—and a concomi-
tant swing—that notably differentiates Taylor's rendering of the song from
the Broadway cast version. A mere four bars later, relatively straightfor-
ward syncopation gives way to more of Taylor's seemingly arrhythmic
playing, and for the next minute or so this alternates with both off-beat
and between-beat syncopation, all three of these modes occasionally man-
ifesting the rapidly played subfractional notes Taylor has already deployed

during the first half of the performance. Finally, about a minute before the end of the recording, Taylor and the rhythm section together return to a standard 3/4 meter as Taylor once more takes up the composed melody, offering a slight variation on the initial three refrain sections. Twenty seconds (or ten bars) subsequent to this, the percussion cuts out altogether, to be followed by the bass ten seconds later as Taylor proceeds slowly (and generally softly) toward the close of the piece, rejoined by cymbals and intermittent bass just fifteen seconds before the finish.

■■ ■ ■ ■

Clearly, the various interrelated cadences achieved by bass, percussion, and piano in Taylor's recording of "This Nearly Was Mine" make for a rhythmic scheme that is significantly altered from the one indicated on the score and manifested in the Broadway cast recording. Meanwhile, the piano part alone effects changes to the composition that extend beyond the already-cited reworking of the melody line—paradoxically most notable in the relatively few moments when Taylor recognizably hews to that line, as these often present chords that diverge from what is notated on the sheet music. In Taylor's initial iteration of the refrain, for example, C emerges as a salient pitch in the two opening bars of the first section (comprising the E-flat–E-flat–D–E-flat–E-flat melody sequence), despite its not appearing at all in the relevant measures of the published composition, while D does the same in Taylor's rendering of the first two bars of this refrain's third section (where the melody line runs as G–G–F-sharp–G–G–C–F). Similarly anomalous pitches are in evidence both within this instance of the refrain and at the several other points where Taylor offers up identifiable fragments of the composed melody. All these unsanctioned tones in Taylor's performance combine with the prescribed notes to provide a harmonic arrangement quite different from that on the Ezio Pinza recording, which maintains the officially notated chord progression, duly transposed along with the rest of the production from the key of E-flat to C.

Indeed, it is doubtless the effectively "blue" tones that Taylor achieves through his distinctive note combinations that accounts for the "bluesy" quality Baraka detects in the recording—the "'blue' insistence" that he

suggests culminates by the end of the performance. For example, the two renderings of the initial bridge section discussed earlier (occurring right around the eight-minute mark and again around nine minutes and fifteen seconds into the piece) present distinct unscripted G-flat pitches in conjunction with pure G tones—a pairing that constitutes a classic blue note within the E-flat scale on which the composition is based. The same combination—plus the similarly "blue" amalgams of D-flat and D and of A and B-flat—appears in the interpretation of the final scripted refrain that Taylor pursues just a minute before the end of the recording, and the preponderance of such blue notes in this last rendering of the score (to say nothing of the improvised portions of the performance) would seem both to substantiate and to explain Baraka's contention regarding the mounting "bluesy"-ness of Taylor's playing on this track.[74]

Turning to the other songs from *The World of Cecil Taylor* that Baraka mentions, it is possible as well to discover the melding of rhythm and melody that he notices in them. This effect consists largely in the synchronicity between Taylor's staccato piano playing and the percussion that is often manifested on these cuts, as during the five-second stretch that begins about half a minute into "E.B." or the four-second span that starts roughly twelve seconds into "Port of Call."[75] If melody and rhythm seem somewhat more subtly interrelated on the 1958 recording "Of What," this is likely because there they sustain complementary but slightly divergent beats, rather than the sort of unitary pulse pattern frequently in evidence in the later releases.[76] Nevertheless, Baraka cites the recording's exemplary status with respect to melodic-rhythmic interplay, declaring that "'Of What' shows exactly how melody and rhythm can be integrated to form a musical object of extraordinary power."[77] Baraka's characterization of the piece as an "integrated" "musical object" would seem to be very much to the point, in that it evokes the state of autonomous concretization that I have suggested music approximates in its most non-externally-referential—that is, its most *abstract*—instances. Ultimately, however, Baraka is not interested in the abstract character of Taylor's music, nor is he fundamentally concerned with the specific melodic, harmonic, and rhythmic rearrangements that Taylor might work on a preexistent composition. Indeed, even

Baraka's clear investment in the "bluesy" quality that Taylor evidently achieves on "This Nearly Was Mine" is of a very particular sort, signaled by his assertion that Taylor has fashioned the song into "the kind of delicate blues that Montana Taylor could do so well."[78]

Born a full quarter century before Cecil Taylor, the evidently unrelated Arthur "Montana" Taylor issued recordings in the late 1920s and the mid-1940s and died in 1954, just as the younger artist was beginning his career as a lead musician.[79] In comparing Cecil Taylor to this pianist from the preceding generation, rather than to any then-current practitioner, Baraka invests him with a condition of lineal descendancy that mitigates the extent to which he might register as musically original, just as, in positing Taylor's rendition of "This Nearly Was Mine" as a blues, Baraka suggests that Taylor is participating in a genre that by 1960 is hardly novel. These effects are of a piece with the overall objective of Baraka's essay, which is in fact wholly committed to establishing not the thoroughgoing *originality*, but the inarguable *precedentedness* of Taylor's music.

Baraka allows in his opening paragraph that he has been pondering a particular question "for quite a while now," to wit: "Has Cecil Taylor really succeeded in finding a separate or *new* kind of jazz music, or is he merely applying an amazingly fresh musical personality to a quite 'traditional' form?" He then offers an answer: "Actually, on the basis of this album, I would have to say the latter idea seems true."[80] It is by way of elaborating and substantiating this claim that Baraka cites Taylor's extensive rearrangement of "This Nearly Was Mine," effectively dispensing with the particulars of that rearrangement in asserting that

> the real point . . . is that Taylor can and does go to old forms . . . and make his own music. A music which I am beginning to think is about as 'traditional' as any really fresh and exciting jazz music can be. And by traditional here I mean . . . the *use* of materials and ideas that are perhaps cultural inheritances . . . things Taylor has taken from the inordinately vital 'history' of jazz and worked over into something for himself.[81]

At stake here is not the substance of Taylor's reworking of "This Nearly Was Mine" but rather the mere *fact* of it, for Taylor's "go[ing] to old forms . . . and mak[ing] his own music" establishes him as an adherent of practices whose recognized centrality within jazz dates to the earliest days of the genre. Similarly, and more specifically, Baraka insists that Taylor's "insertion of the rhythmic pulse of the music directly into the melody"—evident in "Port of Call," "E.B.," and "Of What"—"is not really innovation. . . . Thelonius [*sic*] Monk and Charlie Parker both utilized this concept in their writing and playing, as did most of the boppers."[82] Contrary to what we might imagine, Baraka is not disparaging Taylor in disputing the supposed newness of his musical contributions. Rather, by positing him as the heir to practices pursued by African American musicians prior to his own emergence, Baraka is recuperating Taylor for a black "tradition" that he seems always in danger of disavowing, owing to what Baraka himself identifies as the clearly European aspects of Taylor's music.[83] Indeed, Baraka clinches this recuperation by tracing Taylor's melding of rhythm and melody specifically to Monk, Parker, and other practitioners of bop—or *bebop*—from the early 1940s, inasmuch as, in the words of one well-established commentator, "bop . . . was a wholly black invention," the result of "changes in black thinking" that themselves derived from powerful "social forces" that had culminated by the late 1930s.[84] More tendentiously—and therefore more illustratively— Baraka's Howard University classmate A. B. Spellman has claimed that "the bebop era was the first time that the black ego was expressed in America with self-assurance."[85] Whether Spellman's assertion is objectively valid is of no concern here. It matters only that bop is readily taken to epitomize an ethic of African American self-determination that is just as readily understood to define proper racial blackness per se. Given the general purchase of these notions, to trace Cecil Taylor's musical lineage to bop (and, beyond that, to the blues playing of Montana Taylor) is to assert the fundamental "blackness" of his music, which now registers as a specifically historical effect rather than the function of a vague "emotional sensibility" that Baraka elsewhere suggests is intrinsic to Taylor himself.

Honing somewhat the account just sketched, wherein bebop derives specifically from "changes in black thinking" that manifested in increased "self-assurance" among African Americans during the early 1940s, yet another analyst has pithily glossed the overall African American experience around World War II as one of "rising expectations met by intransigent racism, leading to a new sense of militancy." Considering this situation specifically as it bore on black musicians, this writer notes that the latter had understandably come to anticipate professional and social advancement continuous with what they enjoyed in the late 1930s, during the heyday of swing and the steady growth of the entertainment industry. In the event, however,

> the Swing Era inevitably cooled off, competition stiffened and the underlying inequities of race were felt with renewed force. Entrenched patterns of segregation, both in the music industry and in society at large, automatically gave white musicians a nearly insuperable advantage in the mainstream market, blunting black ambition and forcing it into new channels.
>
> Bebop was a response to this impasse, an attempt to reconstitute jazz—or more precisely, the specialized idiom of the improvising virtuoso—in such a way as to give its black creators the greatest professional autonomy within the marketplace.[86]

This incisive assessment accounts for the "blackness" of bebop in terms familiar from the brief genealogy of eighteenth- and nineteenth-century African American music offered earlier in this chapter, which similarly traced the restrictions that were systematically imposed on persons of African descent and thus helped to constitute them as a more or less cohesive collectivity. Like the constraints on black people's access to instruments and instruction cited in that discussion, the checks on World War II–era black musicians' professional opportunities were specifically *social* conditions that factored in the continued making of an African American demographic cohort—and, by extension, in the development of (a certain genre of) African American music.

Also crucial, of course, were the properly *musical* functions that black players would mobilize under the prevailing circumstances, the most relevant being those afforded by West African–derived musical custom. Indeed, during the period of bebop's ascendancy, certain advocates for the new mode strategically emphasized these aspects of the music so as to counter assertions (made alike by avid proponents and hostile critics) that it fundamentally diverged from all previous instances of jazz practice.[87] Thus, while granting that "the lack of polyphony or counterpoint in bebop . . . is the most serious weakness of the new form, and its sole point of inferiority to earlier jazz by commonly accepted standards," one influential late-1940s observer nevertheless insisted that the emergence of bebop was an "organic" development in the history of jazz as a whole, which "extend[s] across the time and space of twentieth-century America, and back into the roots of African culture."[88]

On the view expounded by this writer, bebop entails nothing other than "a thorough re-examination of the basic problems of polyrhythmics, collective improvisation, and jazz intonation"—concerns whose long-standing centrality among practitioners is indicated here precisely by their characterization as *basic*.[89] Most crucially, while acknowledging that "perhaps the most controversial aspect of bebop jazz is its rhythmic organization"—and averring that "bebop rhythmics, or better polyrhythmics, are so revolutionary that they have been largely misunderstood"—this commentator at the same time traces "the roots of bebop rhythmics" to the very big-band swing norms that bop had been understood to reject: "in the simplest terms, the new rhythm section is a modification of the Count Basie section."[90] Indeed, at key moments in the Count Basie Orchestra's 1937 recording of "One O'clock Jump" (for instance, during the first ten seconds or so of the production and again for the twenty seconds beginning around the one-minute mark), one can clearly hear the percussionist Jo Jones keeping time not on the drum (as had been standard in earlier jazz) but on the cymbal, generally providing a 2/4 accent to each four-beat measure.[91] On the band's 1938 recording of "Jumpin' at the Woodside," not only is the 2/4 accentuation slightly more attenuated than on the earlier cut (from around the fourth to the twenty-fourth second of

the track, for example), but Jones also works his cymbals in such a way that each stroke of the instrument is followed by a sustained shimmery aftertone that merges into the succeeding beat.[92] It was the resultant fluid or legato effect (as contrasted with the more definite and punctual drum line theretofore customary in jazz)—along with the cymbals' time-keeping function itself—that was adopted and maximized in such bebop classics as Charlie Parker's 1947 recording "Klactoveesedstene," where at the hands of the percussionist Max Roach it manifests as a virtually unbroken sonic backdrop of metallic vibration.[93] With its effective 4/4 rhythm—as distinct from the more clearly accentuated 2/4 beat of earlier jazz subgenres—being carried by the cymbals, bebop characteristically recruited the bass drum, snare, and other elements of the percussion kit to the function of providing counterrhythms in relation both to the ground beat and to the improvisations of the other instruments.[94]

This proliferation of beat patterns constitutes the polyrhythmic aspect of bebop, which establishes the style as continuous with West African musical practice. That this particular polyrhythmic mode was cultivated by a group of African American musicians in the context of the curtailment of their professional opportunities *as* African American musicians additionally establishes bebop as a sociohistorically African American musical genre. These musical and social genealogies intertwine to substantiate the fundamental "blackness" of bebop jazz, to which Amiri Baraka tacitly appeals when he declares that Cecil Taylor's infusion of a rhythmic pulse into his melodic line was anticipated by such boppers as Thelonious Monk and Charlie Parker, effectively attesting that it is by virtue of this connection that Taylor's music is "still black."

This account should not seem at all novel, given that it echoes the one regarding slavery-era African American music provided earlier, just as I have intimated it would. There, too, the collective experience of African-descended persons in the American context conditions the possibilities of their musical practice, which is noticeably informed by West African–derived elements in conjunction with other modes of musicality. By the

same token, Cecil Taylor's adaptation of already-recognized elements of black music—blues intonation, the reworking of preexistent materials endemic to jazz, bebop's melding of rhythm and melody—together with whatever significance is ascribed to his African American identification (however speciously), constitutes his music as "black" for whoever is convinced that these features (the musical adaptation, the racial identification) do objectively obtain in Taylor's case. Variations on this story could be repeated endlessly by way of characterizing any number of musical instances, but the basic components would remain constant, inasmuch as musical "blackness" will always necessarily depend on the acknowledged interrelation of received musical custom and social disposition—even if the latter amounts to nothing more than a musician's understood racial identity.

The real crux of the matter lies with the *convincing* to which I have referred, since it cannot be assumed that any given listener will inevitably perceive the factors of African musical descendancy and demographic blackness requisite to conceiving a particular manner or instance of musical production as "black." For example, I might decide that, on the face of it, the elements of Cecil Taylor's composition and performance are in my estimation not sufficiently Africanist for his music to attain to the status of "blackness." It is apparently his concern about this eventuality that leads Amiri Baraka to trace those elements back to bebop and the blues, so as to demonstrate the solidity of Taylor's African American musical lineage, notwithstanding his evident European influences and his early classical conservatory training.[95] In other words, the argument through which Baraka seeks to persuade potential skeptics that Taylor's music is "still black" consists precisely in the musical genealogy that Baraka posits, which joins with Taylor's presumed manifestation of what I am calling "demographic blackness" to clinch the point in the fashion outlined earlier.

As we have noted, both this demographic blackness and African American musical genealogy implicate a fundamental narrative principle. In the case at hand, that principle is attested and literalized by the fact and form of Baraka's argument, which duly affirms and orders the connections between the various instances of assumedly black music that Baraka in-

vokes, leading up to and including Cecil Taylor's own contributions. It is in the context of such narrative that (again, as we have already seen) a black racial import is vested in musical phenomena that otherwise manifest as profoundly abstract and so incapable of referentially evoking either racial experience or any other social fact; a good example here is the seemingly self-complete "object" that Baraka claims is comprised in Taylor's song "Of What," through its perfect integration of rhythmic pattern and melodic line. Having tacitly established the aesthetic abstractness of this particular musical instance, Baraka himself then immediately positions the latter within a narrative account in which it is prefigured by the characteristic practice of the beboppers. Thus situated, Taylor's work now factors into that narrative's inescapably referential means of instating musical "blackness," without at all forfeiting its own representationally abstract character.

Hence Baraka's account of Taylor's music perfectly exemplifies and encapsulates the point I have been at pains to make in the preceding pages: music does not by virtue of its received abstractness forgo the social significance that would constitute it as the epitome of African American cultural blackness. That significance, however, is the effect of specifically historical developments whose import is not necessarily explicit in the music itself. Not only do those developments implicate the consequentiality that I have noted is foundational to narrative logic (ensuing one from another as they do), but they must be recounted *in* narrative in order to be made intelligible to audiences unaware of their impact on the musical production. This is to say that the blackness of black music is itself a *function* of narrative, and that (as I have already suggested) to understand any musical instance as "black" is to apprehend it as a *narrative* element, rather than as music per se.[96] While Baraka's assessment of Cecil Taylor's composition and performance practices illustrates especially well narrative's centrality to the constitution of "black music," one other rendering even more succinctly demonstrates its essential import along these lines, thereby warranting our consideration here.

The music of the Art Ensemble of Chicago is recognized as drawing on European sources (among myriad others) no less than does that of Cecil Taylor, incorporating (for example) such genres as the march and the waltz.[97] More pertinent here than its specifically musical practices, though, is the motto under which the group has pursued much of its activity during the past thirty years or so: "Great Black Music—Ancient to the Future."[98] To the extent that the first phrase in this slogan is meant to characterize the work of the Art Ensemble itself, it clearly begs the question that the foregoing analysis addresses in relation to Cecil Taylor: what constitutes music as *black* to begin with? Having established in the preceding discussion that musical blackness derives as a matter of course from the combination of sociohistorical circumstance and African-informed musical lineage, we could no doubt trace these factors in the Ensemble's music and thereby fairly well confirm its blackness, just as we have done for instances of Taylor's recorded oeuvre.[99] The need for such an examination is effectively obviated, however, by the second of the motto's two phrases, which on initial consideration seems merely to qualify the referent of the first: "great black music" evidently comprises a long tradition—extending from antiquity through the next new thing—to which the Art Ensemble presumably pays homage precisely by participating in it at the present moment. Simultaneously, though, the sense of historical succession and development signaled by "ancient to the future" entails the same principle of narrative consequentiality that we have noted founds the very blackness of black music. In light of this, it seems less the case that "ancient to the future" characterizes the historical scope of the Ensemble's engagement with a self-evident "black music" than that it defines and authenticates this entity in the first place. By at once explicitly invoking "black music" and presenting the bare-bones version of the narrative through which it is constituted as such (the account of temporal succession condensed in "ancient to the future"), this fragmentary motto accomplishes for the Art Ensemble of Chicago what even the laconic Baraka requires a full four print paragraphs to accomplish for Cecil Taylor, substantiating the blackness of the group's music by affirming its position within a historical continuum.

Indeed, precisely because it is so pithy, the slogan can circulate semi-independent of both the Ensemble and its music and can thus function as a sort of caption for the two of them, glossing their cultural import in such a way that audiences need not actually encounter either one in order to ascertain its substantive blackness. While we would of course have to perform careful analysis of the music itself in order to determine exactly *how* it is continuous with earlier recognizedly black productions, that process would effectively amount to nothing more than our working up a customized elaboration of the basic narrative principle that we know is essential to the constitution of musical blackness wherever it obtains. Whatever the specifics of any such elaboration, without narrative per se there is no racial blackness—a fact that the Art Ensemble of Chicago seems always already to have acknowledged by positing its music in terms of a lineal trajectory extending from antiquity to an eternally pending tomorrow.

I suggested earlier in the chapter that narrative stands in counterrelation to the abstraction that is a fundamental concern of this volume. Understood in terms of the distance separating artistic presentation and lived social reality, abstraction constitutes the conceptual space in which productive social critique can be forwarded—a space that I have argued is made manifest through the *abstractionist* aesthetics for which I am advocating throughout. I have also contended that this effect of abstractionism is at present likely to register most powerfully beyond the realm of visual culture, notwithstanding the prominence of abstraction within that field since the beginning of the twentieth century.

On first consideration, it seems that music would offer a prime context for abstractionist-based African Americanist social critique, given that it is commonly—apparently *paradoxically*—taken to be at once the most abstract and the blackest of all the arts. As this chapter demonstrates, however, the means by which music accedes to blackness—and, more to the point, racial blackness itself—consists not in a specifically sonic modality but in a narrative discursivity that is not properly musical at all. Thus,

while music per se can certainly attain to the sort of abstractionism I described earlier (as when King Oliver modifies the sound of his cornet so that it simultaneously approximates the sound of the human voice and yet underscores its divergence from the latter), as soon as we attempt to mobilize the import of that abstractionism in a critique of the politics enmeshing African American subjectivity, we forsake the domain of music as such and inexorably encroach on the realm of narrative.

This fact hints that it is indeed *narrative* to which we should purposefully turn if we seek the mode of cultural activity in which abstractionist aesthetics can be most critically effective at present, and this suggestion is buttressed by the proposition that narrative and abstraction conventionally register as contrary presentational modes. The analysis provided in this chapter at once assimilates, discloses, and explicates that contrary manifestation, for it emphasizes that *narrative* affords a purchase on the material function of historical change that *abstraction* is understood to disavow, and it takes this situation as one of its own foundational premises. Considered not in regard to its specific practical effects, however, but in the broader theoretical terms laid out in chapter 1, narrative is just as abstract as any other representational instance, in that it obtains at an irreducible remove from its correlative real-world events. That it seems assiduously to dissemble this fact—and thus to sustain a powerful correspondence with lived reality—attests that narrative is in general only minimally *abstractionist*, and this implies that those relatively rare moments when its abstracted character *is* made manifest must be particularly jarring and potent. Furthermore, if African American blackness (like any other racial identity) is itself a function of narrative, the disclosure of narrative's socially abstracted quality would seem to promise an equally unsettling and productive disturbance of received ideas about both that blackness and the sociopolitical contexts in which it derives its meaning. In order to determine whether this promise holds good, however, we must first establish exactly what *constitutes* abstractionism in the domain of narrative. Only then will it be possible to judge what sort of critique, if any, this aesthetic mode makes it possible for its consumers to mount.

Telling It Slant

If it is specifically by means of narrative that any cultural instance is constituted as *African American*, it was also through its assimilation to a narrative function that Kara Walker's imagery became susceptible to African Americanist *critique* during the late 1990s, inasmuch as the "sexual abuse" and "hypersexuality" that Walker was charged with depicting can register as such only amid a preexistent context that founds their significance in those terms, by a consequentialist logic that is the very essence of narrative per se. While, as I argue in chapter 1, the static character of Walker's silhouettes should rightly militate against their being received in this fashion, no such defense can be mounted for a set of works that provoked similar controversy during the two decades preceding Walker's rise to eminence, as these unabashedly assumed a narrative form. Most notoriously exemplified in Steven Spielberg's 1985 film adaptation of the 1982 Alice Walker novel *The Color Purple*, these narratives comprised the offerings of what was by the late 1980s routinely figured as a coordinated detachment of Black Women Writers including, in addition to Alice Walker herself, Gloria Naylor, whose *Women of Brewster Place* was published in the very same month as *The Color Purple*, and Ntozake Shange,

whose "choreopoem" *for colored girls who have considered suicide/when the rainbow is enuf* (mentioned in chapter 2) generated an extraordinary amount of critical acclaim and popular contention after being produced on Broadway in 1976.[1] Drawing scrutiny specifically for their delineation of black male characters, these writers' works preceded Kara Walker's silhouettes in eliciting charges of "negative" portrayal, the gist of which is conveyed in a retrospective account published by one of the complainants in 1996. Focusing first on *for colored girls*, the social and cultural critic Earl Ofari Hutchinson asserts, "Shange introduced us to Willie Beau [*sic*]. He was an irresponsible, loathsome drunk who pisses on himself and wallows in his vomit. He hates his woman (and himself) so much that he throws his own kids out the window."[2] Taking up Naylor and Walker in turn, Hutchinson continues:

> Gloria Naylor's *The Women of Brewster Place* introduced four black women. Not one had a real man. They had to suffer through guys who were mostly liars, unstable egomaniacs, dick grabbers, pussy chasers, and gang rapists. One woman doggedly tried to make a go of it with her man. For her efforts, she was ignored, cursed out, and whacked. When he finally decides to walk out, she begs him to stay, pleading, "I love you." He rewards her devotion by gruffly telling her, "Well, that ain't good enough." BAM.
>
> Alice Walker's *The Color Purple* finally drove some black men to revolt. Alice named her black man simply "Mister." "Mister" was anyman. He was a misogynist, tyrant, abuser, child beater, and wife batterer. Even though he saw the light and became a better man at the end of the story, the damage had been done. "Mister" would be remembered as a brute.[3]

In keeping with my point that narrative meaning depends on context, these accounts fall short insofar as they neglect the specific circumstances among which each author situates her character's actions. In the case of Beau Willie Brown—from "a nite with beau willie brown," the penultimate piece in Shange's *for colored girls*—the most clearly relevant circumstance is Beau Willie's recent military service in Vietnam and its detrimental effect on his mental stability. Evidently suffering from what we would now call posttraumatic stress disorder, once he is back home from the

war, Beau Willie is sent into a panic by routine aspects of life in the city. Alone in his room,

> he'd see the spotlights in the alleyways downstairs movin
> in the air/ cross his wall over his face/ & get under the
> covers & wait for an all clear or til he cd hear traffic
> again/[4]

Despite (or perhaps because of) his clear susceptibility to delusion, Beau vehemently denies to his sometime girlfriend and the mother of his children that he is in any way impaired, his protestation rendered in free indirect discourse—that is, through the grammatical locus of the third-person narrator but via the consciousness of the character himself—in the immediately succeeding lines:

> there waznt nothin wrong with him/ there waznt nothin wrong
> with him/ he kept tellin crystal/
> any niggah wanna kill vietnamese children more n stay home
> & raise his own is sicker than a rabid dog/[5]

The next verse paragraph counters Beau's sanguine self-assessment by presenting the narrator's own terse retrospective account:

> he came home crazy as hell/ he tried to get veterans benefits
> to go to school & they kept right on puttin him in
> remedial classes/ he cdnt read wortha damn/ so beau
> cused the teachers of holdin him back & got himself
> a gypsy cab to drive/ but his cab kept breakin
> down/ & the cops was always messin wit him/ plus not
> gettin much bread/[6]

It is in the context of these various stresses that Beau Willie commits the first of the series of violent acts that culminates in his dropping his young children from their fifth-floor apartment window:

> & crystal went & got pregnant again/ beau most beat
> her to death when she tol him/ . . .[7]

Thus, while it may well be that Beau Willie Brown "hates his woman (and himself)," Shange roots that hatred in the overlapping factors of Beau's experiences in Vietnam, his educational impoverishment, his chronic legal difficulties, and his inability to earn a living—even as she undeniably fore-grounds its consequences for Crystal and her children (it is in response to Crystal's refusal to marry him so that he can "get some more veterans benefits" that Beau Willie drops the children to their evident deaths).[8]

A similar set of circumstances seems to influence the actions of Eugene, the husband of Lucielia "Ciel" Turner in Gloria Naylor's *Women of Brewster Place*, who does indeed tell Ciel that her loving him "ain't good enough" a reason for him to stay with her (though he does not, as Hutchinson claims, ever "whack" Ciel, instead dealing chiefly in verbal abuse).[9] In particular, Naylor implies that Eugene's lack of employment is the principal factor in his poor treatment of Ciel, who herself excuses Eugene's behavior—and her own decision to welcome him back after his first abandonment of her and their child—by insisting to her protective and skeptical older friend Mattie, "He's really straightened up this time. He's got a new job on the docks that pays real good, and he was just so depressed before with the new baby and no work."[10] Indeed, it is the eventual loss of this new job that reignites Eugene's anger toward Ciel, who by now is pregnant with a second child. Having come home early from work, Eugene confronts Ciel with the news: "'I lost my job today,' he shot at her, as if she had been the cause." Later in the same conversation, he vents his frustration regarding the expected baby: "And what the hell we gonna feed it when it gets here, huh—air? With two kids and you on my back, I ain't never gonna have nothin'. He came and grabbed her by the shoulders and was shouting into her face. 'Nothin', do you hear me, nothin'!'"[11]

It is evidently this promise of "nothing" that precipitates Eugene's final desertion, which he attempts to dissemble as his merely pursuing the op-portunity of employment in New England. That there apparently really is no job waiting for him at all—which Ciel guesses when he slips up and tells her that he is headed for "the docks in Newport" after having initially said that he was bound for Maine—further establishes unemployment as the defining condition of Eugene's life and as the primary contextual

circumstance amid which his actions take place.[12] This is not to say that Eugene, any more than Beau Willie, is fundamentally a sympathetic character. It is, however, to suggest that both Naylor and, even more explicitly, Shange indicate that their characters' failure to be so-called real men stems from complex external factors that severely restrict the scope of their opportunities.[13] Understood in this way, these characters do not constitute an essentially "negative" black male image so much as they serve as vectors for the deleterious effects of far-reaching social processes. Thus they are no less the victims of repressive forces than are the female and juvenile characters who are the immediate objects of their assault.

For its part, in its presentation of its narrative antagonist *The Color Purple* engages with at least two different sets of contextual circumstances— one that is internal to the story itself and one that consists in the dual literary traditions in which the work participates, as both an epistolary novel and a narrative of personal oppression and deliverance. That participation is signaled by the text's routinely referring to the character as Mr. _____ (and not "Mister," as Hutchinson would have it), which harks back, on the one hand, to the inaugural epistolary fictions of Samuel Richardson and, on the other, to the prototypical African slave narrative of Olaudah Equiano, both of these dating from the eighteenth century. Indeed, it was in 1740 that Richardson published *Pamela*, in which the lascivious "Esquire of Bedfordshire" persistently attempts to debauch the innocent title character, a young servant in his household.[14] Already in the first edition of that frequently revised and reissued novel Pamela's tormentor is more than once referred to as "Mr. B------" (as distinct from simply "Mr. B.," which is how the text more regularly designates him); and this dash formulation is adopted throughout numerous editions of the work published from the early nineteenth century on.[15] As has been noted by at least one commentator on the novel (in which, as the subtitle indicates, Pamela ultimately sees her "virtue rewarded" through her marriage to her reformed erstwhile oppressor), the antagonist's "undisclosed full name suggests a discreet allusion to a real family."[16]

Be this as it may, however, the point is actually not that Richardson's text might refer to a historically existent family but rather that it *conveys the impression* that it could. This is to say that the long dash inscribed after the first letter of the squire's name—like the general mode of anonymous reference that it and the similarly abbreviating period both enact—constitutes an emergent convention of novelistic realism whose effect derives from a comparable usage within such nonfictional prose writing as Equiano's 1789 autobiography, which quite evidently *does* implicate living persons in the depredations of West Indian slavery in the mid-1760s.[17] In recounting a number of the horrors with which he became familiar during that period, Equiano for instance recalls, "One Mr. D------ told me that he had sold 41000 negroes, and that he once cut off a negro-man's leg for running away------I asked him if the man had died in the operation, how he as a christian could answer for the horrid act before God? and he told me, answering was a thing of another world; what he thought and did were policy."[18] Pointing up the hypocrisy whereby this man disavows any relationship between his actions in this world and his fate in the Christian afterlife in which he putatively believes, Equiano at the same time shields the man from public censure by omitting his full name from the print record.[19]

Both Richardson and Equiano, then, effectively withhold proper names in order to protect those whose culpability their accounts themselves assiduously work to establish. Alice Walker is writing in this very tradition inasmuch as she has her long-suffering protagonist, Celie (whose letters make up the bulk of the novel's text), reference her abusive husband with exactly the sort of name-effacing graphic line that is deployed by the eighteenth-century authors, thereby according him not the generalized "anyman" status that Hutchinson disdains but rather the decorous anonymity that is appropriate to his guilt.[20] And yet however guilty Albert may be (for "Albert" is the actual given name of Celie's adversary), out-and-out incrimination clearly is not the point of Walker's usage, which is also applied to such relatively innocent characters as Samuel (or "the Reverend Mr. _____," who along with his wife, Corrine, has adopted one of the children born to Celie as a consequence of her rape by her presumed

father), Celie's sister Nettie (who is warned by an English church bishop to mind "appearances, Miss _____," when she continues missionary work in Africa alongside Samuel after Corrine has died), and Celie herself, to whom at an early pivotal moment in the narrative her stepson Harpo's visiting girlfriend, Sofia, says, "Mrs. _____, I'd thank you for a glass of water."[21] Given that none of these latter three figures is presented as the nefarious agent that Albert so emphatically constitutes, the construction "M–_____" evidently signifies not so much the characters' *guilt* in the strict sense as their *subjection* within the patriarchal order that is the object of the novel's critique, where *subjection* denotes an individual's enjoyment of social legibility, irrespective of how he or she is positioned in prevailing relations of power (roughly indicated here by the appearance of *Mr.*, *Mrs.*, or *Miss* before the anonymizing score mark).[22]

Inasmuch as it is established specifically through the portrayal of distinctly delineated characters in sustained interaction, this patriarchal order is, as I have put it, effectively internal to the novel itself—a situation made possible by the temporal modality of narrative discourse as contrasted with, say, pictorial depiction. At the same time, though, that portrayal registers its full significance only to the extent that it mobilizes gender (and, less directly, racial) differences endemic to a realm of lived reality that lies beyond the novel per se and that the latter is understood to reflect. Indeed, it is precisely its capacity for extensively realized mimesis—its ability to represent not only objective entities but also social relations familiar to us from real life—that recommends fictional narrative as a prime genre through which social critique might be lodged, as such mimesis enables audiences to recognize that what transpires in the realm of the story is applicable in the world they inhabit.[23] Somewhat paradoxically, however, it is also the *accomplishment* of such mimesis that renders a narrative vulnerable to the sort of criticism elicited by Shange's, Walker's, and Naylor's writings, in that the plausible correspondence of the works' characters and their actions to persons and occurrences in the real world is what permits readers to conclude that (1) the works actually depict characters who are to be understood as "black men" and (2) these characters are presented as behaving in ways that reflect "negatively" on

them—and thus, by extension, on the real-life black men whom they are taken to emblematize.

To apprehend fictional-narrative representation in this way is to deploy the realist ethic of reception that I discussed in chapter 1 in concert with the understandable concern about stereotype acknowledged in that same chapter. In my consideration of responses to Kara Walker's silhouettes, I focused in particular on why those works should be received in realist terms at all, given the clearly nonrealist elements they incorporate. This question is not relevant in our discussion of Shange's, Naylor's, and Alice Walker's writings, however, since they all inarguably solicit realist interpretation by adhering to well-established protocols for realist narrative portrayal: the characterization of fictional personages in terms recognizable from real life; the plotting of dramatic development through occurrences understood as comparatively routine by the characters—and, often, by readers as well; the invocation of real-world locations (Maine, Vietnam, Africa) amid which the characters' experiences are situated; the presentation of events as taking place consequentially, in a manner that jibes with commonly received understandings of the passage of time and of cause and effect; and so on. Indeed, these various mechanisms for more or less tacitly asserting a fictional narrative's congruency with the realm of lived reality are epitomized in the means by which Alice Walker suppresses the surnames of her socially subjected characters. Standing in, according to custom, for the name of an actual person best left unidentified—and so hinting that the entire narrative might similarly represent real-life occurrences—the horizontal line effectively figures as a seam between lived reality and fictional representation that itself suggests the latter's correspondence to the former.

Thus the controversy that Shange's, Naylor's, and Walker's narrative works have generated does not derive from their being inappropriately received in realist terms by their critics. Rather, it derives from conflicting notions about the relationship that obtains between their patently realist representations and the world of lived experience from which those

representations draw their power. Shange was explicit about her conception of her own work in this regard in comments she made during the early 1980s, responding to an interviewer's pointed query—"Why did you have to tell about Beau Willie Brown?"—in pithily illustrative terms: "Because I have to live around people like him."[24] This reply suggests that Shange understood her representations to function in a particularistic manner, corresponding narrowly with personages and occurrences known to her through direct experience, and it thus seems to comport with other of her remarks made elsewhere in the same interview: "One time a critic said that the people I had written about couldn't possibly exist. That would mean that everybody I knew did not exist."[25] Her further commentary on Beau Willie indicates that "knowing" here means something broader for Shange than we might initially think, however, consisting not just in intimate familiarity but in a worldly awareness that is itself the source of her literary portrayals: "My critics can say that he doesn't exist. Then they can try to explain to me why there are two million American children who are abused by their parents every single year."[26] While Shange's turn to statistics in this remark effectively depersonalizes the reference of her depictions, though, it does not entirely undercut their specificity but instead merely enlarges the stage on which it obtains, as is made clear by a final pair of excerpts from the interview.

Referring to another of her poems about the physical and sexual abuse of women and children, which appeared in her 1978 collection *Nappy Edges*, Shange tells the interviewer, "'With No Immediate Cause' was based directly on quotes in *The New York Times*, and people got upset with me. I said, 'Why get upset with me when I'm simply telling you what's in the newspaper? Don't you read the newspaper?' It's not my fault that they reported these things."[27] At another juncture, Shange invokes the newspaper yet again, but in the service of a slightly different point: "I got really upset one night. A man was interviewing me for *The New York Times* He told me he had never raped anybody." Then, speaking directly to her present interlocutor, Shange glosses her enraged response to this attempt by the *Times* reporter to disclaim personal responsibility for rape: "That is a denial of reality. It does *not* matter if you did or did not do something. If

you didn't do it, does that mean it didn't happen?"[28] The particularity of Shange's representational practice becomes especially clear here, inasmuch as her message to the *Times* reporter is that, if he has never raped anyone, then he is not a referent of her depictions along these lines; bluntly put, in the work in which she depicts perpetrators of sexual assault, *she simply is not talking about him.* On the contrary, she is talking *only* about those men who *have* committed the abuses she describes, so that while by her own lights her literary representations are highly mimetic—avowedly based on identifiable antecedents from real life—they are also narrowly referential, keyed only to particular individuals or to cohorts clearly defined by the actions of their members, rather than to the entire class of persons who merely share her characters' status traits, such as evident black male identity.

It is precisely this specificity of representational focus, however, that has elicited intense objection to the work of Shange and the other authors discussed here. In his 1996 reflection on the mid-1980s controversy surrounding Shange, Naylor, and Walker, Earl Hutchinson admits in an italicized note, "*I was one of their critics. I never attacked them for creating demeaning images of black men. I attacked them for creating no other kind of image.*"[29] This concern about the perceived singularity of the black male "image" promulgated by these writers indicates a way of understanding their depictions' representational import that necessarily diverges from Shange's own. Both conceptions assume the portrayals' mimetic-realist character—their reference to and evident patterning on real-world personages and events. Indeed, Hutchinson appeals to precisely the same ethic of narrow mimetic correspondence as Shange when he insists, "*We can all name countless numbers of black men whose lives embody positive images. They don't have to be created.*"[30] This invocation of individuals "we can all name" who might serve as real-life models for "positive" literary depictions of black men is entirely in keeping with Shange's recourse to the received factuality of the *New York Times* as the basis for her depictions of men who commit physical and sexual assault. In what he judges to be the absence of any such "positive" depiction in Shange's work, however (to limit ourselves momentarily to the one author whose own commentary

we have reviewed), Hutchinson understands the scope of reference for her putatively singular "*negative*" portrayal to be much broader than does Shange herself, seeing it as encompassing *all* black men as opposed to just those who, through their actions, have established themselves as prototypes for characters such as Beau Willie Brown.

For her part, and to adapt her own formulation, Shange would evidently contend that, just as her not writing about the reporter from the *Times* does not mean that he does not exist, her not presenting recognizedly "positive" depictions of black men does not suggest that there are no actually existing black men who comport themselves admirably (and this is to assume that she really does *not* offer any such "positive" portrayals, which has hardly been firmly established). Hutchinson, on the other hand, clearly maintains that what he sees as Shange's, Naylor's, and Walker's unitarily "negative" black male depictions imply that the real world itself holds just one, equally unsympathetic type of black man. It is in this sense that, as I have already intimated, he understands these authors' portrayals of black men as not simply mimetic, or convincingly reflective of real-life black men in their varied individuality, but *emblematic*—that is, representative of the general collectivity of black men per se.

It is fairly easy to grasp why such emblematizing would be viewed warily, since it informs the prejudicial effect that we have identified with the stereotype. Not only is the stereotype by definition reductive, diminishing the complexity of its object by characterizing it through a minimal number of distinguishing attributes (e.g., tyrannicalness, misogyny, abusiveness), but—and herein lies its sinister potential—it also implicates *all* members of the class of persons to which it is understood to refer, just as the emblematic literary depiction is taken to symbolize the broad generality of its own understood referent. Having noted this, however, we are still left with the question of why Shange's, Naylor's, and Walker's portrayals would *register* as emblematic in the first place. One possible reason, of course, is that they are circulating among a readership whose long acquaintance with stereotypic representation might lead it to suspect

that *any* black-masculine rendering bears prejudicial import. Much more analytically relevant, though, is the evident fact that the works themselves do not vigorously assert the terms of their own status as narrative—do not, that is, acknowledge that they necessarily admit only a limited set of elements within their representational domain. Indeed, as anyone who has ever given a narrative account of anything well knows, it is not possible to include even every potentially relevant detail in any story one tells, let alone those elements that appear completely unrelated to the main point.[31] With respect to the writings of Ntozake Shange, Gloria Naylor, and Alice Walker—and to the concerns of their critics—this means that the perceived lack of virtuous black men in the depicted worlds cannot be taken as a simple reflection of their understood absence from the realm of lived reality. Rather, it can reliably be taken only as a sign that the fictional worlds are restricted in what they can accommodate and that the authors have made certain decisions about what to present.

If this basic fact about narrative representation is easily overlooked by Shange's, Naylor's, and Walker's critical readers, as it apparently is, this is precisely because, as unabashed participants in the project of realist representation, the texts in question work strenuously to dissemble the fictive character of the stories they offer up. Indeed, it is a primary function of the previously mentioned realist literary protocols to suggest that the extent of the narrative world is either equal to or identical with that of the real world and that the narrative world accordingly is not subject to the limits just cited. For example, because what I have called *consequentiality* entails a theoretically endless process whereby one thing issues in another ad infinitum, it implies that the incidents detailed in any narrative are ultimately precipitated by occurrences that lie beyond and precede the narrative beginning—and that they potentially give rise to developments that exceed the narrative's close. (Thus *The Color Purple* is structured so as to suggest [1] that the course of events presented in the novel has been triggered by Celie's unrecounted sexual abuse at the hands of her "Pa," the factors in which likewise emerged prior to the time period addressed by the narrative proper, and [2] that Celie lives beyond the temporal span represented in the novel, existing happily ever after in the company of a

regenerate Mr. _____—now duly referred to by Celie as "Albert"—and members of her extended and composite family, all of them so contented as to feel "the youngest [they have] ever felt.")[32] In both instances, this effect negates the presentational frame that constitutes any narrative as a self-contained story to begin with, for it renders the events of that narrative continuous with occurrences in a world external to it—not necessarily the "real" world inhabited by the reader but one that, however imaginary, is equally vast and comprehensive.[33] By the same token, when a narrative recounts events in such a way as to indicate their generally quotidian character within the depicted world, it establishes a functional parity between that world and the world of lived reality (where a corresponding sense of routine is the predominant experiential affect) and thus implies that the two worlds—real and fictive—are commensurate in depth and complexity, as well as in all other respects. Even further, for a narrative to invoke such real-life reference points as actually existing geographical locations is for it to suggest not only that the world in which the narrated events occur is just as extensive as the real world but that the two worlds share the very same limits—that the world of the narrative in fact *is* the world in which the reader lives and breathes.

While readers thus might reasonably expect a realist narrative to present a maximally inclusive and diverse cast of characters, however (notwithstanding the practical constraints on such an undertaking), modern realism typically works not just by credibly depicting seemingly objective phenomena but also by plausibly limning its characters' subjective sensibilities and thereby conveying a sense of the characters' psychic interiority.[34] With this aim in view, a narrative necessarily *restricts* its representational range to the scope of the characters' own cognitive awareness, the partialness of which is itself a factor in the work's verisimilitude, as it mimics the limited quality of real-life human consciousness.[35] Regarding the narrative instances at hand, this means that readers' knowledge of the depicted worlds derives chiefly—if not entirely—through the knowledge borne by the principal characters (Crystal, Celie, the various women of Brewster Place), since it is these personages with whose psychic lives the narratives are primarily concerned.[36] Hence, if readers encounter rela-

tively few admirable black male characters in these works, this is because such figures do not loom prominently in the consciousness of the protagonists themselves. In thus hewing to such a realistic portrayal of their characters' subjective dispositions, however—narrowing the range of their black male reference to comport with the characters' own experiential knowledge—these narratives inevitably retreat from presenting the fictive world as boundlessly expansive, and in this sense they undercut the efficacy of their own realist delineation of the *objective* circumstances amid which their characters move.[37]

Thus the multiple demands of contemporary realism constitute a double bind in the instances of literary production at issue here. Staking their social-critical effect on their clear relevance to real-life concerns, the works under review partake in what we might call a naturalistic social realism that establishes the worlds they depict as commensurate with the real world in which they circulate.[38] This equivalence implies that the fictive world is just as complex in its makeup as is the real world itself, peopled by a correspondingly varied cast of characters. Given this, it is reasonable that readers should balk at what they perceive to be the narrowness of the works' black male characterizations, as it violates the very precepts of realist representation to which the works themselves evidently subscribe. On the other hand, in the interest of accurately delineating not only externalized objective phenomena but also the subjective experience sustained by their principal characters, these same works take the bounds of that experience as the limit of their representational purview, thereby pulling back from the depictive comprehensiveness they otherwise seem to promise. Committed to this latter conceptual regime, an author (or her advocate) could quite reasonably say that to depict any phenomenon that lies beyond the protagonists' ken—such as a sympathetic black male personage—would be to violate the tenets of the specifically *psychological* realism that the work is meant to uphold.

The impasse in this dispute thus arises from the multifaceted—and potentially self-contradictory—character of the realism to which both of the contending parties appear equally committed, and it remains insurmountable so long as realism itself constitutes those parties' chief interest. The

problem, simply put, is that even the most sophisticated and accomplished realist narrative is limited by its representational mode, constrained to present what it presents, emphasize what it emphasizes, and omit what it omits. That presentation, emphasis, or omission may well be *explained*—as in my review of the contextual factors that evidently account for Beau Willie's abuse of Crystal, Eugene's neglect of Ciel, or Albert's manifestation to Celie as an anonymous "Mr. _____"—but it is not by that token *negated*, which is to say that any such explanation may simply fail to appease a person who finds fault with a given realist-narrative depiction, while the complaint itself remains perfectly well founded in the very realist principles that the depiction embodies.

I have remarked that the narrative realism just described consists largely in the impression of *consequentiality*, which joins a recognized sense of temporal elapse with received understandings of cause and effect. As noted in the preceding chapter, however, this consequentiality is also the defining characteristic of narrative *as such*, inasmuch as narrative accounts for the occurrences it represents in terms of both succession and causality. Thus we might say that narrative strictly defined is *always* realist, in that it partakes of the consequentiality that is well familiar to us from real life, if only because we employ it in order to make sense of our own day-to-day experience.[39] On this view, the disruption of that consequentiality is tantamount to the subversion of realism itself, and in thus marking a verbal account's divergence from the lived reality to which it evidently refers, such disruption constitutes *abstractionism* within the realm of narrative—just as, conversely, properly consolidated narrative practically counters such aesthetic *abstraction* as is exemplified by music, per the analysis offered up in chapter 2.

Unlike the elements of specifically *visual* abstractionism that are featured in Kara Walker's silhouettes, however, the disruption of narrative consequentiality is sure to be noticed by anyone who is confronted with it, because it contravenes principles that define both narrative per se and the very linguistic system that provides the latter with its primary medium. In-

deed, I emphasize that language is a *system* precisely in order to highlight its rule-bound character—the fact that it must be deployed according to certain fixed laws if it is to "work" properly and convey intelligible meaning, which cannot be said of visual representation. Those laws crucially pertain as much to syntax as to denotation, which means that however clearly any set of words might refer to a corresponding set of concepts or entities, it only *makes sense* insofar as it is structured in a prescribed order, itself discernible only over time. Thus when Naylor's narrator tells us that, having finally realized that Eugene does indeed intend to leave her, Ciel is at last able to see him "just as he really was—a tall, skinny black man with arrogance and selfishness twisting his mouth into a strange shape," there can be no doubt that we are meant to envision a lanky male person of African descent whose facial expression is distorted by intense egoism, made clear by Eugene's deciding to abandon Ciel despite her having aborted the pregnancy that he so resented rather than deliver the second child she herself so desperately wanted.[40] This is partly, of course, because we are proficient enough in the language to see that the *a* in the passage's appositive phrase is an indefinite article denoting the singleness of the entity subsequently invoked; *tall* indicates that that entity is of relatively great height; *skinny* marks it as being of overall negligible girth; *black* here means "of sub-Saharan African derivation"; *man* signals "adult male human being"; and so forth. More than this, though, the passage's constituent elements are ordered in a linguistically sanctioned way such that we realize in the first place that the words *tall*, *skinny*, and *black* all describe the individual indicated by the succeeding term, *man*. Further still, and granting that we are trained from the outset to apprehend the components of English text in left-to-right succession, such features of the passage as adverbs, conjunctions, articles, adjectives, prepositions, commas, and dashes necessarily *urge us on* in this respect, since they become intelligible only in relation to what follows them in a particular construction. Overall, then, the printed text channels readers' attention along a forward course that is scarcely checked even by such graphic devices as punctuation marks or paragraph indentions; and this impetus itself bespeaks a logic of consequentiality that is understood to found the self-coherence of any given textual instance.[41]

It is arguably in response to this circumstance that verse poetry resorts to the line break in order to achieve the unpredictably foreshortened phrasal constructions—and hence the highly compressed semantic units—that are understood to define the genre, as this seems to halt the progress of readerly engagement with a force that surpasses even that of the paragraph division.[42] The point is famously illustrated by William Carlos Williams's 1934 piece "This Is Just to Say," which is constituted as a poem—rather than just an intradomestic communiqué—almost entirely by its line and stanza breaks alone:

> I have eaten
> the plums
> that were in
> the icebox
>
> and which
> you were probably
> saving
> for breakfast
>
> Forgive me
> they were delicious
> so sweet
> and so cold[43]

Indeed, here line breaks effectively substitute for punctuation, with the result that the entailed pauses are even more emphatic than they would be if they were indicated by commas, semicolons, dashes, or even periods, as each of those marks is understood to imply something about the relationship between what precedes it and what follows it in a given text. A line break, by contrast, constitutes an absolute syntactical hiatus, such that even when the grammar of a couplet dictates that one must read beyond the break in order to establish the lines' semantic coherency (as with the enjambed prepositional phrase "in the icebox" in Williams's lines 3 and 4), the break itself works to fix one's attention on the line that it terminates, which thereby registers as a primary unit of poetic significance,

irrespective of its embeddedness within a larger grammatical formulation. In this sense, then, the "meaning" of the break—semantically void in itself—consists in its investment of the line with meaning.[44]

Beyond this, though, because the poetic line break is understood to happen not by accident but on purpose, it implies the existence of some deliberative subjectivity that effectively dwells "behind" the verse and adjudicates each of its line divisions.[45] This entity, determinative as it is, stands in tense relation to the alternate subjectivity that evidently emerges *in* the verse, since the integrity of the latter is a function of the work's overall syntactical fluency, which the partitioning of the poem into lines serves to disrupt.[46] Instanced in the first-person pronoun "I" that inaugurates the piece, such subjectivity as emerges in Williams's poem theoretically presents as increasingly consolidated and effectual the more completely it "speaks" the sentences that constitute the work, but those sentences appear most complete when they are unbroken and punctuated in accordance with their semantic import: "I have eaten the plums that were in the icebox, and which you were probably saving for breakfast. Forgive me; they were delicious—so sweet, and so cold." Here the onward flow of the linguistic engagement—checked but also facilitated by the punctuation that marks it—is one with the elaboration of the speaker's subjectivity, which approximates ever more closely to a fully human character by in turn asserting itself as "I"; establishing its agency as the one who "ha[s] eaten the [comparatively impassive] plums"; distinguishing itself against a direct addressee—"you"—with whom it is mutually constituted; and manifesting not only a moral faculty ("forgive me") and a sensuous capacity ("they were delicious—so sweet, and so cold"), but also an intellectual aptitude, having after all properly formulated the sentences that now confront us.

Of course, the semantics of Williams's poem as it is actually published are the same as what obtains in the punctuated prose version I offer, inasmuch as the verbal components of the two instances are identical. The subjectivity that issues forth in the printed verse, however, neither consolidates over the course of the poem nor ultimately manifests as particularly coherent, precisely because the discourse through which it asserts itself is fragmented into discrete lines that militate against that subjectivity's

steady elaboration. Indeed, rather than the organically integrated entity that emerges in the recast version of the poem that I provide, the sharp truncation of Williams's published lines—seemingly enacted by some agency that is ulterior to the poem itself—instates a subjectivity whose chief characteristics are fracture and disarticulation, exemplified in the robotic staccato of its own clipped expressions. In this respect, then, the "meaning" of the poetic line break is its disruption of the subjectivity discursively elaborated in the verse, which evidently occurs at the initiative of some *other* subjective entity operating beyond the poem and determining its overall form.[47]

This disruptive effect is endemic within verse, and it implicates not only the putatively "speaking" subjectivity that a poem discursively conjures but also the *reading* subjectivity that similarly derives through the work's discursive operation.[48] Comprising not the actual *person* who peruses a given poem but rather the mode of *consciousness* a person assumes in that very perusal, such a reading subjectivity can make sense of the literarily represented world only by acquiescing to the discursively elaborated subject's own conceptual logic—the logic, for instance, whereby Williams's speaker eats the plums, confesses to the offense, and retrospectively relishes the experience—however alien it might appear beyond the context of the readerly engagement.[49] Inasmuch as it is only the coherency of the text's discursive development that renders that logic sufficiently intelligible to be granted in the first place, the reading subjectivity depends on that coherency no less than does the "speaking" subjectivity itself, and thus is equally infringed on each time a line break curtails a poem's discursive momentum—again, seemingly at the initiative of some ultratextual force. To invoke once more this study's primary theoretical concern, we can say that the line break's telegraphing of such an ulterior agency constitutes a central element in the *abstractionism* of any work in which it appears, in that it establishes the text's status as a deliberately crafted artifact rather than an organically occurring entity. This abstractionist effect is only intensified, moreover, when the line break is joined with other features

that register as similarly "artificial" in relation to the norms of everyday linguistic practice. Unusual diction, tightly intricated syntax, figurative reference, heightened rhythmicality—all these indicate more powerfully than do relatively prosaic formulations that the text in which they appear is a consciously wrought object, while also potentially introducing discursive complexities that trouble the easy consolidation of a reading subjectivity.

If the aforementioned textual features are both as estranging and as characteristic of verse poetry as I have implied, then it is reasonable to propose that that genre comprises the most resolutely abstractionist mode of textual representation among all those on offer within the contemporary context. Functionally speaking, however, poetry is arguably *less* abstractionist than it might be, if only because it is customarily *expected* to present such formal peculiarities as I have cited, and hence to register as characteristically "difficult" even in the myriad instances in which its diction appears commonplace and unexceptional.[50] Indeed, it is precisely for this reason that the prose poem, as distinct from its verse counterpart, can be mobilized to routinely bracing effect, since in eschewing conventional stanzaic structure it seems also to repudiate poetic difficulty, only to reassert the latter through the challenging semantics that authorize its own claim to the title of poetry. Exemplary in this regard is Carolyn Forché's well-known 1978 piece "The Colonel," which testifies to the poet's sojourn in El Salvador during the lead-up to the civil war that pitted leftist rebels against the country's long-standing and brutal U.S.-supported military dictatorship:

> WHAT YOU HAVE HEARD is true. I was in his house. His wife carried a tray of coffee and sugar. His daughter filed her nails, his son went out for the night. There were daily papers, pet dogs, a pistol on the cushion beside him. The moon swung bare on its black cord over the house. On the television was a cop show. It was in English. Broken bottles were embedded in the walls around the house to scoop the kneecaps from a man's legs or cut his hands to lace. On the windows there were gratings like those in liquor stores. We had dinner, rack of lamb, good wine, a gold bell was on the table for calling the maid. The maid brought green mangoes, salt, a type of

bread. I was asked how I enjoyed the country. There was a brief
commercial in Spanish. His wife took everything away. There was
some talk then of how difficult it had become to govern. The parrot
said hello on the terrace. The colonel told it to shut up, and pushed
himself from the table. My friend said to me with his eyes: say
nothing. The colonel returned with a sack used to bring groceries
home. He spilled many human ears on the table. They were like
dried peach halves. There is no other way to say this. He took one
of them in his hands, shook it in our faces, dropped it into a water
glass. It came alive there. I am tired of fooling around he said. As
for the rights of anyone, tell your people they can go fuck them-
selves. He swept the ears to the floor with his arm and held the last
of his wine in the air. Something for your poetry, no? he said. Some
of the ears on the floor caught this scrap of his voice. Some of the
ears on the floor were pressed to the ground.[51]

Crucial here is the speaker's deceptively direct assertion that "there is no
other way to say this," which on its face seems to constitute an outright
disavowal of metaphoric figuration—of that *other way* of saying some-
thing than through literal statement—and hence to index the ensuing flat
declaration that the colonel "took one of [the severed ears] in his hands,
shook it in our faces, dropped it into a water glass." The situation is com-
plicated, however, by the ambiguity of "this," the referent of which could
just as easily be the metaphorical fact that the ears "were like dried peach
halves," in which case "there is no other way to say this" would have to
mean that *only* figurative language—manifesting here specifically as sim-
ile—is capable of adequately conveying the full import of this particular
moment at the colonel's house.[52] Such an affirmation of the incomparable
power of metaphor would comport with what we might now note is in
fact the poem's frequent deployment of it, whether in the moon's "swing-
ing" "on its black cord," the glass shards' potentially cutting a man's hands
"to lace," the submerged organ's "coming alive" in the water glass, or the
upturned ears' "catching" the "scrap" of the colonel's voice. Because the
poem does not firmly commit itself to this type of figuration, however, but
instead vacillates between figurative reference and the literalism of blunt
pronouncement ("On the television was a cop show," "The maid brought

green mangoes, salt, a type of bread," "He spilled many human ears on the table," etc.), "The Colonel" registers a fundamental ambivalence about the very metaphorical practice that is understood to be poetry's stock-in-trade, only to mobilize that ambivalence as the engine of its own poetic effect.[53] Indeed, at the climax of the piece, the colonel himself both recapitulates and knowingly acknowledges this paradoxical project, first announcing that he is "tired of fooling around," and thus evidently forswearing such silliness as the double-talk of metaphor; next indirectly imploring the speaker's "people" to "go fuck themselves," thereby indulging in one of the most violently contemptuous instances of metaphor generally available to English-language speakers; and then slyly remarking that the entire episode—including both the metaphoric indirection of the dinner conversation and the all-too-literal sweeping of the ears to the floor—will constitute ample fodder for his guest's poetry. That it does indeed do this is of course attested by the poem at hand, not only through its thematics but in its own evident ambivalence about metaphorical reference, which is brought to a head in its concluding sentence.[54] If that sentence tells us that "some of the ears on the floor were pressed to the ground," then it must literally mean that they lay cup-downward, even as it appears both metaphorical ("*pressed* to the ground") and metaphorically ambiguous, suggesting either that many will remain deaf to the poem's testimony or that, galvanized by the imparted information, they will be on the listen for future developments in the conflict.[55]

The key point here is not simply that "The Colonel" achieves its power by carefully deploying metaphor against the foil of literalism, since this is after all the hallmark of poetry as such.[56] Rather, it is that the work's participation in this typically poetic enterprise evidently contravenes its formulation as *prose* and hence founds its abstractionist potential, precisely because prose is generally taken to promise a maximally direct mode of reference.[57] That said, not every piece of abstractionist prose will necessarily register as a prose *poem*; nor am I advocating specifically for the value of that latter genre in itself (a fact that renders my chapter title

somewhat ironic, inasmuch as it is lifted from what is widely taken as Emily Dickinson's verse brief for poetry per se). Its value in this context is simply that it epitomizes the abstractionism that might well characterize *any* prose composition, irrespective of whether, like "The Colonel" (which was included in Forché's 1981 collection *The Country between Us*), it is effectively *constituted* as poetry through the circumstances of its publication. A prime case in point is Gertrude Stein's classic 1914 freestanding prose work *Tender Buttons*, whose radical fracturing of syntax is evident from its very first paragraph, headed "A CARAFE, THAT IS A BLIND GLASS":

> A kind in glass and a cousin, a spectacle and nothing strange a single hurt color and an arrangement in a system to pointing. All this and not ordinary, not unordered in not resembling. The difference is spreading.[58]

This paragraph baffles accustomed attempts at logical interpretation, chiefly because it does not offer sufficient verbal or prepositional constructions to make clear either the significance of the entities it names or the connections that link them. That we wonder about these matters in the first place speaks substantially to the expectations generated by the work's manifestation as prose, the very form of which, as I have already suggested, strongly implies a text's logical coherence through the principle of continuous onward progression that it seems to embody.[59] Should we by contrast encounter this passage in the form not of a prose paragraph but of a verse poem, the line breaks themselves would largely (though by no means entirely) offset our expectation that the text should constitute a syntactically coherent entity, instead making for relatively independent semantic units that, as in Williams's "This Is Just to Say," demand to be considered individually, line by line:

> A kind in glass
> and a cousin,
> a spectacle
> and nothing strange
> a single hurt color

and an arrangement in a system
to pointing.

All this and not ordinary,
not unordered
in not resembling.
The difference is spreading.

Indeed, if the rupture effected by the line breaks here seems to comple-
ment rather than to contradict the tenor of the published prose paragraph,
this only confirms the extent to which that paragraph manifests as syntac-
tically fragmented to begin with. This syntactic fragmentation—like the
calculated use of figurative language in Forché's "The Colonel"—is only
one of a variety of mechanisms by which a prose composition can defamil-
iarize the discursive norms to which it might be expected to adhere and
thus register an abstractionist effect, just as the line break is but the most
characteristic counter to syntactical coherence within verse poetry. If some
of the others are not so striking as what Stein gives us in *Tender Buttons*,
they are still necessarily less accustomed within prose than is the line break
itself within poetry, or they would not attain to a recognizable abstraction-
ism in the first place. Stein herself offers a good example of another such
abstractionist mechanism in a text that slightly predates *Tender Buttons*,
and because that work engages the racialized subject matter that concerns
us here, it warrants extended attention as we consider literary abstraction-
ism's potential for enacting African Americanist critique.

Commenting in 1926 on her "negro story" "Melanctha"—completed
around 1906 and collected in the 1909 volume *Three Lives*—Stein remarked
that, in that piece, "there was a constant recurring and beginning."[60] The
tale of (among other things) the tortured romance between the unapolo-
getically sensual Melanctha Herbert and the steadfastly sober Jefferson
Campbell, "Melanctha" does indeed manifest "recurrence" by persistently
reiterating signal elements of its phraseology and thereby continually

unsettling readers' understanding of the narrative's key points.[61] For example, in providing background information about Jane Harden, the "roughened" older friend who guides the young Melanctha to worldly knowledge, the narrator tells us that Jane had been forced to leave both the "colored college" at which she once studied and the "colored school" in which she once taught, "on account of her bad conduct," further explaining that "it was her drinking that always made all the trouble for her, for that can never be really covered over."[62] Here referring to the particular difficulty of disguising excessive alcohol consumption, about a dozen paragraphs later the narrator turns similar wording to notably different purport: describing the situation whereby Melanctha eventually becomes "stronger" than Jane, who had formerly been her tutor in "wisdom," and so spends significantly less time with her, the narrator remarks, "Jane did not like that very well and sometimes she abused Melanctha, but her drinking soon covered everything all over."[63] In this instance, "drinking" is the subject rather than the object of "covering over," which accordingly now denotes the promotion of forgiving obliviousness (for in the stupor of drunkenness Jane evidently pardons Melanctha's transgressions) rather than the concealment of a vicious habit (which in the case of Jane's alcoholism the narrator has already suggested it is impossible to achieve in any event).

Five pages later, we are presented with an example of Jane's "abuse" of Melanctha, her complaints about whom (which she issues to Jeff Campbell when he attends her in his capacity as a physician) are rendered in free indirect discourse:

> [Jane] didn't have any use now any more for Melanctha, and if Dr. Campbell saw her he better tell her Jane didn't want to see her, and she could take her talk to somebody else, who was ready to believe her. And then Jane Harden would drop away and forget Melanctha and all her life before, and then she would begin to drink and so she would cover everything all over.[64]

Here the effective subject of "covering over" is not the drink itself but *Jane*, who is depicted as deliberately employing alcohol as a means in that

process (and who thus appears to enjoy greater agency in this dubious enterprise than she ever could in actually hiding her drinking). At the same time, the "everything" that is the object of that covering over is paradoxically more expansive in this passage, where it refers to "all [Jane's] life before" she became sick, than it is in the earlier one, where it refers specifically to Jane's felt experience of having been wronged by Melanctha. Thus "covering over" in this instance entails Jane's disavowal of Melanctha (along with all the other elements of her former life), rather than the forgiveness implied in the earlier formulation.

Finally, in the paragraph immediately following the passage just cited, Jeff Campbell ruminates lamentingly on Jane's dissipated condition: "He knew Jane Harden had a good mind, and she had had power, and she could really have done things, and now this drinking covered everything all over."[65] While in this passage it is once again the drinking that effects the "covering over," it is Jane's capacity for self-actualization that is now the object of that procedure, which here amounts to a mode of suppression or forestallment. In these four different iterations, then, "covering over" signifies four different things: the (unachieved) hiding of vice from public view; forgiveness of an acquaintance's offenses; repudiation of one's erstwhile companions and social activities; and the frustration of one's potential for accomplishment. Thus not only does the recurrence of the expression continually thwart the narrative's syntactical progress; it also short-circuits the narration's semantic coherence, repeatedly forcing the reader to reassess the meaning of the phrase in light of the varied contexts of its appearance.[66] By the same token, and even more suggestively, "Jane Harden" in these passages necessarily takes on different grammatical positions relative to the process of "covering over," serving first as the prospective and ineffectual tacit subject of that process (where Jane's drinking is its object); then as its indirect object (where the drinking is the *subject*, and the direct object is Jane's recognition of Melanctha's faults); then as its explicit and efficacious subject (where the object is Jane's previously experienced mode of life, and drinking is auxiliary in the latter's repression); and then again as its indirect object (where the drinking is once more the subject, and the direct object is Jane's intrinsic potentiality). Indeed, the

syntactical mobility of "Jane Harden" in these four passages implies that the characters in "Melanctha" serve more as manipulable counters in readers' own cognitive proceedings than as mimetic representations of real-life human subjects, in which capacity they arguably fall rather flat.[67]

This assessment would comport with the sense potentially conveyed by the most notorious instances of recurrence and repetition in "Melanctha," where pointedly racialist epithets are deployed as the primary means for describing the characters. Thus Melanctha herself is first presented to us as "a graceful, pale yellow, intelligent, attractive negress," "always full with mystery and subtle movements"; and subsequently as "a graceful, pale yellow, good looking, intelligent, attractive negress, a little mysterious sometimes in her ways, and always good and pleasant, and always ready to do things for people"; and later as "graceful and pale yellow and very pleasant, and always ready to do things for people, and . . . mysterious in her ways"; and still later as having a "pale yellow and attractive face."[68] As it happens, Melanctha is not entirely unlike her mother, "'Mis' Herbert," who is initially described by the narrator as having been "a sweet[-]appearing and dignified and pleasant, pale yellow, colored woman," "always . . . a little wandering and mysterious and uncertain in her ways"; and later as a "pleasant, sweet-appearing, pale yellow woman, mysterious and uncertain and wandering in her ways"; and at several points simply as Melanctha's "pale yellow, sweet-appearing mother"—or, alternatively, as just her "pale yellow mother."[69] While we are indeed told explicitly early on, however, that "Melanctha was pale yellow and mysterious and a little pleasant like her mother," we are also assured that "the real power in Melanctha's nature came through her robust and unpleasant and very unendurable black father," James Herbert. James, in his turn, is duly referred to as "a big black virile negro"; as Melanctha's "black coarse father," "her virile and unendurable black father," and "her very unendurable black father"; and as "'Mis' Herbert's" "big black virile husband."[70]

If these descriptions thus verge dangerously on the one-dimensionality of stereotype, however, it is worth noting that other modes of repetition in

Stein's story actually help to establish the main characters as fully sentient subjects with deeply emotional interior lives.[71] Those lives are marked primarily by the experience of *passion* in its dual sense—entailing both ardent desire and profound suffering—in that Melanctha and Jeff are powerfully drawn to each other physically and emotionally but at the same time are continually troubled by the apparent dissonance of their moral sensibilities: whereas Melanctha has evidently pursued an unabashedly fleshly existence prior to meeting Jeff, Jeff, by contrast, staunchly eschews voluptuous "excitements," preferring to such "animality" the sort of "good quiet feeling in a family when one does his work, and is always living good and being regular."[72] The effects of this difference manifest intensely in a pair of letters that Melanctha and Jeff exchange after Jeff—having heard from Jane Harden that Melanctha once widely "wandered" among "different men, white ones and blacks"—stays away from Melanctha for several days without explanation.[73] The missive that Melanctha finally sends Jeff is worth quoting in full:

> I certainly don't rightly understand what you are doing now to me Jeff Campbell. . . . I certainly don't rightly understand Jeff Campbell why you ain't all these days been near me, but I certainly do suppose it's just another one of the queer kind of ways you have to be good, and repenting of yourself all of a sudden. I certainly don't say to you Jeff Campbell I admire very much the way you take to be good Jeff Campbell. I am sorry Dr. Campbell, but I certainly am afraid I can't stand it no more from you the way you have been just acting. I certainly can't stand it any more the way you act when you have been as if you thought I was always good enough for anybody to have with them, and then you act as if I was a bad one and you always just despise me. I certainly am afraid Dr. Campbell I can't stand it any more like that. I certainly can't stand it any more the way you are always changing. I certainly am afraid Dr. Campbell you ain't man enough to deserve to have anybody care so much to be always with you. I certainly am awful afraid Dr. Campbell I don't ever any more want to really see you. Good-by Dr. Campbell I wish you always to be real happy.[74]

Marshaling his own version of the distinctive syntax featured in this note, Jeff replies, "Dear Melanctha,"

I certainly don't think you got it all just right in the letter, I just been reading, that you just wrote me. I certainly don't think you are just fair or very understanding to all I have to suffer to keep straight on to really always to believe in you and trust you. I certainly don't think you always are fair to remember right how hard it is for a man, who thinks like I was always thinking, not to think you do things very bad very often. I certainly don't think, Melanctha, I ain't right when I was so angry when I got your letter to me. I know very well, Melanctha, that with you, I never have been a coward. I find it very hard, and I never said it any different, it is hard to me to be understanding, and to know really what it is you wanted, and what it is you are meaning by what you are always saying to me. I don't say ever, it ain't very hard for you to be standing that I ain't very quick to be following whichever way that you are always leading. You know very well, Melanctha, it hurts me very bad and way inside me when I have to hurt you, but I always got to be real honest with you. There ain't no other way for me to be, with you, and I know very well it hurts me too, a whole lot, when I can't follow so quick as you would have me. I don't like to be a coward to you, Melanctha, and I don't like to say what I ain't meaning to you. And if you don't want me to do things honest, Melanctha, why I can't ever talk to you, and you are right when you say, you never again want to see me, but if you got any real sense of what I always been feeling with you, and if you got any right sense, Melanctha, of how hard I been trying to think and to feel right for you, I will be very glad to come and see you, and to begin again with you. I don't say anything now, Melanctha, about how bad I been this week, since I saw you, Melanctha. It don't ever do any good to talk such things over. All I know is I do my best, Melanctha, to you, and I don't say, no, never, I can do any different than just to be honest and come as fast as I think it's right for me to be going in the ways you teach me to be really understanding. So don't talk any more foolishness, Melanctha, about my always changing. I don't change, never, and I got to do what I

think is right and honest to me, and I never told you any different, and you always knew it very well that I always would do just so. If you like me to come and see you to-morrow, and go out with you, I will be very glad to, Melanctha. Let me know right away, what it is you want me to be doing for you, Melanctha.

<div style="text-align:right">

Very truly yours,

JEFFERSON CAMPBELL[75]

</div>

These letters convey the characters' vexation not only in the substance of their complaints but also via the form in which the latter are registered, which suggests the agonized fitfulness of the writers' mental states. In the letter from Melanctha to Jeff, for instance, the phrase "I certainly" is reiterated no fewer than ten times, implying less the assuredness that the terminology denotes than Melanctha's attempt to quell, through sheer repetition, her profound sense of irresolution regarding her relationship with Jeff. This doubtfulness is explicitly indicated in Melanctha's twice-issued assertion that she "do[es]n't rightly understand" Jeff's behavior toward her; more often, however, it is registered through the oxymoronic pairing of positive declaration and unsure speculation, most succinctly instanced in the phrase "I certainly do suppose," in which the incontrovertible sureness of "certainty" is paradoxically joined with the hypothetical conjecture of "supposition." Thus, in a formulation that occurs four times, Melanctha "certainly" (i.e., as a matter of absolute positivity) is "afraid" (i.e., is speculatively inclined to think) that her relationship with Jeff is in one way or another untenable. Moreover, two of these instances, in which Melanctha says to Jeff, "I certainly am afraid . . . I can't stand it any [or 'no'] more," alternate in the letter with her less equivocal declaration that she "certainly can't stand it any more," so that the oscillation between more and less definitive formulations suggests Melanctha's own vacillation in her feelings about the matter.

For his part, Jeff matches Melanctha's quadruple iteration with his own fourfold pronouncement, issued at the beginning of each of the first four sentences of his letter, that he "certainly do[es]n't think" that Melanctha is being fair in her assessment of him or that he was in the wrong to have

been upset with her. Here, again, the unqualified assuredness indicated by *certainly* is coupled with—and potentially mitigated by—the implication of mere surmise and conjecture, signaled in this case by the word *think*.[76] Further, and more particularly, the stuttering repetition of the phrase "I certainly don't think" at the beginning of Jeff's letter seems rhetorically to figure his avowedly halting progress in "following whichever way that [Melanctha is] always leading." The crux of the pair's interpersonal difficulty consists, after all, in Jeff's abiding reluctance to credit the specifically carnal wisdom whose value Melanctha would evidently have him recognize. Jeff more than once openly confesses this hesitancy in his letter, in one passage telling Melanctha, "it is hard to me to be understanding, and to know really what it is you wanted, and what it is you are meaning by what you are always saying to me"; at another point acknowledging, "I can't follow so quick as you would have me"; and still elsewhere insisting, "I can do [no] different than just to be honest and come as fast as I think it's right for me to be going in the ways you teach me to be really understanding." As with Melanctha, then, the peculiarities of verbal repetition that Stein imputes to Jeff can be understood as corresponding to the intellectual and emotional tumult he experiences in the context of the relationship. By thus suggesting a degree of psychic and moral depth on the part of those who enact them, these instances of repetition potentially offset the stereotyped one-dimensionality with which the epithetic reiterations discussed earlier threaten to imbue Stein's characters.[77]

At the same time, though, if "Melanctha" does in fact present in-depth characterization, then it is of course less abstractionist than it superficially appears to be, effectively forwarding through psychological mimesis the very realism that it seemingly renounces through its reiterative narration. Indeed, because the racialized descriptors that the text so insistently repeats do not float freely, as it were, but instead are attached to precisely such fully realized personalities as emerge in the preceding letters, their recurrence arguably serves to *heighten* rather than to diminish the work's susceptibility to realist reception, just as the racial recognizability of Kara

Walker's silhouette figures apparently elicits the realist interpretation that their evident abstractionism would seem to preclude.[78]

From this perspective, the mimetic characterizations in "Melanctha" expose both the limits of the work's abstractionism and, perhaps unsurprisingly, the comparative weakness—not to say the utter nonexistence—of its African Americanist critique, despite its sustained treatment of African American themes. The logical implication is that both literary abstractionism and its potential social-critical effect might best flourish not only in narrative but in narrative where the demands of character development have been refused. What such refusal would look like—and how a specifically African Americanist critique can be lodged in the absence of obviously African American characterization—is demonstrated by a late-millennium text that is worth considering in detail, as it exemplifies the project for which I have been advocating throughout this book.

The work at issue is John Keene's pithy and aphoristic 1995 volume *Annotations*, the opening sentences of which both exemplify the style of the whole and suggest how characteral development is repudiated throughout the text:

> Such as it began in the Jewish Hospital of St. Louis, on Fathers' Day, you not some babbling prophet but another Negro child, whose parents' random choices of signs would disorient you for years. It was a summer of Malcolms and Seans, as Blacks were transforming the small nation of Watts into a graveyard of smoldering metal. A crueler darkening, as against the assured arrival of dusk. Selma-to-Montgomery. Old folks liked to say he favored the uncle who died young, an artist. In that way, a sense of tradition was upheld, one's place in the reference-chain secured. Digression. Brick houses uniform as Monopoly props lined the lacework of street for miles. Before there was Arlington, there was Palm, indeed a dimmer entity which burns in one's memory like iodine. "Baltimore Law." They eventually settled on a single-family detached, in the Walnut Park section of the city, after months of wrangling with the agent, as it was quite naturally assumed that they, like others who worked for a living, would eventually own their own property.[79]

More or less straightforwardly invoking a "you" whom it in short order describes as "another Negro child," this passage evidently undertakes to delineate its primary dramatis persona only simultaneously to retreat from that task—not just by confusingly deploying the second-person pronoun (which correlates neither to the reader nor to any character identified in the text) but by transferring the syntactical centrality initially afforded "you," first to the third-person "he" that follows four sentences on, then to the "one" whose "place in the reference-chain [is] secured," and finally to the "they" who "settled on a single-family detached," each of these pronominal instances being either officially indefinite or without grammatical antecedent, and hence unclear as to its specific referent. This latter situation obviously induces the kind of abstractionist disruption of narrative flow that I described earlier, inasmuch as a conventional pronoun always effectively deflects readers' attention backward through a text, in search of the precursor term that imbues it with meaning, and the lack of antecedents here short-circuits that process of semantic corroboration and thus inhibits readerly progress.[80] More to the point of the current discussion, though, because the passage presents pronouns that are not merely ambiguous but also varied and profuse, it militates against the emergence of distinct and coherent narrative personae, in a manner that typifies the entire highly elliptical text.

Indeed, this same strategy for forestalling conventional characterization is discernible even in a passage that demonstrates the work's alternative means for positing an organizing consciousness through which to focus its social critique. Because that means consists in a rhetorical pattern that emerges only over the textual long haul, an unusually extensive extract is called for:

> Many of the children, except those whose parents were considered "strivers," would walk to the neighborhood school. They first launched his punt at a Montessori Academy, which was thought to enhance a youngster's chances in life. There we could play with Legos of innumerable colors, a pint-sized oven that actually baked, and the other kids, including Patty, who soon became enamored of the red-haired boy. This was before one gained

a sense of the "body" and could picture oneself "in affliction." Double talk. Eventually they took turns reading the "Negro" poets from those yellow-papered books whose covers had long ago disappeared. . . . Further down the boulevard sat the unimposing branch library, further still the artist's studio. His wife, an artist in her own right, had sculpted the papier-mâché painting of Kali, which hung for years like a totem above the sofas. Chain of Rocks. You drew not only numerous studies of people, but a series of scenes to accompany them, yet they still denied that a child was capable of such work, convinced instead that you had traced or forged. . . . The subsequent art teacher showed a mastery of the art of drawing lips and eyes, and thus encouraged us all to indulge in more identifiably "African" forms. Use a pen or pencil and answer all questions. A simpler example: a V with a circle on top, or a colorless ice-cream cone. . . . Yet, whenever the ice-cream truck would come by, the first impulse was to run to the window and perform the dance of seven wails. Who would not relent, before such shameless displays of talent. These episodes ceased, however temporarily, in the presence of "company," and at the family reunions, when all small ones were expected to be on their "absolute best behavior." Eventually the blight of crime and drugs would subsume the entire area, forcing a capitulation to the prerogatives of personal safety. And so, as his cousin said more eloquently than the mayor and the experts, when officials speak of "Urban Renewal," it's the Black folks that got to go.[81]

Notwithstanding its seemingly forthright reference to "many of the children" (which in fact is less clear than might be assumed, given that we are never told exactly *which* children are under discussion), this passage replicates the earlier one in successively invoking a number of indeterminate pronouns—"they," "we," "one," "you"—the variation among which evidently precludes the emergence of a unitary subjectivity that would constitute a recognizable narrative protagonist. If such a subjectivity does not materialize through the pronouns per se, however, it arguably *does* do so through the larger rhetorical formulations in which those pronouns appear, since these manifest a structural regularity that itself founds the text's perceptual coherence.

The pattern is already nascent by the time we arrive at the first excerpted sentence. Syntactically and thematically unrelated to the lyrical yet cryptic passage that precedes it in the text (which is why "the children" remain unspecified), this sentence nevertheless clearly establishes the terms by which we are to make sense of the succeeding one, despite the vagueness of the pronominal reference in "his punt."[82] Indeed, while we are never told who this "he" is, we still understand that "he" is the one whose early educational course is being recounted here, which is to say that the passage conjures a subject with specific traits even if the text as a whole refrains from according that subject a specific identity. By the same token, the sentence that notes that the branch library and artist's studio were "further down the boulevard" bears no evident connection to the vatic pronouncement that directly precedes it ("Our ears hammer impressions into audible jewels") and so leaves uncertain further down than *what* these sites were located.[83] It is, however, solidly linked to the subsequent sentences, in that "the artist's studio" clearly telegraphs the antecedent for the "his" in "his wife" (which thus differs from the indeterminate "his" of "his punt"), and the references to the couple's artistic activities join thematically with the later pronouncement that "You drew not only numerous studies of people, but a series of scenes to accompany them," even if "you" is never explicitly identified.[84] Finally, the observation that "eventually the blight of crime and drugs would subsume the entire area" is at best only loosely related to the immediately preceding account of "the dance of seven wails," but it unmistakably qualifies the import of "Urban Renewal," whose invocation in the succeeding sentence once again implicates a "he" (through "his cousin") that remains wholly unspecified in itself.

Each of these three passages, then, presents a general thematic consideration (scholastic pursuit, artistic undertaking, urban-neighborhood deterioration) followed by a pronominal reference to an undefined person for whom that thematic is thus established as a primary concern, and who is further shown to bear certain distinguishing attributes (educational experience, avocational interests, familial relations) despite not being explicitly identified as a distinct individual. This formula recurs time and again throughout Keene's brief work, with the result that its accumulated

iterations all seem to evoke the same person (whether signaled pronomi-nally by *he*, *you*, *one*, *we*, or *they*), and that "person" thereby emerges as the cognitive and moral center of the textual world—*without*, however, manifesting as a fully developed character.

<center>▪▪▪▪▪</center>

A corollary of this latter fact is that characters do not constitute the prin-cipal means by which *Annotations* engages with racial blackness. Indeed, the opening reference to "you . . . another Negro child" comprises the only instance in which the text directly ascribes black identity to a specifically invoked personage, and because that personage itself is not comprehen-sively delineated, its putative "Negroness" remains comparatively shallow. This shallowness does not, however, preclude the book from clearly estab-lishing the blackness of its own sociocultural orientation, which it does obliquely but firmly even within its first few sentences, citing the popular-ity of the name "Malcolm" around the time of the August 1965 Watts Riots (six months subsequent to the murder of Malcolm X) and alluding to the Selma-to-Montgomery, Alabama, voting-rights marches led by Mar-tin Luther King, Jr., in March of that same year.[85] The second of the two passages cited earlier proceeds in a similar vein, recounting the commu-nal reading of "the 'Negro' poets," relating the art teacher's promotion of "more identifiably 'African' forms," and detailing "Black folks'" particular experiences of "Urban Renewal." In other words, *Annotations* posits racial blackness as a function not of personal attributes but of sociocultural interests, figured here in references to the Civil Rights and Black Power movements, to "New Negro" and pan-Africanist aesthetic programs, and to black-urban community formation and disintegration. In necessary accordance with this, it recruits readers to its ethical perspective, not by inviting them to identify with recognizably black characters but by solicit-ing their investment in those identifiably black interests.[86]

That solicitation is deftly forwarded through the text's distinctive dis-cursive and rhetorical strategies, which effectively require readers to as-sume the work's perceptual vantage in order to comprehend moments that would otherwise remain inexplicable. The book's opening passage, for in-

stance, cites as "quite natural" the supposition that an unspecified "they" "would eventually own their own property," "they" being "like others who worked for a living." At the same time, though, inasmuch as that which can be "naturally assumed" is that which effectively goes without saying, the text's defensive assertion of it here suggests that that naturalness is in fact *not* universally recognized, and hence that the "they" in question must also be *unlike* those others in key respects—or indeed why the necessity of their "wrangling" with a realtor who apparently would have forestalled their purchase? Any confusion on this score is obviated, however, provided a reader grasps the difficult real-estate dealings in terms of the racial politics already adverted to in the previously cited references to black protest and civil unrest, in which case he or she gains a workable understanding of the text precisely by adopting its critical perspective on the racial-political situation it adduces.[87]

The second passage quoted earlier goes even further in this regard, forcibly channeling readers' judgment along lines dictated by the text itself and thus ineluctably implicating them in its critical project. The effect is generated specifically through the word *as* in the phrase "as his cousin said." Meaning most fundamentally "in accordance with that which," the word as it appears in this clause indicates that the facts under review objectively substantiate the cousin's contention that "when officials speak of 'Urban Renewal,' it's the Black folks that got to go." It thereby endows that proposition with an authoritative validity that we as readers cannot deny without contravening the moral logic of the entire work—especially inasmuch as its invocation here signals that the narrator, too, subscribes to the cousin's understanding of the matter. Hence this iteration of *as* essentially sutures together the perspectives—and so correlates the judgments—of the cousin, who first posits the relevant opinion; the narrator, who subtly endorses it; and the reader, who must accept it in order not to violate the ethos of the work as a whole.[88]

In thus conscripting the reader to its own analytical perspective, *Annotations* intensifies the purchase of its social critique, which, following a

point sketched in chapter 1, entails demonstrating the historical—or, in other words, the *mutable*—character of the structures and conditions it addresses. If it does this especially effectively with respect to social identity itself, this is because it conceives the latter not as an intrinsic property of either individuals or groups but as a function of situational factors that are themselves potentially subject to change.[89] Indeed, this conception informs not only the book's treatment of racial blackness, as we have seen, but also its rather more secondary engagement with gender and sexual identity:

> "Straight-A, Straight-A, nothing but a sissyboy who's scared to play," they screamed burning tracks across the playground, their faces brown, blazing globes of glee, as he crumpled near the swingset like a raveling, forgotten husk-doll. Repression's effects assume manifold forms. One option proposed seriously was that of skipping a grade, though they feared that might warp her emotional development. In other words, neither parent had expected such a fragile character, though they bore the verdict better once they had bought it.[90]

Epitomized in the "fragile character" cited in the final sentence, the aberrancy at issue here seems more a function of the very jeers it presumedly elicits than a recognized aspect of an inwardly prevailing personal "nature"—partly because it is specifically under the onslaught of derision that "he" "crumples" in the first place (this being the only action recounted that might corroborate the hecklers' charge of "sissiness") but also because *he* morphs into *she* in the report of concern about "*her* emotional development," suggesting that for all the effort to prevent psychic "warping," the narrative subject's "development" had already been affected by factors beyond the strict purview of "they" but still by no means irremediable. This sense is additionally furthered in a passage that appears a scant fifteen pages later:

> "Don't be bringing no babies into this house," uttered as much to persuade as to warn. They seemed incapable of conceiving of gay or lesbian people, except in terms of slurs or epithets. A word is a sword that cuts with less effort, though the wounds will often last longer. The man in the hat and

trenchcoat approached him in a way that was not considered quite accept-able. A sly glance, espied, from the corners of the eyes. Shame, and more of the same. Oppression is most effective when its aims are effected voluntarily. The one or two girls that you raised the courage to call wanted more than anything to be considered best friends. Still one dreamt up schemes to enter that schema, which conferred on its residents the validation of "normality." She giggled, then inched towards the passenger-side door when your hand flopped fish-flat onto her thigh. Primitive parameters. Intuition provided the first step, information the second, until he realized that by combining the two he was creating a handy index of being. We were always the first to grace the dance floor, for our self-esteem derived primarily from others initially identified in us physiquely. Evonce. Boys should not flap their arms when they run downstairs, or cover their mouths when they laugh. Dignity is occasionally a byproduct of discretion. Let's get it on. By focusing on his footwork, he could think of the men he had spotted on the street and still not lose his rhythm. Meanwhile, her shawl slid down unhurriedly, to reveal lightly lotioned, amber shoulders. Who had no idea of how to meet another, or how to love another, and this was before our current plague era.[91]

Here, much as in the opening reference to "you . . . another Negro child," we have an early invocation of a particular social identity (i.e., the men-tion of "gay or lesbian people"), followed by a series of narrative snippets that do not so much ascribe that identity to any specific individual as sketch the experiential means by which it is realized: "slurs" and "epithets"; unsanctioned advances; guilt and self-reproach; longing after "normal-ity"; physical self-consciousness and interpersonal awkwardness; keen attunement to gender norms; carefully concealed desire; interactional uncertainty; and so on. The relative impassivity that generally marks these experiences as described here suggests that lesbian or gay identity is con-stituted at least as much by external factors to which one is subjected as by deliberate actions that one undertakes—and, in accordance with this, that modification of those factors could alter the meaning of such identity in any number of ways.

Indeed, alteration constitutes both a primary topic and a signal modality of *Annotations*, which mobilizes it to maximum critical impact. Consider, for instance, the book's midpoint reminiscence that, with a view to those occasions when "they would put on the albums or forty-fives and dim the basement lights, and begin to perform the newest dance," "everyone studied their moves with care so that at someone else's house they would not slip up. In this way," the passage continues, "a sense of tradition was nurtured, which others wrongly attributed to their 'nature.'"[92] Explicitly adapting the opening segment's much-earlier claim that, through the "old folks['] . . . say[ing] he favored the uncle who died young . . . a sense of tradition was upheld," these later sentences broaden the meaning of *tradition* to encompass not just genealogical lineage but a communal heritage that is recognized even by unaffiliated "others." At the same time, the passage insists that those others "wrongly" construe that tradition—obliquely but clearly identified here as a collective facility for dance—taking as a "natural" legacy that which really derives from assiduous practice over time. In thus exposing a stereotypically native-black characteristic as in fact an effect of repetition and refinement, the passage posits blackness itself—and by extension racial identity per se—as a historical construction. Further, though, by actually *manifesting* such repetition and refinement in the shift from "in that way, a sense of tradition was upheld" to "in this way, a sense of tradition was nurtured," the passage *enacts* the very principle of historical modification that it takes as its thematic focus.

Nor is this enactment limited to the foregoing example but rather is in evidence throughout the entirety of the text. For instance, in a complement of passages that again includes one we have already cited, we get the following:

> Eventually they took turns reading the "Negro" poets from those yellow-papered books whose covers had long ago disappeared.

Then, thirty pages later:

> We took turns reciting the "Negro" poets at one of those gatherings for children that bourgeois yet working-class parents felt would instill a sense of pride and self-recognition.

And, finally, thirty-six pages beyond that:

> We took turns reciting poems by the Black Arts poets from one of those
> volumes now growing dusty on the godmother's bookshelves.[93]

Not only does the shift from "the 'Negro' poets" to "the Black Arts poets"
track an evolution in African American culture from the first decades of
the twentieth century through the 1960s, but the multiplicity of contexts
in which the poetry is reviewed—ranging from the schoolroom (as is
implied by the larger passage in which the first excerpt appears) to the
community assembly to the private home—suggests the myriad circum-
stances in which that culture is continually constructed, and hence the
dynamism that necessarily characterizes it.[94]

Similarly, having been alerted by the second sentence of the book to the
association between black urban unrest and patterns of African American
nomenclature ("It was a summer of Malcolms and Seans, as Blacks were
transforming the small nation of Watts into a graveyard of smoldering
metal"), we are primed to register the significance of two other sentences,
which appear respectively fourteen and sixty-nine pages after the one just
cited:

> And so by the end of the Detroit riots they had chosen completely new
> names, thereby casting off another aspect of their heritage.

And:

> By the time of the Miami riots they had selected new names and identities,
> thereby casting off another aspect of their oppressive heritage.[95]

In addition to charting both the geographical scope of postwar African
American dissent (extending from Los Angeles to Detroit to Miami) and
its temporal duration (running from 1965 through 1967 and all the way to
1980), these passages together suggest that repeated efforts at nominal self-
fashioning are a perennial aspect of African American life, while the slight
variation in the final clauses of the two later sentences figures the uncer-
tain import of those very efforts, tacitly raising the question of whether the
legacies they are meant to jettison really are unambiguously "oppressive."[96]

Finally, an additional set of sentences explicitly thematizes histori-cal effect per se, without yoking it specifically to considerations of racial blackness:

> Our generation possesses only a cursory sense of the world that our ances-tors braved, though the burdens of history bear unmovably upon us.

And, eighteen pages beyond that:

> Our generation lacks more than a cursory sense of the world that our ances-tors faced, which surprises no one cognizant of the contempt in which the nuances of history are currently held.[97]

On the one hand evoking the lineal continuity typically associated with cultural tradition (through explicit reference to "our ancestors"), these passages in the same instant openly acknowledge that continuity's inevi-table rupture over time (manifest in the fact that the current generation has only a minimal appreciation for the experiences of its forbears), for-mally *enact* that rupture (in the variation that distinguishes the two initial clauses from each other), and yet warn that the experiential disjuncture between an older and a younger generational cohort does not immunize the latter against the consequences of what has gone before (i.e., "the bur-dens of history bear unmovably upon us").

These examples by no means comprise all the instances of varying repetition that characterize *Annotations*, in which, for one thing, the key terms of each list-like chapter heading are retooled in full-blown sentences that appear at more or less distant points within the main text.[98] They do, however, give a sense of how the device operates in much of the book. As an intrinsically self-enhancing rhetorical feature (since for it to register in the first place is for it to register as already redoubled), repetition per-forms the fundamental abstractionist function of impressing readers with the text's formal construction, as distinct from its semantic import.[99] At the same time, of course, since it is precisely semantic expressions that are being reiterated, the repetitive structure cannot help but draw attention to meaning *as well as* to form. Indeed, we have seen this operate to question-able purpose in Stein's "Melanctha," where the repetition of such descrip-

tive phrases as "a pale yellow . . . , attractive negress" or "a big black virile negro" posits as an intractable fact the very racial identity whose social reconstitution we would hope to promote. *Annotations*, by contrast, presents no characters to which racial identity can be properly ascribed even, let alone the epithetic reiteration through which its significance might be decisively fixed. Hence there is nothing in Keene's text to distract us from the semantic *mutation* that characterizes its reiterative format—the discrepancy, for instance, between the meanings of "their heritage" and "their oppressive heritage," and what it might imply in the context in which it arises. *Annotations* thus figures rhetorically the very principle of historical change that it otherwise establishes as constitutive of racial blackness itself. It thereby exposes the latter's susceptibility to productive revision— the object of all social critique worth the name.[100]

It is difficult to imagine what more could be reasonably demanded of African American art, and if *Annotations* meets the exigencies of that category especially well—as my sustained focus on it implies—this is only because it so rigorously epitomizes abstractionist principles that are also discernible in other instances of African American literature. Indeed, the self-reflexivity and mimetic problematization that *Annotations* manifests (via repetition and narrative disjuncture) are the very hallmarks of a literary postmodernism that encompasses the metafictionalism of Charles Johnson, Clarence Major, and Ishmael Reed; the magic-realist fabulation of Toni Morrison and Gayl Jones; the fractured diegesis of Carlene Hatcher Polite and Toni Cade Bambara; the exuberant satire of William Melvin Kelley, Fran Ross, Darius James, and Paul Beatty; the science-fictional speculation of Octavia Butler and Samuel Delany; and even the utopic fantasy of Alice Walker and Gloria Naylor themselves. After all, while *The Color Purple* ends with blissful reconciliation and extended-familial reunion, *The Women of Brewster Place* concludes with an equally unrealistic nested-dream sequence that heralds both the triumph of the titular characters and the demise of the ghetto that had threatened to subdue them. If these fairy-tale endings comprise just such a self-aware

critique of realism as I am promoting, however, they do not by that token *neutralize* the realism that the novels otherwise so forcefully exemplify, largely through the resolute delineation of character that even the most unorthodox of the works alluded to earlier also forward, which, as we have seen, powerfully forestalls an abstractionist engagement. *Annotations*, on the other hand, constitutes an ideal case study for my purposes precisely because its maximally stringent abstractionism forces us to reckon with it in kind, potentially making us more sensitive to the less conspicuous abstractionism that characterizes superficially conventional works (or works—such as W. E. B. Du Bois's *Souls of Black Folk* and Jean Toomer's *Cane*—whose formal *un*conventionality has been *rendered* inconspicuous through long-standing reading practices that recruit the texts to realist significance).[101] This is to say not only that highly abstractionist African American literature can register trenchant social critique but also that it can train us in reading protocols that differ productively from current realist norms. It can only do that, however, if it is *recognized* as African American literature in the first place—a tall order given its extreme marginalization within the prevailing realist hegemony. Thus our objective must be both to r*eassert* literature as a prime focus of African Americanist commentary and also to r*econceive* literature as a much more capacious category than African Americanist discourse has typically allowed. That domain right now affords scant leeway for the attenuated characterization, referential indeterminacy, and rhetorical repetition that typifies *Annotations*—or Mackey's own continuous novel or Claudia Rankine's intergeneric texts or the no-doubt-numerous works that have flown under the realism-attuned radar; and yet those very features are the ones from which we might benefit most, as they demonstrate not only that realism is likely overrated but that the real itself should be vigorously countered, in the interest of a future that is better than the present.

Coda

The Literary Advantage

There are, of course, many ways of telling a story, which means that there are also many different possible mechanisms for achieving the narrative disruption that I have discussed in the foregoing pages. Consider, for instance, a pivotal early scene in the 2009 film *Precious: Based on the Novel "Push" by Sapphire.*[1] The adolescent title character (played by Gabourey Sidibe) is standing over the kitchen sink, washing dishes in the Harlem apartment she shares with her mother, Mary (Mo'Nique), whom the camera reveals sitting in the living room behind Precious as it pulls back from an extreme close-up of Precious's forward-facing form and tilts upward to give us a view beyond her left shoulder, to the far right side of the screen (fig. 37). Mary, turned about three-quarters away from her daughter and toward the television show she is watching, asks Precious, "You get my cigarettes?" Precious, still bending to her task, replies, "Naw, they didn't have it. I played the number though. I couldn't box it." After a few beats during which Precious continues her dishwashing, her back still to her mother, Mary, evidently enraged by Precious's failure to complete her assigned errands, takes from a nearby table what the film's 2008 shooting script describes as "a thick glass ashtray" and hurls it at her daughter, striking her

37 Precious (Gabourey Sidibe) bends over the kitchen sink as her mother, Mary (Mo'Nique), watches television in the background. From *Precious: Based on the Novel "Push" by Sapphire*, dir. Lee Daniels (Lions Gate, 2009).

in the back of the head.[2] Knocked unconscious, Precious immediately falls, but she is shown landing not on the kitchen floor but rather onto a slightly disheveled bed, over which looms a large bare-chested man who swiftly removes the belt from his jeans, pulls up the long nightdress Precious is wearing, and climbs on top of the young girl. In a brief montage sequence of about thirty seconds, we see and hear the compression and extension of the bedsprings under the man's shifting weight, an egg sizzling in a cast-iron skillet amid the grease of melting fatback, the lid being removed from a jar of petroleum jelly, the man evidently lubricating himself with the Vaseline and penetrating Precious, a meowing cat clambering on an overstuffed armchair, more bedspring activity, and the man continuing his assault on Precious as Mary watches from the shadows beyond the bedroom doorway. The camera then cuts to a close-up of Precious's face as she gazes toward the ceiling, and then to a point-of-view shot of the peeling plaster on which she is seemingly fixated (fig. 38). After another sequence of alternating shots of Precious and the cracked ceiling—during which the man, in the midst of his thrusting, declares, "Daddy loves you"—the plaster and lathing fall away entirely so as to reveal a richly dressed and expertly coiffed Precious making her way along a red carpet through a throng of reporters, photographers, and admirers, a suave and handsome escort (with leashed terrier) at her side. Cameras flash, applause rings out,

38 A flashback montage depicting Precious's sexual abuse by her father. From
 Precious: Based on the Novel "Push" by Sapphire, dir. Lee Daniels (Lions
 Gate, 2009).

and fans exclaim as Precious graciously submits to the queries of journal-
ists and the requests of autograph seekers, after what has evidently been
the wildly successful premiere of a film starring Precious herself. Without
warning, though, there is a crash of thunder, and the revelers are drenched
in a sudden downpour. Precious looks skyward, her expression reflecting
consternation and bewilderment as the rain pelts her face (fig. 39). Then

39 Precious's escapist fantasy. From *Precious: Based on the Novel "Push" by Sapphire*, dir. Lee Daniels (Lions Gate, 2009).

there is an abrupt cut to a surge of water violently cascading onto the head of a prostrate Precious, dressed now in the same loose yellow T-shirt she had been wearing at the kitchen sink. She quickly regains consciousness, sputtering and wiping her face, as her mother, who has clearly just emptied a bucket on her, mystifyingly declares, "I ain't gonna say it no more," and walks away (fig. 40).

What we have just witnessed, then, is Precious's twofold psychic retreat under the stresses to which she is subjected: blacked out as a result of the blow to her head, Precious mentally relives her evident sexual abuse at the hands of the man whom we ultimately surmise to be her father; during the

40 Precious is brought back to consciousness by her mother, Mary. From *Precious: Based on the Novel "Push" by Sapphire*, dir. Lee Daniels (Lions Gate, 2009).

41 Precious at the kitchen stove. From *Precious: Based on the Novel "Push" by Sapphire*, dir. Lee Daniels (Lions Gate, 2009).

instance of abuse to which this recollection makes us privy, she disengages from the immediate experience by fantasizing that she is in fact living a life of glamour and celebrity within the entertainment industry. Her return to consciousness clearly marks the resumption of the narrative sequence that this dissociative episode had interrupted, in that it is immediately followed by a cut back to Precious in the kitchen, wearing the same T-shirt and maintaining a similar attitude as before (fig. 41). She is not doing dishes

this time, however, but instead is at the stove, boiling a pot of what looks like chitlins and pigs' feet, frying up pieces of chicken, simmering a pan of beans. Mary is once again in front of the television, asleep now—or at least until she is roused by the doorbell, which is rung repeatedly, insistently, until Mary says to Precious, "Tell them assholes stop ringing my bell." As it happens, though, the culprit is not the "assholes" that Mary and Precious both evidently think it is—the crack addicts who regularly buzz their apartment in an attempt to gain access to the building—but rather Mrs. Lichenstein, the principal of Precious's school. She is there to follow up on a conversation she and Precious have had in her office, witnessed by the film's viewers immediately prior to the scene in which Mary hits Precious with the ashtray. That exchange ended with Mrs. Lichenstein suspending Precious from school, owing to her being pregnant (for the second time in her sixteen years), and Mrs. Lichenstein has now come to tell Precious about an alternative educational program that she has arranged for her to attend. Thus the scene continues two narrative lines that had been initiated prior to the depiction of Precious's collapse: that involving the domestic interaction between Precious and Mary and the one begun earlier involving the ramifications of an apparently unbidden pregnancy for Precious's educational prospects. For its part, the sequence that follows the play of Precious's unconscious mind serves two auxiliary narrative functions, both of which depend on the predominant visuality that characterizes cinema itself, inasmuch as they derive from the audience's being made to see what Precious "sees" during her period of insensibility: on the one hand, in tracking Precious's own retrospection on her experience of sexual trauma, the sequence provides viewers with a backstory that helps to explain the character's present situation; on the other hand, in tracing the escapist reverie by which Precious has evidently attempted to manage her traumatic experience, the sequence conveys the intensity of that experience's psychic effects while also familiarizing viewers with the character's motive preoccupations.

By contrast, the novel from which the film derives its story cannot accomplish either of these objectives with anything like the same efficiency, since its narrative vehicle consists not in visual imagery that lends itself to

fast-cut assembly, but in linguistic formulations whose import becomes clear only over a relatively long duration. Indeed, the instance of combined contextualization and plot development that *Precious* forwards in just about half a minute extends over fourteen of the novel's 138 narrative-expository pages, where it entails fairly complex strategies of verbal elaboration.[3] On the other hand, those strategies themselves provide for disjunctive cognitive effects that are disallowed by the cinematic medium, so while Sapphire's resolutely realist *Push* hardly qualifies as an example of the abstractionism that I have been advocating throughout, its mobilization of specifically linguistic resources helps us to see why, of all the mediums in which narrative might be simultaneously advanced and problematized, it is literature that harbors maximum abstractionist potential.

The crux of the matter lies in the way the novel's first-person narration at once establishes the time frame for the occurrences it recounts and temporally situates itself in relation to those events. This dual process initially makes for a fair amount of readerly confusion, as when Precious tells us in the novel's opening sentences, "I was left back when I was twelve because I had a baby for my fahver. That was in 1983. I was out of school for a year. This gonna be my second baby." The problem, of course, is that while we now know that Precious was twelve years old in 1983—clearly some time ago relative to the moment of the narration—we as yet have no idea either how old she is at that latter moment or on what date that latter moment falls. We seem to be given at least a partial answer three paragraphs later, when Precious says, "So, OK, it's Thursday, September twenty-four 1987," but any notion that this date constitutes Precious's own present instant is upended by the immediately following clause—"and I'm walking down the hall"—where the colloquial present-progressive construction "I'm walking" implies not that she is walking down the hall even as she "speaks" to us, but rather that she is still retailing *past* events, albeit events that occurred somewhat later than the birth of her first child in 1983. This implication is borne out in what follows, which it turns out relates what happened to Precious at "I.S. 146 on 134th Street between Lenox Avenue

and Adam Clayton Powell Jr Blvd.," at a point when, as she puts it, "I was on my way to maff class," the use of the simple past tense here confirming that she is indeed referring to occurrences that have taken place in advance of the narrative moment.[4] Thus that moment itself has to fall sometime *after* "Thursday, September twenty-four 1987," but we still do not yet know exactly *how long* after.

The uncertainty is exacerbated by the fact that, in between declaring, "I'm walking down the hall," and telling us, "I was on my way to maff class," Precious first describes her established math-class routine, using the habitual present tense ("I jus' fall in Mr Wicher's class sit down. . . . I don't say nuffin' to him. He don't say nuffin' to me, *now*"), and then contrasts this currently prevailing custom against her and her teacher's initial encounter at the beginning of the school term: "First day he say, 'Class turn the book pages to page 122 please.' I don't move. He say, 'Miss Jones, I *said* turn the book pages to page 122.' I say, 'Mutherfucker I ain't deaf!'" For one thing, while the italicized "now" in this context properly refers to the present *period*—that is, "nowadays" as opposed to an earlier phase of Precious's and Mr. Wicher's relationship—because it is invoked by a first-person narrator, it also inevitably indexes the present *moment* at which it is "uttered," thereby blurring two overlapping but nevertheless distinct modes of present-temporality. The effect is only intensified, moreover, by Precious's similarly ambiguous reference to the "first day" of class, in the account of that day that is embedded in her story about the more recent "September twenty-four 1987." Having explained that she refrained on that day from opening her book to page 122 because she was at that point unable to read ("page 122 look like page 152, 22, 3, 6, 5—all the pages look alike to me"), she goes on to attest, "Everyday [i.e., over a durational period that has commenced prior to and yet encompasses this 'first day'] I tell myself something gonna happen. . . . I'm gonna break through or somebody gonna break through to me—I'm gonna learn, catch up, be normal. . . . But again," she laments, "it has not been that day," *it* here logically referring to the recounted *first day* of class but also unavoidably connoting both the present moment at which she is telling this story and, owing to the vagueness generated by the invocation of "everyday," the September

1987 date as well. Immediately thereafter, as if to resolve our confusion in this regard, she begins a new paragraph with, "But thas the first day I'm telling you about," the clarifying effect of which is paradoxically undercut by the actual ambiguity of the noun phrase: is "the first day I'm telling you about" in fact the first day *of class*, or is it instead simply the day that Precious elects to describe *first*, even though it did not constitute the inaugural moment for the sequence of events detailed in her larger story? The succeeding sentence settles the question in favor of the former alternative, but only by introducing its own ambiguity, in that it declares, "Today is not the first day"—thereby technically indicating the day on which Precious is relating her tale—but immediately follows this with, "and like I said I was on my way to maff class when Mrs Lichenstein snatch me out the hall to her office," which makes it clear that "today" here really refers to the earlier moment of "September twenty-four 1987."[5]

The sort of temporal vacillation traced here characterizes the entire introductory portion of the novel, which, as we have seen, begins by addressing events from 1983. The focus then shifts briefly to the present time of the narration, with Precious informing us that she is now "in the ninfe grade" (although she should be in the eleventh), having been "left back" once before, when she was seven. Then the narrative begins its account of "September twenty-four 1987," embedded within which is the flashback to the earlier "first day" of math class, considered previously, plus a couple of references to Precious's habitual activity, of the sort we have also already reviewed. Then, after a break in the text, we are given a view onto an indeterminate moment during which Precious is washing dishes in her apartment kitchen and neglecting to answer as her mother calls her name. However unsure the specific date, though, we know that it has to be sometime after 1983, because Precious tells us, "I was standing at this sink the last time I was pregnant," recalling that she was in that earlier instant first overcome with abdominal pains and then suddenly physically assaulted by her mother, who purported to have just realized that Precious was pregnant, even though she was so advanced in her condition at that point as evidently to be going into labor. Precious's retrospective narration continues with an account of her being tended to by the emergency medi-

cal technician whom a neighbor has summoned, finding herself in Harlem Hospital after having given birth, confirming to the attending nurses that she really is only twelve years old and that her own father is the father of her newborn child, and refusing to answer the questions of the police officers whom the hospital staff have called to her bedside.[6]

At the conclusion of this flashback sequence, Precious is still standing at the kitchen sink as her mother, Mary, calls, "Precious! Precious!"; "but," she tells us, "my head not here, it in four years ago when I had the first baby," thereby situating this local instance of narration in 1987. We soon realize, moreover, that it must occur sometime *after* September 24 of that year, for this nascent interaction between Precious and Mary is interrupted by the ringing of their apartment buzzer at the hand of Mrs. Lichenstein, who has come to continue the discussion she and Precious had on that day after Mrs. Lichenstein "snatch [Precious] out the hall to her office." The ensuing sequence corresponds closely with the cinematic version of it discussed earlier, except that while the filmic scene resumes the "real-time" narrative that had been disrupted by depiction of Precious's dissociative experience, the novelistic passage effectively *introduces* just such a narrative disruption, in that immediately after recounting Mrs. Lichenstein's departure, Precious tells us of falling asleep that night to thoughts of the Hotel Theresa's "nineteenth floor"—site of the alternative school mentioned by Mrs. Lichenstein—and accordingly dreaming that she is "in an elevator that's going up up up" to open eventually on the sympathetic emergency medical technician who delivered her baby, urging her to "*push*." This dream interlude is immediately followed by Precious's consciously remembering "the last time [she] pushed," which leads to her providing an account of the aftermath of her baby's 1983 birth that runs to a full five pages, telling us, among other things, that the child was born with Down syndrome; that upon leaving the hospital the baby was taken to live with Precious's grandmother in another part of Harlem; and that a few months after the birth Precious's mother, infuriated by her husband's having abandoned her once his illicit paternity came to light, brutally beat Precious, slapping her, kicking her, and striking her with a cast-iron skillet.[7]

Finally, after another section break, Precious brings the narrative's temporal equivocation to a close, emphatically asserting both the pastness of the events she has just recounted and her age at the present juncture: "I'm twelve, no I *was* twelve, when that shit happen. I'm sixteen now." Having thus checked the temporal disorder that has characterized her narration so far, she immediately goes on to attribute it to the psychic confusion she has recently suffered: "For past couple of weeks or so, ever since white bitch Lichenstein kick me outta school shit, 1983 and 1987, twelve years old and sixteen years old, first baby and this one coming, all been getting mixed up in my head." She then muses uncertainly, "Mama jus' hit me wif fryin' pan? Baby, brand-new and wrapped in white blankets, or fat and dead eyed lying in crib at my grandmother's house. Everything seem like clothes in washing machine at laundry mat—round 'n round, up 'n down." Then, as if to fix her temporal position—and end the reader's perplexity—once and for all, she declares, "But now, right *now*, I'm standing at the sink finishing the dishes. Mama sleep on couch. It's Friday, October sixteen, 1987."[8]

Of course, if we take seriously the import of her asserted "now," we have to recognize that Precious really is *not* "standing at the sink finishing the dishes" at this critical moment—or at least that this is not *all* she is doing—for her primary present activity, as far as we are concerned, is her narration of the very story we are reading. But if Precious here implausibly collocates telling (or narrating) and doing (i.e., dishwashing), elsewhere she rigorously distinguishes between the two, precisely on the basis of their differing temporal dispensations. Indeed, the opening page of the novel has Precious offering up an explicitly reflexive rumination, directly telling the reader, "I don't know how far I'm gonna go with this story, or whether it's even a story or why I'm talkin'; whether I'm gonna start from the beginning or right from here or two weeks from now." Then, ventriloquizing the skeptical query she anticipates in response to this last proposition, she wonders aloud, "Two weeks from now?" and confidently responds, "Sure you can do anything when you talking or writing,

it's not like living when you can only do what you doing."[9] In locating the distinctiveness of verbal narrative in its ability to engage alike past, present, and even future occurrences, Precious actually hits on a primary element in the form's abstractionist capacity, since a verbal account can render those temporalities intelligible only by conforming to the grammatical criteria by which we judge its overall coherency—and hence, as I argue in chapter 3, potentially recognize its abstractionist character.[10] In other words, temporal reference is just one of numerous respects in which any such narrative is judged for its formal correctness, against a standard that obtains for all verbal productions; indeed, it is on this principle that I find Precious's narration in *Push* to be insufficiently clear both about the sequence of the events it relates and about the specific moment at which it relates them. (To be more exact, Precious's account is insufficiently clear insofar as it functions as *literary narration*, the rules of which are rather different from what obtain for colloquial English of whatever variety— including the African American vernacular that Precious uses—where precise temporal reference might well be achieved through intonation or other aspects of speech that cannot make their way into a written text.) Cinema, by contrast, has no such standard—which is to say, no grammar—so while we inevitably experience a degree of uncertainty when *Precious* cuts from the shot of the protagonist being drenched with water to the one of her standing at the stove (for their mere juxtaposition cannot explain the relationship between them), we would be hard-pressed to posit a more "correct" way for the film to proceed.[11] Instead, we simply accept the cinematographic discontinuity and likely conclude (as I did earlier) that the latter scene resumes the narrative sequence initiated by the dishwashing episode. In so doing, we effectively acquiesce to the cinema's lack of a regulatory grammar and go about making sense of the film *in spite* of it. (That this lack inescapably limits cinema's capacity for narrative coherency is tacitly acknowledged through films' occasional recourse to the expository surety of intertitles or voice-over narration, with *Precious* itself trafficking heavily in the latter. In fact, it is through voice-over that we learn of Precious's assumption that crack addicts, rather than Mrs. Lichenstein, are ringing her apartment bell.)

Beyond merely serving as a touchstone for the technical correctness of verbal formulations, though, grammar also confers meaning on such formulations, even when they are obviously designed to confound it. After all, if a given verbal production evidently violates a tenet of compositional propriety (as the introductory section of *Push* arguably does by providing insufficient temporal reference for the events it recounts), it does not by that token *negate* any aspect of the prevailing grammatical order, which never ceases to govern our approach to instances of verbal discourse. Thus, far from throwing over our expectation that a narrative should clearly situate its reported events in time, *Push*'s failure in this regard simply induces us to see the novel as figuring a *muddled* temporality that comports with Precious's own psychic disorientation. More than this, it also impels us to *participate* in that figuration, since in following the narrative's account we ineluctably recapitulate its distinctive grammatical engagement, acquiescing in the alternative semantic order that it thereby promulgates. This point is crucial, for if the efficacy of *Precious* lies in its leading us to see what the protagonist sees, that seeing is essentially inconsequential insofar as it lacks a grammar to endow it with reliable meaning. Inasmuch as to *deploy* grammar—even through its own violation—is necessarily to *produce* meaning, however, then for *Push* to have us "say" what Precious *says* is for it to recruit us into an effectively world-making activity that potentially extends beyond the novel per se.[12]

Of course, this same effect has also been claimed for live theater, which, because it comprises an "experiential field shared . . . by audience, performer, and character," as one influential theorist has put it, activates "a feature that characterizes extratheatrical experience as well"—namely, the modulation of present experience by aspects of the imaginary.[13] It is no doubt the capacity for such modulation that constitutes theater as the *locus classicus* for Brechtian alienation (the model, after all, for the abstractionism I detail in this volume), whose achievement within African American stage work has been convincingly demonstrated by recent scholarship in the field. Indeed, one commentator powerfully anticipates the terms of my

own argument by averring that "modern black theater . . . annuls inherited mechanisms of social reproduction"—that is, that it achieves substantive social critique—precisely via "its refiguration of mimesis, and the concomitant espousal of postnaturalist presentational techniques"—or, in other words, through its aesthetic abstractionism.[14] He goes on to adduce Adrienne Kennedy's *The Owl Answers* (1965) as a play that "both highlights and distantiates narrative's shibboleths of causation and motivation" such that, "rather than seeking to produce an essential image of blackness, [it comprises] an obstinate struggle with the very question of black identity," installing the audience as "the main locus of . . . epistemological critique and ontological innovation"—a claim substantially borne out by the work itself.[15]

Incorporating a stock—and historically well-founded—script from the ongoing saga of U.S. black-white racial strife, *The Owl Answers* centers on a main character designated as "SHE who is CLARA PASSMORE who is the VIRGIN MARY who is the BASTARD who is the OWL," who in straightforward realist terms (which the play evokes only thoroughly to undercut) is the illegitimate daughter of "the Richest White Man in the Town and somebody that cooked for him"—repeatedly identified in the text as the "Black Mother" of the "Bastard" who is Clara Passmore herself.[16] Having been raised by her adoptive "Negro" parents, the Reverend Passmore and the Reverend's Wife, SHE WHO IS nevertheless seeks to claim the cultural inheritance of her now-dead white father, in order to mourn whom she has traveled from Georgia to London, where she is imprisoned and her pretensions to social legitimacy mocked by such icons of English history as William the Conqueror, Geoffrey Chaucer, Anne Boleyn, and William Shakespeare. That nothing comes of this quest is entirely in keeping with the play's utter repudiation of linear development—signaled characterially in the fact that the three primary dramatic figures each comprise multiple personages (so that the BASTARD'S BLACK MOTHER is THE REVEREND'S WIFE is ANNE BOLEYN, and her GODDAM FATHER is the RICHEST WHITE MAN IN THE TOWN is the DEAD WHITE FATHER is REVEREND PASSMORE, while SHE WHO IS herself appears in the multiple incarnations already indicated) and spatially in the fact that

the scene of the drama "is a New York Subway is the Tower of London is a Harlem hotel room is St. Peter's," with the players continually discarding and reassuming their various guises and the stage set regularly revolving to indicate shifts in locale.[17]

The action of the play consists principally in the protagonist's repeatedly asserting her claim on the Dead White Father ("He is my blood father. I am almost white, am I not? Let me into St. Paul's Chapel. Let me please go down to St. Paul's Chapel. I am his daughter."), and her repeatedly being rebuffed by the aforementioned guardians of English legitimacy, whose disdain for her demand is indicated in their subversion of the very terms of familial inheritance: "If you are his ancestor," they ask collectively, "why are you a Negro?"[18] The absurdist circularity and irresolution that characterize the play further what the previously cited commentator identifies as Kennedy's objective "not . . . so much to disclose the veiled truth of her protagonists or even to offer them as exemplars of a quest for discovery as . . . to lay bare the network of relations in which they're caught," so that "we are made to share SHE's own recognition that she is being placed within—indeed, that she 'is'—a series of repetitions and substitutions that fuel the machineries of cultural, familial, and personal desire, assigning her overdetermined places in an historical melodrama populated by alternately eminent (white) and generic (black) dramatis personae."[19] Thus the work's disavowal of naturalistic dramatic norms (the "shibboleths of causation and motivation") actually facilitates its disclosure of the social-historical relations that constitute black racial identity, which in turn potentially engenders "epistemological critique" on the part of the audience—much as I suggest that nonconventional prose itself does in my own chapter 3.

More recent dramatic work in a similarly nonnaturalist mode achieves a comparable effect. In fact, Suzan-Lori Parks's 1989 play *Imperceptible Mutabilities in the Third Kingdom* engages the same theme of illicit interracial sex as does *The Owl Answers*, presenting in its part 3 (titled "Open House") a domestic-familial configuration that is at once rather perplexing

and yet wholly familiar from national-historical memory. The action—largely unexplicated, temporally disjunctive and multilayered, and overall highly surrealistic—centers on a woman named Aretha who appears as what can only be called the "mammy" to two young siblings, Blanca and Anglor Saxon. We meet the trio on the point of a leave-taking, it being Aretha's "last day" with the family. Blanca and Anglor face this development with noticeable consternation, for Aretha is evidently both a slave on the eve of Emancipation and an allegorical instantiation of a soon-to-be-abolished slavery itself, and they are accordingly concerned when she announces, "Mm goin uhway. . . . Goin uhway tuh—tuh swallow courses uh meals n fill up my dance card! Goin uhway tuh live, I guess." "Live?" Blanca exclaims. "Get me my doll. My doll wants to wave goodbye. Who's going to sew up girl doll when she pops?!" Anglor continues the questioning: "Who's going to clean our commodes?!" he demands of Aretha, then declaring,

> We won't visit you because we won't be changed! We'll be sitting in our own filth because we won't have been changed we won't have been fed we won't have been aired we won't have manners we won't have plaits we'll have gone without sunshine.

ARETHA: Spect your motherll have to do all that.

BLANCA AND ANGLOR: Who!??![20]

Well might the children be confused and uncomprehending, since the play elsewhere suggests that Aretha herself is not just effectively the only mother they have ever known (implied by her evidently nursing them at their "feedin time")[21] but also their mother in actual fact. She is, after all, not simply "Aretha" but "Mrs. Aretha Saxon," widow of a "Charles Saxon" who quite possibly is the same Charles who appears to her in what the text designates as her "dreamtime," during which visitations she refers to him alternately as "Mr. Charles" and, much more familiarly, as plain "Charles."[22]

Indeed, when Blanca and Anglor later appear as incestuous adult "newlyweds" who proclaim their intention "to have a big family," Aretha medi-

tatively reflects, "A family. Had me uh family once. They let me go." When they further implore her, "guess where we met!" Aretha tellingly asserts, "Charles got you tuhgether"—a contention they implicitly confirm when Blanca says, "We're childhood sweethearts. From childhood. We met way back. In the womb. . . . We're twins!" Thus we are fully prepared to imagine a more-than-circumstantial connection among all these figures by the time Aretha musingly recalls, "I left him. Had to go. Two babies to care for. . . . Had tuh go. He gived me his name," whereupon Blanca remarks, "We've got the same name," thereby bringing fully to the fore the issues of irregular kinship, relational identity, and racial-political history that percolate throughout the play.[23]

In fact, one of the principal effects of the play's part 3 is that it registers the ongoing significance of U.S. racial-political history by vividly figuring the implication of past events and experiences in the present-day action that it depicts. It does this not only by, say, presenting an adult Anglor and Blanca in a scene understood to be temporally subsequent to the one in which they are presented as children (as previously noted), but also by presenting a number of individual scenes as already historically sedimented unto themselves—precisely insofar as they are presented as comprising Aretha's "dreamtime," as cited earlier. Indeed, the scene in which Blanca and Anglor respond to Aretha's impending departure itself functions as one of those "dream" moments, a fact made especially clear and resonant in the play's original production. Characteristically minimal to begin with, the stage directions that Parks provides for this scene call for

a double-frame slide show: Slides of ARETHA hugging ANGLOR and BLANCA. Dialogue begins and continues with the slides progressing as follows: (1) they are expressionless; next (2) they smile; next (3) they smile more; next (4) even wider smiles. The enlargement of smiles continues. Actors speak as the stage remains semi-dark and the slides flash overhead.[24]

Ultimately, however, director Liz Diamond evidently discounted these instructions, taking fairly literally the suggestion that Aretha is dreaming by presenting her supine in bed downstage, clutching white Raggedy Ann– and Raggedy Andy–like dolls to her breast and tossing fitfully in her

sleep while, in lieu of slide projections, live black actors in whiteface stood upstage and thus effectively "overhead" Aretha, speaking as a wholly "conscious" Blanca and Anglor within Aretha's dream, while Aretha herself spoke from within her restless slumber.[25] Thus, more emphatically than the script itself, Diamond's staging implied that the children's previously quoted complaints regarding Aretha's "last day" have in the world of the play originally been issued *prior to* Aretha's present "dreamtime," and that in recalling and responding to them in her contemporary unconscious state, Aretha herself is indicating just how thoroughly affected she is by historical experiences, which can never be properly "past."

If this aspect of Diamond's staging thus figured present-day racial politics as a function of ongoing historical processes ripe for revision, so too did a different element of her production similarly register the extent to which one historical moment is implicated in the significance of another, thereby making history itself the focus of critical reflection. The fourth and final part of Parks's play, "Greeks (or The Slugs)," alternately presents an African American soldier, "Mr. Sergeant Smith," who is stationed abroad during a mid-twentieth-century military conflict (World War II or, perhaps, the Korean War), and his ever-growing family—his wife and the children he apparently fathers during his periodic leaves—who are ensconced back in the States. The action on the home front consists largely of Mrs. Smith's repeatedly reminiscing to her children about what transpired during Mr. Sergeant Smith's "last furlough," and the dialogue in section D of part 4 hews to this pattern, with Mrs. Smith rhetorically querying her daughters, Buffy and Muffy:

> You girls know what he told me last furlough? . . . He told me that over there, where he's stationed, on his island home, over there they are uh whole day ahead of us. Their time ain't our time. Thuh sun does—tricks—does tricks n puts us all off schedules. When his time's his own he tries tuh think of what time it is here. For us. And what we're doin. He's in his quarters stowin away his checkers game and it's dark but you're whinin out thuh lumps in your Cream of Wheat, Buffy and Muffy, you're tearin at your plaits and it's Tuesday mornin and it's yesterday. And thuh breakfast goes cold

today. I redo Miss Muff's head and fasten it with pins but it ain't today for him. Ssstomorrow. Always tomorrow. Iduhn't that somethin?[26]

Under Diamond's direction, the utterance of that last "isn't that something?" was immediately followed by a period of silence during which the mother and two daughters—all seated downstage-right during the speech—gradually and in unison turned their heads, their faces frozen in simultaneously solemn and beatific half smiles, so that their collective gaze panned slowly from upstage-left, where Mr. Sergeant Smith sat in partial shadow, as if present in their minds if not in their home, to the far corner of the auditorium on their own right-hand side. This movement, which lasted for a full thirty seconds in all, had a complex effect: on the one hand, it conveyed the sense that Buffy, Muffy, and Mrs. Smith were hopefully shifting their concentration from the "today" they inhabited to the "tomorrow" that always obtained for the sergeant—and hence to what for them was an indeterminate yet anticipatedly promising future—since from the onstage perspective they turned their attention from left to right, in the manner that in Western visual culture signifies forward progress; on the other hand, because from the audience's vantage they turned their focus not only from the sergeant himself, already installed in "tomorrow," to their own side of the room and thus to "today," but also *from right to left*, they appeared to be casting their attention *backward* in time. The characters' thus seemingly glancing toward *yesterday* at the same time as they were putatively pondering *tomorrow*—all the while enveloped in a silence that implied their complete mental absorption—uncannily suggested the extent to which the one moment ineluctably informs the other, thereby at once implicating the spectators in that phenomenon of historical relation (as they followed the trajectory of the characters' gaze) and inviting them to contemplate its abiding significance.

If the foregoing examples are any indication, then, nonnaturalistic theater does indeed entail the same sort of abstractionism—and so holds the same potential for engendering social critique—as does the nonconventional

prose that I champion in this book. As my discussion of *Imperceptible Muta-bilities* suggests, however, its doing so depends on its being fully realized *as theater*, rather than mere dramaturgical study or archival transcription. In other words, and crucially, the aspects of Kennedy's and Parks's drama considered here—that is, the actors' successive assumption of different roles, the physical manipulation of the set, the presentation of black actors in white-face, the staging of key action as a character's dream-state retrospection, the enactment of unscripted stylized gesture—achieve their abstractionist effect *only in performance*;[27] and this fact itself limits that abstractionism's overall critical potential, since there are practical constraints on the dissemination of theatrical performance that militate against its widespread impact.

Indeed, in 2012 (the latest year for which full information was available as of this writing), theater attendance in the U.S. totaled well under half the number of new print-fiction books sold, and this is to say nothing of electronic books (which accounted for 20 percent of all U.S. book sales); bound volumes that were resold, borrowed from libraries, or otherwise circulated beyond their original purchasers; or works published in periodicals.[28] Then, too, the relative cheapness and portability of the published text have long underwritten its centrality in precisely that context where African American cultural practice is now most systematically promulgated as such—to wit, the U.S. academy, where a rich and varied black studies project effectively sets the terms of "black culture" per se, and where that culture itself is routinely epitomized in curricula by the putatively "representative" prose-fictional work.[29] Thus, if there are at least two necessary preconditions for the critical efficacy of African American-ist abstractionism, one of those seems already to have been met, for even now the prose publications that I contend are abstractionism's most apt medium circulate widely among an interested readership. What remains is to establish abstractionist works themselves as paradigmatic agents of African Americanist critique—exemplars of socially committed black art—however paradoxical that proposition may seem. This is an academic project if ever there was one, but it is in no way by that token inconsequential. If *Abstractionist Aesthetics* does anything to forward it, then its own effects will be both concrete and beneficial.

Acknowledgments

This book has had many beginnings, none more crucial than my spring 2002 graduate seminar "Problems in the Representation of Blackness," where I was privileged to test my ideas on the following students in NYU's American Studies and English programs: Aliyyah Abdur-Rahman, Rich Blint, Emily Cone-Miller, Sybil Cooksey, Descha Daemgen, Peter James Hudson, Leigh Claire La Berge, Carmelo Larose, Njoroge Njoroge, Megan Obourn, Michael Palm, Khary Polk, Rachel Rosen, Jonathan Imber Shaw, Jenny Chuck Su, and Adam Waterman. Then, too, that course developed from the highly tentative propositions put forth in two papers I had delivered over the preceding three years at several different universities, including Cornell, Duke, Emory, Johns Hopkins, Northwestern, and the University of Rochester. My thanks to the audiences for those lectures and to the friends and colleagues who arranged them: Mary Pat Brady, Jacqueline Goldsby, Maurice Wallace, Frances Smith Foster, Robert F. Reid-Pharr, Sasha Torres, Jeffrey Masten, Douglas Crimp, Rosemary Kegl, and Jeffrey Tucker.

A Visiting Professor appointment at Johns Hopkins in fall 2004 gave me the opportunity to sketch the entire argument in a series of presenta-

tions to the English department there, and for their trenchant questions and commentary I am indebted to then Hopkins faculty members Sharon Cameron, Simon During, Jonathan Goldberg, Richard Halpern, Neil Hertz, Michael Moon, Irene Tucker, Lisa O'Connell, the late Allen Grossman, and, especially, Amanda Anderson, who organized my residency. More recently, I presented a portion of the project in the University of Michigan English department, visiting under the auspices of Theresa Tinkle and Michael Schoenfeldt and especially benefiting from the insights of Michael Awkward, David Halperin, Adela Pinch, Xiomara Santamarina, and Gillian White.

At NYU, I received invaluable response to my argument in a faculty colloquium held in the Department of Social and Cultural Analysis, in addition to having had innumerable productive conversations about the project with a host of colleagues, past and present, including John Archer, Neil Brenner, Mary Carruthers, Una Chaudhuri, Arlene Dávila, Patrick Deer, Carolyn Dinshaw, Ana Dopico, Elaine Freedgood, Jacqueline Goldsby, Adam Green, John Guillory, Martin Harries, Anselm Haverkamp, Virginia Jackson, Walter Johnson, Don Kulick, Elizabeth McHenry, Harvey Molotch, Jennifer Morgan, Mary Poovey, Ross Posnock, Mary Louise Pratt, Renato Rosaldo, Tricia Rose, Andrew Ross, Sukhdev Sandhu, Lytle Shaw, Judith Stacey, and Gabrielle Starr. From beyond NYU, Steve Botticelli, Tina Campt, J. P. Cheuvront, Brent Edwards, Noah Glassman, Saidiya Hartman, Bruce Ledbetter, W. J. T. Mitchell, Jeff Nunokawa, Matthew Pucciarelli, and Keith Vincent have been helpful interlocutors throughout the drafting of the book, while Henry Abelove, Michael Awkward, Douglas Crimp, Jonathan Flatley, Rosemary Kegl, and Marlon Ross all read parts of the work in its earliest incarnations and provided essential moral and material support.

Nicholas Boggs, Christopher Cannon, Shelly Eversley, Juliet Fleming, Bill Goldstein, Peter Nicholls, Sonya Posmentier, and Michael Ralph reviewed and commented on the entire manuscript in its final preproduction stages, and I am extremely grateful for their generosity and collegiality. Similarly, Sybil Cooksey, David Hobbs, Joan Morgan, and Cameron Williams offered vital encouragement upon reading the version of the book

that was submitted for press review. Alan Thomas assiduously pressed me to make the argument tighter, stronger, and better overall, while two anonymous readers for NYU Press offered additional expert advice on how to do just that. My editor, Eric Zinner, waited patiently, not only for me to complete those recommended revisions but for me to come home to NYU Press in the first place; my deepest thanks both to him and to former NYU Press director Steve Maikowski for their years of support, and to assistant editor Alicia Nadkarni for facilitating my completion of the project.

At any given moment during the writing and revision process, I depended on one or another of several research assistants who frankly made the whole enterprise possible: Aliyyah Abdur-Rahman, Rich Blint, Conor Creaney, Laura Fisher, Miles Grier, Peter James Hudson, and Cameron Williams. A fellowship from the American Council of Learned Societies allowed me to research and draft the whole of chapter 2; the production of the book has been financed in part by the NYU Department of English through its Abraham and Rebecca Stein Faculty Publication Fund. Andrew Katz copyedited the manuscript with gratifying alacrity, while Stefanie Dorman and Cameron Williams expertly proofread the entire book.

I could not have completed the work without the wise counsel and steady support of Michael Koetting, David Longmire, Saul Raw, Dr. Gregory Alsip, and Dr. Robin Goodman; nor would I have wanted to do so absent the companionship of Thom Freedman, who has quickened my efforts from the very beginning and urged me along through the very end. May his patience be repaid, and his sacrifice have been worth it.

<div align="right">P.B.H.

NEW YORK CITY

JULY 2015</div>

Notes

Unless otherwise indicated, all web pages were last retrieved on February 4, 2015.

INTRODUCTION

1 This is a definition similar to and yet crucially broader than the one offered up for African American literature by Kenneth Warren in his much-discussed 2011 volume, precisely in that I do in fact aim to emphasize *practices* over *institutions*, being less concerned than Warren with the "coherence" or "distinctness" of the African American cultural project; he is, after all, interested specifically in "*a*[*n* African American] literature" (my emphasis), singular and evidently unified unto itself. See Warren, *What Was African American Literature?* (Cambridge, MA: Harvard University Press, 2011), chap. 1, esp. 1–9. For a sample of the critical conversation that Warren's book has generated, see the contributions (including Warren's own) to the "Theories and Methodologies" section in *PMLA* 128, no. 2 (2013): 386–408.

2 For instances that collectively exemplify the gamut, see Langston Hughes, "The Negro Artist and the Racial Mountain," *Nation*, June 23, 1926, 692–94; W. E. B. Du Bois, "Criteria of Negro Art," *Crisis*, October 1926, 290–97; Richard Wright, "Blueprint for Negro Writing," *New Challenge* 11 (2, no. 2; 1937): 53–65; LeRoi Jones (Amiri Baraka), "Expressive Language," *Kulchur* 3, no. 12 (1963): 77–81; Larry Neal, "The Black Arts Movement," *Drama Review* 12, no. 4 (1968): 29–39; Addison Gayle, Jr., introduction to *The Black Aesthetic*, ed. Gayle (Garden City, NY: Doubleday, 1971), xv–xxiv; Trey Ellis, "The New Black Aesthetic," *Callaloo* 38 (Winter 1989): 233–43. The quoted

phrases are, respectively, from Neal, "Black Arts Movement," 29, and Ellis, "New Black Aesthetic," 235.

3 Recent works that seek to counter the notion that African American cultural representation necessarily entails black "racial realism" indicate in their very existence just how much currency the idea generally enjoys. For a critique of this conception of African American art within the field of visual culture, see Darby English, *How to See a Work of Art in Total Darkness* (Cambridge, MA: MIT Press, 2007). For similar analysis in literary studies, see Gene Andrew Jarrett, ed., *African American Literature beyond Race: An Alternative Reader* (New York: NYU Press, 2006); the term "racial realism" is taken from Jarrett's introduction (2).

4 For critiques of the concept of racial "authenticity" that informs this demand, see John L. Jackson, *Real Black: Adventures in Racial Sincerity* (Chicago: University of Chicago Press, 2005); Shelly Eversley, *The Real Negro: The Question of Authenticity in Twentieth-Century African American Literature* (New York: Routledge, 2004); E. Patrick Johnson, *Appropriating Blackness: Performance and the Politics of Authenticity* (Durham, NC: Duke University Press, 2003); J. Martin Favor, *Authentic Blackness: The Folk in the New Negro Renaissance* (Durham, NC: Duke University Press, 1999); and my own *Are We Not Men? Masculine Anxiety and the Problem of African-American Identity* (New York: Oxford University Press, 1996).

5 Brecht defines non-Aristotelian plays as those that are "not dependent on empathy"; see his "Alienation Effects in Chinese Acting" (1936), in *Brecht on Theatre: The Development of an Aesthetic*, ed. and trans. John Willett (1964; repr., New York: Hill and Wang, 1992), 91. The epigraph to my introduction is from Brecht, "A Short Organum for the Theatre," in *Brecht on Theatre*, 204.

6 Bertolt Brecht, "The Street Scene: A Basic Model for an Epic Theatre" (ca. 1938, 1950), in *Brecht on Theatre*, 125. For Shklovsky's foundational account of *defamiliarization*—or, better, *estrangement*—see his "Art as Technique" (1917), in *Russian Formalist Criticism: Four Essays*, trans. and introd. Lee T. Lemon and Marion J. Reis (Lincoln: University of Nebraska Press, 1965), 3–24. On Shklovskian defamiliarization as compared with Brechtian alienation, see Willett's endnote to "Alienation Effects in Chinese Acting," 99; Stanley Mitchell, "From Shklovsky to Brecht: Some Preliminary Remarks towards a History of the Politicisation of Russian Formalism," plus Ben Brewster's response, "From Shklovsky to Brecht: A Reply," *Screen* 15, no. 2 (1974): 74–81, 82–102; and John Fuegi, *Bertolt Brecht: Chaos, According to Plan* (Cambridge: Cambridge University Press, 1987), 82. For a recent argument that Shklovsky is not merely an "apolitical Formalist critic" as contrasted with Brecht, see Cristina Vatulescu, *Police Aesthetics: Literature, Film, and the Secret Police in Soviet Times* (Stanford, CA: Stanford University Press, 2010), 161–73 (167 for the quotation).

7 See Brecht, "Alienation Effects in Chinese Acting," 98; and Brecht, "Short Description of a New Technique of Acting Which Produces an Alienation Effect" (1940, 1951), in *Brecht on Theatre*, 136–147 (140 for the key passage).

8 Bertolt Brecht, "Theatre for Pleasure or Theatre for Instruction" (ca. 1936, 1957), in *Brecht on Theatre*, 71.

9 Brecht, "Alienation Effects in Chinese Acting," 92.

10 Theater and theater criticism unsurprisingly constitute one arena of African American cultural activity where Brechtian theory has in fact been influential, as is made a bit clearer in my coda.

11 As quoted in the short video "Fred Wilson 2011 Joyce Award," FredWilsonIndy.org, n.d., archived at https://web.archive.org/web/20130928015112/http://www.fredwilsonindy.org/aboutproject.html, minutes 1:26–1:54.

12 All three of these questions are from Fred Wilson. The first two are taken from the publicity video "Fred Wilson Introduces E Pluribus Unum," FredWilsonIndy.org, n.d., archived at https://web.archive.org/web/20130928015112/http://www.fredwilsonindy.org/aboutproject.html, minutes :00 to 1:03; the third is from the video recording of a radio interview Wilson conducted with the Indianapolis media personality Amos Brown. "Amos Interviews Fred Wilson, Designer of Cultural Trail 'Slave' Statue," PraiseIndy.com, October 20, 2010, http://praiseindy.com/434401/audio-amos-interviews

-fred-wilson-designer-of-cultural-trail-slave-statue/, roughly minutes 5:13–5:18. The characterization of the revised figure as "upright" and "empowered" is cited by Leroy Robinson, "Sculpture Is Appalling," letter to the editor, parts 1 and 2, *Indianapolis Recorder*, September 17 and September 24, 2010, Opinions section.

13 "Amos Interviews Fred Wilson," 14:15–15:22. Wilson's comment about his "outsider" status is in "Fred Wilson Introduces E Pluribus Unum," 1:03–1:12; emphasis added.

14 This practice, which has long characterized Wilson's work, can be understood in terms of situationist *détournement*. See Guy Debord and Gil Wolman, "A User's Guide to Détournement" (1956) and the unattributed statement on "Definitions" (1958), both in the *Situationist International Anthology*, rev. and exp. ed., ed. and trans. Ken Knabb (Berkeley, CA: Bureau of Public Secrets, 2006), 14–21, 51–52.

15 Coverage of—and contribution to—the debate is comprised in the nearly thirty items published from April 2010 through September 2011 in the city's daily newspaper, the *Indianapolis Star*, and in its African American weekly, the *Indianapolis Recorder*.

16 "Amos Interviews Fred Wilson," 13:35–14:15. For the demand that the sculptural figure be fully clothed, see Citizens Against Slave Image, "Why We Oppose the Slave Image," letter to the editor, *Indianapolis Recorder*, August 5, 2011, Opinions section.

17 See the CASI website at http://1slave
 -enough.wix.com/inindy; emphasis
 added.

18 This is according to the official press
 release issued by the Indianapolis
 Cultural Trail: Central Indiana
 Community Foundation, "Fred Wilson
 Public Art Project Discontinued," press
 release, Indianapolis Cultural Trail,
 December 13, 2011, archived at https://
 web.archive.org/web/20130828114659/
 http://www.indyculturaltrail.org/
 epluribusunumdiscontinued.html. See
 also Jay Harvey, "Local Groups Pleased
 Sculpture Won't Be Here," *Indianapolis
 Star*, December 14, 2011, Local—Metro
 and State section; and Jessica Williams-
 Gibson, "Controversial Public Art
 Project Is Discontinued," *Indianapolis
 Recorder*, December 16, 2011, A1+.

19 Examples of Wilson's references to the
 flag appear in "Fred Wilson 2011 Joyce
 Award," 1:56–2:13; and "Fred Wilson
 Introduces E Pluribus Unum,"
 4:20–4:55.

20 Indeed, a major impediment to the
 flag's immediately conveying its
 intended black-racial import is
 precisely that it is "more of a[n]
 abstract image" than the sculptural
 figure, as Wilson himself put it in
 "Fred Wilson 2011 Joyce Award,"
 2:08–2:13. A similar point is made in
 "Fred Wilson Introduces E Pluribus
 Unum," 4:40–4:50.

21 Shklovsky himself notes the historicity
 of the specific techniques of literary
 defamiliarization; see "Art as
 Technique," 22–23.

22 Indeed, this is likely what constitutes
 music as an unproblematic mode of
 aesthetic abstraction from an African

Americanist perspective, as the fact
that music is understood as nonrefer-
ential to begin with means that
musical abstraction can never register
as a lapse from proper realist
representation or, thus, as a betrayal of
black people's lived reality.

23 On the African Americanist privileg-
 ing of realism, see Jarrett, *African
 American Literature beyond Race*; and
 Aldon Lynn Nielsen, *Black Chant:
 Languages of African-American
 Postmodernism* (Cambridge:
 Cambridge University Press, 1997),
 chap. 1, esp. 8. On the critical neglect of
 black experimental writing, see
 Nathaniel Mackey, "Other: From Noun
 to Verb," in *Discrepant Engagement:
 Dissonance, Cross-Culturality, and
 Experimental Writing* (Cambridge:
 Cambridge University Press, 1993),
 265–85, esp. 284; and Evie Shockley,
 *Renegade Poetics: Black Aesthetics and
 Formal Innovation in African American
 Poetry* (Iowa City: University of Iowa
 Press, 2011), introduction, esp. 1. For
 the pithy assertion that "all art is
 abstract," which anticipates one of my
 fundamental points here, see the
 sculptor Melvin Edwards's contribution
 to the 2006 roundtable "Black Artists
 and Abstraction," in *Energy/
 Experimentation: Black Artists and
 Abstraction, 1964–1980*, exhibition
 catalog (New York: Studio Museum in
 Harlem, 2006), 113. My thanks to one
 of the anonymous reviewers for NYU
 Press for bringing Edwards's remarks
 to my attention.

24 Mackey, *Discrepant Engagement*, 19.
 While I completely agree with Mackey
 that registering racial-political critique

is by no means *all* these writers do (see ibid., 2–4, 16–19), my particular polemical objective requires that I emphasize that critical function in this book.

25 In addition to the works by Mackey, Nielsen, and Shockley cited in note 23 to this introduction, see Nathaniel Mackey, *Paracritical Hinge: Essays, Talks, Notes, Interviews* (Madison: University of Wisconsin Press, 2005); Aldon Lynn Nielsen, *Integral Music: Languages of African American Innovation* (Tuscaloosa: University of Alabama Press, 2004); Tony Bolden, *Afro-Blue: Improvisations in African American Poetry and Culture* (Urbana: University of Illinois Press, 2004); and Bolden "Cultural Resistance and Avant-Garde Aesthetics: African American Poetry from 1970 to the Present," in *The Cambridge History of African American Literature*, ed. Maryemma Graham and Jerry W. Ward, Jr. (Cambridge: Cambridge University Press, 2011), 532–65. See too "Expanding the Repertoire," special issue, *Tripwire: A Journal of Poetics* 5 (Fall 2001).

It is not the case that Mackey and Nielsen, at least, do not discuss prose fiction *at all*. Aside from Robert Creeley's short stories, though, it is really just the prose work of the Guyanese writer Wilson Harris on which Mackey has focused his critical attention, notwithstanding his admission that his conception of "discrepant engagement" emerged out of his work on his own extended novel (see Mackey, "Paracritical Hinge," in *Paracritical Hinge*, 207), thus far

comprising *Bedouin Hornbook* (Lexington: Callaloo Fiction Series / University of Kentucky Press, 1986); *Djbot Baghostus's Run* (Los Angeles: Sun and Moon, 1993); *Atet A.D.* (San Francisco: City Lights, 2001); and *Bass Cathedral* (New York: New Directions, 2008). The first three of these have been issued together as *From a Broken Bottle Traces of Perfume Still Emanate: Volumes 1–3* (New York: New Directions, 2010). For Mackey's discussions of Creeley and Harris, see *Discrepant Engagement*, chaps. 6, 9–12. For places where Mackey glancingly touches on the differences between poetry and prose—and proposes the worrying of their boundaries—see "Paracritical Hinge," 208–10; and the "Editors' Note" to *Moment's Notice: Jazz in Poetry and Prose*, ed. Art Lange and Mackey, (Minneapolis: Coffee House, 1993), i–ii, esp. ii.

Nielsen, for his part, typically attends to prose works only in order to amplify a primary complaint regarding the critical marginalization of black *poetry*—particularly *experimental* black poetry—while simultaneously striving to redress that neglect (see, for example, *Black Chant*, esp. 3–18). This otherwise wholly legitimate approach paradoxically elides the generic distinctions between prose and verse that I would argue underwrite the differences in their experimentalist effects.

26 I am quoting here from Fred Moten, *In the Break: The Aesthetics of the Black Radical Tradition* (Minneapolis: University of Minnesota Press, 2003), 32–33, and am alluding to discussions

in that book that appear respectively on pages 64–73, 94–102, 116–18, 22, 41–63, 107, 224–29, and 233–54. Scrupulously following Mackey's injunction that we attend to black culture's manifestation as "marronage, divergence, flight, fugitive tilt" (Mackey, "Other," 285), Moten has been assiduous in theorizing these latter as the modalities of blackness itself. Besides *In the Break*, see Moten's "Knowledge of Freedom," *CR: The New Centennial Review* 4, no. 2 (2004): 269–310; "The Case of Blackness," *Criticism* 50, no. 2 (2008): 177–218; "Black Op," *PMLA* 123, no. 5 (2008): 1743–47; and, on "Afro-pessimism" versus "black optimism," "Blackness and Nothingness (Mysticism in the Flesh)," *South Atlantic Quarterly* 112, no. 4 (2013): 737–80. See also Stefano Harney and Fred Moten, *The Undercommons: Fugitive Planning and Black Study* (New York: Autonomedia / Minor Compositions, 2013), esp. "Blackness and Governance," 44–57.

27 Nielsen, *Integral Music*, xiv. See also Harryette Mullen, untitled essay in "Expanding the Repertoire," 11–14, esp. 11.

28 This is true even within Anthony Reed's *Freedom Time: The Poetics and Politics of Black Experimental Writing* (Baltimore: Johns Hopkins University Press, 2014), which although it pays some attention to dramatic and prose-fictional works—and grants the "intergeneric" character of much of the writing it treats (7)—is self-admittedly focused on poetry (6). Indeed, while Reed's book offers an

argument entirely consonant with my own, it refrains from the comparative evaluation of art forms and literary genres that I present here.

29 For prime examples in which black music "provides a reference point" for critics' discussions of specific writers (Mackey, *Discrepant Engagement*, 6)—largely because it serves similarly for the writers themselves—see Mackey, *Discrepant Engagement*, chap. 2; Nielsen, *Black Chant*, esp. the considerations of Norman Pritchard, Stephen Chambers, A. B. Spellman, Jayne Cortez, and the *Dasein* poets; Nielsen, *Integral Music*, chaps. 2, 5; Shockley, *Renegade Poetics*, chap. 3; Bolden, *Afro-Blue*; and Meta DuEwa Jones, *The Muse Is Music: Jazz Poetry from the Harlem Renaissance to Spoken Word* (Urbana: University of Illinois Press, 2011).

For tacit acknowledgment that music can of course inform not only verse but also prose, see Mackey's discussion of his work in *From a Broken Bottle* (Mackey, "Paracritical Hinge," 208–10) and Moten's characterization of his aspirations for his own critical writing ("'Words Don't Go There': An Interview with Fred Moten," by Charles Henry Rowell, *Callaloo* 27, no. 4 [2004]: 953–66, esp. 957, 961).

Finally, for a discussion of African American aesthetics that posits not music per se but the sonic in general as a crucial mechanism of politically committed black literary experimentalism—and that *does* give sustained attention to prose writing (albeit without theorizing it as

such)—see Carter Mathes, *Imagine the Sound: Experimental African American Literature after Civil Rights*

(Minneapolis: University of Minnesota Press, 2015).

CHAPTER 1. BLACK PERSONHOOD IN THE MAW OF ABSTRACTION

1 For a list of the accomplishments and accolades garnered by Walker in the years following the controversy summarized here, see her current and past biographies at the website of her representing gallery, Sikkema Jenkins & Co: http://www.sikkemajenkinsco .com/index.php?v=artist&artist=4eece 69f3eb4e; and https://web.archive.org/ web/20120417074821/http://sikke majenkinsco.com/karawalker_bio.pdf (archived April 17, 2012).

2 Juliette Bowles, "Extreme Times Call for Extreme Heroes" (unsigned opinion piece), in "Stereotypes Subverted? Or for Sale?," special issue, *International Review of African American Art* 14, no. 3 (1997): 15. The precipitating factor in the publication of Bowles's essay—and, indeed, in the whole controversy—was Walker's receipt of one of the famous MacArthur Foundation "genius" grants in June 1997 (see William H. Honan, "MacArthur Foundation Chooses Grant Winners," *New York Times*, June 17, 1997, Late edition— Final, sec. A, 16). It was specifically in July of that year that Saar penned her letter charging Walker with presenting "negative images" of black people, which she subsequently sent to numerous key figures within African Americanist cultural circles. For further evidence of the tumult, see Karen C. C. Dalton, Michael D. Harris,

and Lowery Stokes Sims, "The Past Is Prologue but Is Parody and Pastiche Progress? A Conversation," in "Stereotypes Subverted? Or for Sale?," 17–29; the special feature "Stereotypes Subverted? The Debate Continues," in *International Review of African American Art* 15, no. 2 (1998): 44–52; and the accounts provided from 1997 through 1999 by daily newspapers in Atlanta, Boston, St. Louis, and Los Angeles, where Walker's work was exhibited or discussed—or both— during the period in question.

For a sample of the detailed analysis of Walker's silhouettes that has proliferated since the turn of the twenty-first century, see Gwendolyn DuBois Shaw, *Seeing the Unspeakable: The Art of Kara Walker* (Durham, NC: Duke University Press, 2004); Glenda Carpio, *Laughing Fit to Kill: Black Humor in the Fictions of Slavery* (New York: Oxford University Press, 2008), 162–90; and English, *How to See a Work of Art in Total Darkness*, 71–135, and "This Is Not about the Past: Silhouettes in the Work of Kara Walker," in *Kara Walker: Narratives of a Negress*, exhibition catalog, ed. Ian Berry, English, Vivian Patterson, and Mark Reinhardt (Cambridge, MA: MIT Press, 2003), 141–67.

3 The response to Fred Wilson's proposed *E Pluribus Unum*, discussed in the introduction, is a prime case in

point. The same general period also saw criticisms lodged by some African American commentators against the film director Lee Daniels for the "demeaning" depictions in his 2009 film *Precious: Based on the Novel "Push" by Sapphire* (Lions Gate)—criticisms that largely replicated those faced by Sapphire herself after the publication of the novel in 1996. While I briefly address both the film and the novel in my coda, the critical response to them is not my primary concern there. For reactions to Daniels's film, see Felicia R. Lee's newspaper article "To Blacks, Precious Is 'Demeaned' or 'Angelic,'" *New York Times*, November 20, 2009; Ishmael Reed's op-ed piece "Fade to White," *New York Times*, February 5, 2010, New York City edition, A25; and Sapphire's own letter to the editor, "Why Stories Like 'Precious' Need to Be Told," *New York Times*, February 12, 2010, New York City edition, A30. For criticism of *Push* from around the date of its release (by Knopf, New York), see Vaughn A. Carney, "Publishing's Ugly Obsession," *Wall Street Journal*, June 17, 1996, Eastern edition, A1.

4 For Walker's account of her adoption of the silhouette—from just before the eruption of the controversy discussed here—see her interview with Alexander Alberro, *Index* 1 (February 1996): 25–28; reprinted in *Kara Walker: Upon My Many Masters—An Outline*, exhibition brochure, with text by Gary Garrels (San Francisco: San Francisco Museum of Modern Art, 1997).

5 *Abstract*, from the Latin *abstract-us*, "drawn away" (*abs*, "off, away" +

tractus, past participle of *trahĕre*, "to draw"). See "abstract, *adj.* and *n*." *OED Online*, December 2014, Oxford University Press, http://www.oed.com/view/Entry/758.

6 On abstraction and perception, see Rudolf Arnheim, *Visual Thinking* (Berkeley: University of California Press, 1969), esp. chaps. 9, 10, and 11. On the abstractness of even figurative representation—and thus the continuity between conventionally "abstract" and figurative art—see Peter Hobbis, "Representing and Abstracting," in *Philosophy and the Visual Arts: Seeing and Abstracting*, ed. Andrew Harrison (Dordrecht, Netherlands: D. Reidel, 1987), 97–120, esp. sec. 2, 98–102; and, on 135–45 of the same collection, Dieter Peetz, "On Attempting to Define Abstract Art," esp. 141.

7 Even such child sexual abuse as Walker has been accused of portraying obtains only where the impropriety of sexual relations between an adult and a child—or even between children—is recognized in the prevailing moral and legal codes.

8 This is to say that in deploying these alternatives to the representation of repetitive action, the work would inevitably remind viewers that it cannot, in fact, represent repetitive action. Indeed, the representational limits sketched here are essentially those that constrain all attempts at pictorial narrative. On this point, see Anabel Thomas, *An Illustrated Dictionary of Narrative Painting* (London: John Murray, 1994), introduction, esp. x.

9 By 1997, Walker's work was already typified by exact figural outlines connoting such generic period personages as the mammy and the pickaninny, Sambo and Zip Coon, the brawny black "buck" and the lusty "nigger wench," along with white figures including the master, the mistress, and the infant charge. As deployed by Walker, then, the silhouette generally registers neither the staid gentility that it conveyed within eighteenth-century aristocratic portraiture nor the homely quaintness that it telegraphed within nineteenth-century folk-art practice. On Walker's persistent interrogation of antebellum U.S. racial history, see Annette Dixon, ed., *Kara Walker: Pictures from Another Time* (Ann Arbor: University of Michigan Museum of Art, 2002)—the companion volume to the exhibit *Kara Walker: An Abbreviated Emancipation (from The Emancipation Approximation)*, University of Michigan Museum of Art, Ann Arbor, MI, March 9–May 26, 2002—esp. Robert F. Reid-Pharr, "Black Girl Lost," 27–41. For a history of the silhouette from its earliest manifestations, see R. L. Mégroz, *Profile Art through the Ages: A Study of the Use and Significance of Profile and Silhouette from the Stone Age to Puppet Films* (New York: Philosophical Library, 1949), esp. chap. 9. Mégroz himself draws on Emily Nevill Jackson, *Silhouette: Notes and a Dictionary* (New York: Scribner, 1938), reprinted in 1981 as *Silhouettes: A History and Dictionary of Artists* (New York: Dover). On the use of the silhouette within African Americanist visual culture, see Leesa Rittelmann, "Winold Reiss to Kara Walker: The Silhouette in Black American Art," in *From Black to Schwarz: Cultural Crossovers between African America and Germany*, ed. Maria Diedrich and Jürgen Heinrichs (Berlin: LIT Verlag; East Lansing: Michigan State University Press, 2010), 287–307. For an incisive account of how the silhouette's historical significance informs the effect of Walker's work specifically, see English, "This Is Not about the Past."

10 This is to say that there is a difference between sheer mimetic reference and thoroughgoing realism, even if the former helps define the latter and furthers its hegemony (which consists partly in the literalist reception modes I interrogated earlier). Indeed, while within realism mimetic reference arguably affirms the objective conditions it adduces, it might within other aesthetic regimes serve to challenge their legitimacy, as I argue shortly.

11 In other words, while the silhouette by definition achieves incomparable verisimilitude in its outline, it just as essentially *repudiates* verisimilitude in its resolute flatness. For Walker's own commentary on this paradox, see her quoted remarks in David Joselit, "Notes on Surface: Toward a Genealogy of Flatness," *Art History* 23, no. 1 (2000): 30. Joselit himself (29–32) suggests that the very flatness of Walker's silhouettes helps to "animate" critically the racial stereotypes that the work engages (a contention with

which I am fundamentally sympathetic), but that same racial engagement seems also to *offset* the silhouettes' flatness, thereby making the work susceptible to literalist—and, indeed, *biographical*—interpretation, even among commentators who profess to know better. (On this latter point, see English, "This Is Not about the Past," 143–45.) Similarly ambiguous effects appear to have been generated by Aaron Douglas's Africanist silhouette drawings of the 1920s, which were alternately extolled for their "sense of dramatic design" (Alain Locke, "The Negro and the American Stage," *Theatre Arts Monthly* 10 [February 1926]: 118) and excoriated for their "grotesque" character (Rean Graves, review of *Fire!!*, *Baltimore Afro-American*, December 25, 1926).

12 Indeed, while allowing for such "notable exceptions" as abstract art and music, Denis Dutton lists "imitation" as one of the seven "signal characteristics of art considered as a universal, cross-cultural category," thereby indicating the preeminence that representational reference enjoys from the perspective of Western aesthetic philosophy. See Dutton, "Aesthetic Universals," in *The Routledge Companion to Aesthetics*, ed. Berys Gaut and Dominic McIver Lopes (London: Routledge, 2001), 211. On the putative abstractness of music in relation to African American culture, see my chapter 2.

13 Clement Greenberg, "Avant-Garde and Kitsch" (1939), in *Art and Culture: Critical Essays* (1961; repr., Boston: Beacon, 1989), 3–21, esp. 5–7. See also

Harold Osbourne, *Abstraction and Artifice in Twentieth-Century Art* (Oxford: Oxford University Press, 1979), 9. While Meyer Schapiro, too, cites the self-referentiality of abstract art, he also notably insists that it is a function of "nonaesthetic" experiential concerns—such as sociohistorical ones—that originate beyond the artwork itself. See Schapiro, "Abstract Art," comprising "The Nature of Abstract Art" (1937), "Recent Abstract Painting" (1957), and "On the Humanity of Abstract Painting" (1960), in *Modern Art: 19th and 20th Centuries: Selected Papers* (New York: George Braziller, 1979), 185–211, 213–26, and 227–32; esp. 185–86, 195–96, 197, 215, 222, 228–29.

On the problem posed by full-on abstraction for a theory of black visual art in which real-world racial-political reference is essential, see Sharon F. Patton, *African-American Art* (Oxford: Oxford University Press, 1998), 217–32; and Richard Powell, *Black Art and Culture in the 20th Century* (London: Thames and Hudson, 1997), chaps. 4 and 5, esp. 121–38. See, too, Lowery Stokes Sims, "The African-American Artist and Abstraction," in *Norman Lewis: Black Paintings, 1946–1977*, exhibition catalog (New York: Studio Museum in Harlem, 1998), 42–50; and the more recent exhibition catalog *Energy/Experimentation*.

14 Cf. Carolyn Wilde's claim that, in "break[ing] with previous conventions and style," an abstract artwork can "provide for different possibilities of response to the social or natural phenomena of the world" (Wilde,

"Painting, Expression, Abstraction," in Harrison, *Philosophy and the Visual Arts*, 31). For the classic theoretical expositions of this more or less standard Marxist account (focused principally on literary and dramatic practices), see Ernst Bloch, Georg Lukács, Bertolt Brecht, Walter Benjamin, and Theodor Adorno, *Aesthetics and Politics* (1977; repr., London: Verso, 1980), especially Brecht, "Against Georg Lukács," 68–85, and Adorno, "Reconciliation under Duress," 151–76. For a comprehensive study of the debates in which these writers were engaged, see Eugene Lunn, *Marxism and Modernism: An Historical Study of Lukács, Brecht, Benjamin, and Adorno* (1982; repr., Berkeley: University of California Press, 1984), esp. chaps. 3 and 9. Peter Bürger offers both historicization and critique of the disputants' positions in *Theory of the Avant-Garde* (1974), trans. Michael Shaw (Minneapolis: University of Minnesota Press, 1984), particularly in his chapter 5.

For a rather different early assessment of aesthetic abstraction's import with respect to the social world and our activity within it, see Wilhelm Worringer, *Abstraction and Empathy: A Contribution to the Psychology of Style* (1908), trans. Michael Bullock (1953; repr., Chicago: Ivan R. Dee, 1997).

15 In other words, African American art is widely held to eschew the Kantian notion of aesthetic *disinterestedness*, whereby the proper aesthetic object is experienced specifically as an end in itself. See Immanuel Kant, *Critique of Judgement* (1790), trans. James Creed Meredith (Oxford: Oxford University Press, 2007), 35–42. On the historicity—and the historical *interestedness*—of the Kantian conception, see Martha Woodmansee, *The Author, Art, and the Market: Rereading the History of Aesthetics* (New York: Columbia University Press, 1994), esp. chap. 1.

16 The two strategies described here constitute what I have elsewhere called *mimetic realism* and *simulacral realism*, respectively. See my *Are We Not Men?*, chap. 7, esp. 160–63.

17 This is not to say that realist representation per se cannot induce critical interrogation but rather that Walker's detractors—who take Walker's silhouettes as themselves realist but also as racial-politically bankrupt—seem not to believe that it can.

18 On the proliferation of black-caricatural imagery from the 1880s through the 1910s, see Kenneth W. Goings, *Mammy and Uncle Mose: Black Collectibles and American Stereotyping* (Bloomington: Indiana University Press, 1994), 1. "The nadir" is the historian Rayford Logan's term; see Logan, *The Negro in American Life and Thought: The Nadir, 1877–1901* (New York: Dial, 1954).

19 Martha Banta takes up precisely this expanded purview of caricature in her *Barbaric Intercourse: Caricature and the Culture of Conduct, 1841–1936* (Chicago: University of Chicago Press, 2003).

20 On caricature's disclosure of "like in unlike," see E. H. Gombrich and Ernst Kris, *Caricature* (Harmondsworth,

UK: Penguin, 1940), esp. 10–13. See also Gombrich, *Art and Illusion: A Study in the Psychology of Pictorial Representation*, millennium ed. (Princeton, NJ: Princeton University Press, 2000), 343–48; Edward Lucie-Smith, "What Is Caricature?," in *The Art of Caricature* (Ithaca, NY: Cornell University Press, 1981), 7–19, esp. 14–19; and Thomas Wright, *History of Caricature and Grotesque in Literature and Art* (1865), introd. Frances K. Barasch (New York: Frederick Ungar, 1968).

21 Bowles, "Extreme Times" 4. For a review of additional black artists who similarly reconceived Aunt Jemima in the 1960s and '70s, see Michael D. Harris, *Colored Pictures: Race and Visual Representation* (Chapel Hill: University of North Carolina Press, 2003), chap. 3, esp. 107–24.

22 Bowles, "Extreme Times," 4. Interestingly enough, in 1997 Walker herself was also reported to collect "racist Americana." See Catherine Fox, "Genius at Work: MacArthur Grant Winner Left the South's Shadow but Reflects It in Her Art," *Atlanta Journal-Constitution*, July 6, 1997, sec. L.

23 Patricia A. Turner, *Ceramic Uncles and Celluloid Mammies: Black Images and Their Influence on Culture* (New York: Anchor, 1994), 8.

24 Goings, *Mammy and Uncle Mose*, xxiii–xxiv, ix.

25 Cf. Bill Brown's suggestion that the point of such collecting is "to decommodify the collectibles and to assert semiotic control over this concrete record of the production and distribution of black stereotypes."

Brown, "Reification, Reanimation, and the American Uncanny," *Critical Inquiry* 32, no. 2 (2006): 194.

26 On this point, see Marilynn Gelfman Karp, "Loving the Unloved: A Passion for Collecting," *Things* 10 (Summer 1999): 55–62, esp. 61–62; and, for a somewhat more ambivalent account, Susan Stewart, "The Collection, Paradise of Consumption," pp. 151–69 of chapter 5 in *On Longing: Narratives of the Miniature, the Gigantic, the Souvenir, the Collection* (1984; repr., Durham, NC: Duke University Press, 1993), esp. 152, 159.

On the proposition that personal selfhood is indeed enhanced through property ownership, see William James, *The Principles of Psychology*, vol. 1 (1890; repr., New York: Dover, 1950), 291; and, for a more legalistic consideration, Margaret Radin, "Property and Personhood," *Stanford Law Review* 34 (May 1982): 957–1015. This conception of selfhood is evidently continuous with—but not identical to—the understanding of possessive individualism derived principally from John Locke and most fully elaborated by C. B. Macpherson in *The Political Theory of Possessive Individualism: Hobbes to Locke* (1962; repr., Oxford: Oxford University Press, 1964); see esp. 139, 142.

27 Henry Louis Gates, Jr., "The Trope of a New Negro and the Reconstruction of the Image of the Black," *Representations* 24 (Fall 1988): 149. The whole formulation evidently confirms that, as Karp has posited, not only is collecting "a self-committing responsibility"; it is also both

"self-defining" and "self-affirming." See Karp, "Loving the Unloved," 62.

The panel discussion "Collecting and Exhibiting Black Memorabilia" in which Bond made his statement (and in which Gates and Goings also participated) was an element of "Change the Joke and Slip the Yoke," a symposium "on the use of black stereotypes in contemporary visual practice" held in Cambridge, Massachusetts, on March 18 and 19, 1998, and sponsored by the Harvard University Art Museums, the Carpenter Center for Visual Arts, and the W. E. B. Du Bois Institute for Afro-American Research.

28 On blacks' much-higher chances of being *objects* of chattel property than possessors of such from just before the turn of the nineteenth century until at least the beginning of the Civil War, see John Hope Franklin and Alfred A. Moss, Jr., *From Slavery to Freedom: A History of African Americans*, 7th ed. (New York: McGraw-Hill, 1994), 123–25, 148–50.

On "racial commodity slavery" as contrasted with the mechanisms of social "incorporation" and "exclusion" comprised in precolonial African slavery, see Warren R. Perry, *Landscape Transformations and the Archaeology of Impact: Social Disruption and State Formation in Southern Africa* (New York: Kluwer Academic / Plenum, 1999), 142–46.

29 For a magisterial account of the emergence of a slave-plantation economy in mainland North America, see Ira Berlin, *Many Thousands Gone: The First Two Centuries of Slavery in North America* (Cambridge, MA: Harvard University Press, 1998), chaps. 5–8, 12.

30 Michael Warner, *The Letters of the Republic: Publication and the Public Sphere in Eighteenth-Century America* (Cambridge, MA: Harvard University Press, 1990), 65. See also Edmund S. Morgan, *Inventing the People: The Rise of Popular Sovereignty in England and America* (New York: Norton, 1988), 291–92; and Jay Grossman, *Reconstituting the American Renaissance: Emerson, Whitman, and the Politics of Representation* (Durham, NC: Duke University Press, 2003), 11.

For Warner's fuller discussion of the presumptive white-maleness of the abstract citizen-subject, see "The Mass Public and the Mass Subject" (1991), chap. 4 in *Publics and Counterpublics* (New York: Zone Books, 2002), 159–86 (165–67 for the relevant passage). See, too, Lauren Berlant, "National Brands / National Body: *Imitation of Life*" (1991), chap. 3 in *The Female Complaint: The Unfinished Business of Sentimentality in American Culture* (Durham, NC: Duke University Press, 2008), 107–44, esp. 110–11.

31 Indeed, as the "Gentleman from Connecticut," Ebenezer Devotion, put it in his 1766 *Letter . . . to His Friend in London*, opposing the American colonists' taxation by Parliament, "the very terms *representative* and *represented*, suppose likeness between one and the other." Quoted in Grossman, *Reconstituting the American Renaissance*, 12; the original is in Devotion, *The Examiner Examined: A Letter from a Gentleman*

in Connecticut, to His Friend in London (New London, CT: Timothy Green, 1766), 17, available at Readex, "Early American Imprints, Series I: Evans, 1639–1800" (10280). See also Morgan, *Inventing the People*, 44, 244.

"Popular rule" is of course etymologically implied by the very phrase "democratic republicanism": *Democracy*, from Greek *dēmos* = "the commons, the people" + *-kratia*, combining form of *kratos* = "rule, sway, authority" ("democracy, *n.*" *OED Online*, December 2014, Oxford University Press, http://www.oed.com/view/Entry/49755?redirectedFrom=democracy); *republic*, from Latin *rēs* = "thing, affair, matter" + *publicus* = "public" ("republic, *n.*" *OED Online*, December 2014, Oxford University Press, http://www.oed.com/view/Entry/163158?redirectedFrom=republic).

32 Benjamin Franklin, *The Autobiography* (1868; repr., New York: Vintage / Library of America, 1990), 79, 81, 82–84. On the date of Franklin's undertaking, see page 171 of the "Chronology" presented in this edition of the *Autobiography*.

33 Ibid., 86–87.

34 This effect is itself epitomized in the grid of the Cartesian coordinate system, inasmuch as the irreducible logicality of the phenomenal world that is presupposed by Descartes's rationalist philosophy both predicates the plotting method in which the grid is deployed and, consequently, is figured in the regularity that it graphically manifests. See Descartes's 1637 *Discourse on Method*, in *A Discourse on Method; Meditations on*

the First Philosophy; Principles of Philosophy* (1912), ed. Tom Sorell (London: Everyman, 1994), 1–57, esp. part 2, 10–17. See also the 1637 essay *Geometry*, available as *The Geometry of René Descartes*, trans. David Eugene Smith and Marcia L. Latham (Chicago: Open Court, 1925).

35 For a prototypical statement on the presumedly limited intellect of peoples of African descent, see Thomas Jefferson, *Notes on the State of Virginia* (1785), ed. Frank Shuffelton (New York: Penguin, 1999), 146. The classic scholarly review of Euro-American perceptions of Africans and their descendants during the early modern period is Winthrop Jordan's *White over Black: American Attitudes toward the Negro, 1550–1812* (Chapel Hill: University of North Carolina Press, 1968).

36 In other words, white-maleness functions perfectly as an element in the institutional *discipline* that, according to Michel Foucault, perpetually "compares, differentiates, hierarchizes, homogenizes, excludes"—or, in sum, "*normalizes*"—a process whose "'value-giving' effect" is as beneficial for the normative subject as it is dubious for the nonnormative one. Foucault, *Discipline and Punish: The Birth of the Prison* (1975), trans. Alan Sheridan (1978; repr., New York: Vintage, 1995), 183; emphasis in original.

Regarding the distribution of privilege and power within the United States, in 2014 white men held 65 percent of all the nation's elected

offices at the county level and above, while in 2012 they accounted for fully 71 percent of U.S. individuals with an annual income of $250,000 or more and 37.9 percent of U.S. residents twenty-five years and older who had completed at least four years of college—though they made up only *33 percent* of the total twenty-five-and-older population. They thus attained postsecondary education at a higher rate than white women, even though the latter constituted the plurality of those with at least four years of college, owing to their greater absolute numbers. See the Women Donors Network's Reflective Democracy Campaign, "Who Leads Us?," http://wholeads.us/; *ProQuest Statistical Abstract of the United States 2015* (Lanham, MD: Bernan, 2015), 482, table 727, "Money Income of People—Number by Income Level and by Sex, Race, and Hispanic Origin: 2012"; U.S. Census Bureau, *Current Population Survey*, Educational Attainment, CPS Historical Time Series Tables, Table A-2, "Percent of People 25 Years and Over Who Have Completed High School or College, by Race, Hispanic Origin and Sex: Selected Years 1940 to 2013," http://www.census.gov/hhes/socdemo/education/data/cps/historical/; and National Center for Health Statistics, *Health, United States, 2013: With Special Feature on Prescription Drugs* (Hyattsville, MD: National Center for Health Statistics, 2014), 49–51, Trend Table 1, "Resident Population, by Age, Sex, Race, and Hispanic Origin: United States, Selected Years 1950–2012."

37 Vitruvius, *The Ten Books on Architecture* (ca. 30–20 BCE), trans. Morris Hicky Morgan (Cambridge, MA: Harvard University Press, 1914), 72. For a sense of the gender trouble posed by the supposedly neutral Latin word *homo* (as by the English *man*), consider the divergent translations of "*hominis bene figurati*" by Frank Granger (who cites the proportions "of a finely-shaped human body") and Ingrid D. Rowland (who adduces the symmetry "of a well-formed human being")—as well as the varied renderings of "*Namque si homo conlocatus fuerit supinus*," which appears later in the quoted Vitruvius passage (Morgan: "For if a man be placed flat on his back," 73; Granger: "For if a man lies on his back"; Rowland: "For if a person is imagined lying back"). See Vitruvius, *On Architecture* (dual-language edition), ed. and trans. Frank Granger, 2 vols. (Cambridge, MA: Harvard University Press, 1931), 1:158, 159, 160, 161; plus Vitruvius, *Ten Books on Architecture*, trans. Ingrid D. Rowland (Cambridge: Cambridge University Press, 1999), 47.

38 Vitruvius, *Ten Books on Architecture*, trans. Morgan, 73.

39 For a similar point about this same Vitruvian passage, see Toby Lester, *Da Vinci's Ghost: Genius, Obsession, and How Leonardo Created the World in His Own Image* (New York: Free Press, 2012), 40.

40 Vitruvius, *Ten Books on Architecture*, trans. Morgan, 173–74. Lester, too, notes the imperialist import of Vitruvius's assertion here; see *Da Vinci's Ghost*, 35.

41 On the emergence of modern racial thought at the end of the fifteenth century, see Audrey Smedley and Brian D. Smedley, *Race in North America: Origin and Evolution of a Worldview*, 4th ed. (Boulder, CO: Westview, 2012), 13.

 On the use of the idealized human figure as the template for early modern alphabetic—and not just architectural—forms, see Tom Conley, *The Self-Made Map: Cartographic Writing in Early Modern France* (Minneapolis: University of Minnesota Press, 1996), esp. chap. 2; and Jeffrey Masten, "On Q: An Introduction to Queer Philology," in *Queer Philologies: Language, Sex, and Affect in Shakespeare's Time* (Philadelphia: University of Pennsylvania Press, forthcoming).

42 Michael S. Harper, "Apollo Vision: The Nature of the Grid," in *History Is Your Own Heartbeat* (Urbana: University of Illinois Press, 1971), 90–91, lines 28–33 (closing stanza).

43 Michael S. Harper, "Michael Harper," in *Interviews with Black Writers*, ed. John O'Brien (New York: Liveright, 1973), 106. The poem under discussion here is "Zeus Muse: History as Culture," which appears on 86–87 of *History Is Your Own Heartbeat*, in the same section of the volume as "Apollo Vision."

44 See the so-called Land Ordinance of 1785, officially "An Ordinance for Ascertaining the Mode of Disposing of Lands in the Western Territory," *Journals of the Continental Congress 1774–1789*, vol. 28, *January 11–June 30, 1785*, edited from the original Library of Congress records by John C. Fitzpatrick (Washington, DC: United States Government Printing Office, 1933), 375–81. For historical accounts of the development, see Edward C. Kirkland, *A History of American Economic Life*, rev. ed. (New York: F. S. Crofts, 1939), 134–44; John W. Reps, *The Making of Urban America: A History of City Planning in the United States* (Princeton, NJ: Princeton University Press, 1965), 214–17; Leonardo Benevolo, *History of Modern Architecture* 2 vols., 3rd rev. ed., trans. H. J. Landry (London: Routledge and Kegan Paul; Cambridge, MA: MIT Press, 1971), 1:199–205; Vernon Carstensen, "Patterns on the American Land," *Publius: The Journal of Federalism* 18, no. 4 (1988): 31–39; and A. E. J. Morris, *History of Urban Form: Before the Industrial Revolutions*, 3rd ed. (New York: Prentice Hall, 1994), 335.

45 In other words, the 1785 section plan was politically and developmentally *rational* from the point of view of U.S. national interest. On this point, see Kirkland, *History of American Economic Life*, 138–39; Morris, *History of Urban Form*, 335; and David A. Johnson, "Speculations on the Bounds of Rationality in US Planning," in *Rationality in Planning: Critical Essays on the Role of Rationality in Urban and Regional Planning*, ed. Michael J. Breheny and Alan J. Hooper (London: Pion Limited, 1985), 183–95 (190–92 for the relevant discussion). Regarding the striking regularity of the property lines that resulted from the implementation of the ordinance, see Reps, *Making of Urban America*, 216; and Philip Fisher,

Still the New World: American Literature in a Culture of Creative Destruction (Cambridge, MA: Harvard University Press, 1999), 43.

46 On the extent of the rectangular survey system, see Carstensen, "Patterns on the American Land," 31; and Hildegard Binder Johnson, *Order upon the Land: The U.S. Rectangular Land Survey and the Upper Mississippi Country* (New York: Oxford University Press, 1976), the third of her unnumbered preface pages.

47 Both Reps and Fisher imply that this notional—and notionally *uniform*—emptiness promotes a relatively high level of "internal mobility" among U.S. residents (Fisher, *Still the New World*, 44; see also Reps, *Making of Urban America*, 331, caption to fig. 16-1).

While Hannah Higgins argues that the grid often serves merely to "frame"—rather than to void—such "living material" as was comprised in presurvey U.S. landholdings, the key point for my purposes is that it nevertheless *can* be used to obliterative effect and indeed typically *has* been in the contexts reviewed here. See Higgins, *The Grid Book* (Cambridge, MA: MIT Press, 2009), 6.

48 David Johnson observes that these native peoples "were considered to be outside the rationality bounds of the decision process" ("Speculations on the Bounds of Rationality in US Planning," 191), and he might have added that, as non-Europeans held to be incapable of analytical thought, they were effectively considered to be outside the bounds of rationality *per se*—a rationality that, as discussed

earlier, is conventionally emblematized by the grid itself. For the rational decision-making model that Johnson and his fellow essay contributors all engage, see Herbert A. Simon, *Models of Man—Social and Rational: Mathematical Essays on Rational Human Behavior in a Social Setting* (New York: Wiley, 1957). Johnson refers most directly to "Rational Choice and the Structure of the Environment" (Simon, *Models of Man*, 261–73) and draws in particular on the introduction to part 4 of Simon's book, "Rationality and Administrative Decision Making," 196–206, esp. 198–99. On Euro-American attitudes toward indigenous American peoples, see Robert F. Berkhofer, Jr., *The White Man's Indian: Images of the American Indian from Columbus to the Present* (1978; repr., New York: Vintage, 1979), 71–80.

49 This is by no means to suggest that Euro-American settlement commenced instantaneously with the completion of the land survey. On the fitful progress of westward migration during the twenty-five years following the passage of the Land Ordinance, see Reps, *Making of Urban America*, 216; and Joseph M. Petulla, *American Environmental History: The Exploitation and Conservation of Natural Resources* (San Francisco: Boyd and Fraser, 1977), 79.

50 On the significance of *plotting*, see "plat, *n.*²," "plat, *n.*³," and "plot, *n.*," *OED Online*, December 2014, Oxford University Press, http://www.oed.com/view/Entry/145332?rskey=nMwcTd&result=2&isAdvanced=false; http://www

.oed.com/view/Entry/145333; http://
www.oed.com/view/Entry/145915.

51 Morris, for instance, contends that San
Francisco's rectangular street pattern
runs entirely counter to the city's hilly
landscape (*History of Urban Form*,
356–57). On the implementation of the
grid in Boston and New York, see
Reps, *Making of Urban America*,
140–46, 294–99; and Morris, *History of
Urban Form*, 331–33, 341–45.

52 Rosalind Krauss, "The Originality of
the Avant-Garde" (1981), in *The
Originality of the Avant-Garde and
Other Modernist Myths* (Cambridge,
MA: MIT Press, 1985), 158. See also
Krauss, "Grids" (1978), in ibid., 9–22.

53 Yves-Alain Bois, "The Iconoclast," in
Piet Mondrian, 1872–1944, exhibition
catalog (Boston: Little, Brown, 1995),
332. My characterization of Mondrian's
career trajectory derives from the title
of the exhibition *Mondrian: From
Figuration to Abstraction*, which
toured Japan in 1987; see the catalog of
the same name (London: Thames and
Hudson, 1988).

54 According to the *OED*, to *cancel* is "to
deface or obliterate (writing), properly
by drawing lines across it lattice-wise;
to cross out, strike out." The word
derives from the Latin *cancellāre*, "to
make lattice-wise, to cross out a
writing," from *cancellus, cancelli*,
"cross-bars, lattice." See definition 1.a.
in "cancel, *v.*," *OED Online*, December
2014, Oxford University Press, http://
www.oed.com/view/Entry/26916?rskey
=G6kSjD&result=2&isAdvanced
=false.

55 Mark Stevens, "Skin Games," *New
York*, February 2, 2004, 50.

56 For a sense of Beecroft's compositional
practice, see the photographic
documentation of her performances
since 1993, available on her website:
http://www.vanessabeecroft.com/. See
also Beecroft and David Hickey, *VB
08-36: Vanessa Beecroft Performances*
(Ostfildern, Germany: Hatje Cantz,
2000); Beecroft, *Vanessa Beecroft
Performances, 1993–2003*, ed. Marcella
Beccaria (Milan: Skira, 2003); and
*Vanessa Beecroft: Photographs, Films,
Drawings*, exhibition catalog, ed.
Thomas Kellein (Ostfildern, Germany:
Hatje Cantz, 2004). Interestingly, and
as is revealed by a comparison of the
biographies provided on the websites
for Beecroft and Walker (see note 1 to
this chapter), Beecroft and Walker are
almost exact contemporaries in terms
of both simple chronology and
professional activity.

57 Stevens is no doubt influenced by the
context in which he viewed the
photograph—namely, the 2004
omnibus exhibition *Only Skin Deep:
Changing Visions of the American Self*
(mounted at New York's International
Center of Photography), which
"show[ed] how fluctuating concep-
tions of race, nation, and self have
been fixed or transformed through the
unique attributes and strategic uses of
photography." Willis Hartshorn,
"Director's Foreword," in *Only Skin
Deep: Changing Visions of the
American Self*, exhibition catalog, ed.
Coco Fusco and Brian Wallis (New
York: International Center of
Photography; Abrams, 2003), 6.

58 Interestingly, because McGrath is
black, her work on this project

rendered strikingly concrete the process whereby racial nonwhiteness serves to shore up and consolidate whiteness itself. For the quotation on the performance's color palette, see Roberta Smith, "Critic's Notebook: Standing and Staring, yet Aiming for Empowerment," *New York Times*, May 6, 1998, Late edition (East Coast), sec. E. —*Show* was organized by the curatorial consulting agency Yvonne Force, Inc. (whose literature designated —*Show* as the proper title of the performance), and materials relating to it were archived online through December 17, 2006, at http://www .yvonneforceinc.com/yfinew/ framecon.htm.

59 See Margaret C. Harrell et al., *Barriers to Minority Participation in Special Operations Forces* (Santa Monica, CA: RAND, 1999), chap. 2, esp. 24; for the nonwhite composition of the SEALs specifically, see 8.

60 R. Smith, "Critic's Notebook."

61 Guy Trebay, "Racism on the Runway: Not an Ethnic Moment," *Village Voice*, May 9, 1995, 24. Of course, the lament about the tiny number of blacks working in the fashion industry— whether as models or in less public capacities—was by no means new at the time of Trebay's writing, and it has been recurrent ever since. See, for instance, Deborah Gregory and Patricia Jacobs, "The Ugly Side of the Modeling Business," *Essence*, September 1993, 89–90+; Veronica Webb, "Where Have All the Black Models Gone?," *Essence*, September 1996, 108+; Trebay, "Ignoring Diversity, Runways Fade to White,"

New York Times, October 14, 2007; Vicki Woods, "Is Fashion Racist?," *Vogue*, July 2008, 134–41+; Constance White, "Black Out: What Has Happened to the Black Models?," *Ebony*, September 2008, 98–100; Robin Givhan, "Why Fashion Keeps Tripping over Race," *New York*, February 21–28, 2011, 66–70; and Eric Wilson, "Fashion's Blind Spot," *New York Times*, August 8, 2013, Late edition, sec. E.

62 Former fashion publicist Susan Portnoy, quoted in Givhan, "Why Fashion Keeps Tripping over Race," 68.

63 Quoted in Webb, "Where Have All the Black Models Gone?," 110.

64 The manner of this falling short is of course suggested by the word *blank* itself, which derives from French *blanc*, meaning "white." See "blank, *adj.* and *adv.*," *OED Online*, December 2014, Oxford University Press, http:// www.oed.com/view/Entry/19885?rskey =eC3fNU&result=2&isAdvanced=false.

65 This point has been made fairly extensively since the early 1990s within the burgeoning field of whiteness studies. With respect to the terms of my own consideration, it is especially usefully registered by Peggy Phelan in *Unmarked: The Politics of Performance* (London: Routledge, 1993); see in particular 94–95 of chap. 4, "The Golden Apple: Jennie Livingston's *Paris Is Burning*." See, too, Richard Dyer, *White* (London: Routledge, 1997), 1–2, 38–40, 44–45, and 212, where, borrowing a formulation from Annette Kuhn, Dyer suggests that whiteness is "invisible, but all-pervasive."

66 On the conception of personal identity adduced here, see John Locke, *An Essay Concerning Human Understanding*, 2nd ed. (1694; repr., New York: Dover, 1959), book 2, "Of Ideas," chap. 27, "Of Identity and Diversity," § 7 and § 11 (pp. 444, 449).

67 Anna Wintour, "Letter from the Editor: Fashion's New Faces," *Vogue*, July 1997, 26. See also Gary Younge, "Fashion Industry Scandal: The Trends that Make Beauty Skin Deep," *Guardian* (UK), November 24, 1999, 3. It is unclear whether this is still reputed to be the case, now that media celebrities have largely displaced professional models from the covers of most fashion magazines—a development that has accelerated since the late 1990s. See Alex Kuczynski, "Trading on Hollywood Magic: Celebrities Push Models Off Women's Magazine Covers," *New York Times*, January 30, 1999; and Christine Haughney, "On Newsstands, Allure of the Film Actress Fades," *New York Times* June 5, 2013. On the roots of this mythology, see Janice Cheddie, "The Politics of the First: The Emergence of the Black Model in the Civil Rights Era," *Fashion Theory* 6, no. 1 (2002): 61–81, esp. 61–62.

68 Quoted in Younge, "Fashion Industry Scandal."

69 Of course, they might by virtue of that very styling also register as problematically "objectified" in the manner widely theorized within second-wave feminism, often with reference to normative nineteenth-century bourgeois womanhood. See, for instance, Betty Friedan, *The Feminine Mystique* (1963; repr., New York: Norton, 2001), 81. That they have instead generally been understood as registering a *critique* of such objectification perhaps suggests the extent to which postmodernist art practice has assimilated feminist concerns as contrasted with antiracist ones. For the assessment that effectively established the understanding of Beecroft's work as critique, see Dave Hickey, "Vanessa Beecroft's Painted Ladies," in Beecroft and Hickey, *VB 08-36: Vanessa Beecroft Performances*, 4–8.

70 Leslie Camhi, "Skin Deep," *Village Voice*, May 12, 1998, 141.

71 *Vanessa Beecroft: Photographs, Films, Drawings*, 135.

72 The first three quotations are from ibid.; the last is from *Her Bodies: Cindy Sherman & Vanessa Beecroft*, exhibition catalog (Cheonan-si, Chungnam, Korea: Arario, 2004), VB22; published in conjunction with the exhibition of the same name, shown at the Arario Gallery, Korea, September 1–November 21, 2004.

73 *Vanessa Beecroft: Photographs, Films, Drawings*, 142.

74 Ibid., 142, 143.

75 Ibid., 143. The mandate for "fair"-complexioned women was put forth in ads posted by Beecroft's operation for the purpose of soliciting participants for the performance. See Julia Steinmetz, Heather Cassils, and Clover Leary, "Behind Enemy Lines: Toxic Titties Infiltrate Vanessa Beecroft," in "New Feminist Theories of Visual Culture," ed. Jennifer Doyle and Amelia Jones, special issue, *Signs: Journal of*

Women in Culture and Society 31, no. 3 (2006): 753–83, esp. 754.

76 Helena Kontova and Massimiliano Gioni, "Vanessa Beecroft: Skin Trade," *Flash Art* (international edition), January–February 2003, 97.

77 The phrase "the black performance" is Beecroft's own, and if as of February 2004 she could speak in the singular, she soon went on to mount several more thoroughgoingly "black" installations, including *VB54* (2004), *VB58* (2005), *VB61* (2007), and *VB65* (2009). On these, plus the 2006 "special project" *VBSouthSudan*, see James Westcott, "*VB54*: Black Tie vs. Black Face," *TDR* 49, no. 1 (2005): 114–18; Elisabetta Povoledo, "Beecroft's Living, Breathing Indictments," *New York Times*, March 26, 2009; and the film *The Art Star and the Sudanese Twins*, dir. Pietra Brettkelly (KinoSmith, 2008). On the film itself, see Logan Hill, "'Art Star' Vanessa Beecroft: Slammed at Sundance," *Vulture* (blog), *New York*, January 18, 2008, http://www.vulture.com/2008/01/vanessa_beecroft_slammed_at_su.html.

78 Ken Johnson, "Art in Review: Vanessa Beecroft—'VB45/VB48,'" *New York Times*, April 12, 2002.

79 Officially titled the *International Exhibition of Modern Art*, the show was held at New York City's 69th Infantry Regiment Armory.

80 Hence the Armory Show essentially furthered the effects of the 1910 London exhibition *Manet and the Post-Impressionists*, which famously induced Virginia Woolf to propose that, "on or about December, 1910,

human character changed." Woolf, "Mr. Bennett and Mrs. Brown" (1924), in *The Captain's Death Bed and Other Essays* (1950; repr., San Diego: Harcourt Brace Jovanovich, 1978), 96. Regarding the earlier show, see the exhibition catalog from London's Grafton Galleries, *Manet and the Post-Impressionists, Nov. 8th to Jan. 15th, 1910–1911* (London: Ballantyne, 1910); and J. B. Bullen, ed., *Post-Impressionists in London* (London: Routledge, 1988). On the Armory Show, see the Association of American Painters and Sculptors, *The Armory Show: Exhibition of Modern Art, 1913* (New York: Arno, 1972); and Milton Wolf Brown, *The Story of the Armory Show*, 2nd ed. (New York: Abbeville, 1988).

81 To contend that we now readily discern a "nude descending a staircase" in Duchamp's emphatically nonrealist painting is to suggest, following Peter Hobbis, that the work has achieved "referentiality" without "illusiveness"—an effect that Hobbis argues was first strived for by the analytical cubism of the early 1910s. See Hobbis, "Representing and Abstracting," esp. part 2, 98–102, and part 5, 112–18.

82 Quoted in Bowles, "Extreme Times," 5.

83 Visuality's preeminence within contemporary culture is at this point so widely recognized as to be axiomatic, and it is accordingly invoked in passing by scholars in a number of different fields, from cognitive psychology (Donald D. Hoffman, *Visual Intelligence: How We Create What We See* [New York:

Norton, 1998], xii) to art history (Nicholas Mirzoeff, *An Introduction to Visual Culture* [London: Routledge, 1999], 1) to media studies (Lisa Cartwright and Marita Sturken, *Practices of Looking: An Introduction to Visual Culture* [Oxford: Oxford University Press, 2001], 1) to sociology (Chris Jenks, "The Centrality of the Eye in Western Culture: An Introduction," in *Visual Culture*, ed. Jenks [London: Routledge, 1995], 2). For one exceptionally nuanced historical account of visuality's rise to autonomous significance, see Martin Jay, *Downcast Eyes: The Denigration of Vision in Twentieth-Century French Thought* (Berkeley: University of California Press, 1993), introduction and chap. 1.

84 Donald Hoffman, for instance, suggests that all human beings "share the same innate rules that guide their visual constructions" along such logico-realist lines—what Hoffman calls "the rules of universal vision" (*Visual Intelligence*, 14).

85 See Paul Messaris, *Visual "Literacy": Image, Mind, and Reality* (Boulder, CO: Westview, 1994), esp. 166.

86 Rittelmann, "Winold Reiss to Kara Walker," 289. The piece to which Rittelmann refers is actually part of a series by Simpson that also includes *Untitled (guess who's coming to dinner)* and *Untitled (on a cuban bus)*, both from 2001.

87 Robert Storr, "A Funny Thing Happened . . . ," in *Ellen Gallagher*, exhibition catalog for *Watery Ecstatic* (Boston: Institute of Contemporary Art, 2001), 32. See also Mark van de Walle, "Openings: Ellen Gallagher," *Artforum International*, February 1996, 76–77; David Bourdon, review of Ellen Gallagher at Mary Boone (New York), *Art in America*, April 1996, 111; Alexi Worth, review of Gallagher at Mary Boone, *ARTnews*, April 1996, 132; Martin Coomer, review of Gallagher at Anthony d'Offay (London), *Flash Art International*, January–February 1997, 100; Ron Hunt, "Ellen Gallagher," *Modern Painters* 11, no. 4 (1998): 98; Frances Richard, review of Gallagher at Gagosian Gallery (New York), *Artforum International*, Summer 2001, 182–83; and Holland Cotter, "Abstract on the Surface, With Layers of Meaning," *New York Times*, December 14, 2001, Late edition (East Coast), sec. E.

88 Of course, even in the absence of such an overarching system, relative size and placement will often suggest which elements should be granted interpretive priority in a given pictorial work. See Rudolf Arnheim, *The Power of the Center: A Study of Composition in the Visual Arts*, new version (Berkeley: University of California Press, 1988).

CHAPTER 2. HISTORICAL CADENCE AND THE NITTY-GRITTY EFFECT

1 June Jordan, "Nobody Mean More to Me than You and the Future Life of Willie Jordan," in *On Call: Political Essays* (Boston: South End, 1985), 129.

2 M. Harper, "Apollo Vision," 90, lines 15–21.

3 Ntozake Shange, "no more love poems #3," in *for colored girls who have*

considered suicide/when the rainbow is enuf (New York: Macmillan, 1977), 44–45, lines 1–4, 6–9. This volume substantially extends and revises a precursor version of the work, published under the name "Ntosake Shange" (San Lorenzo, CA: Shameless Hussy, 1975).

4 Walter Pater, "The School of Giorgione" (1877), in *The Renaissance: Studies in Art and Poetry—The 1893 Text*, ed. Donald L. Hill (Berkeley: University of California Press, 1980), 106.

5 Cf. Eduard Hanslick, *On The Musically Beautiful*, 8th ed. (1891), trans. Geoffrey Payzant (Indianapolis: Hackett, 1986), 28; and William Henry Hadow, "Music and Musical Criticism: A Discourse on Method," in *Studies in Modern Music—First Series: Hector Berlioz, Robert Schumann, Richard Wagner*, 12th ed. (New York: Macmillan, 1892), 3–68, esp. 6 and 9.

6 The self-sufficiency of music is emphatically touted, for example, in the current entry on "musical criticism" in the *Encyclopædia Britannica*, which flatly declares, "Music is autonomous. It refers to nothing outside itself"—but which also muddies the situation somewhat by wrongly attributing to Arthur Schopenhauer Pater's assertion that "all art . . . aspires towards the condition of music." Alan Walker, "Musical Criticism," *Encyclopædia Britannica Online*, http://www.britannica.com/EBchecked/topic/399158/musical-criticism. Indeed, what Schopenhauer actually *did* say complicates the proposition that music "refers to nothing outside itself," in that while he maintained that music, unlike the other arts, presents no "copy" of any "Idea," he nevertheless contended that it constitutes "the *copy of the will itself*," of which "Ideas" are only a second-order manifestation. For the full account, see Schopenhauer, *The World as Will and Idea*, 4th ed., 3 vols., trans. R. B. Haldane and J. Kemp (London: Kegan Paul, Trench, Trübner, 1896), esp. vol. 1, book 2, "The World as Will—First Aspect," and vol. 1, book 3, "The World as Idea—Second Aspect"; the quoted passages are from §52 in vol. 1, book 3, 330, 332–333; emphasis in original.

7 Both Marsalis's and Glaser's comments are presented in *Jazz: A Film by Ken Burns* (dir. Ken Burns; prod. Ken Burns and Lynn Novick / Florentine Films, broadcast January 8–31, 2001, on PBS)—specifically, episode 2, "The Gift," broadcast on PBS January 9, 2001.

 On the size of the viewership for *Jazz*, see Gary Edgerton, "Ken Burns," *Encyclopedia of Television*, 2nd ed., vol. 1, ed. Horace Newcomb (New York: Fitzroy Dearborn, 2004), 370–72. Notwithstanding the significant number of criticisms that have been lodged against the series (summarized in Steven F. Pond, "Jamming the Reception: Ken Burns, *Jazz*, and the Problem of 'America's Music,'" *Notes* 60, no. 1 [2003]: 11–45), its clear influence within the precincts of middlebrow reception makes it a legitimate reference for conventional understandings of jazz aesthetics, "middlebrow reception" here denoting nonexpert audiences' aspirational engagement with relatively arcane "high-artistic" practices. For the theoretical underpinnings of this

conception, see Pierre Bourdieu, "The Market of Symbolic Goods" (1971), trans. Rupert Swyer, in *The Field of Cultural Production: Essays on Art and Literature*, ed. Randal Johnson (New York: Columbia University Press, 1993), 112–41. For a claim about such middlebrow reception in the field of literature, see Janice Radway, *A Feeling for Books: The Book-of-the-Month Club, Literary Taste, and Middle-Class Desire* (Chapel Hill: University of North Carolina Press, 1997), 9–10. For a review of the career of the term *middlebrow* during the first half of the twentieth century, see Joan Shelley Rubin, *The Making of Middlebrow Culture* (Chapel Hill: University of North Carolina Press, 1992), introduction.

8 From "Swing: The Velocity of Celebration," episode 6 of *Jazz: A Film by Ken Burns*, broadcast on PBS January 22, 2001.

9 Regarding the variety of musical traditions that informed early New Orleans jazz, see James Lincoln Collier, *The Making of Jazz: A Comprehensive History* (1978; repr., New York: Dell, 1979), 57–71; Ted Gioia, *The History of Jazz* (1997; repr., New York: Oxford University Press, 1998), chaps. 1 and 2; and Eileen Southern, *The Music of Black Americans: A History*, 3rd ed. (New York: Norton, 1997), chap. 9 and 367–69. On collective improvisation in Oliver's bands, see Martin Williams, *King Oliver* (1960), in *Kings of Jazz*, ed. Stanley Green (South Brunswick, NJ: A. S. Barnes, 1978), 241–72 (257 for the relevant passage). See also Walter C.

Allen and Brian A. L. Rust's *"King" Oliver* (1955), revised by Laurie Wright (Chigwell, UK: Storyville, 1987), 265.

10 On the way some black New Orleans musicians negotiated this situation around the turn of the century, see Samuel Charters, *A Trumpet Around the Corner: The Story of New Orleans Jazz* (Jackson: University Press of Mississippi, 2008), 52, 60–62. On the relative paucity of available instruments, see Collier, *Making of Jazz*, 63–64.

11 Gunther Schuller, *Early Jazz: Its Roots and Musical Development* (New York: Oxford University Press, 1968), 80.

12 Such mechanisms constitute literature's *diegetic* (or *narrative*)—as differentiated from its *mimetic* (or *imitative*)—function. The distinction (which derives from Plato) is arguably troubled, however, insofar as diegesis, by registering temporal elapse, effectively mimics historical development itself. On this point, see Erich Auerbach, *Mimesis: The Representation of Reality in Western Literature* (1946), trans. Willard R. Trask (1953; repr., Princeton, NJ: Princeton University Press, 1968), 191. For Plato's discussion, see the *Republic*, in *Plato V*, rev. ed., trans. Paul Shorey (Cambridge, MA: Harvard University Press, 1937), 3.6–9 (225–45).

Following Gérard Genette, most contemporary commentary understands literary mimesis to be epitomized in the presentation of direct discourse—the seemingly unmediated registration (often paradoxically achieved through the use of quotation marks) of a

personage's utterances, which thereby appear simply to issue "from life." See Genette, *Narrative Discourse: An Essay in Method*, trans. Jane E. Lewin (Ithaca, NY: Cornell University Press, 1980), 169–73.

13 In fact, music per se has been understood as *essentially* mimetic in a tradition extending as far back as classical antiquity. See Plato, *Timaeus* 47d, in *Plato IX: Timaeus/Critias/ Cleitophon/Menexenus/Epistles*, trans. R. G. Bury (1929; repr., Cambridge, MA: Harvard University Press, 1999), esp. 109; Aristotle, *Politics*, in *Aristotle XXI*, trans. H. Rackham (1932; repr., Cambridge, MA: Harvard University Press, 1944), 8.5.8 (esp. 659); and Plotinus, *The Enneads*, 3rd ed., trans. Stephen MacKenna, rev. B. S. Page (London: Faber and Faber, 1962), 5.9.11 (esp. 441). Like Schopenhauer long after them, though, all these thinkers ascribe to music a mimetic object that lies beyond the phenomenal world, whereas I am interested in music's capacity to approximate *specifically* phenomenal entities (i.e., aural manifestations) by virtue precisely of its own phenomenal status—that is, its existence as sound.

For a concise summary of classical theories of musical mimesis, see Lewis Rowell, *Thinking about Music: An Introduction to the Philosophy of Music* (1983; repr., Amherst: University of Massachusetts Press, 1984), chap. 4 (esp. 48–51) and 83–88. On the intricacies of classical mimeticism more generally—including the point that, unlike the modern version, it implicated not only *representation* but

also *expression*—see Stephen Halliwell, *The Aesthetics of Mimesis: Ancient Texts and Modern Problems* (Princeton, NJ: Princeton University Press, 2002), esp. 158–64 and chap. 8.

14 Hadow acknowledges as much when he laments that "attempts to make Music reproduce actual sounds . . . are always failures" ("Music and Musical Criticism," 9), though my own concern lies less with the aesthetic success of such attempts than with the fact that they are singularly feasible within music.

15 For an example in this regard, consider Oliver's progressive modification of the melodic line throughout the three final iterations of the chorus on a December 24, 1923, recording of "Mabel's Dream" (Paramount 20292-B [1622-1]), which is discussed both by Martin Williams (*King Oliver*, 258–59) and by Gunther Schuller (*Early Jazz*, 80–82).

16 The effect is comparable to that of graphic distortion in visual caricature, but it is more aesthetically self-assertive, in that the improvisatory riff evokes an antecedent that is itself wholly sonic in character, further fastening our attention on the phenomenal modality of music per se.

17 For (sometimes conflicting) accounts of Armstrong's tenure with Oliver's band, see Louis Armstrong, *Satchmo: My Life in New Orleans* (1954), centennial ed. (New York: Da Capo, 1986), 226–28; Schuller, *Early Jazz*, 72–77; and Laurence Bergreen, *Louis Armstrong: An Extravagant Life* (New York: Broadway, 1997), 172–232. See also Frederic Ramsey, Jr., "King Oliver

and His Creole Jazz Band," in *Jazzmen*, ed. Ramsey and Charles Edward Smith (New York: Harcourt, Brace, 1939), 59–91, esp. 69–75; William Russell, "Louis Armstrong," in Ramsey and Smith, *Jazzmen*, 119–42, esp. 124–27; Barry Ulanov, *A History of Jazz in America* (1952; repr., New York: Viking, 1955), 72–73; Marshall W. Stearns, *The Story of Jazz* (New York: Oxford University Press, 1956), 170; Max Jones and John Chilton, *Louis: The Louis Armstrong Story, 1900–1971* (Boston: Little, Brown, 1971), 59–78; James Lincoln Collier, *Louis Armstrong: An American Genius* (New York: Oxford University Press, 1983), 93–114; Allen and Rust, *"King" Oliver*, 14–41; Southern, *Music of Black Americans*, 379–81; Gary Giddins, *Satchmo* (1992; repr., New York: Da Capo, 1998), 72–81; Gioia, *History of Jazz*, 48–56; Terry Teachout, *Pops: A Life of Louis Armstrong* (Boston: Houghton Mifflin Harcourt, 2009), 59–60.

18 On Oliver's and, especially, Armstrong's legendary influence among such white musicians as Paul Whiteman, Bix Beiderbecke, and Hoagy Carmichael in early-1920s Chicago, see George Wettling, "Lincoln Gardens," *HRS Society Rag*, December 1940, 24–26; Hoagy Carmichael, *The Stardust Road* (1946), in *The Stardust Road & Sometimes I Wonder: The Autobiographies of Hoagy Carmichael* (New York: Da Capo, 1999), 53; Lil Hardin Armstrong, "Satchmo and Me" (1956), in *American Music* 25, no. 1 (2007), 106–18, esp. 111–12; Stearns, *Story of Jazz*, 175–76;

Jones and Chilton, *Louis*, 60–61; Collier, *Louis Armstrong*, 94; Bill Crow, *Jazz Anecdotes* (1990), new ed. (New York: Oxford University Press, 2005), 233–34; and Bergreen, *Louis Armstrong*, 209–12. See also Ramsey, "King Oliver and His Creole Jazz Band," 72; Edward J. Nichols, "Bix Beiderbecke," in Ramsey and Smith, *Jazzmen*, 143–60, esp. 147–48; Charles Edward Smith, "The Austin High School Gang," in Ramsey and Smith, *Jazzmen*, 161–82, esp. 164; Gioia, *History of Jazz*, 78–79; Teachout, *Pops*, 125.

19 On this widely accepted point, see Schuller, *Early Jazz*, 86–91; Collier, *Making of Jazz*, 160; Southern, *Music of Black Americans*, 381; Gioia, *History of Jazz*, 51, 55–63; Teachout, *Pops*, 85–86.

20 Quoted in Allen and Rust, *"King" Oliver*, 267.

21 See, for instance, David G. Such on the bassist Charles Mingus's improvised "dialogues" with the drummer Max Roach and with the bass clarinetist Eric Dolphy. Such, *Avant-Garde Jazz Musicians: Performing "Out There"* (Iowa City: University of Iowa Press, 1993), 51.

22 This is wholly apt inasmuch as approximation of the human voice is widely held to be a primary objective of instrumental jazz itself. See Southern, *Music of Black Americans*, 367; Collier, *Making of Jazz*, 155; Gioia, *History of Jazz*, 49–51. On the mutes cited both here and later in the text, see Clifford Bevan and Alyn Shipton, "Mute," in *The New Grove Dictionary of Jazz*, 2nd ed., 3 vols., ed. Barry Dean

Kernfeld (New York: Grove, 2002), 2:858–62.

23 See Allen and Rust, *"King" Oliver*, 267; Bevan and Shipton, "Mute," 2:861.

24 Keith Nichols, "Muted Brass," *Storyville* 30 (August–September 1970): 203–6, esp. 204–5.

25 King Oliver's Creole Jazz Band, "Dipper Mouth Blues" (Gennett 5132-A), recorded April 6, 1923.

26 See note 19 to this chapter.

27 See Collier, *Louis Armstrong*, 102, 105.

28 King Oliver's Creole Jazz Band, "Chimes Blues" (Gennett 5135-B), recorded April 5, 1923; Louis Armstrong and His Hot Five, "Struttin' with Some Barbecue" (OKeh 8566), recorded December 9, 1927. On the formation of the Hot Five, see Gioia, *History of Jazz*, 60–61; Teachout, *Pops*, 92.

29 Louis Armstrong and His Hot Five, "West End Blues" (OKeh 8597), recorded June 28, 1928; Louis Armstrong, "Weather Bird" (OKeh 41454), recorded December 5, 1928.

30 Regarding Armstrong's accomplishment on these recordings, see Teachout, *Pops*, 116–17; Collier, *Louis Armstrong*, 197; and Schuller, *Early Jazz*, 124.

31 Louis Armstrong and His Harlem Hot Band, "Dinah," live performance October 21, 1933, Copenhagen, Denmark, incorporated in the feature film *København, Kalundborg og–?* (1934) and released on the compact disc *Louis Armstrong in Scandinavia, Vol. 1* (Storyville 1018348, 2005); Glaser's remarks about this performance appear in the transcript of a January 30, 1998, interview with Ken Burns, posted online at http://www.pbs.org/jazz/about/pdfs/Glaser.pdf. Louis Armstrong and His Orchestra, "Lazy River" (OKeh 41541), recorded November 3, 1931.

32 Glaser's commentary is featured in "The True Welcome," episode 4 of *Jazz: A Film by Ken Burns*, broadcast on PBS January 15, 2001.

33 This chapter's analyses of musical recordings have been facilitated—though not necessarily *perfected*—by the Transcribe! music-transcription computer software program.

34 Louis Armstrong and His Orchestra, "Chinatown, My Chinatown" (OKeh 41534), recorded November 3, 1931.

35 Commentary presented in "True Welcome," and quoted here from Glaser's interview with Ken Burns, cited in note 31 to this chapter.

36 Cf. Schopenhauer on music's representational primacy vis-à-vis the will itself (see note 6 to this chapter).

37 Ralph Ellison, *Invisible Man* (New York: Random House, 1952), 7.

38 Ibid., 10.

39 Ibid., 12.

40 "True Welcome."

41 Andy Razaf, Thomas (Fats) Waller, and Harry Brooks, "(What Did I Do to Be So) Black and Blue" (New York: Mills Music, 1929).

42 Louis Armstrong and His Orchestra, "(What Did I Do to Be So) Black and Blue" (OKeh 8714), recorded July 22, 1929.

43 For a complementary discussion of this same point, see Alexander Weheliye, *Phonographies: Grooves in Sonic Afro-Modernity* (Durham, NC: Duke University Press, 2005), chap. 2.

44 The capaciousness and incorporative-
ness of narrative is of course
epitomized in the novel. See Mikhail
Bakhtin, "Discourse in the Novel"
(written ca. 1934–35, published 1975),
in *The Dialogic Imagination: Four
Essays*, ed. Michael Holquist, trans.
Caryl Emerson and Holquist (Austin:
University of Texas Press, 1981),
259–422.

45 See Lewis Ehrenberg, *Steppin' Out:
New York Nightlife and the
Transformation of American Culture,
1890–1930* (1981; repr., Chicago:
University of Chicago Press, 1984),
chap. 8; and Lisa Gitelman, *Always
Already New: Media, History, and the
Data of Culture* (Cambridge, MA: MIT
Press, 2006), part 1.

46 See Collier, *Making of Jazz*, 228–29;
Lewis Porter, *Lester Young* (1985), rev.
ed. (Ann Arbor: University of
Michigan Press, 2005), 10–11, 33–35;
Luc Delannoy, *Pres: The Story of Lester
Young* (1987), trans. Elena B. Odio
(Fayetteville: University of Arkansas
Press, 1993), 47–48; John Chilton, *The
Song of the Hawk: The Life and
Recordings of Coleman Hawkins* (Ann
Arbor: University of Michigan Press,
1990), 114–15; Frank Büchmann-
Møller, *You Just Fight for Your Life: The
Story of Lester Young* (New York:
Praeger, 1990), 46; Dave Gelly, *Lester
Young* (Tunbridge Wells, UK:
Spellmount, 1984), 14; and Gelly, *Being
Prez: The Life and Music of Lester
Young* (Oxford: Oxford University
Press, 2007), 42–44.

47 On Holiday's singing style, see Collier,
Making of Jazz, 310–12; Burnett James,
Billie Holiday (Tunbridge Wells, UK:

Spellmount, 1984), 67–68; Gunther
Schuller, *The Swing Era: The
Development of Jazz, 1930–1945* (New
York: Oxford University Press, 1989),
530; Robert O'Meally, "Listening to
Billie," part 1 of *Lady Day: The Many
Faces of Billie Holiday* (New York:
Arcade, 1991), 23–53; Stuart Nicholson,
Billie Holiday (London: Victor
Gollancz, 1995); Donald Clarke, *Billie
Holiday: Wishing on the Moon* (1994;
repr., New York: Da Capo, 2002),
91–92.

48 Billie Holiday and Her Orchestra,
"The Man I Love" (Vocalion/OKeh
5377), recorded December 13, 1939.

49 On *swing*, see Barry Kernfeld, *What to
Listen For in Jazz* (New Haven, CT:
Yale University Press, 1995), chap. 2,
esp. 12–17.

50 In other words, Holiday and Young's
swing in this instance constitutes
transitive rather than *intransitive*
expression. See Roger Scruton, *The
Aesthetic Understanding: Essays in the
Philosophy of Art and Culture*
(London: Methuen, 1983), chap. 6; and,
informing Scruton, Ludwig
Wittgenstein, "Brown Book" (1934–35),
in *The Blue and Brown Books:
Preliminary Studies for the
"Philosophical Investigations"* (1958),
2nd ed. (New York: Harper and Row,
1960), 177–79.

51 Such an accounting is what I have in
mind when I say that diegetic
elaboration—i.e., *narrative*—figures
historical development itself (see note
12 to this chapter). For a different view,
see H. Porter Abbott, *The Cambridge
Introduction to Narrative* (Cambridge:
Cambridge University Press, 2002), 12.

See, too, Roland Barthes, "Introduction to the Structural Analysis of Narratives" (1966), in *Image–Music–Text*, trans. Stephen Heath (New York: Hill and Wang, 1977), 79–124, esp. 88–104; Shlomith Rimmon-Kenan, *Narrative Fiction: Contemporary Poetics* (London: Methuen, 1983), 2–3; Mieke Bal, *Narratology: Introduction to the Theory of Narrative* (1980), trans. Christine van Boheemen (Toronto: University of Toronto Press, 1985), 5; David Bordwell, *Narration in the Fiction Film* (Madison: University of Wisconsin Press, 1985), 49–53; Brian Richardson, *Unlikely Stories: Causality and the Nature of Modern Narrative* (Newark: University of Delaware Press, 1997), 15.

52 On this point, see Scruton, *Aesthetic Understanding*, 57. The contingency at issue here characterizes symbolic signification per se. See Charles Sanders Peirce, "Logic as Semiotic: The Theory of Signs" (1897–1910), in *Philosophical Writings of Peirce*, ed. Justus Buchler (1940; repr., New York: Dover, 1955), 98–119, esp. 102–3.

53 James Lincoln Collier and Barry Kernfeld, "Billie Holiday," in Kernfeld, *New Grove Dictionary of Jazz*, 2:264.

54 Cf. Peirce on the *index*, "Logic as Semiotic," 102.

55 LeRoi Jones (Amiri Baraka), *Blues People: Negro Music in White America* (1963), Quill ed. (1999; repr., New York: Perennial, 2002), ix; Baraka is glossing Sterling Brown. For a materialist theory of musical significance that differs slightly from my own, see John Shepherd, *Music as Social Text* (Cambridge, UK: Polity, 1991), chap. 5, esp. 90–92.

56 For a comprehensive elaboration of this point, see Ronald Radano, *Lying up a Nation: Race and Black Music* (Chicago: University of Chicago Press, 2003).

57 On U.S. slaves' highly charged relation to literacy, see Frederick Douglass, *Narrative of the Life of Frederick Douglass, An American Slave, Written by Himself* (Boston: Anti-Slavery Office, 1845); and Linda Brent (Harriet Jacobs), *Incidents in the Life of a Slave Girl, Written by Herself* (Boston, 1861).

58 Southern, *Music of Black Americans*, 48, 50. Southern's work provides the basis for the succeeding account.

59 Ibid., 49.

60 Ibid., 64–67, 171–72.

61 This is wholly in keeping with musicians' historically widespread function as servants. See Gioia, *History of Jazz*, 7.

62 See Southern, *Music of Black Americans*, chap. 4, esp. 97–136.

63 Ibid., 48–52.

64 Ibid., 172. See also Stearns, *Story of Jazz*, 21; Collier, *Making of Jazz*, 17; Gioia, *History of Jazz*, 7.

65 Southern, *Music of Black Americans*, 9–15. See also Stearns, *Story of Jazz*, 3–4, 8–10; Schuller, *Early Jazz*, 11–12, 27–28; Collier, *Making of Jazz*, 9–11, 13; Gioia, *History of Jazz*, 9–11.

66 Southern, *Music of Black Americans*, 21–22. See also Stearns, *Story of Jazz*, 16–17; Collier, *Making of Jazz*, 16; Gioia, *History of Jazz*, 7.

67 On the banjo as a West African-derived instrument and as a staple in early-twentieth-century rural "downhome" blues, see, respectively, Michael T. Coolen, "Senegambian

Influences on Afro-American Musical Culture," *Black Music Research Journal* 11, no. 1 (1991): 1–18; and Southern, *Music of Black Americans*, 374–78.

68 Since 1945, *Billboard* magazine has tracked African American musical productions on singles charts devoted variously to *race* recordings, *rhythm & blues*, *R&B*, *soul*, *black* music, and *hip-hop*. See Joel Whitburn, *Joel Whitburn Presents Top R&B/Hip-Hop Singles, 1942–2004* (Menomonee Falls, WI: Record Research, 2004), 7–8. On *jazz* as a de facto synonym for "Negro music," see Duke Ellington, quoted in Nat Hentoff, "This Cat Needs No Pulitzer Prize" (1965), in *The Duke Ellington Reader*, ed. Mark Tucker (New York: Oxford University Press, 1993), 363.

69 LeRoi Jones, "The Changing Same (R&B and New Black Music)," in *Black Music* (New York: William Morrow, 1967), 196. By Baraka's criteria, Taylor's music is "determinedly Western and modern" not just in its thematic "references" but also in its very centering of the solo performance (194–95).

70 Ibid., 196–97; see also Hentoff, *Jazz Is* (New York: Random House, 1976), 229. Taylor's "European" sound no doubt derives from his classical training. See A. B. Spellman, "Cecil Taylor," in *Four Lives in the Bebop Business* (1966; repr., New York: Limelight, 1994), 1–78, esp. 54–55; Valerie Wilmer, *As Serious as Your Life: John Coltrane and Beyond* (1977; repr., London: Serpent's Tail, 1992), chap. 3, esp. 51–52; Gary Giddins, "The Avant-Gardist Who Came in from the

Cold" (1975–79), in *Riding on a Blue Note: Jazz and American Pop* (1981; repr., New York: Da Capo, 2000), 274–96, esp. 277; Whitney Balliett, "Cecil," in *American Musicians II: Seventy-Two Portraits in Jazz* (New York: Oxford University Press, 1996), 514–20, esp. 518; and Gioia, *History of Jazz*, 346–47.

71 Cecil Taylor, *The World of Cecil Taylor* (Candid 8006/9006), recorded October 12–13, 1960.

72 LeRoi Jones (Amiri Baraka), "Cecil Taylor" (1962), in *Black Music*, 110–11.

73 Ezio Pinza, "This Nearly Was Mine," *South Pacific*, original Broadway cast recording (Columbia ML 4180 / OL 4180, 1949).

74 On the *blue note*, see Schuller, *Early Jazz*, 45, 374.

75 This synchronicity is in keeping with Taylor's conception of the piano as primarily a percussion rather than a string instrument. See Spellman, "Cecil Taylor," 46; Wilmer, *As Serious as Your Life*, 51; Giddins, "Avant-Gardist," 280; Gioia, *History of Jazz*, 347.

76 Cecil Taylor Quartet, "Of What," *Looking Ahead!* (Contemporary 7562/3562, 1959), recorded June 9, 1958.

77 Jones (Baraka), "Cecil Taylor," 111.

78 Ibid.

79 Gérard Herzhaft, *Encyclopedia of the Blues*, 2nd ed., trans. Brigitte Debord (Fayetteville: University of Arkansas Press, 1997), 21; Eugene Chadbourne, "Montana Taylor," in *All Music Guide to the Blues: The Definitive Guide to the Blues*, 3rd ed., ed. Vladimir Bogdanov, Chris Woodstra, and Stephen Thomas Erlewine (San Francisco: Backbeat,

2003), 541; "Montana Taylor," in *The Encyclopedia of Popular Music*, 4th ed., vol. 8, ed. Colin Larkin (New York: Muze; Oxford University Press, 2006), 68–69.

80 Jones (Baraka), "Cecil Taylor," 110; emphasis in original.

81 Ibid., 110–11; final ellipsis in original.

82 Ibid., 111–12.

83 Indeed, Baraka is joined in this undertaking by Wilmer (*As Serious as Your Life*, 48–51), Spellman ("Cecil Taylor," 28), and Taylor himself (quoted in Wilmer, *As Serious as Your Life*, 50, 58; and in Spellman, "Cecil Taylor," 31).

84 Collier, *Making of Jazz*, 341, 360.

85 Spellman, "Cecil Taylor," 193. Spellman and Baraka were both influenced by the poet and Howard professor Sterling Brown (see note 55 to this chapter; and Baraka [Jones], *Blues People*, viii–ix).

86 Scott DeVeaux, *The Birth of Bebop: A Social and Musical History* (Berkeley: University of California Press, 1997), 25, 27.

87 For both negative and positive accounts in this vein, see Sol Babitz, "Bebop," *Record Changer*, December 1947, 9; Lennie Tristano, "What's Wrong with the Beboppers," *Metronome*, June 1947, 16; and Tristano, "What's Right with the Beboppers," *Metronome*, July 1947, 14, 31.

88 Ross Russell, "Bebop" (1948–49), in *The Art of Jazz: Ragtime to Bebop*, ed. Martin T. Williams (1959; repr., New York: Da Capo, 1981), 199, 195–96.

89 Ibid., 197.

90 Ibid., 188–89, 191.

91 Count Basie Orchestra, "One O'clock Jump" (Decca 62332), recorded July 7, 1937.

92 Count Basie and His Orchestra, "Jumpin' at the Woodside" (Decca 64474), recorded August 22, 1938.

93 Charlie Parker Quintet, "Klactoveesedstene" (Dial 1040), recorded November 4, 1947.

94 On this registration of the ground beat by the top cymbal rather than the drum (with varying accounts of its origin), see Ulanov, *History of Jazz in America*, 274; Stearns, *Story of Jazz*, 230–31; Collier, *Making of Jazz*, 347–48; David H. Rosenthal, *Hard Bop: Jazz and Black Music, 1955–1965* (New York: Oxford University Press, 1992), 12; Thomas Owens, *Bebop: The Music and Its Players* (New York: Oxford University Press, 1995), 180; Southern, *Music of Black Americans*, 487; and DeVeaux, *Birth of Bebop*, 218.

95 See note 70 to this chapter.

96 This is by no means to deny the existence of black music or to suggest that black music, once it has been apprehended as such, cannot be understood to lodge its own manner of social-political critique. Many of the works adduced in this chapter trace just such social-critical significance within the music they discuss; for an exemplary instance, see DeVeaux, *Birth of Bebop*. See also Moten, *In the Break*; and Kodwo Eshun, *More Brilliant than the Sun: Adventures in Sonic Fiction* (London: Quartet, 1998).

Anticipating somewhat my concerns here, Brent Edwards suggests that not only narrative but literary practice in general is a necessary

complement to the putatively paramount art form of African American music. See Edwards, "The Literary Ellington," *Representations* 77 (Winter 2002): 1–29.

97 On the Ensemble's musical eclecticism, see Ekkehard Jost, *Free Jazz* (1974; repr., New York: Da Capo, 1994), 178–79.

98 On the extended significance of this slogan, see George E. Lewis, *A Power Stronger than Itself: The AACM and American Experimental Music* (Chicago: University of Chicago Press, 2008), esp. xlii–xliii, 240–43, 389–96, 448–52, 504–7.

99 These two bodies of work converge in the 1990 collaboration Art Ensemble of Chicago with Cecil Taylor, *Thelonious Sphere Monk: Music Inspired by and Dedicated to Thelonious Sphere Monk*, Dreaming of the Masters, vol. 2 (DIW-846-E, 1991), recorded January–March 1990.

CHAPTER 3. TELLING IT SLANT

1 Alice Walker, *The Color Purple* (New York: Harcourt Brace Jovanovich, June 1982), film adaptation dir. Steven Spielberg (Warner Bros., 1985); Gloria Naylor, *The Women of Brewster Place: A Novel in Seven Stories* (New York: Viking, June 1982). *for colored girls* opened in New York City's Booth Theatre (after a three-month off-Broadway run) on September 15, 1976; on the work's publication history, see chapter 2, note 3.

 For examples of the positive critical response to Shange's piece, see Mel Gussow, "Stage: 'Colored Girls' Evolves," *New York Times*, September 16, 1976, 47; Edwin Wilson, "The Black Experience: Two Approaches," *Wall Street Journal*, September 21, 1976, 24; John Beaufort, "For Colored Girls . . . ," under the main headline, "Broadway's 'I Have a Dream': A Stirring Reminder," *Christian Science Monitor*, September 23, 1976, 22; and Dan Sullivan, "Confessions by 'Colored Girls,'" *Los Angeles Times*, February 7, 1977, E1, 11. Among those who faulted the work were the columnist Vernon Jarrett ("A Vicious Lynching Delights Audience," *Chicago Tribune*, January 1, 1978, A6) and Abiodun Oyewole, of the Last Poets, who penned his own play as a rejoinder to Shange's (see Mel Tapley, "Abiodun Oyewole's 'Comments' Answer 'For Colored Girls' Applauded," *New York Amsterdam News*, May 14, 1977, D15; "'Comments' Benefit for HCEC," *New York Amsterdam News*, June 25, 1977, D19; and Tapley, "Gallery Benefit Performance of 'Comments,'" *New York Amsterdam News*, November 19, 1977, D8).

 In addition to Shange, Walker, and Naylor, the controversy adverted to here variously encompassed such authors as Toni Morrison, Gayl Jones, and Toni Cade Bambara.

2 Earl Ofari Hutchinson, "Why Are They Waiting to Exhale?," chap. 9 in *The Assassination of the Black Male Image* (New York: Simon and Schuster, 1996), 104. Per his title, Hutchinson in this piece is commenting primarily on Terry McMillan's wildly popular 1992 novel *Waiting to Exhale* (New York: Viking) and its 1995 film adaptation

(dir. Forest Whitaker; 20th Century-Fox), both of which he sees as continuing the trend established by the earlier works, including Michele Wallace's 1979 volume of social criticism *Black Macho and the Myth of the Superwoman* (New York: Dial). (On the commercial success of McMillan's novel, see Maureen O'Brien, "Waiting to Publish," *Publishers Weekly*, February 19, 1996, 124.)

For examples of critical reaction to the key works of the 1970s and '80s, see Robert Staples, "The Myth of Black Macho: A Response to Angry Black Feminists," *The Black Scholar* 10, nos. 6–7 (1979): 24–33 (which was immediately followed by a special issue of the journal titled "The Black Sexism Debate," *Black Scholar* 10, nos. 8–9 [1979]); Stanley Crouch, "Aunt Jemima Don't Like Uncle Ben," *Village Voice*, April 16, 1979, 93, 101; Robert Towers, "Good Men Are Hard to Find," *New York Review of Books*, August 12, 1982, 35–36; Haki Madhubuti, "Lucille Clifton: Warm Water, Greased Legs, and Dangerous Poetry," in *Black Women Writers (1950–1980): A Critical Evaluation*, ed. Mari Evans (Garden City, NY: Anchor/Doubleday, 1984), 150–60; Ishmael Reed, "An Interview with Ishmael Reed," by Mel Watkins, *Southern Review* 21, no. 3 (1985): 603–14; Philip M. Royster, "In Search of Our Fathers' Arms: Alice Walker's Persona of the Alienated Darling," *Black American Literature Forum* 20, no. 4 (1986): 347–70; Mel Watkins, "Sexism, Racism and Black Women Writers," *New York Times Book Review*, June 15, 1986, 1, 35–37; Richard Barksdale, "Castration Symbolism in Recent Black American Fiction," *CLA Journal* 29, no. 4 (1986): 400–413; and Darryl Pinckney, "Black Victims, Black Villains," *New York Review of Books*, January 29, 1987, 17–20.

For profeminist reflections on the controversy, see Calvin C. Hernton, *The Sexual Mountain and Black Women Writers: Adventures in Sex, Literature, and Real Life* (1987; repr., New York: Anchor, 1990), xxv–xxvi; and Deborah McDowell, "Reading Family Matters," in *Changing Our Own Words: Essays on Criticism, Theory, and Writing by Black Women*, ed. Cheryl A. Wall (New Brunswick, NJ: Rutgers University Press, 1989), 75–97. For a sense of the debate's long afterlife, see "'Women of Brewster Place' Is Put to Music," transcript from the radio program *Tell Me More*, NPR, October 18, 2007, http://www.npr.org/templates/story/story.php?storyId=15393016/.

3 Hutchinson, "Why Are They Waiting to Exhale?," 104. In fact, *The Women of Brewster Place* centers on a total of seven black female characters, though two of these are lesbian partners and a third is concerned only with the well-being of her grown son, to the exclusion of all other male figures. Thus it must be their evident disinterest in romantic or sexual relations with "a real man" that prevents Hutchinson from seeing them as actual women.

4 Ntozake Shange, "a nite with beau willie brown," in *for colored girls*, 55, lines 9–12.

5 Ibid., lines 13–16.

6 Ibid., 55–56, lines 26–32.

7 Ibid., 56, lines 33–34.

8 Ibid., 57, line 61; 60, line 137.

9 Naylor, *Women of Brewster Place*, 100.

10 Ibid., 91–92.

11 Ibid., 94, 95.

12 Ibid., 99. Cf. Maxine Lavon
 Montgomery, "Good Housekeeping:
 Domestic Ritual in Gloria Naylor's
 Fiction," in *Gloria Naylor's Early
 Novels*, ed. Margot Anne Kelley
 (Gainesville: University Press of
 Florida, 1999), 55–69, esp. 58. Of
 course, in the further account that
 Naylor offers up in the 1998 compan-
 ion work *The Men of Brewster Place*
 (New York: Hyperion), Eugene's
 torment over his suppressed homo-
 sexuality emerges as the central fact of
 his own existence and the principal
 factor in his abuse of Ciel (or "Ceil," as
 the later book has it). See Naylor, *Men
 of Brewster Place*, 65–94.

13 For this same point with respect to
 Shange's Beau Willie, see Sandra
 Hollin Flowers, "*Colored Girls*:
 Textbook for the Eighties," *Black
 American Literature Forum* 15, no. 2
 (1981): 51–54, esp. 52; Sandra L.
 Richards, "Conflicting Impulses in the
 Plays of Ntozake Shange," *Black
 American Literature Forum* 17, no. 2
 (1983): 73–78, esp. 77; Carolyn
 Mitchell, "'A Laying On of Hands':
 Transcending the City in Ntozake
 Shange's *for colored girls who have
 considered suicide/when the rainbow is
 enuf*," in *Women Writers and the City:
 Essays in Feminist Literary Criticism*,
 ed. Susan Merrill Squier (Knoxville:
 University of Tennessee Press, 1984),
 230–48, esp. 236–37; Helene Keyssar,
 "Rites and Responsibilities: The

Drama of Black American Women," in
*Feminine Focus: The New Women
Playwrights*, ed. Enoch Brater (New
York: Oxford University Press, 1989),
226–40, esp. 234–35; Neal Lester,
"Shange's Men: *for colored girls*
Revisited, and Movement Beyond,"
African American Review 26, no. 2
(1992): 319–28, esp. 320; and Pamela
Hamilton, "Child's Play: Ntozake
Shange's Audience of Colored Girls," in
*Reading Contemporary African
American Drama: Fragments of
History, Fragments of Self*, ed. Trudier
Harris with Jennifer Larson (New
York: Peter Lang, 2007), 79–97, esp. 89.
All these works counter Andrea
Benton Rushing's suggestion that
Shange's portrayal amounts to
"blaming the victim"; see Rushing,
"For Colored Girls, Suicide or
Struggle," *Massachusetts Review* 22, no.
3 (1981): 541.

For similar arguments regarding
Naylor's depiction of male characters,
see Jill L. Matus, "Dream, Deferral,
and Closure in *The Women of Brewster
Place*," *Black American Literature
Forum* 24, no. 1 (1990): 49–64; and
Barbara Christian, "Gloria Naylor's
Geography: Community, Class, and
Patriarchy in *The Women of Brewster
Place* and *Linden Hills*," in *Reading
Black, Reading Feminist: A Critical
Anthology*, ed. Henry Louis Gates, Jr.
(New York: Meridian, 1990), 348–73.

14 Samuel Richardson, *Pamela; or, Virtue
 Rewarded*, 2 vols. (London: C.
 Rivington and J. Osborn, 1741 [1740]),
 available at Literature Online, http://
 gateway.proquest.com/openurl/
 openurl?ctx_ver=Z39.88-2003&xri

:pqil:res_ver=o.2&res_id=xri:lion
-us&rft_id=xri:lion:ft:pr:Zooo045354
:o, 1:130 for the Bedfordshire reference.
On the primacy of Richardson's
epistolary fictions in terms of their
achievement of psychological realism,
if not their absolute chronological
precedence, see Joe Bray, *The
Epistolary Novel: Representations of
Consciousness* (London: Routledge,
2003), chap. 2, esp. 33–34. Linda S.
Kauffman makes a similar, though
more specific, point in her *Special
Delivery: Epistolary Modes in Modern
Fiction* (Chicago: University of
Chicago Press, 1992), 41.

15 See Richardson, *Pamela*, 1:58 (where
the reference is specifically to "Mr.
B ---") and 2:59 (which invokes "Mr.
B-----"). It appears to be specifically
within editions of *Pamela* published in
omnibus collections of Richardson's
writings—and in editions based on
those collected versions—that "Mr.
B------" entirely replaces "Mr. B." See,
for instance, the editions published in
The Novels of Samuel Richardson, Esq.,
3 vols. (London: Hurst, Robinson,
1824); *The Novels of Mr. Samuel
Richardson*, 19 vols. (London:
Heinemann, 1902); and *Writings of
Samuel Richardson*, 20 vols. (London:
Chapman and Hall, 1902). A free-
standing edition of *Pamela* first issued
in 1902—and reissued in both 1904
and 1906—by the Century Company
in New York adopts these collected
editions' method of designating the
character, as does the 1980 Signet
edition discussed later.

Although she does not specifically
address Richardson's strategies for
designating his villain in *Pamela*,
Janine Barchas intensively investigates
the significance of various typographi-
cal constructions—including the
dash—in the eighteenth-century
British novel. See Barchas, *Graphic
Design, Print Culture, and the
Eighteenth-Century Novel* (Cambridge:
Cambridge University Press, 2003),
esp. chap. 6.

16 John M. Bullitt, introduction to
*Pamela, by Samuel Richardson;
Shamela, by Henry Fielding* (New York:
Signet, 1980), 2.

17 The uncertainty that has surrounded
some of Equiano's autobiographical
claims since at least 1999 has no
bearing on my review of the work's
typographical peculiarities. See the
following key works by Vincent
Carretta: "Olaudah Equiano or
Gustavus Vassa? New Light on an
Eighteenth-Century Question of
Identity," *Slavery & Abolition* 20, no. 3
(1999): 96–105; "Questioning the
Identity of Olaudah Equiano, or
Gustavus Vassa, the African," in *The
Global Eighteenth Century*, ed. Felicity
A. Nussbaum (2003; repr., Baltimore:
Johns Hopkins University Press, 2005),
226–35; and the preface to *Equiano, the
African: Biography of a Self-Made Man*
(2005; repr., New York: Penguin,
2006), xi–xix, esp. xiv–xv. On the
influence of Equiano's *Narrative* on the
African American slave narrative, see
Carretta, "Olaudah Equiano: African
British Abolitionist and Founder of
the African American Slave Narrative,"
in *The Cambridge Companion to the
African American Slave Narrative*, ed.
Audrey A. Fisch (Cambridge:

Cambridge University Press, 2007), 44–60.

18 Olaudah Equiano, *The Interesting Narrative of the Life of Olaudah Equiano, or Gustavus Vassa, the African: Written by Himself*, 2nd ed., 2 vols. (London: T. Wilkins, 1789), 1:207. I cite the second edition of Equiano's *Narrative* because the paragraph in which Mr. D------ is referred to does not appear in the first edition (2 vols.; London, 1789); it would have occurred there at 1:207. On the other hand—and in keeping with my point later that the system of anonymous reference under discussion here often implicates the innocent along with the guilty—the first edition *does* refer to the kindly "Mr. C------" and "the Rev. Mr. P------," both of whom assist Equiano in his conversion to Christianity (see 2:115–49, esp. 133–34 and 139) and both of whom are once again anonymously cited in the second edition of the book (see 2:120–55, esp. 139 and 145).

19 Or at least he did until the publication of the eighth, enlarged edition of the *Narrative* (Norwich, UK, 1794), which identifies Mr. D------ as "Mr. Drummond" (134), in addition to revealing the Rev. Mr. P------ as "the late Rev. Dr. Peckwell" (278) and the second edition's (2:141) "reverend gentleman Mr. G." (another of Equiano's Christian tutors, who remains anonymous in the first edition [2:135]) as "Mr. Green" (276). (See also Equiano, *The Interesting Narrative and Other Writings*, ed. and introd. Vincent Carretta [1995], rev. ed. [New York: Penguin, 2003], 270n303, 289n516, 289n519.) Mr. C------ remained

unidentified through the ninth edition (London, 1794), which Carretta characterizes as the latest reliable text (because the last published during Equiano's lifetime) and uses as the basis for his own edition (see Carretta, "A Note on the Text," in Equiano, *Interesting Narrative and Other Writings*, xxxi–xxxii).

20 Indeed, this was precisely the point as well within Richardson's and Equiano's eighteenth-century context. See Ian Watt, "The Naming of Characters in Defoe, Richardson, and Fielding," *Review of English Studies* 25, no. 100 (1949): 322–38.

Unlike her predecessors, Walker does not furnish her anonymous character with a nominal initial, which means that while there is at least one more "Mr. _____" in *The Color Purple* beyond Celie's husband, this becomes clear only from the context in which that other "Mr. _____" is invoked—and only *after* the reader has likely been shocked and bemused as a result of misconstruing the reference (Walker, *Color Purple*, 14; see also 28, 29). That said, Walker's particular choice of punctuation itself empha-sizes and intensifies her participation in the tradition exemplified in the eighteenth-century works, in that the sublineation she deploys (as contrasted with the more customary two- or three-em dash) effectively underscores the very space from which the character's proper name has been omitted. On two- and three-em dashes, see Anne Stilman, *Grammatically Correct: The Writer's Essential Guide to Punctuation*,

Spelling, Style, Usage and Grammar (Cincinnati: Writer's Digest Books, 1997), 164–65. On the history of the dash within English literary texts, see (in addition to Barchas, *Graphic Design*) Anne C. Henry, "The Re-mark-able Rise of '. . .': Reading Ellipsis Marks in Literary Texts," in *Ma(r)king the Text: The Presentation of Meaning on the Literary Page*, ed. Joe Bray, Miriam Handley, and Henry (Ashgate, UK: Aldershot, 2000), 120–42, esp. 124–28.

On *The Color Purple*'s continuity with eighteenth-century epistolary fiction, see Kauffman, *Special Delivery*, 186–89; Molly Hite, "Writing—and Reading—the Body: Female Sexuality and Recent Feminist Fiction," *Feminist Studies* 14, no. 1 (1988): 121–42, esp. 127; Hite, "Romance, Marginality, Matrilineage: Alice Walker's *The Color Purple* and Zora Neale Hurston's *Their Eyes Were Watching God*," *Novel: A Forum on Fiction* 22, no. 3 (1989): 257–73, esp. 262; and Anne Bower, *Epistolary Responses: The Letter in 20th-Century American Fiction and Criticism* (Tuscaloosa: University of Alabama Press, 2007), 113. On the novel's one deviation from the epistolary mode, see bell hooks, "Writing the Subject: Reading *The Color Purple*" (1989), in Gates, *Reading Black, Reading Feminist*, 454–70, esp. 455. hooks's observation slightly qualifies Gates's own otherwise apt contention that, because "no one speaks" in *The Color Purple*, the novel presents "no true mimesis . . . , only diegesis," where "true mimesis" refers specifically to direct discourse (see

note 12 to chapter 2) and not to the more general real-life correspondence that I argue is understood to characterize *The Color Purple*, *The Women of Brewster Place*, and *for colored girls* alike. Gates, *The Signifying Monkey: A Theory of African-American Literary Criticism* (New York: Oxford University Press, 1988), chap. 7 (249 for the quoted passage).

On *The Color Purple*'s participation in the tradition of the slave narrative, see Alice Walker, "Saving the Life That Is Your Own: The Importance of Models in the Artist's Life" (1976), in *In Search of Our Mothers' Gardens: Womanist Prose* (San Diego: Harcourt Brace Jovanovich, 1983), 3–14; esp. 5; Hernton, *Sexual Mountain*, chap. 1; and hooks, "Writing the Subject."

21 Walker, *Color Purple*, 14 (and elsewhere), 197, 31. We are informed of Mr. _____'s first name on p. 43.

22 Interestingly, the only characters in *The Color Purple* who are granted (presumably patronymic) surnames are those who most actively resist patriarchal propriety: Shug Avery, the blues-singing lover of Albert's youth who eventually awakens Celie to her own sexuality; and Sofia herself, whose last name is Butler (see ibid., 8, 29).

For a deployment of anonymity that is similar to Walker's, see Frederick Douglass's *Narrative*, 81. Regarding *subjection*, see Judith Butler, *The Psychic Life of Power: Theories in Subjection* (Stanford, CA: Stanford University Press, 1997), introduction, esp. 2, 10.

23 For a pithy assertion of this correspondentialist ethic, see George Becker,

"Modern Realism as a Literary Movement," in *Documents of Modern Literary Realism*, ed. Becker (Princeton, NJ: Princeton University Press, 1963), 3–38, esp. 36.

24 See Ntozake Shange, interview by Claudia Tate, in *Black Women Writers at Work*, ed. Tate (New York: Continuum, 1984), 158.

25 Ibid.

26 Ibid.

27 Ibid., 159; Ntozake Shange, "with no immediate cause," in *Nappy Edges* (1978; repr., New York: Bantam, 1980), 111–13.

28 Shange, interview by Tate, 159.

29 Hutchinson, "Why Are They Waiting to Exhale?," 105; emphasis in original.

30 Ibid.; emphasis in original.

31 For a discussion of such omissible inessentials (i.e., *catalyzers* or *complementary elements*) in relation to the indispensable narrative *nuclei* or *cardinal functions*, see Barthes, "Introduction to the Structural Analysis of Narratives," 91–95. Barthes's contention that the deletion of any catalyzer will alter the *discourse* of a narrative without changing the *story* it tells suggests that Shange, Naylor, and Walker might divest their narratives of what their critics take to be an anti-black-male discourse while leaving their core stories intact. Such a move is likely precluded, however, by the authors' evident commitment to the psychological realism I discuss later, since the narratives' existing complementary elements would seem to be dictated by the works' fidelity to their protagonists' points of view.

32 Walker, *Color Purple*, 244.

33 Thus the realism at issue here effectively combines the *correspondence* cited earlier with the *coherence* characteristic of what Damian Grant calls "conscious realism," which is distinguished by its truthfulness to a systematic order whose governing laws are generated by and within the literary work itself, irrespective of its mimetic purchase on objective reality; see Grant, *Realism* (London: Methuen, 1970), esp. 13–17. See also Darío Villanueva on *formal* and *genetic* realism: *Theories of Literary Realism* (1992), rev. ed., trans. Mihai Spariosu and Santiago García-Castañón (Albany: State University of New York Press, 1997), esp. ix.

34 On the various ways this has been accomplished, see Dorrit Cohn, *Transparent Minds: Narrative Modes for Presenting Consciousness in Fiction* (1978; repr., Princeton, NJ: Princeton University Press, 1983); and also Leon Edel's earlier, more tentative, and more narrowly focused study *The Psychological Novel, 1900–1950* (New York: Lippincott, 1955), later retitled *The Modern Psychological Novel* and ultimately reissued in an expanded edition (New York: Grosset and Dunlap, 1964). While Cohn dates the ascendancy of what she calls "psycho-narration" to the late nineteenth century (see her chap. 1, esp. 21–26), I would contend that it is now so established a feature of fictional literary narrative as to constitute a de facto requirement of realism as such.

35 Alternatively, of course, information beyond the characters' ken could be conveyed by a third-person narrator,

but the latter's apparent omniscience would itself be unrealistic. On the inverse relationship between third-person narratorial saliency and fictional characters' manifestation of psychological depth, see Cohn, *Transparent Minds*, 25–26.

36 In other words, each protagonist—Celie, Ciel, Crystal—also serves as the *focalizer* of her narrative (see Bal, *Narratology*, 100–115). On black female characters' function in this regard (conceived in terms of "voice"), see Mary O'Connor, "Subject, Voice, and Women in Some Contemporary Black American Women's Writing," in *Feminism, Bakhtin, and the Dialogic*, ed. Dale M. Bauer and S. Jaret McKinstry (Albany: State University of New York Press, 1991), 199–217, esp. 215; and, specifically concerning *The Women of Brewster Place*, Karla Holloway, *Moorings and Metaphors: Figures of Culture and Gender in Black Women's Literature* (New Brunswick, NJ: Rutgers University Press, 1992), esp. 79. For a consideration of how such focalization centers not just the psychic but also the *physical* lives of Naylor's characters, see Laura Tanner, *Intimate Violence: Reading Rape and Torture in Twentieth-Century Fiction* (Bloomington: Indiana University Press, 1994), chap. 1, esp. 27–34.

For concerted efforts to keep readers' sights trained on Naylor's and Shange's black women rather than on their male antagonists, see Matus, "Dream, Deferral, and Closure," 62; C. Mitchell, "A Laying On of Hands," 238; Susan Hubert, "Singing a Black Girl's Song in a Strange Land: *for colored girls* and the Perils of Canonicity," *Literary Griot* 14, nos. 1–2 (2002): 94–102, esp. 99; and Shange, "At the Heart of Shange's Feminism: An Interview," by Neal Lester, *Black American Literature Forum* 24, no. 4 (1990): 717–30, esp. 729–30n4.

37 They thus paradoxically fall short of the bar putatively set by such "great realists" as Honoré de Balzac, Maxim Gorky, and Thomas Mann, whose works Georg Lukács argues "reveal the relations between [subjective] appearance and [objective] essence without the need for any external commentary"—either that or, as I am arguing here, realism itself comprises a rather less straightforward and more problematic pursuit than Lukács admits. See Lukács, "Realism in the Balance" (1938), in Bloch et al., *Aesthetics and Politics*, 33–34.

38 This is to say that they mobilize an abiding presumption that realist literary depiction will largely correspond to lived social reality, notwithstanding the challenges to that presumption that have been posed by scholars of American literature (among others) since at least the 1980s. For a review of some of this work, see Michael Anesko, "Recent Critical Approaches," in *The Cambridge Companion to American Realism and Naturalism: Howells to London*, ed. Donald Pizer (Cambridge: Cambridge University Press, 1995), 77–94, esp. 77–87.

39 See note 12 to chapter 2.

40 Naylor, *Women of Brewster Place*, 100.

41 This logic is summarized in Ferdinand de Saussure's account of the *syntagmatic* relations among linguistic units

in discourse. See Saussure, *Course in General Linguistics*, ed. Charles Bally and Albert Sechehaye, with Albert Riedlinger (1915), trans. Wade Baskin (1959; repr., New York: McGraw-Hill, 1966), 123.

42 Cf. Jonathan Culler, *Structuralist Poetics* (1975; repr., London: Routledge, 2002), chap. 8, esp. 214–17; and Rachel Blau DuPlessis, "Codicil on the Definition of Poetry," in "Manifests," *diacritics* 26, nos. 3–4 (1996): 51.

43 William Carlos Williams, "This Is Just to Say" (1934), in *Selected Poems*, ed. Charles Tomlinson (New York: New Directions, 1985), 74. Culler, too, uses this poem to demonstrate how any given verbal construct is constituted as a lyric in the first place (*Structuralist Poetics*, 205), while William Waters suggests that, in this particular case, it is not lineation alone that confers the piece with its lyric quality (Waters, *Poetry's Touch: On Lyric Address* [Ithaca, NY: Cornell University Press, 2003], 20–21). For a provocative and compelling account of the reading practices through which specific instances of textual production are rendered as lyric poems—especially in the U.S. context—see Virginia Jackson, *Dickinson's Misery: A Theory of Lyric Reading* (Princeton, NJ: Princeton University Press, 2005).

44 Cf. Culler, *Structuralist Poetics*, 215–16; for a contrasting view, see James Longenbach, *The Art of the Poetic Line* (St. Paul, MN: Graywolf, 2008), xii and chap. 1.

45 This agential subjectivity corresponds to the *implied author* first theorized by Wayne Booth, albeit specifically with respect to its function in prose fiction. See Booth, *The Rhetoric of Fiction* (1961), 2nd ed. (Chicago: University of Chicago Press, 1983), 70–77.

46 The "implied author" who seemingly "stands behind" the verse is effectively cognate with the *enunciating subject* described within linguistics and psychoanalysis (and critically deployed within literary and cinematic narratology), while the entity that emerges *in* the verse corresponds to the *subject of the statement* as posited within those same theoretical traditions (however difficult it might be to distinguish these two "subjects," given that they are both textually generated). On the relevant concepts, see Emile Benveniste, "The Nature of Pronouns" (1956), chap. 20 in *Problems in General Linguistics* (1966), trans. Mary Elizabeth Meek (Coral Gables, FL: University of Miami Press, 1971), 217–22, esp. 218; Jacques Lacan, "The Subversion of the Subject and the Dialectic of Desire in the Freudian Unconscious" (1960), chap. 9 in *Écrits: A Selection*, trans. Alan Sheridan (New York: Norton, 1977), 292–325, esp. 298; and Lacan, *The Four Fundamental Concepts of Psycho-Analysis* (1973), ed. Jacques-Alain Miller, trans. Alan Sheridan (1978; repr., New York: Norton, 1981), chap. 11, esp. 138–40. For a useful summary, see Kaja Silverman, "Emile Benveniste," in *Narrative Theory: Critical Concepts in Literary and Cultural Studies*, vol. 3, ed. Mieke Bal (London: Routledge, 2004), 11–19.

47 Williams himself maintained that the key element in that formal determination—what made the poem

a poem—was not the work's line breaks but, rather, its "absolutely regular" meter. Like Marjorie Perloff, I do not believe the piece manifests metrical regularity, but whatever meter it does manifest necessarily depends on its line breaks and so still registers as the work of a subjectivity existing beyond the poem itself. See William Carlos Williams, "An Interview with William Carlos Williams," by John Gerber (1950), ed. Emily M. Wallace, *Massachusetts Review* 14, no. 1 (1973): 141; and Perloff, *Dance of the Intellect: Studies in the Poetry of the Pound Tradition* (1985; repr., Evanston, IL: Northwestern University Press, 1996), 90–91.

For empirical corroboration of my point that line breaks in poetry are understood as functionally distinct from (even if interrelated with) syntax, see James Stalker, "Reader Expectations and the Poetic Line," *Language and Style* 15, no. 4 (1982): 241–52.

48 This entity aligns with what Silverman calls "the category of the spoken subject" ("Emile Benveniste," 14).

49 This phenomenon correlates with what Roman Ingarden designates as readerly *concretization*, whereby one mentally fills in a literary work's inevitable presentational gaps so as to achieve a coherent understanding of the fictive world the work is meant to portray. Ingarden, *The Cognition of the Literary Work of Art* (1968), trans. Ruth Ann Crowley and Kenneth R. Olson (1973; repr., Evanston, IL: Northwestern University Press, 1979), 47–50. (By the same token, the reading

subjectivity that emerges through this process corresponds to what Wolfgang Iser calls the *implied reader*, who in Silverman's terms [see note 48 to this chapter] is effectively "spoken" by the text. See Iser, *The Implied Reader: Patterns of Communication in Prose Fiction from Bunyan to Beckett* [1972], English ed. [1974; repr., Baltimore: Johns Hopkins University Press, 1978], esp. xii.) Ingarden contends that, while it is not necessary to concretize (and thus sympathize with) a third-person prose-fictional narrator in order to concretize the world that narrator shapes for us, it *is* always necessary to "concretize the lyrical subject in its mental state or in its momentary psychic transformation," because it is only by sympathetically apprehending a work's articulating *I* that we conceive the work as *lyric* in the first place (*Cognition of the Literary Work of Art*, 263–64). On this view, subjective concretization registers as a key aspect of the reading practice by which Virginia Jackson suggests the lyric is socially constituted (*Dickinson's Misery*, 10–11, and chaps. 1 and 2).

50 For Perloff, the proliferation of such instances in the postwar-U.S. literary context constitutes poetry's increased privileging of *authentic speech* over *verbal artifice*, with significant consequences for how we understand high modernism to have ramified in the late twentieth century. See Perloff, *Radical Artifice: Writing Poetry in the Age of Media* (1991; repr., Chicago: University of Chicago Press, 1994), esp. 29–35, 40–46, 54–57.

Of course, the extent to which commentators take Shange's *for colored girls* as a collection of straightforwardly realist narratives that presumably do *not* manifest great formal complexity suggests that the work's official status as poetry is widely unacknowledged. This is doubtless due not only to the intensity of Shange's own commitment to authentic-speech poetics (likely traceable as much to Black Arts and feminist influences as to the legacies of modernism) but also to the fact that the work is frequently encountered as performance rather than as printed text, which makes its verse forms all the more difficult to discern.

51 Carolyn Forché, "The Colonel," *Pequod* 11 (1980): 92, reprinted in *Women and War: El Salvador* (New York: Women's International Resource Exchange, 1981), 22; reproduced here from Forché, *The Country between Us* (New York: Harper and Row, 1981), 16. On the relevant historical and political developments, see Tommie Sue Montgomery, *Revolution in El Salvador: From Civil Strife to Civil Peace* (1982), 2nd ed. (Boulder, CO: Westview, 1995); and Robert Armstrong and Janet Shenk, *El Salvador: The Face of Revolution* (Boston: South End, 1982).

52 The ambiguity stems from the fact that *this* is a *deictic*, or *shifter*, whose "general meaning," as Roman Jakobson has put it, "cannot be defined without a reference to the message" in which it is embedded. Because the "message" comprised in Forché's passage offers two alternative points of reference,

however, it only intensifies the inherent indeterminacy of the shifter itself. See Jakobson, "Shifters, Verbal Categories, and the Russian Verb" (1957), chap. 5 in *Russian and Slavic Grammar: Studies, 1931–1981*, ed. Linda R. Waugh and Morris Halle (Berlin: Mouton, 1984), 42. See also Emile Benveniste on *indicators*, in "The Nature of Pronouns," 218–19.

53 On the centrality of figurative language to poetry, see Jonathan Culler, *Literary Theory: A Very Short Introduction* (1997; repr., Oxford: Oxford University Press, 2000), 69. On the centrality of *metaphor* within the poetic deployment of figurative language, see Percy Bysshe Shelley, "A Defence of Poetry" (drafted 1821), in *Essays, Letters from Abroad, Fragments*, vol. 1, ed. Mary Shelley (London: Edward Moxon, 1840), 1–57, esp. 5. On exactly *why* metaphor is understood to exemplify figurative language as such, see Culler, *The Pursuit of Signs: Semiotics, Literature, Deconstruction* (1981; repr., London: Routledge, 2001), chap. 10.

For Forché's seeming irresolution as to the generic status of "The Colonel," see Forché, interview with Bill Moyers in *The Language of Life: A Festival of Poets*, by Moyers, ed. James Haba with David Grubin (New York: Doubleday, 1995), 129–41, esp. 135; and Forché, "El Salvador: An Aide Memoire," *American Poetry Review* 10, no. 4 (1981): 3–7, esp. 3. That irresolution has been recapitulated in the critical literature, with some commentators extolling the meticulous prosody of "The Colonel" while others see the

piece as an exemplar of direct reportage. See Terence Diggory, "Witnesses and Seers," *Salmagundi* 61 (Fall 1983): 112–24, esp. 117–18; John Mann, "Carolyn Forché: Poetry and Survival," *American Poetry* 3, no. 3 (1986): 51–69, esp. 58–59; Leonora Smith, "Carolyn Forché: Poet of Witness," in *Still the Frame Holds: Essays on Women Poets and Writers*, ed. Sheila Roberts with Yvonne Pacheco Tevis (San Bernardino, CA: Borgo, 1993), 15–28, esp. 22; Sharon Doubiago, "Towards an American Criticism: A Reading of Carolyn Forché's *The Country between Us*," *American Poetry Review* 12, no. 1 (1983): 35–39, esp. 36; Mary DeShazer, *A Poetics of Resistance: Women Writing in El Salvador, South Africa, and the United States* (Ann Arbor: University of Michigan Press, 1994), chap. 6, esp. 267; Nora Mitchell and Emily Skoler, "History, Death, Politics, Despair," *New England Review* 17, no. 2 (1995): 67–81, esp. 75, 76; Alice Templeton, "What's the Use? Writing Poetry in Wartime," *College Literature* 34, no. 4 (2007): 43–62, esp. 47–48; Imogen Forster, "Constructing Central America," *Red Letters* 16 (Spring–Summer 1984): 48–55, esp. 55; Anita Helle, "Elegy as History: Three Women Poets 'By the Country's Deathbed,'" *South Atlantic Review* 61, no. 2 (1996): 51–68, esp. 55.

54 Forché has herself acknowledged the complex status of figuration within the sort of "poetry of witness" that "The Colonel" exemplifies, in which, she suggests, metaphor is not a fault to be avoided but "a problem" to be negotiated ("El Salvador," 7).

55 Paul Rea somewhat differently proposes that "ears 'pressed to the ground' suggests both oppression and recollection." Rea, "The Poet as Witness: Carolyn Forché's Powerful Pleas from El Salvador," *Confluencia* 2, no. 2 (1987): 98.

56 See Culler, *Literary Theory*; Culler, *Pursuit of Signs*; and Shelley, "Defence of Poetry."

57 Indeed, in marshaling "poetic" metaphor so as to contravene not only its own formal presentation as an unlineated paragraph but also its modal status as a straightforwardly declarative text, "The Colonel" juxtaposes the conventional formal and modal attributes of prose against the figurative functions of poetry without ever settling on *either* the poetic *or* the prosaic as the privileged means of registering its point. It thus constitutes one possible answer to Michel Delville's trenchant question, "How are we to approach a prose text labeled as poetry at a time when"— owing precisely to the rise of the "authentic speech" model— "traditional notions of poetic language have become so problematic?" See Delville, *The American Prose Poem: Poetic Form and the Boundaries of Genre* (Gainesville: University Press of Florida, 1998), 4.

58 Gertrude Stein, *Tender Buttons: Objects, Food, Rooms* (New York: Claire Marie, 1914), 9.

59 Cf. Delville's suggestion, in light of this same *Tender Buttons* passage, that Stein's piece "resist[s] the power of prose syntax to 'name' its object and undermin[es] the reader's attempts to

naturalize the text into a conventional piece of descriptive prose" (*American Prose Poem*, 67).

60 Gertrude Stein, "Composition as Explanation" (1926), in *Selected Writings of Gertrude Stein*, ed. Carl Van Vechten (1946, 1962; repr., New York: Vintage, 1990), 517.

61 Of course, scholars have long noted that "Melanctha" comprises a structure of "motivated repetition" (Lisa Ruddick, *Reading Gertrude Stein: Body, Text, Gnosis* [Ithaca, NY: Cornell University Press, 1990], 44), and they have based a variety of arguments on that fact. Most resonant with my discussion here is that forwarded by L. T. Fitz ("Gertrude Stein and Picasso: The Language of Surfaces," *American Literature* 45, no. 2 [1973]: 228–37, esp. 231), but see also Richard Bridgman, "Melanctha," *American Literature* 33, no. 3 (1961): 350–59, esp. 352; Marianne DeKoven, *A Different Language: Gertrude Stein's Experimental Writing* (Madison: University of Wisconsin Press, 1983), 51–53; Laura Doyle, "The Flat, the Round, and Gertrude Stein: Race and the Shape of Modern(ist) History," *Modernism/Modernity* 7, no. 2 (2000): 249–71, esp. 266; and Steven Meyer, *Irresistible Dictation: Gertrude Stein and the Correlations of Writing and Science* (Stanford, CA: Stanford University Press, 2001), 123.

62 Gertrude Stein, "Melanctha," in *Three Lives: Stories of the Good Anna, Melanctha and the Gentle Lena* (New York: Grafton, 1909), 103, 105. The characterizations of Jane Harden as "roughened" occur on 104, 107, and 113.

63 Ibid., 107–8.

64 Ibid., 113.

65 Ibid.

66 This is all the more the case given that "covering over" is invoked in relation not only to Jane but also to Melanctha, both before and after Jane becomes known either to Melanctha or to the reader (see ibid., 96, 102, 107). These additional uses of the phrase only further substantiate my point that the work actively recruits the reader's cognitive exertion in the determination of its meaning.

67 It is for this reason that I tend to demur at the manner in which most critics who pay any attention at all to the character propose to make sense of Jane Harden's function in the text, reading her "roughened" state as cognate with the "hardness" that her name connotes. See, for instance, Lawren Farber, "Fading: A Way. Gertrude Stein's Sources for *Three Lives*," *Journal of Modern Literature* 5, no. 3 (1976): 463–80, esp. 475–476. For an astute corrective in this regard, see Michael North, *The Dialect of Modernism: Race, Language, and Twentieth-Century Literature* (New York: Oxford University Press, 1994), 74.

68 Stein, "Melanctha," 86, 89, 107, 109, and 137.

69 Ibid., 90, 96, 110.

70 See ibid., 90, 96, 106.

71 It is partly this tendency toward "stereotype" that puts off Bridgman, who demonstrates deep skepticism about "Melanctha" overall; see Bridgman, "Melanctha," 352. Milton Cohen amends and yet ultimately

affirms Bridgman's judgment of the work's racial politics (Cohen, "Black Brutes and Mulatto Saints: The Racial Hierarchy of Stein's 'Melanctha,'" *Black American Literature Forum* 18, no. 3 [1984]: 119–21), while Doyle argues that the work not only mobilizes "the power of racism" but also imputes that racism to its presumed readers ("The Flat, the Round, and Gertrude Stein," 263). Paul Peppis most closely approximates my own position, suggesting that the verbal repetitions in "Melanctha" have a "destabilizing" effect on the very "racialism" in which the text itself traffics. See Peppis, "Thinking Race in the *Avant Guerre*: Typological Negotiations in Ford and Stein," *Yale Journal of Criticism* 10, no. 2 (1997): 388–89.

72 Stein, "Melanctha," 116, 124.

73 Ibid., 143–44.

74 Ibid., 145.

75 Ibid., 146–47.

76 While Bridgman sees the repetition of "certainly" as the characters' absurdist attempt to assert control amid "an indifferent universe" (Bridgman, "Melanctha," 359), Peppis, North, and Nathaniel Mackey all understand it in terms of the fundamental instability of linguistic and conceptual structures (see Peppis, "Thinking Race," 389; North, *Dialect of Modernism*, 73–74; Mackey, "Other," 281–82). Although the latter three commentators' characterizations all strike me as largely correct, my own immediate interest lies less with the cognitive regimes that the repetition illuminates than with the psychological complexity that the characters register in

negotiating those regimes, through their ambivalent oscillation between conviction and doubt.

77 Cf. Fitz's contention that in "Melanctha" "character is unfolded gradually, and through much repetition" ("Gertrude Stein and Picasso," 231). See also complementary claims by Doyle ("The Flat, the Round, and Gertrude Stein," 260) and Corinne Blackmer ("African Masks and the Arts of Passing in Gertrude Stein's 'Melanctha' and Nella Larsen's *Passing*," *Journal of the History of Sexuality* 4, no. 2 [1993]: 230–63, esp. 240).

78 In other words, there are evidently limits on the extent to which "Melanctha" can "destabilize" "racialism," as Peppis otherwise convincingly suggests it does ("Thinking Race," 388–89).

79 John Keene, *Annotations* (New York: New Directions, 1995), 3–4.

80 Cf. Colson Whitehead's suggestion that Keene makes "each sentence . . . simultaneously embellish and refute its predecessor" (Whitehead, review of *Annotations*, by Keene, in "Briefs," *Voice Literary Supplement*, *Village Voice*, December 5, 1995, SS8). Given that this discontinuity is at once the book's defining and, as I am arguing, most productive feature, it is somewhat curious that Brian Evenson charges Keene with "occasionally . . . disrupting the narrative in nonproductive ways"; see Evenson, review of *Annotations*, by Keene, *Review of Contemporary Fiction* 16, no. 1 (1996): 149.
 It is worth noting that, for all its oscillation among personal pronouns,

Annotations invokes the first-person singular *I* only once, in a metalevel commentary on the word's very significance that appears on page 76. In this respect, Keene's text diverges from the pattern established in Lyn Hejinian's *My Life*, which it otherwise powerfully recalls and whose influence it explicitly registers (note the epigraph on Keene's unnumbered page 1); see Hejinian, *My Life* (Providence, RI: Burning Deck, 1980); Hejinian, *My Life* (Los Angeles: Sun and Moon, 1987); and for a post-*Annotations* installment, Hejinian, *My Life in the Nineties* (New York: Shark, 2003).

The fact that *Annotations* shuns first-person enunciation has not prevented commentators from asserting its autobiographical quality, though their recognition that it largely repudiates standard autobiographical form sometimes leads them to characterize it as a sort of modified *memoir*. See Whitehead, review of *Annotations*; Evenson, review of *Annotations*; the anonymous review in *Virginia Quarterly Review* 72, no. 3 (1996): SS93; and the *Annotations* jacket copy itself.

81 Keene, *Annotations*, 12–14.

82 The immediately preceding passage most centrally invokes the Vietnam War and, even more specifically, the March 1968 My Lai Massacre; see ibid., 12.

83 The most logical possibility in this regard is "the corner store" (ibid., 12), the reference to which, however, is separated from the mention of the library and the studio by fully four sentences whose import diverges

radically from the two in question and thus drastically attenuates the connection between them. The "audible jewels" sentence appears on p. 13.

84 This is so despite the interposed reference to "Chain of Rocks," identified in one of the book's couple-dozen endnotes as "a series of bluffs, with a park, overlooking the Mississippi River north of St. Louis City" (ibid., 83). Then, too, although it anchors the meaning of "his wife," "the artist" is never any more fully identified than "he," as this is the only invocation of the phrase in the entire text; the same is true of "Patty" and "the red-haired boy." Thus whatever distinctness these personages seem to manifest is actually an illusion that derives from their being designated by proper nouns or definite articles.

85 On these historical events, see Franklin and Moss, *From Slavery to Freedom*, 424, 518, 509–10, 513–14.

86 This investment can be understood as an aspect of the Ingardenian *concretization* whereby readers cognitively realize the world that *Annotations* figures. See note 49 to this chapter.

87 The success with which the book induces readers to adopt its analytical perspective is demonstrated by a 2009 essay in which Sandra Wilson Smith, in a discussion of a 1954 Chester Himes novel, turns to the *Annotations* passages considered here to substantiate her assertion that "th[e] belief in the ideal of home ownership has been long-standing in the black community"—not only obviously understanding Keene's text to represent black people's sociopolitical

interests but also evidently seeing it less as an imaginative work than as a sociological treatise whose propositions are self-evidently valid. See Smith, "Chester Himes's *The Third Generation*: A Dystopic Domestic Novel," *Southern Literary Journal* 41, no. 2 (2009): 49–50.

88 For the originary psychoanalytic theorization of *suture*—along with its earliest deployment in cinematic narratology and a commentary on both—see "Dossier on Suture" (*Screen* 18, no. 4 [1977]: 23–76), comprising Jacques-Alain Miller, "Suture (Elements of the Logic of the Signifier)" (1965, 1966), trans. Jacqueline Rose, 24–34; Jean-Pierre Oudart, "Cinema and Suture" (1969), trans. Kari Hanet, 35–47; and Stephen Heath, "Notes on Suture," 48–76.

For a demonstration of how *suture* has been at once mobilized in the study of film and adapted to the consideration of prose narrative, see Steven Cohan and Linda M. Shires, *Telling Stories: A Theoretical Analysis of Narrative Fiction* (London: Routledge, 1988), chap. 6, esp. 161–75.

89 Taken along with more specifically subjective considerations, such situational factors constitute the "social construction" of collective identity that has been much bruited in critical analysis since at least the mid-1970s (for a concise characterization, see Richard Jenkins, *Social Identity*, 3rd ed. [Abingdon, UK: Routledge, 2008], 12). It is well worth emphasizing the externality of these factors, since critics of minoritarian "identity politics" (the problematic

character of which I sketch in this very volume) often tend to imply that it is solely members of minority groups themselves who are responsible for the ongoing production of the identities they are understood to bear—and who by extension are typically guilty of invoking "identity" at sites and in moments where it is inappropriate to do so. On the contrary, whatever their limitations in specific instances, minoritarian deployments of identity-politics discourse have to be understood as a response to a long-lived, state-supported, *institutional* identity politics that is rarely called out by name even though its legacy has been profound and persistent. For a full elaboration of this point, see Lisa Duggan, *The Twilight of Equality? Neoliberalism, Cultural Politics, and the Attack on Democracy* (Boston: Beacon, 2003).

For a foundational theorization of *social constructionism* per se, influential instances of its critical elaboration, and a judicious and clarifying response to its widespread promulgation, see Peter Berger and Thomas Luckmann, *The Social Construction of Reality: A Treatise in the Sociology of Knowledge* (Garden City, NY: Doubleday, 1966); Michel Foucault, *Archaeology of Knowledge* (1969), trans. A. M. Sheridan Smith (New York: Pantheon, 1972); Foucault, *Discipline and Punish*; Foucault, *The History of Sexuality, Vol. 1.: An Introduction* (1976), trans. Robert Hurley (New York: Pantheon, 1978); and Ian Hacking, *The Social Construction of What?* (Cambridge,

MA: Harvard University Press, 1999).

90 Keene, *Annotations*, 21.

91 Ibid., 34–35. "Evonce," as one of the book's endnotes instructs the uninformed reader, is "a composition by Danny Quebec West and Idrees Sulieman, played by Thelonious Monk and his combo in a Blue Note recording from the 1940s" (ibid., 84).

92 Ibid., 38.

93 Ibid., 12, 42, 78.

94 For a brief discussion of changes in African Americans' mode of collective self-designation from the late nineteenth through the late twentieth centuries, see my *Are We Not Men?*, chap. 3, esp. 56–62.

95 Keene, *Annotations*, 3, 17, 72.

96 On the Detroit and Miami riots of 1967 and 1980, see the relevant entries by Max Herman and Gladys L. Knight, respectively, in Walter C. Rucker and James N. Upton, eds., *Encyclopedia of American Race Riots*, vol. 1 (Westport, CT: Greenwood, 2007), 165–70, 414–19.

97 Keene, *Annotations*, 22, 40.

98 Thus the title of the eighth chapter, "Signs, Scenes, a Psychic Trail of Assignations" (ibid., 33), is reconfigured in the seventeenth as "The parents misread the signals or misconstrued each scene as they doggedly followed the trail of assignations" (73), while the title of the eighteenth chapter, "Literature as a Guide to the Life Lived, a Deliverance" (75), recycles elements from a sentence that appears in the eleventh: "They consequently decried literature as a guide to the life that one lived, as mere retreat, fool's flight from the world's

true horrors, but instead he derived from these stories, those poems, maps to realizable liberty, and took in each finished text a step ever closer to the zone of deliverance" (46).

99 This may well mean that black expressive culture is *inherently* abstractionist, inasmuch as James Snead has famously identified repetition itself as a defining feature of African-diasporic cultural practice, going so far as to remark that black music in particular "draws attention to its own repetitions." If so, then a commitment to realist representation within African American culture entails a commitment to repressing both its characteristic repetition and its distinctive abstractionist quality. See Snead, "Repetition as a Figure of Black Culture" (1981), in *Black Literature and Literary Theory*, ed. Henry Louis Gates, Jr. (London: Methuen, 1984), 59–79 (69 for the quotation).

100 Indeed, the investment in historicist engagement that *Annotations* registers should be understood as a complement to the autobiographical impulse that readers so readily discern in the text (see note 80 to this chapter). As Keene himself puts it, in a virtual gloss on the work itself, "encased in each attempt to make himself heard lies the aim to site his personal development *within the broader historical record*" (*Annotations*, 32; emphasis added).

101 A primary such practice entails considering these works not as hybrid wholes but rather in excerpted sections that thus appear as discrete lyrics, short fictions, or prose essays.

CODA

1 See note 3 to chapter 1.

2 Geoffrey Fletcher, *Precious*, shooting script of January 16, 2008 (New York: Push Pictures, 2007), 10.

3 Sapphire, *Push* (1996; repr., New York: Vintage, 1997), 9–22.

4 Ibid., 3, 4, 5.

5 Ibid., 4, 5.

6 Ibid., 9, 10–13.

7 Ibid., 13, 16, 16–21.

8 Ibid., 21–22.

9 Ibid., 3.

10 Those criteria can be understood in terms of what Saussure calls *langue*—i.e., the system of rules by which language is governed (even in its "nonstandard" versions), as distinct from the concrete instances in which it is actually deployed, characterized by Saussure as *parole*. See Saussure, *Course in General Linguistics*, 7–17.

11 As James Monaco puts it, "it's impossible to be ungrammatical in film," which is to say that cinema's lack of syntactical rules (as opposed to organizational *conventions*, which it certainly *does* have) renders wholly metaphorical the myriad references to "film grammar" that characterize the relevant literature—ditto invocations of "visual grammar" in discussions of graphic design and related practices. See Monaco, *How to Read a Film: Movies, Media, and Beyond*, 4th ed. (New York: Oxford University Press, 2009), 170; and Christian Leborg, *Visual Grammar* (2004), trans. Diane Oatley (New York: Princeton Architectural Press, 2006), preface.

12 For an influential account of *worldmaking*, and a prime example of its elaboration in literary studies, see Nelson Goodman, *Ways of Worldmaking* (Indianapolis: Hackett, 1978); and Paul Hernadi, "Why Is Literature: A Coevolutionary Perspective on Imaginative Worldmaking," *Poetics Today* 23, no. 1 (2002): 21–42.

13 Stanton B. Garner, Jr., *Bodied Spaces: Phenomenology and Performance in Contemporary Drama* (Ithaca, NY: Cornell University Press, 1994), 41–42. See also ibid., chap. 3; and Alice Rayner, *Ghosts: Death's Double and the Phenomena of Theatre* (Minneapolis: University of Minnesota Press, 2006), esp. chaps. 3 and 4. Both Garner and Rayner draw productively on Bert O. States's classic work *Great Reckonings in Little Rooms: On the Phenomenology of Theater* (Berkeley: University of California Press, 1985).

14 Kimberly W. Benston, *Performing Blackness: Enactments of African-American Modernism* (London: Routledge, 2000), 29. Notably, however, Benston explicitly disassociates black theater's accomplishment in this respect from what he sees as a politically *disabling* Brechtian avant-gardism.

15 Ibid., 72, 71, 78.

16 Adrienne Kennedy, *The Owl Answers* (1965, 1969), in *The Adrienne Kennedy Reader*, introd. Werner Sollors (Minneapolis: University of Minnesota Press, 2001), 29, 32.

17 Ibid., 29.

18 Ibid., 31–32, 30.

19 Benston, *Performing Blackness*, 71–72, 73.

20 Suzan-Lori Parks, *Imperceptible Mutabilities in the Third Kingdom*, first produced 1989 (Los Angeles: Sun and Moon, 1995), 29–30; all citations are to this edition unless otherwise noted. Regarding Aretha's allegorical significance, note that it is specifically upon the invocation of "Amendment XIII," which eliminated slavery within the U.S., that Aretha is elsewhere in the play told, "You have been extracted from the record. . . . You are free. You are clear. You may go"; see ibid., 43.

21 Thus the play not only recognizes but also consolidates what Kimberly Wallace-Sanders calls the black mammy's "dual role as surrogate and biological mother," since it suggests that Aretha's "white charges" and her "own children" (to use Wallace-Sanders's terms) are in fact one and the same. See Wallace-Sanders, *Mammy: A Century of Race, Gender, and Southern Memory* (Ann Arbor: University of Michigan Press, 2008), esp. 4–8 (6, 7 for the quotations). For evidence of Aretha's wet-nurse service in *Imperceptible Mutabilities*, see 37–38.

22 For the "Mr. Charles" references, see Parks, *Imperceptible Mutabilities*, 29, 37; for "Charles," see 44–45. While the cited edition of the play has Aretha three times explicitly name Charles as her "husband" (34, 36, 41), an evidently later version substitutes the word *master* for *husband* in the latter two of these iterations. See Parks, *Imperceptible Mutabilities in the Third Kingdom*, in *The America Play and Other Works* (New York: Theatre Communications Group, 1995), 45, 47, 51.

23 Parks, *Imperceptible Mutabilities*, 40, 40–41, 42.

24 Ibid., 28.

25 *Imperceptible Mutabilities in the Third Kingdom*, written by Suzan-Lori Parks, dir. Liz Diamond, premiered at BACA Downtown, Brooklyn, New York, September 9, 1989. The commentary presented here is based on review of the video recording of this production housed in the Billy Rose Theatre Collection at the New York Public Library for the Performing Arts.

Given Diamond's use of the dolls in this scene, it worth noting that in 1926, Raggedy Ann and Raggedy Andy's creator, John Gruelle, provided the characters with their own mammy, Beloved Belindy; see Wallace-Sanders, *Mammy*, 35.

26 Parks, *Imperceptible Mutabilities*, 57–58.

27 Benston himself would seem to be making this point when he asserts that, unlike Kennedy's supposedly more authorially bound *The Owl Answers*, Shange's *for colored girls* successfully resists being turned into mere "text" (and thus is more critically efficacious than Kennedy's work), by virtue of its emphatically collectivist and performative character—except that he deduces that character precisely from Shange's text alone, absent any consideration of the piece in live performance (see Benston, *Performing Blackness*, 80–112). Then, too, I would argue that whatever interpretive flexibility *for colored girls* thus allows is curtailed by its manifestation as realist narrative (or as a collection of such narratives)—hence

its vulnerability to the sort of vitriolic criticism that greeted its production in the mid- to late 1970s, as noted in chapter 3.

28 Note as well that only 75 percent of book retailers reported their sales figures for tabulation. See Jim Milliot, "Rate of Print Decline Flattened in 2012," *Publishers Weekly*, January 7, 2013, 3; Milliot, "BEA 2013: The E-book Boom Years," *Publishers Weekly*, May 29, 2013, http://www. publishersweekly.com/pw/by-topic/ industry-news/bea/article/57390-bea-2013-the-e-book-boom-years.html; and Roland J. Kushner and Randy Cohen, *National Arts Index 2014* (Washington, DC: Americans for the Arts, 2014), 64, 65, 72, indicators 46, 47, and 54.

29 This observation comports with Homer Obed Brown's claim that the novel currently enjoys academic-institutional legitimation in proportion with its evident "relevance to contemporary concerns" (Brown, *Institutions of the English Novel: From Defoe to Scott* [Philadelphia: University of Pennsylvania Press, 1997], x–xi; see also Brown, "Why the Story of the Origin of the (English) Novel Is an American Romance (If Not the Great American Novel)," in *Cultural Institutions of the Novel*, ed. Deidre Lynch and William Warner [Durham, NC: Duke University Press, 1996], 11–42). On the limits potentially posed for black studies curricula by the textualism of "traditional humanities programs," see Fabio Rojas, *From Black Power to Black Studies: How a Radical Social Movement Became an Academic Discipline* (Baltimore: Johns Hopkins University Press, 2007), 198–99.

Bibliography

Unless otherwise indicated, all web pages were last retrieved on February 4, 2015.

Abbott, H. Porter. *The Cambridge Introduction to Narrative*. Cambridge: Cambridge University Press, 2002.

Adorno, Theodor. "Reconciliation under Duress." 1958. Translated by Rodney Livingstone. In Bloch et al., *Aesthetics and Politics*, 151–76.

Allen, Walter C., and Brian A. L. Rust. *"King" Oliver*. 1955. Revised by Laurie Wright. Chigwell, UK: Storyville, 1987.

"Amos Interviews Fred Wilson, Designer of Cultural Trail 'Slave' Statue." PraiseIndy.com, October 20, 2010, http://praiseindy.com/434401/audio-amos-interviews-fred-wilson -designer-of-cultural-trail-slave-statue/.

Anesko, Michael. "Recent Critical Approaches." In *The Cambridge Companion to American Realism and Naturalism: Howells to London*, edited by Donald Pizer, 77–94. Cambridge: Cambridge University Press, 1995.

Aristotle. *Politics*. In *Aristotle XXI*, translated by H. Rackham. 1932. Reprint, Cambridge, MA: Harvard University Press, 1944.

Armstrong, Lil Hardin. "Satchmo and Me." 1956. *American Music* 25, no. 1 (2007): 106–18.

Armstrong, Louis. *Satchmo: My Life in New Orleans*. 1954. Centennial ed. New York: Da Capo, 1986.

———. "Weather Bird." With piano accompaniment by Earl Hines. OKeh 41454. Recorded December 5, 1928.

Armstrong, Robert, and Janet Shenk. *El Salvador: The Face of Revolution*. Boston: South End, 1982.

Arnheim, Rudolf. *The Power of the Center: A Study of Composition in the Visual Arts*. New version. Berkeley: University of California Press, 1988.

———. *Visual Thinking*. Berkeley: University of California Press, 1969.

Art Ensemble of Chicago with Cecil Taylor. *Thelonious Sphere Monk: Music Inspired by and Dedicated to Thelonious Sphere Monk*. Dreaming of the Masters, vol. 2. DIW-846-E, 1991. Recorded January–March 1990.

Art Star and the Sudanese Twins, The. Directed by Pietra Brettkelly. KinoSmith, 2008.

Association of American Painters and Sculptors. *The Armory Show: Exhibition of Modern Art, 1913*. New York: Arno, 1972.

Auerbach, Erich. *Mimesis: The Representation of Reality in Western Literature*. 1946. Translated by Willard R. Trask. 1953. Reprint, Princeton, NJ: Princeton University Press, 1968.

Babitz, Sol. "Bebop." *Record Changer*, December 1947, 9.

Bakhtin, Mikhail. "Discourse in the Novel." Written ca. 1934–35, published 1975. In *The Dialogic Imagination: Four Essays*, edited by Michael Holquist, translated by Caryl Emerson and Holquist, 259–422. Austin: University of Texas Press, 1981.

Bal, Mieke. *Narratology: Introduction to the Theory of Narrative*. 1980. Translated by Christine van Boheemen. Toronto: University of Toronto Press, 1985.

Balliett, Whitney. "Cecil." In *American Musicians II: Seventy-Two Portraits in Jazz*, 514–20. New York: Oxford University Press, 1996.

Banta, Martha. *Barbaric Intercourse: Caricature and the Culture of Conduct, 1841–1936*. Chicago: University of Chicago Press, 2003.

Barchas, Janine. *Graphic Design, Print Culture, and the Eighteenth-Century Novel*. Cambridge: Cambridge University Press, 2003.

Barksdale, Richard. "Castration Symbolism in Recent Black American Fiction." *CLA Journal* 29, no. 4 (1986): 400–413.

Barthes, Roland. "Introduction to the Structural Analysis of Narratives." 1966. In *Image–Music–Text*, translated by Stephen Heath, 79–124. New York: Hill and Wang, 1977.

Beaufort, John. "Broadway's 'I Have a Dream': A Stirring Reminder." *Christian Science Monitor*, September 23, 1976, 22.

Becker, George. "Modern Realism as a Literary Movement." In *Documents of Modern Literary Realism*, edited by Becker, 3–38. Princeton, NJ: Princeton University Press, 1963.

Beecroft, Vanessa. Artist's website. http://www.vanessabeecroft.com/.

———. *Vanessa Beecroft Performances, 1993–2003*. Edited by Marcella Beccaria. Milan: Skira, 2003.

Beecroft, Vanessa, and David Hickey. *VB 08-36: Vanessa Beecroft Performances*. Ostfildern, Germany: Hatje Cantz, 2000.

Benevolo, Leonardo. *History of Modern Architecture*. 2 vols. 3rd rev. ed. Translated by H. J. Landry. London: Routledge and Kegan Paul; Cambridge, MA: MIT Press, 1971.

Benston, Kimberly W. *Performing Blackness: Enactments of African-American Modernism*. London: Routledge, 2000.

Benveniste, Emile. "The Nature of Pronouns." 1956. Chap. 20 in *Problems in General Linguistics* (1966), 217–22. Translated by Mary Elizabeth Meek. Coral Gables, FL: University of Miami Press, 1971.

Berger, Peter, and Thomas Luckmann. *The Social Construction of Reality: A Treatise in the Sociology of Knowledge*. Garden City, NY: Doubleday, 1966.

Bergreen, Laurence. *Louis Armstrong: An Extravagant Life*. New York: Broadway, 1997.

Berkhofer, Robert F., Jr. *The White Man's Indian: Images of the American Indian from Columbus to the Present*. 1978. Reprint, New York: Vintage, 1979.

Berlant, Lauren. "National Brands / National Body: *Imitation of Life*." 1991. Chap. 3 in *The Female Complaint: The Unfinished Business of Sentimentality in American Culture*, 107–44. Durham, NC: Duke University Press, 2008.

Berlin, Ira. *Many Thousands Gone: The First Two Centuries of Slavery in North America*. Cambridge, MA: Harvard University Press, 1998.

Bevan, Clifford, and Alyn Shipton. "Mute." In Kernfeld, *New Grove Dictionary of Jazz*, 2:858–62.

Billie Holiday and Her Orchestra. "The Man I Love." Vocalion/OKeh 5377. Recorded December 13, 1939.

Blackmer, Corinne. "African Masks and the Arts of Passing in Gertrude Stein's 'Melanctha' and Nella Larsen's *Passing*." *Journal of the History of Sexuality* 4, no. 2 (1993): 230–63.

"Black Sexism Debate, The." Special issue, *Black Scholar* 10, nos. 8–9 (1979).

Bloch, Ernst, Georg Lukács, Bertolt Brecht, Walter Benjamin, and Theodor Adorno. *Aesthetics and Politics*. 1977. Reprint, London: Verso, 1980.

Bois, Yves-Alain. "The Iconoclast." In *Piet Mondrian, 1872–1944*, 313–72. Exhibition catalog. Boston: Little, Brown, 1995.

Bolden, Tony. *Afro-Blue: Improvisations in African American Poetry and Culture*. Urbana: University of Illinois Press, 2004.

———. "Cultural Resistance and Avant-Garde Aesthetics: African American Poetry from 1970 to the Present." In *The Cambridge History of African American Literature*, edited by Maryemma Graham and Jerry W. Ward, Jr., 532–65. Cambridge: Cambridge University Press, 2011.

Booth, Wayne. *The Rhetoric of Fiction*. 1961. 2nd ed. Chicago: University of Chicago Press, 1983.

Bordwell, David. *Narration in the Fiction Film*. Madison: University of Wisconsin Press, 1985.

Bourdieu, Pierre. "The Market of Symbolic Goods." 1971. Translated by Rupert Swyer. In *The Field of Cultural Production: Essays on Art and Literature*, edited by Randal Johnson, 112–41. New York: Columbia University Press, 1993.

Bourdon, David. Review of Ellen Gallagher at Mary Boone (New York). *Art in America*, April 1996, 111.

Bower, Anne. *Epistolary Responses: The Letter in 20th-Century American Fiction and Criticism*. Tuscaloosa: University of Alabama Press, 2007.

Bowles, Juliette. "Extreme Times Call for Extreme Heroes." Unsigned opinion piece. In "Stereotypes Subverted? Or for Sale?," special issue, *International Review of African American Art* 14, no. 3 (1997): 3–15.

Bray, Joe. *The Epistolary Novel: Representations of Consciousness*. London: Routledge, 2003.

Brecht, Bertolt. "Against Georg Lukács." 1938, 1967. Translated by Stuart Hood. In Bloch et al., *Aesthetics and Politics*, 68–85.

———. "Alienation Effects in Chinese Acting." 1936. In Brecht, *Brecht on Theatre*, 91–99.

———. *Brecht on Theatre: The Development of an Aesthetic*. Edited and translated by John Willett. 1964. Reprint, New York: Hill and Wang, 1992.

———. "Short Description of a New Technique of Acting Which Produces an Alienation Effect." 1940, 1951. In Brecht, *Brecht on Theatre*, 136–47.

———. "A Short Organum for the Theatre." In Brecht, *Brecht on Theatre*, 179–205.

———. "The Street Scene: A Basic Model for an Epic Theatre." Ca. 1938, 1950. In Brecht, *Brecht on Theatre*, 121–29.

———. "Theatre for Pleasure or Theatre for Instruction." Ca. 1936, 1957. In Brecht, *Brecht on Theatre*, 69–77.

Brent, Linda (Harriet Jacobs). *Incidents in the Life of a Slave Girl, Written by Herself*. Boston, 1861.

Brewster, Ben. "From Shklovsky to Brecht: A Reply." *Screen* 15, no. 2 (1974): 82–102.

Bridgman, Richard. "Melanctha." *American Literature* 33, no. 3 (1961): 350–59.

Brown, Bill. "Reification, Reanimation, and the American Uncanny." *Critical Inquiry* 32, no. 2 (2006): 175–207.

Brown, Homer Obed. *Institutions of the English Novel: From Defoe to Scott*. Philadelphia: University of Pennsylvania Press, 1997.

———. "Why the Story of the Origin of the (English) Novel Is an American Romance (If Not the Great American Novel)." In *Cultural Institutions of the Novel*, edited by Deidre Lynch and William B. Warner, 11–42. Durham, NC: Duke University Press, 1996.

Brown, Milton Wolf. *The Story of the Armory Show*. 2nd ed. New York: Abbeville, 1988.

Büchmann-Møller, Frank. *You Just Fight for Your Life: The Story of Lester Young*. New York: Praeger, 1990.

Bullen, J. B., ed. *Post-Impressionists in London*. London: Routledge, 1988.

Bullitt, John M. Introduction to *Pamela, by Samuel Richardson; Shamela, by Henry Fielding*, 1–18. New York: Signet, 1980.

Bürger, Peter. *Theory of the Avant-Garde*. 1974. Translated by Michael Shaw. Minneapolis: University of Minnesota Press, 1984.

Butler, Judith. *The Psychic Life of Power: Theories in Subjection*. Stanford, CA: Stanford University Press, 1997.

Camhi, Leslie. "Skin Deep." *Village Voice*, May 12, 1998, 141.

Carmichael, Hoagy. *The Stardust Road*. 1946. In *The Stardust Road & Sometimes I Wonder: The Autobiographies of Hoagy Carmichael*. New York: Da Capo, 1999.

Carmichael, Hoagy, and Sidney Arodin. "Lazy River." New York: Peer, 1931.

Carney, Vaughn A. "Publishing's Ugly Obsession." *Wall Street Journal*, June 17, 1996, Eastern edition, A1.

Carpio, Glenda. *Laughing Fit to Kill: Black Humor in the Fictions of Slavery*. New York: Oxford University Press, 2008.

Carretta, Vincent. *Equiano, the African: Biography of a Self-Made Man*. 2005. Reprint, New York: Penguin, 2006.

———. "A Note on the Text." In *The Interesting Narrative and Other Writings*, by Olaudah Equiano, ed. Carretta, xxxi–xxxii. 1995. Rev. ed. New York: Penguin, 2003.

———. "Olaudah Equiano: African British Abolitionist and Founder of the African American Slave Narrative." In *The Cambridge Companion to the African American Slave Narrative*, edited by Audrey A. Fisch, 44–60. Cambridge: Cambridge University Press, 2007.

———. "Olaudah Equiano or Gustavus Vassa? New Light on an Eighteenth-Century Question of Identity." *Slavery & Abolition* 20, no. 3 (1999): 96–105.

———. "Questioning the Identity of Olaudah Equiano, or Gustavus Vassa, the African." In *The Global Eighteenth Century*, edited by Felicity A. Nussbaum, 226–35. 2003. Reprint, Baltimore: Johns Hopkins University Press, 2005.

Carstensen, Vernon. "Patterns on the American Land." *Publius: The Journal of Federalism* 18, no. 4 (1988): 31–39.

Cartwright, Lisa, and Marita Sturken. *Practices of Looking: An Introduction to Visual Culture*. Oxford: Oxford University Press, 2001.

Cecil Taylor Quartet. "Of What." *Looking Ahead!* Contemporary 7562/3562, 1959. Recorded June 9, 1958.

Central Indiana Community Foundation. "Fred Wilson Public Art Project Discontinued." Press release. Indianapolis Cultural Trail, December 13, 2011. Archived at https://web.archive.org/web/20130828114659/http://www.indyculturaltrail.org/epluribusunumdiscontinued.html.

Chadbourne, Eugene. "Montana Taylor." In *All Music Guide to the Blues: The Definitive Guide to the Blues*, 3rd ed., edited by Vladimir Bogdanov, Chris Woodstra, and Stephen Thomas Erlewine, 541. San Francisco: Backbeat, 2003.

"Change the Joke and Slip the Yoke." Symposium sponsored by the Harvard University Art Museums, the Carpenter Center for Visual Arts, and the W. E. B. Du Bois Institute for Afro-American Research, Harvard University, Cambridge, MA, March 18–19, 1998.

Charlie Parker Quintet. "Klactoveesedstene." Dial 1040. Recorded November 4, 1947.

Charters, Samuel. *A Trumpet around the Corner: The Story of New Orleans Jazz*. Jackson: University Press of Mississippi, 2008.

Cheddie, Janice. "The Politics of the First: The Emergence of the Black Model in the Civil Rights Era." *Fashion Theory* 6, no. 1 (2002): 61–81.

Chilton, John. *The Song of the Hawk: The Life and Recordings of Coleman Hawkins*. Ann Arbor: University of Michigan Press, 1990.

Christian, Barbara. "Gloria Naylor's Geography: Community, Class, and Patriarchy in *The Women of Brewster Place* and *Linden Hills*." In Gates, *Reading Black, Reading Feminist*, 348–73.

Citizens Against Slave Image. "Why We Oppose the Slave Image." Letter to the editor. *Indianapolis Recorder*, August 5, 2011, Opinions section.

Clarke, Donald. *Billie Holiday: Wishing on the Moon*. 1994. Reprint, New York: Da Capo, 2002.

Cohan, Steven, and Linda M. Shires. *Telling Stories: A Theoretical Analysis of Narrative Fiction*. London: Routledge, 1988.

Cohen, Milton. "Black Brutes and Mulatto Saints: The Racial Hierarchy of Stein's 'Melanctha.'" *Black American Literature Forum* 18, no. 3 (1984): 119–21.

Cohn, Dorrit. *Transparent Minds: Narrative Modes for Presenting Consciousness in Fiction*. 1978. Reprint, Princeton, NJ: Princeton University Press, 1983.

Collier, James Lincoln. *Louis Armstrong: An American Genius*. New York: Oxford University Press, 1983.

———. *The Making of Jazz: A Comprehensive History*. 1978. Reprint, New York: Dell, 1979.

Collier, James Lincoln, and Barry Kernfeld. "Billie Holiday." In Kernfeld, *New Grove Dictionary of Jazz*, 2:263–64.

Color Purple, The. Directed by Steven Spielberg. Warner Bros., 1985.

"'Comments' Benefit for HCEC." *New York Amsterdam News*, June 25, 1977, D19.

Conley, Tom. *The Self-Made Map: Cartographic Writing in Early Modern France*. Minneapolis: University of Minnesota Press, 1996.

Coolen, Michael T. "Senegambian Influences on Afro-American Musical Culture." *Black Music Research Journal* 11, no. 1 (1991): 1–18.

Coomer, Martin. Review of Ellen Gallagher at Anthony d'Offay (London). *Flash Art International*, January–February 1997, 100.

Cotter, Holland. "Abstract on the Surface, with Layers of Meaning." *New York Times*, December 14, 2001, Late edition (East Coast), sec. E.

Count Basie and His Orchestra. "Jumpin' at the Woodside." Decca 64474. Recorded August 22, 1938.

Count Basie Orchestra. "One O'clock Jump." Decca 62332. Recorded July 7, 1937.

Crouch, Stanley. "Aunt Jemima Don't Like Uncle Ben." *Village Voice*, April 16, 1979, 93, 101.

Crow, Bill. *Jazz Anecdotes*. 1990. New ed. New York: Oxford University Press, 2005.

Culler, Jonathan. *Literary Theory: A Very Short Introduction*. 1997. Reprint, Oxford: Oxford University Press, 2000.

———. *The Pursuit of Signs: Semiotics, Literature, Deconstruction*. 1981. Reprint, London: Routledge, 2001.

———. *Structuralist Poetics*. 1975. Reprint, London: Routledge, 2002.

Dalton, Karen C. C., Michael D. Harris, and Lowery Stokes Sims. "The Past Is Prologue but Is Parody and Pastiche Progress? A Conversation." In "Stereotypes Subverted? Or for Sale?," special issue, *International Review of African American Art* 14, no. 3 (1997): 17–29.

Debord, Guy, and Gil J. Wolman. "A User's Guide to Détournement." 1956. In Knabb, *Situationist International Anthology*, 14–21.

"Definitions." 1958. In Knabb, *Situationist International Anthology*, 51–52.

DeKoven, Marianne. *A Different Language: Gertrude Stein's Experimental Writing*. Madison: University of Wisconsin Press, 1983.

Delannoy, Luc. *Pres: The Story of Lester Young*. 1987. Translated by Elena B. Odio. Fayette-ville: University of Arkansas Press, 1993.

Delville, Michel. *The American Prose Poem: Poetic Form and the Boundaries of Genre*. Gainesville: University Press of Florida, 1998.

Descartes, René. *Discourse on Method*. 1637. In *A Discourse on Method; Meditations on the First Philosophy; Principles of Philosophy* (1912), edited by Tom Sorell, 1–57. London: Everyman, 1994.

———. *Geometry*. 1637. Translated by David Eugene Smith and Marcia L. Latham as *The Geometry of René Descartes*. Chicago: Open Court, 1925.

DeShazer, Mary. *A Poetics of Resistance: Women Writing in El Salvador, South Africa, and the United States*. Ann Arbor: University of Michigan Press, 1994.

DeVeaux, Scott. *The Birth of Bebop: A Social and Musical History*. Berkeley: University of California Press, 1997.

Devotion, Ebenezer. *The Examiner Examined: A Letter from a Gentleman in Connecticut, to His Friend in London*. New London, CT: Timothy Green, 1766. Available at Readex, "Early American Imprints, Series I: Evans, 1639–1800" (10280).

Diggory, Terence. "Witnesses and Seers." *Salmagundi* 61 (Fall 1983): 112–24.

Dixon, Annette, ed. *Kara Walker: Pictures from Another Time*. Ann Arbor: University of Michigan Museum of Art, 2002. Published in conjunction with the exhibition *Kara Walker: An Abbreviated Emancipation (from The Emancipation Approximation)*, University of Michigan Museum of Art, Ann Arbor, MI, March 9–May 26, 2002.

"Dossier on Suture." *Screen* 18, no. 4 (1977): 23–76.

Doubiago, Sharon. "Towards an American Criticism: A Reading of Carolyn Forché's *The Country between Us*." *American Poetry Review* 12, no. 1 (1983): 35–39.

Douglass, Frederick. *Narrative of the Life of Frederick Douglass, an American Slave, Written by Himself*. Boston: Anti-Slavery Office, 1845.

Doyle, Laura. "The Flat, the Round, and Gertrude Stein: Race and the Shape of Modern(ist) History." *Modernism/Modernity* 7, no. 2 (2000): 249–71.

Du Bois, W. E. B. "Criteria of Negro Art." *Crisis*, October 1926, 290–97.

———. *The Souls of Black Folk: Essays and Sketches*. Chicago: A. C. McClurg, 1903.

Duggan, Lisa. *The Twilight of Equality? Neoliberalism, Cultural Politics, and the Attack on Democracy*. Boston: Beacon, 2003.

DuPlessis, Rachel Blau. "Manifests." *diacritics* 26, nos. 3–4 (1996): 31–53.

Dutton, Denis. "Aesthetic Universals." In *The Routledge Companion to Aesthetics*, edited by Berys Gaut and Dominic McIver Lopes, 203–14. London: Routledge, 2001.

Dyer, Richard. *White*. London: Routledge, 1997.

Edel, Leon. *The Psychological Novel, 1900–1950*. New York: Lippincott, 1955. Reissued as *The Modern Psychological Novel*. 1955. Rev. and enlarged ed. New York: Grosset and Dunlap, 1964.

Edgerton, Gary. "Ken Burns." In *Encyclopedia of Television*, 2nd ed., vol. 1, edited by Horace Newcomb, 370–72. New York: Fitzroy Dearborn, 2004.

Edwards, Brent. "The Literary Ellington." *Representations* 77 (Winter 2002): 1–29.

Ehrenberg, Lewis. *Steppin' Out: New York Nightlife and the Transformation of American Culture, 1890–1930.* 1981. Reprint, Chicago: University of Chicago Press, 1984.

Ellis, Trey. "The New Black Aesthetic." *Callaloo* 38 (Winter 1989): 233–43.

Ellison, Ralph. *Invisible Man.* New York: Random House, 1952.

Energy/Experimentation: Black Artists and Abstraction, 1964–1980. Exhibition catalog. New York: Studio Museum in Harlem, 2006.

English, Darby. *How to See a Work of Art in Total Darkness.* Cambridge, MA: MIT Press, 2007.

———. "This Is Not about the Past: Silhouettes in the Work of Kara Walker." In *Kara Walker: Narratives of a Negress*, edited by Ian Berry, English, Vivian Patterson, and Mark Reinhardt, 141–67. Exhibition catalog. Cambridge, MA: MIT Press, 2003.

Equiano, Olaudah. *The Interesting Narrative and Other Writings.* Edited and introduced by Vincent Carretta. 1995. Rev. ed. New York: Penguin, 2003.

———. *The Interesting Narrative of the Life of Olaudah Equiano, or Gustavus Vassa, the African: Written by Himself.* 2 vols. London, 1789.

———. *The Interesting Narrative of the Life of Olaudah Equiano, or Gustavus Vassa, the African: Written by Himself.* 2nd ed. 2 vols. London: T. Wilkins, 1789.

———. *The Interesting Narrative of the Life of Olaudah Equiano, or Gustavus Vassa, the African: Written by Himself.* 8th enlarged ed. Norwich, UK, 1794.

———. *The Interesting Narrative of the Life of Olaudah Equiano, or Gustavus Vassa, the African: Written by Himself.* 9th ed. London, 1794.

Eshun, Kodwo. *More Brilliant than the Sun: Adventures in Sonic Fiction.* London: Quartet, 1998.

Evenson, Brian. Review of *Annotations*, by John Keene. *Review of Contemporary Fiction* 16, no. 1 (1996): 149.

Eversley, Shelly. *The Real Negro: The Question of Authenticity in Twentieth-Century African American Literature.* New York: Routledge, 2004.

"Expanding the Repertoire." Special issue, *Tripwire: A Journal of Poetics* 5 (Fall 2001).

Farber, Lawren. "Fading: A Way. Gertrude Stein's Sources for *Three Lives.*" *Journal of Modern Literature* 5, no. 3 (1976): 463–80.

Favor, J. Martin. *Authentic Blackness: The Folk in the New Negro Renaissance.* Durham, NC: Duke University Press, 1999.

Fisher, Philip. *Still the New World: American Literature in a Culture of Creative Destruction.* Cambridge, MA: Harvard University Press, 1999.

Fitz, L. T. "Gertrude Stein and Picasso: The Language of Surfaces." *American Literature* 45, no. 2 (1973): 228–37.

Fletcher, Geoffrey. *Precious.* Shooting script of January 16, 2008. New York: Push Pictures, 2007.

Flowers, Sandra Hollin. "*Colored Girls*: Textbook for the Eighties." *Black American Literature Forum* 15, no. 2 (1981): 51–54.

Forché, Carolyn. "The Colonel." *Pequod* 11 (1980): 92. Reprinted in *Women and War: El Salvador* (New York: Women's International Resource Exchange, 1981), 22; and in *The Country between Us* (New York: Harper and Row, 1981), 16.

———. "El Salvador: An Aide Memoire." *American Poetry Review* 10, no. 4 (1981): 3–7.

———. Interview with Bill Moyers. In *The Language of Life: A Festival of Poets*, by Moyers, edited by James Haba with David Grubin, 129–41. New York: Doubleday, 1995.

Forster, Imogen. "Constructing Central America." *Red Letters* 16 (Spring–Summer 1984): 48–55.

Foucault, Michel. *The Archaeology of Knowledge*. 1969. Translated by A. M. Sheridan Smith. New York: Pantheon, 1972.

———. *Discipline and Punish: The Birth of the Prison*. 1975. Translated by Alan Sheridan. 1978. Reprint, New York: Vintage, 1995.

———. *The History of Sexuality, Vol. 1.: An Introduction*. 1976. Translated by Robert Hurley. New York: Pantheon, 1978.

Fox, Catherine. "Genius at Work: MacArthur Grant Winner Left the South's Shadow but Reflects It in Her Art." *Atlanta Journal-Constitution*, July 6, 1997, sec. L.

Franklin, Benjamin. *The Autobiography*. 1868. Reprint, New York: Vintage / Library of America, 1990.

Franklin, John Hope, and Alfred A. Moss, Jr. *From Slavery to Freedom: A History of African Americans*. 7th ed. New York: McGraw-Hill, 1994.

"Fred Wilson Introduces E Pluribus Unum." FredWilsonIndy.org, n.d. Archived at https:// web.archive.org/web/20130928015112/http://www.fredwilsonindy.org/aboutproject.html.

"Fred Wilson 2011 Joyce Award." FredWilsonIndy.org, n.d. Archived at https://web.archive .org/web/20130928015112/http://www.fredwilsonindy.org/aboutproject.html.

Friedan, Betty. *The Feminine Mystique*. 1963. Reprint, New York: Norton, 2001.

Fuegi, John. *Bertolt Brecht: Chaos, According to Plan*. Cambridge: Cambridge University Press, 1987.

Garner, Stanton B., Jr. *Bodied Spaces: Phenomenology and Performance in Contemporary Drama*. Ithaca, NY: Cornell University Press, 1994.

Gates, Henry Louis, Jr., ed. *Reading Black, Reading Feminist: A Critical Anthology*. New York: Meridian, 1990.

———. *The Signifying Monkey: A Theory of African-American Literary Criticism*. New York: Oxford University Press, 1988.

———. "The Trope of a New Negro and the Reconstruction of the Image of the Black." *Representations* 24 (Fall 1988): 129–55.

Gayle, Addison, Jr. Introduction to *The Black Aesthetic*, ed. Gayle, xv–xxiv. Garden City, NY: Doubleday, 1971.

Gelly, Dave. *Being Prez: The Life and Music of Lester Young*. Oxford: Oxford University Press, 2007.

———. *Lester Young*. Tunbridge Wells, UK: Spellmount, 1984.

Genette, Gérard. *Narrative Discourse: An Essay in Method*. Translated by Jane E. Lewin. Ithaca, NY: Cornell University Press, 1980.

Giddins, Gary. "The Avant-Gardist Who Came in from the Cold." 1975–79. In *Riding on a Blue Note: Jazz and American Pop*, 274–96. 1981. Reprint, New York: Da Capo, 2000.

———. *Satchmo*. 1992. Reprint, New York: Da Capo, 1998.

Gioia, Ted. *The History of Jazz*. 1997. Reprint, New York: Oxford University Press, 1998.

Gitelman, Lisa. *Always Already New: Media, History, and the Data of Culture*. Cambridge, MA: MIT Press, 2006.

Givhan, Robin. "Why Fashion Keeps Tripping over Race." *New York*, February 21–28, 2011, 66–70.

Glaser, Matt. Interview with Ken Burns. January 30, 1998. Transcript available at http://www.pbs.org/jazz/about/pdfs/Glaser.pdf.

Goings, Kenneth W. *Mammy and Uncle Mose: Black Collectibles and American Stereotyping*. Bloomington: Indiana University Press, 1994.

Gombrich, E. H. *Art and Illusion: A Study in the Psychology of Pictorial Representation*. Millennium ed. Princeton, NJ: Princeton University Press, 2000.

Gombrich, E. H., and Ernst Kris. *Caricature*. Harmondsworth, UK: Penguin, 1940.

Goodman, Nelson. *Ways of Worldmaking*. Indianapolis: Hackett, 1978.

Grant, Damian. *Realism*. London: Methuen, 1970.

Graves, Rean. Review of *Fire!! Baltimore Afro-American*, December 25, 1926.

Greenberg, Clement. "Avant-Garde and Kitsch." 1939. In *Art and Culture: Critical Essays*, 3–21. 1961. Reprint, Boston: Beacon, 1989.

Gregory, Deborah, and Patricia Jacobs. "The Ugly Side of the Modeling Business." *Essence*, September 1993, 89–90+.

Grossman, Jay. *Reconstituting the American Renaissance: Emerson, Whitman, and the Politics of Representation*. Durham, NC: Duke University Press, 2003.

Gussow, Mel. "Stage: 'Colored Girls' Evolves." *New York Times*, September 16, 1976, 47.

Hacking, Ian. *The Social Construction of What?* Cambridge, MA: Harvard University Press, 1999.

Hadow, William Henry. "Music and Musical Criticism: A Discourse on Method." In *Studies in Modern Music—First Series: Hector Berlioz, Robert Schumann, Richard Wagner*, 12th ed., vol. 1, 3–68. New York: Macmillan, 1892.

Halliwell, Stephen. *The Aesthetics of Mimesis: Ancient Texts and Modern Problems*. Princeton, NJ: Princeton University Press, 2002.

Hamilton, Pamela. "Child's Play: Ntozake Shange's Audience of Colored Girls." In *Reading Contemporary African American Drama: Fragments of History, Fragments of Self*, edited by Trudier Harris with Jennifer Larson, 79–97. New York: Peter Lang, 2007.

Hanslick, Eduard. *On the Musically Beautiful*. 8th ed. 1891. Translated by Geoffrey Payzant. Indianapolis: Hackett, 1986.

Harney, Stefano, and Fred Moten. *The Undercommons: Fugitive Planning and Black Study*. New York: Autonomedia / Minor Compositions, 2013.

Harper, Michael S. "Apollo Vision: The Nature of the Grid." In M. Harper, *History Is Your Own Heartbeat*, 90–91.

———. *History Is Your Own Heartbeat*. Urbana: University of Illinois Press, 1971.

———. "Michael Harper." In *Interviews with Black Writers*, edited by John O'Brien, 95–107. New York: Liveright, 1973.

———. "Zeus Muse: History as Culture." In M. Harper, *History Is Your Own Heartbeat*, 86–87.

Harper, Phillip Brian. *Are We Not Men? Masculine Anxiety and the Problem of African-American Identity*. New York: Oxford University Press, 1996.

Harrell, Margaret C., et al. *Barriers to Minority Participation in Special Operations Forces*. Santa Monica, CA: RAND, 1999.

Harris, Michael D. *Colored Pictures: Race and Visual Representation*. Chapel Hill: University of North Carolina Press, 2003.

Harrison, Andrew, ed. *Philosophy and the Visual Arts: Seeing and Abstracting*. Dordrecht, Netherlands: D. Reidel, 1987.

Hartshorn, Willis. "Director's Foreword." In *Only Skin Deep: Changing Visions of the American Self*, exhibition catalog, edited by Coco Fusco and Brian Wallis, 6–7. New York: International Center of Photography; Abrams, 2003. Published in conjunction with the exhibition of the same name, International Center of Photography, New York, NY, December 12, 2003–February 29, 2004.

Harvey, Jay. "Local Groups Pleased Sculpture Won't Be Here." *Indianapolis Star*, December 14, 2011, Local—Metro and State section.

Haughney, Christine. "On Newsstands, Allure of the Film Actress Fades." *New York Times*, June 5, 2013.

Heath, Stephen. "Notes on Suture." In "Dossier on Suture," 48–76.

Hejinian, Lyn. *My Life*. Providence, RI: Burning Deck, 1980.

———. *My Life*. Los Angeles: Sun and Moon, 1987.

———. *My Life in the Nineties*. New York: Shark, 2003.

Helle, Anita. "Elegy as History: Three Women Poets 'By the Country's Deathbed.'" *South Atlantic Review* 61, no. 2 (1996): 51–68.

Henry, Anne C. "The Re-mark-able Rise of '. . .': Reading Ellipsis Marks in Literary Texts." In *Ma(r)king the Text: The Presentation of Meaning on the Literary Page*, edited by Joe Bray, Miriam Handley, and Henry, 120–42. Ashgate, UK: Aldershot, 2000.

Hentoff, Nat. *Jazz Is*. New York: Random House, 1976.

———. "This Cat Needs No Pulitzer Prize." 1965. In *The Duke Ellington Reader*, edited by Mark Tucker, 362–68. New York: Oxford University Press, 1993.

Her Bodies: Cindy Sherman & Vanessa Beecroft. Exhibition catalog. Cheonan-si, Chungnam, Korea: Arario, 2004.

Hernadi, Paul. "Why Is Literature: A Coevolutionary Perspective on Imaginative Worldmaking." *Poetics Today* 23, no. 1 (2002): 21–42.

Hernton, Calvin C. *The Sexual Mountain and Black Women Writers: Adventures in Sex, Literature, and Real Life*. 1987. Reprint, New York: Anchor, 1990.

Herzhaft, Gérard. *Encyclopedia of the Blues*. 2nd ed. Translated by Brigitte Debord. Fayetteville: University of Arkansas Press, 1997.

Hickey, Dave. "Vanessa Beecroft's Painted Ladies." In Beecroft and Hickey, *VB 08-36: Vanessa Beecroft Performances*, 4–8.

Higgins, Hannah. *The Grid Book.* Cambridge, MA: MIT Press, 2009.

Hill, Logan. "'Art Star' Vanessa Beecroft: Slammed at Sundance." *Vulture* (blog), *New York,* January 18, 2008. http://www.vulture.com/2008/01/vanessa_beecroft_slammed_at_su.html.

Hite, Molly. "Romance, Marginality, Matrilineage: Alice Walker's *The Color Purple* and Zora Neale Hurston's *Their Eyes Were Watching God." Novel: A Forum on Fiction* 22, no. 3 (1989): 257–73.

——. "Writing—and Reading—the Body: Female Sexuality and Recent Feminist Fiction." *Feminist Studies* 14, no. 1 (1988): 121–42.

Hobbis, Peter. "Representing and Abstracting." In Harrison, *Philosophy and the Visual Arts,* 97–120.

Hoffman, Donald D. *Visual Intelligence: How We Create What We See.* New York: Norton, 1998.

Holloway, Karla. *Moorings and Metaphors: Figures of Culture and Gender in Black Women's Literature.* New Brunswick, NJ: Rutgers University Press, 1992.

Honan, William H. "MacArthur Foundation Chooses Grant Winners." *New York Times,* June 17, 1997, Late edition—Final, sec. A, 16.

hooks, bell. "Writing the Subject: Reading *The Color Purple.*" 1989. In Gates, *Reading Black, Reading Feminist,* 454–70.

Hubert, Susan. "Singing a Black Girl's Song in a Strange Land: *for colored girls* and the Perils of Canonicity." *Literary Griot* 14, nos. 1–2 (2002): 94–102.

Hughes, Langston. "The Negro Artist and the Racial Mountain." *Nation,* June 23, 1926, 692–94.

Hunt, Ron. "Ellen Gallagher." *Modern Painters* 11, no. 4 (1998): 98.

Hutchinson, Earl Ofari. "Why Are They Waiting to Exhale?" Chap. 9 in *The Assassination of the Black Male Image,* 101–13. New York: Simon and Schuster, 1996.

Imperceptible Mutabilities in the Third Kingdom. Directed by Liz Diamond. Written by Suzan-Lori Parks. Premiered at BACA Downtown, Brooklyn, New York, September 9, 1989.

Ingarden, Roman. *The Cognition of the Literary Work of Art.* 1968. Translated by Ruth Ann Crowley and Kenneth R. Olson. 1973. Reprint, Evanston, IL: Northwestern University Press, 1979.

Iser, Wolfgang. *The Implied Reader: Patterns of Communication in Prose Fiction from Bunyan to Beckett.* 1972. English ed. 1974. Reprint, Baltimore: Johns Hopkins University Press, 1978.

Jackson, John L. *Real Black: Adventures in Racial Sincerity.* Chicago: University of Chicago Press, 2005.

Jackson, Emily Nevill. *Silhouette: Notes and a Dictionary.* New York: Scribner, 1938. Reprinted as *Silhouettes: A History and Dictionary of Artists.* New York: Dover, 1981.

Jackson, Virginia. *Dickinson's Misery: A Theory of Lyric Reading.* Princeton, NJ: Princeton University Press, 2005.

Jakobson, Roman. "Shifters, Verbal Categories, and the Russian Verb." 1957. Chap. 5 in *Russian and Slavic Grammar: Studies, 1931–1981,* edited by Linda R. Waugh and Morris Halle, 41–58. Berlin: Mouton, 1984.

James, Burnett. *Billie Holiday*. Tunbridge Wells, UK: Spellmount, 1984.

James, William. *The Principles of Psychology*. Vol. 1. 1890. Reprint, New York: Dover, 1950.

Jarrett, Gene Andrew, ed. *African American Literature beyond Race: An Alternative Reader*. New York: NYU Press, 2006.

———. "Introduction: 'Not Necessarily Race Matter.'" In Jarrett, *African American Literature beyond Race*, 1–22.

Jarrett, Vernon. "A Vicious Lynching Delights Audience." *Chicago Tribune*, January 1, 1978, A6.

Jay, Martin. *Downcast Eyes: The Denigration of Vision in Twentieth-Century French Thought*. Berkeley: University of California Press, 1993.

Jazz: A Film by Ken Burns. Directed by Ken Burns. Produced by Ken Burns and Lynn Novick / Florentine Films. Broadcast January 8–31, 2001, on PBS.

Jefferson, Thomas. *Notes on the State of Virginia*. 1785. Edited by Frank Shuffelton. New York: Penguin, 1999.

Jenkins, Richard. *Social Identity*. 3rd ed. Abingdon, UK: Routledge, 2008.

Jenks, Chris. "The Centrality of the Eye in Western Culture: An Introduction." In *Visual Culture*, edited by Jenks, 1–25. London: Routledge, 1995.

Johnson, David A. "Speculations on the Bounds of Rationality in US Planning." In *Rationality in Planning: Critical Essays on the Role of Rationality in Urban and Regional Planning*, edited by Michael J. Breheny and Alan J. Hooper, 183–95. London: Pion Limited, 1985.

Johnson, E. Patrick. *Appropriating Blackness: Performance and the Politics of Authenticity*. Durham, NC: Duke University Press, 2003.

Johnson, Hildegard Binder. *Order upon the Land: The U.S. Rectangular Land Survey and the Upper Mississippi Country*. New York: Oxford University Press, 1976.

Johnson, Ken. "Art in Review: Vanessa Beecroft—'VB45/VB48.'" *New York Times*, April 12, 2002.

Jones, LeRoi (Amiri Baraka). *Black Music*. New York: William Morrow, 1967.

———. *Blues People: Negro Music in White America*. 1963. Quill ed. 1999. Reprint, New York: Perennial, 2002.

———. "Cecil Taylor." 1962. In Jones, *Black Music*, 110–12.

———. "The Changing Same (R&B and New Black Music)." In Jones, *Black Music*, 180–211.

———. "Expressive Language." *Kulchur* 3, no. 12 (1963): 77–81.

Jones, Max, and John Chilton. *Louis: The Louis Armstrong Story, 1900–1971*. Boston: Little, Brown, 1971.

Jones, Meta DuEwa. *The Muse Is Music: Jazz Poetry from the Harlem Renaissance to Spoken Word*. Urbana: University of Illinois Press, 2011.

Jordan, June. "Nobody Mean More to Me than You and the Future Life of Willie Jordan." In *On Call: Political Essays*, 123–39. Boston: South End, 1985.

Jordan, Winthrop. *White over Black: American Attitudes toward the Negro, 1550–1812*. Chapel Hill: University of North Carolina Press, 1968.

Joselit, David. "Notes on Surface: Toward a Genealogy of Flatness." *Art History* 23, no. 1 (2000): 19–34.

Jost, Ekkehard. *Free Jazz*. 1974. Reprint, New York: Da Capo, 1994.

Kant, Immanuel. *Critique of Judgement*. 1790. Translated by James Creed Meredith. Oxford: Oxford University Press, 2007.

Karp, Marilynn Gelfman. "Loving the Unloved: A Passion for Collecting." *Things* 10 (Summer 1999): 55–62.

Kauffman, Linda S. *Special Delivery: Epistolary Modes in Modern Fiction*. Chicago: University of Chicago Press, 1992.

Keene, John. *Annotations*. New York: New Directions, 1995.

Kennedy, Adrienne. *The Owl Answers*. 1965, 1969. In *The Adrienne Kennedy Reader*, introduced by Werner Sollors, 29–42. Minneapolis: University of Minnesota Press, 2001.

Kernfeld, Barry Dean, ed. *The New Grove Dictionary of Jazz*. 2nd ed. 3 vols. New York: Grove, 2002.

——. *What to Listen For in Jazz*. New Haven, CT: Yale University Press, 1995.

Keyssar, Helene. "Rites and Responsibilities: The Drama of Black American Women." In *Feminine Focus: The New Women Playwrights*, edited by Enoch Brater, 226–40. New York: Oxford University Press, 1989.

King Oliver and His Dixie Syncopators. "Wa Wa Wa." Vocalion B1033. Recorded May 29, 1926.

King Oliver and His Orchestra. "Sugar Blues." Brunswick 6065. Recorded February 18, 1931.

King Oliver's Creole Jazz Band. "Chimes Blues." Gennett 5135-B. Recorded April 5, 1923.

——. "Dipper Mouth Blues." Gennett 5132-A. Recorded April 6, 1923.

King Oliver's Jazz Band. "Mabel's Dream." Paramount 20292-B [1622-1]. Recorded December 24, 1923.

Kirkland, Edward C. *A History of American Economic Life*. Rev. ed. New York: F. S. Crofts, 1939.

Knabb, Ken, ed. *Situationist International Anthology*. Rev. and exp. ed. Translated by Knabb. Berkeley, CA: Bureau of Public Secrets, 2006.

Kontova, Helena, and Massimiliano Gioni. "Vanessa Beecroft: Skin Trade." *Flash Art* (international edition), January–February 2003, 94–97.

Krauss, Rosalind. "Grids." 1978. In Krauss, *The Originality of the Avant-Garde and Other Modernist Myths*, 9–22.

——. "The Originality of the Avant-Garde." 1981. In Krauss, *The Originality of the Avant-Garde and Other Modernist Myths*, 151–70.

——. *The Originality of the Avant-Garde and Other Modernist Myths*. Cambridge, MA: MIT Press, 1985.

Kuczynski, Alex. "Trading on Hollywood Magic: Celebrities Push Models Off Women's Magazine Covers." *New York Times*, January 30, 1999.

Kushner, Roland J., and Randy Cohen. *National Arts Index 2014*. Washington, DC: Americans for the Arts, 2014.

Lacan, Jacques. *The Four Fundamental Concepts of Psycho-Analysis*. Edited by Jacques-Alain Miller. 1973. Translated by Alan Sheridan. 1978. Reprint, New York: Norton, 1981.

————. "The Subversion of the Subject and the Dialectic of Desire in the Freudian Unconscious." 1960. Chap. 9 in *Écrits: A Selection*, 292–325. Translated by Alan Sheridan. New York: Norton, 1977.

Lange, Art, and Nathaniel Mackey. "Editor's Note." In *Moment's Notice: Jazz in Poetry and Prose*, ed. Lange and Mackey, i–ii. Minneapolis: Coffee House, 1993.

Leborg, Christian. *Visual Grammar*. 2004. Translated by Diane Oatley. New York: Princeton Architectural Press, 2006.

Lee, Felicia R. "To Blacks, Precious Is 'Demeaned' or 'Angelic,'" *New York Times*, November 20, 2009.

Lester, Neal. "Shange's Men: *for colored girls* Revisited, and Movement Beyond." *African American Review* 26, no. 2 (1992): 319–28.

Lester, Toby. *Da Vinci's Ghost: Genius, Obsession, and How Leonardo Created the World in His Own Image*. New York: Free Press, 2012.

Lewis, George E. *A Power Stronger than Itself: The AACM and American Experimental Music*. Chicago: University of Chicago Press, 2008.

Locke, Alain. "The Negro and the American Stage." *Theatre Arts Monthly* 10 (February 1926): 112–20.

Locke, John. *An Essay Concerning Human Understanding*. 2nd ed. 1694. Reprint, New York: Dover, 1959.

Logan, Rayford. *The Negro in American Life and Thought: The Nadir, 1877–1901*. New York: Dial, 1954.

Longenbach, James. *The Art of the Poetic Line*. St. Paul, MN: Graywolf, 2008.

Louis Armstrong and His Harlem Hot Band. "Dinah." Live performance, October 21, 1933, Copenhagen, Denmark. Incorporated in the feature film *København, Kalundborg og–?* (directed by Ludvig Brandstrup and Holger-Madsen; Palladium, 1934). Released as an audio recording on the compact disc *Louis Armstrong in Scandinavia, Vol. 1* (Storyville 1018348, 2005).

Louis Armstrong and His Hot Five. "Struttin' with Some Barbecue." OKeh 8566. Recorded December 9, 1927.

————. "West End Blues." OKeh 8597. Recorded June 28, 1928.

Louis Armstrong and His Orchestra. "Chinatown, My Chinatown." OKeh 41534. Recorded November 3, 1931.

————. "Lazy River." OKeh 41541. Recorded November 3, 1931.

————. "(What Did I Do to Be So) Black and Blue." OKeh 8714. Recorded July 22, 1929.

Lucie-Smith, Edward. *The Art of Caricature*. Ithaca, NY: Cornell University Press, 1981.

Lukács, Georg. "Realism in the Balance." 1938. Translated by Rodney Livingstone. In Bloch et al., *Aesthetics and Politics*, 28–59.

Lunn, Eugene. *Marxism and Modernism: An Historical Study of Lukács, Brecht, Benjamin, and Adorno*. 1982. Reprint, Berkeley: University of California Press, 1984.

Mackey, Nathaniel. *Atet A.D.* San Francisco: City Lights, 2001.

————. *Bass Cathedral*. New York: New Directions, 2008.

———. *Bedouin Hornbook*. Lexington: Callaloo Fiction Series / University of Kentucky Press, 1986.

———. *Discrepant Engagement: Dissonance, Cross-Culturality, and Experimental Writing*. Cambridge: Cambridge University Press, 1993.

———. *Djbot Baghostus's Run*. Los Angeles: Sun and Moon, 1993.

———. *From a Broken Bottle Traces of Perfume Still Emanate: Volumes 1–3*. New York: New Directions, 2010.

———. "Other: From Noun to Verb." In Mackey, *Discrepant Engagement*, 265–85.

———. *Paracritical Hinge: Essays, Talks, Notes, Interviews*. Madison: University of Wisconsin Press, 2005.

Macpherson, C. B. *The Political Theory of Possessive Individualism: Hobbes to Locke*. 1962. Reprint, Oxford: Oxford University Press, 1964.

Madhubuti, Haki. "Lucille Clifton: Warm Water, Greased Legs, and Dangerous Poetry." In *Black Women Writers (1950–1980): A Critical Evaluation*, edited by Mari Evans, 150–60. Garden City, NY: Anchor/Doubleday, 1984.

Manet and the Post-Impressionists, Nov. 8th to Jan. 15th, 1910–1911. Exhibition catalog, Grafton Galleries. London: Ballantyne, 1910.

Mann, John. "Carolyn Forché: Poetry and Survival." *American Poetry* 3, no. 3 (1986): 51–69.

Masten, Jeffrey. *Queer Philologies: Language, Sex, and Affect in Shakespeare's Time*. Philadelphia: University of Pennsylvania Press, forthcoming.

Mathes, Carter. *Imagine the Sound: Experimental African American Literature after Civil Rights*. Minneapolis: University of Minnesota Press, 2015.

Matus, Jill L. "Dream, Deferral, and Closure in *The Women of Brewster Place*." *Black American Literature Forum* 24, no. 1 (1990): 49–64.

McDowell, Deborah. "Reading Family Matters." In *Changing Our Own Words: Essays on Criticism, Theory, and Writing by Black Women*, edited by Cheryl A. Wall, 75–97. New Brunswick, NJ: Rutgers University Press, 1989.

McMillan, Terry. *Waiting to Exhale*. New York: Viking, 1992.

Mégroz, R. L. *Profile Art through the Ages: A Study of the Use and Significance of Profile and Silhouette from the Stone Age to Puppet Films*. New York: Philosophical Library, 1949.

Messaris, Paul. *Visual "Literacy": Image, Mind, and Reality*. Boulder, CO: Westview, 1994.

Meyer, Steven. *Irresistible Dictation: Gertrude Stein and the Correlations of Writing and Science*. Stanford, CA: Stanford University Press, 2001.

Miller, Jacques-Alain. "Suture (Elements of the Logic of the Signifier)." 1965, 1966. Translated by Jacqueline Rose. In "Dossier on Suture," 24–34.

Milliot, Jim. "BEA 2013: The E-book Boom Years." *Publishers Weekly*, May 29, 2013. http://www.publishersweekly.com/pw/by-topic/industry-news/bea/article/57390-bea-2013-the-e-book-boom-years.html.

———. "Rate of Print Decline Flattened in 2012." *Publishers Weekly*, January 7, 2013, 3.

Mirzoeff, Nicholas. *An Introduction to Visual Culture*. London: Routledge, 1999.

Mitchell, Carolyn. "'A Laying On of Hands': Transcending the City in Ntozake Shange's *for colored girls who have considered suicide/when the rainbow is enuf*." In *Women Writers*

and the City: Essays in Feminist Literary Criticism, edited by Susan Merrill Squier, 230–48. Knoxville: University of Tennessee Press, 1984.

Mitchell, Nora, and Emily Skoler. "History, Death, Politics, Despair." *New England Review* 17, no. 2 (1995): 67–81.

Mitchell, Stanley. "From Shklovsky to Brecht: Some Preliminary Remarks towards a History of the Politicisation of Russian Formalism." *Screen* 15, no. 2 (1974): 74–81.

Monaco, James. *How to Read a Film: Movies, Media, and Beyond.* 4th ed. New York: Oxford University Press, 2009.

Mondrian: From Figuration to Abstraction. Exhibition catalog. London: Thames and Hudson, 1988.

"Montana Taylor." In *The Encyclopedia of Popular Music*, 4th ed., vol. 8, edited by Colin Larkin, 68–69. New York: Muze; Oxford University Press, 2006.

Montgomery, Maxine Lavon. "Good Housekeeping: Domestic Ritual in Gloria Naylor's Fiction." In *Gloria Naylor's Early Novels*, edited by Margot Anne Kelley, 55–69. Gainesville: University Press of Florida, 1999.

Montgomery, Tommie Sue. *Revolution in El Salvador: From Civil Strife to Civil Peace.* 1982. 2nd ed. Boulder, CO: Westview, 1995.

Morgan, Edmund S. *Inventing the People: The Rise of Popular Sovereignty in England and America.* New York: Norton, 1988.

Morris, A. E. J. *History of Urban Form: Before the Industrial Revolutions.* 3rd ed. New York: Prentice Hall, 1994.

Moten, Fred. "Blackness and Nothingness (Mysticism in the Flesh)." *South Atlantic Quarterly* 112, no. 4 (2013): 737–80.

———. "Black Op." *PMLA* 123, no. 5 (2008): 1743–47.

———. "The Case of Blackness." *Criticism* 50, no. 2 (2008): 177–218.

———. *In the Break: The Aesthetics of the Black Radical Tradition.* Minneapolis: University of Minnesota Press, 2003.

———. "Knowledge of Freedom." *CR: The New Centennial Review* 4, no. 2 (2004): 269–310.

———. "'Words Don't Go There': An Interview with Fred Moten." By Charles Henry Rowell. *Callaloo* 27, no. 4 (2004): 953–66.

Moten, Fred, and Stefano Harney. *The Undercommons: Fugitive Planning and Black Study.* New York: Autonomedia / Minor Compositions, 2013.

National Center for Health Statistics. *Health, United States, 2013: With Special Feature on Prescription Drugs.* Hyattsville, MD: National Center for Health Statistics, 2014.

Naylor, Gloria. *The Men of Brewster Place.* New York: Hyperion, 1998.

———. *The Women of Brewster Place: A Novel in Seven Stories.* New York: Viking, 1982.

Neal, Larry. "The Black Arts Movement." *Drama Review* 12, no. 4 (1968): 29–39.

Nichols, Edward J. "Bix Beiderbecke." In Ramsey and Smith, *Jazzmen*, 143–60.

Nichols, Keith. "Muted Brass." *Storyville* 30 (August–September 1970): 203–6.

Nicholson, Stuart. *Billie Holiday.* London: Victor Gollancz, 1995.

Nielsen, Aldon Lynn. *Black Chant: Languages of African-American Postmodernism.* Cambridge: Cambridge University Press, 1997.

———. *Integral Music: Languages of African American Innovation*. Tuscaloosa: University of Alabama Press, 2004.

North, Michael. *The Dialect of Modernism: Race, Language, and Twentieth-Century Literature*. New York: Oxford University Press, 1994.

O'Brien, Maureen. "Waiting to Publish." *Publishers Weekly*, February 19, 1996, 124.

O'Connor, Mary. "Subject, Voice, and Women in Some Contemporary Black American Women's Writing." In *Feminism, Bakhtin, and the Dialogic*, edited by Dale M. Bauer and S. Jaret McKinstry, 199–217. Albany: State University of New York Press, 1991.

O'Meally, Robert. *Lady Day: The Many Faces of Billie Holiday*. New York: Arcade, 1991.

"1 Slave Is Enough." Website of Citizens Against Slave Image. http://1slave-enough.wix.com/inindy.

"Ordinance for Ascertaining the Mode of Disposing of Lands in the Western Territory, An." *Journals of the Continental Congress 1774–1789*, vol. 28, *January 11–June 30, 1785*, 375–81. Edited from the original records in the Library of Congress by John C. Fitzpatrick. Washington, DC: United States Government Printing Office, 1933.

Osbourne, Harold. *Abstraction and Artifice in Twentieth-Century Art*. Oxford: Oxford University Press, 1979.

Oudart, Jean-Pierre. "Cinema and Suture." 1969. Translated by Kari Hanet. In "Dossier on Suture," 35–47.

Owens, Thomas. *Bebop: The Music and Its Players*. New York: Oxford University Press, 1995.

Parks, Suzan-Lori. *The America Play and Other Works*. New York: Theatre Communications Group, 1995.

———. *Imperceptible Mutabilities in the Third Kingdom*. Los Angeles: Sun and Moon, 1995.

Pater, Walter. "The School of Giorgione." 1877. In *The Renaissance: Studies in Art and Poetry—The 1893 Text*, edited by Donald L. Hill, 102–22. Berkeley: University of California Press, 1980.

Patton, Sharon F. *African-American Art*. Oxford: Oxford University Press, 1998.

Peetz, Dieter. "On Attempting to Define Abstract Art." In Harrison, *Philosophy and the Visual Arts*, 135–45.

Peirce, Charles Sanders. "Logic as Semiotic: The Theory of Signs." 1897–1910. In *Philosophical Writings of Peirce*, edited by Justus Buchler, 98–119. 1940. Reprint, New York: Dover, 1955.

Peppis, Paul. "Thinking Race in the *Avant Guerre*: Typological Negotiations in Ford and Stein." *Yale Journal of Criticism* 10, no. 2 (1997): 371–95.

Perloff, Marjorie. *Dance of the Intellect: Studies in the Poetry of the Pound Tradition*. 1985. Reprint, Evanston, IL: Northwestern University Press, 1996.

———. *Radical Artifice: Writing Poetry in the Age of Media*. 1991. Reprint, Chicago: University of Chicago Press, 1994.

Perry, Warren R. *Landscape Transformations and the Archaeology of Impact: Social Disruption and State Formation in Southern Africa*. New York: Kluwer Academic / Plenum, 1999.

Petulla, Joseph M. *American Environmental History: The Exploitation and Conservation of Natural Resources*. San Francisco: Boyd and Fraser, 1977.

Phelan, Peggy. "The Golden Apple: Jennie Livingston's *Paris Is Burning*." Chap. 4 in *Unmarked: The Politics of Performance*, 93–111. London: Routledge, 1993.

Pinckney, Darryl. "Black Victims, Black Villains." *New York Review of Books*, January 29, 1987, 17–20.

Pinza, Ezio. "This Nearly Was Mine." *South Pacific*, original Broadway cast recording. Columbia ML 4180 / OL 4180, 1949.

Plato. *Republic*. In *Plato V*, 225–45. Translated by Paul Shorey. Rev. ed. Cambridge, MA: Harvard University Press, 1937.

———. *Timaeus*. In *Plato IX: Timaeus/Critias/Cleitophon/Menexenus/Epistles*, 1–253. Translated by R. G. Bury. 1929. Reprint, Cambridge, MA: Harvard University Press, 1999.

Plotinus. *The Enneads*. 3rd ed. Translated by Stephen MacKenna. Revised by B. S. Page. London: Faber and Faber, 1962.

Pond, Steven F. "Jamming the Reception: Ken Burns, *Jazz*, and the Problem of 'America's Music.'" *Notes* 60, no. 1 (2003): 11–45.

Porter, Lewis. *Lester Young*. 1985. Rev. ed. Ann Arbor: University of Michigan Press, 2005.

Povoledo, Elisabetta. "Beecroft's Living, Breathing Indictments." *New York Times*, March 26, 2009.

Powell, Richard. *Black Art and Culture in the 20th Century*. London: Thames and Hudson, 1997.

Precious: Based on the Novel "Push" by Sapphire. Directed by Lee Daniels. Lions Gate, 2009.

ProQuest Statistical Abstract of the United States 2015. Lanham, MD: Bernan, 2015.

Radano, Ronald. *Lying up a Nation: Race and Black Music*. Chicago: University of Chicago Press, 2003.

Radin, Margaret. "Property and Personhood." *Stanford Law Review* 34 (May 1982): 957–1015.

Radway, Janice. *A Feeling for Books: The Book-of-the-Month Club, Literary Taste, and Middle-Class Desire*. Chapel Hill: University of North Carolina Press, 1997.

Ramsey, Frederic, Jr. "King Oliver and His Creole Jazz Band." In Ramsey and Smith, *Jazzmen*, 59–91.

Ramsey, Frederic, Jr., and Charles Edward Smith, eds. *Jazzmen*. New York: Harcourt, Brace, 1939.

Rayner, Alice. *Ghosts: Death's Double and the Phenomena of Theatre*. Minneapolis: University of Minnesota Press, 2006.

Razaf, Andy, Thomas (Fats) Waller, and Harry Brooks. "(What Did I Do to Be So) Black and Blue." New York: Mills Music, 1929.

Rea, Paul. "The Poet as Witness: Carolyn Forché's Powerful Pleas from El Salvador." *Confluencia* 2, no. 2 (1987): 93–99.

Reed, Anthony. *Freedom Time: The Poetics and Politics of Black Experimental Writing*. Baltimore: Johns Hopkins University Press, 2014.

Reed, Ishmael. "Fade to White." *New York Times*, February 5, 2010, New York City edition, A25.

———. "An Interview with Ishmael Reed." By Mel Watkins. *Southern Review* 21, no. 3 (1985): 603–14.

Reid-Pharr, Robert F. "Black Girl Lost." In Dixon, *Kara Walker*, 27–41.

Reps, John W. *The Making of Urban America: A History of City Planning in the United States.* Princeton, NJ: Princeton University Press, 1965.

Review of *Annotations*, by John Keene. *Virginia Quarterly Review* 72, no. 3 (1996): SS93.

Richard, Frances. Review of Ellen Gallagher at Gagosian Gallery (New York). *Artforum International*, Summer 2001, 182–83.

Richards, Sandra L. "Conflicting Impulses in the Plays of Ntozake Shange." *Black American Literature Forum* 17, no. 2 (1983): 73–78.

Richardson, Brian. *Unlikely Stories: Causality and the Nature of Modern Narrative.* Newark: University of Delaware Press, 1997.

Richardson, Samuel. *The Novels of Mr. Samuel Richardson.* 19 vols. London: Heinemann, 1902.

———. *The Novels of Samuel Richardson, Esq.* 3 vols. London: Hurst, Robinson, 1824.

———. *Pamela.* 1741. Reprint, New York: Century, 1902.

———. *Pamela; or, Virtue Rewarded.* 2 vols. London: C. Rivington and J. Osborn, 1741 [1740]. Available at Literature Online, http://gateway.proquest.com/openurl/ openurl?ctx_ver=Z39.88-2003&xri:pqil:res_ver=0.2&res_id=xri:lion-us&rft_id =xri:lion:ft:pr:Z000045354:0.

———. *Writings of Samuel Richardson.* 20 vols. London: Chapman and Hall, 1902.

Richardson, Samuel, and Henry Fielding. *Pamela, by Samuel Richardson [1741]; Shamela, by Henry Fielding [1741].* Edited by John M. Bullitt. New York: Signet, 1980.

Rimmon-Kenan, Shlomith. *Narrative Fiction: Contemporary Poetics.* London: Methuen, 1983.

Rittelmann, Leesa. "Winold Reiss to Kara Walker: The Silhouette in Black American Art." In *From Black to Schwarz: Cultural Crossovers between African America and Germany*, edited by Maria Diedrich and Jürgen Heinrichs, 287–307. Berlin: LIT Verlag; East Lansing: Michigan State University Press, 2010.

Robinson, Leroy. "Sculpture Is Appalling." Letter to the editor, parts 1 and 2. *Indianapolis Recorder*, September 17 and September 24, 2010, Opinions section.

Rodgers, Richard, and Oscar Hammerstein II. "This Nearly Was Mine." New York: Williamson Music, 1949.

Rojas, Fabio. *From Black Power to Black Studies: How a Radical Social Movement Became an Academic Discipline.* Baltimore: Johns Hopkins University Press, 2007.

Rosenthal, David H. *Hard Bop: Jazz and Black Music, 1955–1965.* New York: Oxford University Press, 1992.

Rowell, Lewis. *Thinking about Music: An Introduction to the Philosophy of Music.* 1983. Reprint, Amherst: University of Massachusetts Press, 1984.

Royster, Philip M. "In Search of Our Fathers' Arms: Alice Walker's Persona of the Alienated Darling." *Black American Literature Forum* 20, no. 4 (1986): 347–70.

Rubin, Joan Shelley. *The Making of Middlebrow Culture.* Chapel Hill: University of North Carolina Press, 1992.

Rucker, Walter C., and James N. Upton, eds. *Encyclopedia of American Race Riots*. 2 vols. Westport, CT: Greenwood, 2007.

Ruddick, Lisa. *Reading Gertrude Stein: Body, Text, Gnosis*. Ithaca, NY: Cornell University Press, 1990.

Rushing, Andrea Benton. "For Colored Girls, Suicide or Struggle." *Massachusetts Review* 22, no. 3 (1981): 539–50.

Russell, Ross. "Bebop." 1948–49. In *The Art of Jazz: Ragtime to Bebop*, edited by Martin T. Williams, 187–214. 1959. Reprint, New York: Da Capo, 1981.

Russell, William. "Louis Armstrong." In Ramsey and Smith, *Jazzmen*, 119–42.

Sapphire. *Push*. 1996. Reprint, New York: Vintage, 1997.

——. "Why Stories Like 'Precious' Need to Be Told." *New York Times*, February 12, 2010, New York City edition, A30.

Saussure, Ferdinand de. *Course in General Linguistics*. Edited by Charles Bally and Albert Sechehaye, with Albert Riedlinger. 1915. Translated by Wade Baskin. 1959. Reprint, New York: McGraw-Hill, 1966.

Schapiro, Meyer. "Abstract Art." Comprising "The Nature of Abstract Art" (1937), "Recent Abstract Painting" (1957), and "On the Humanity of Abstract Painting" (1960). In *Modern Art: 19th and 20th Centuries: Selected Papers*, 185–232. New York: George Braziller, 1979.

Schopenhauer, Arthur. *The World as Will and Idea*. 4th ed. 3 vols. Translated by R. B. Haldane and J. Kemp. London: Kegan Paul, Trench, Trübner, 1896.

Schuller, Gunther. *Early Jazz: Its Roots and Musical Development*. New York: Oxford University Press, 1968.

——. *The Swing Era: The Development of Jazz, 1930–1945*. New York: Oxford University Press, 1989.

Scruton, Roger. *The Aesthetic Understanding: Essays in the Philosophy of Art and Culture*. London: Methuen, 1983.

Shange, Ntozake. "At the Heart of Shange's Feminism: An Interview." By Neal Lester. *Black American Literature Forum* 24, no. 4 (1990): 717–30.

——. *for colored girls who have considered suicide/when the rainbow is enuf*. New York: Macmillan, 1977. Previously published in a different version (under the name Ntosake Shange), San Lorenzo, CA: Shameless Hussy, 1975.

——. Interview by Claudia Tate. In *Black Women Writers at Work*, edited by Tate, 149–74. New York: Continuum, 1984.

——. "a nite with beau willie brown." In Shange, *for colored girls who have considered suicide/when the rainbow is enuf*, 55–60.

——. "no more love poems #3." In Shange, *for colored girls who have considered suicide/when the rainbow is enuf*, 44–45.

——. "with no immediate cause." In *Nappy Edges*, 111–13. 1978. Reprint, New York: Bantam, 1980.

Shaw, Gwendolyn DuBois. *Seeing the Unspeakable: The Art of Kara Walker*. Durham, NC: Duke University Press, 2004.

Shelley, Percy Bysshe. "A Defence of Poetry." Drafted 1821. In *Essays, Letters from Abroad, Fragments*, vol. 1, edited by Mary Shelley, 1–57. London: Edward Moxon, 1840.

Shepherd, John. *Music as Social Text*. Cambridge, UK: Polity, 1991.

Shklovsky, Victor. "Art as Technique." 1917. In *Russian Formalist Criticism: Four Essays*, translated and introduced by Lee T. Lemon and Marion J. Reis, 3–24. Lincoln: University of Nebraska Press, 1965.

Shockley, Evie. *Renegade Poetics: Black Aesthetics and Formal Innovation in African American Poetry*. Iowa City: University of Iowa Press, 2011.

Silverman, Kaja. "Emile Benveniste." 1983. In *Narrative Theory: Critical Concepts in Literary and Cultural Studies*, vol. 3, edited by Mieke Bal, 11–19. London: Routledge, 2004.

Simon, Herbert A. *Models of Man—Social and Rational: Mathematical Essays on Rational Human Behavior in a Social Setting*. New York: Wiley, 1957.

———. "Rational Choice and the Structure of the Environment." In Simon, *Models of Man*, 261–73.

———. "Rationality and Administrative Decision Making." In Simon, *Models of Man*, 196–206.

Sims, Lowery Stokes. "The African-American Artist and Abstraction." In *Norman Lewis: Black Paintings, 1946–1977*, 42–50. Exhibition catalog. New York: Studio Museum in Harlem, 1998.

Smedley, Audrey, and Brian D. Smedley. *Race in North America: Origin and Evolution of a Worldview*. 4th ed. Boulder, CO: Westview, 2012.

Smith, Charles Edward. "The Austin High School Gang." In Ramsey and Smith, *Jazzmen*, 161–82.

Smith, Leonora. "Carolyn Forché: Poet of Witness." In *Still the Frame Holds: Essays on Women Poets and Writers*, edited by Sheila Roberts with Yvonne Pacheco Tevis, 15–28. San Bernardino, CA: Borgo, 1993.

Smith, Roberta. "Critic's Notebook: Standing and Staring, yet Aiming for Empowerment." *New York Times*, May 6, 1998, Late edition (East Coast), sec. E.

Smith, Sandra Wilson. "Chester Himes's *The Third Generation*: A Dystopic Domestic Novel." *Southern Literary Journal* 41, no. 2 (2009): 38–52.

Snead, James A. "Repetition as a Figure of Black Culture." 1981. In *Black Literature and Literary Theory*, edited by Henry Louis Gates, Jr., 59–79. London: Methuen, 1984.

Southern, Eileen. *The Music of Black Americans: A History*. 3rd ed. New York: Norton, 1997.

Spellman, A. B. "Cecil Taylor." In *Four Lives in the Bebop Business*, 1–78. 1966. Reprint, New York: Limelight, 1994.

Stalker, James. "Reader Expectations and the Poetic Line." *Language and Style* 15, no. 4 (1982): 241–52.

Staples, Robert. "The Myth of Black Macho: A Response to Angry Black Feminists." *Black Scholar* 10, nos. 6–7 (1979): 24–33.

States, Bert O. *Great Reckonings in Little Rooms: On the Phenomenology of Theater*. Berkeley: University of California Press, 1985.

Stearns, Marshall W. *The Story of Jazz*. New York: Oxford University Press, 1956.

Stein, Gertrude. "Composition as Explanation." 1926. In *Selected Writings of Gertrude Stein*, edited by Carl Van Vechten, 511–23. 1946, 1962. Reprint, New York: Vintage, 1990.

———. "Melanctha." In *Three Lives: Stories of the Good Anna, Melanctha and the Gentle Lena*. New York: Grafton, 1909.

———. *Tender Buttons: Objects, Food, Rooms*. New York: Claire Marie, 1914.

Steinmetz, Julia, Heather Cassils, and Clover Leary. "Behind Enemy Lines: Toxic Titties Infiltrate Vanessa Beecroft." In "New Feminist Theories of Visual Culture," edited by Jennifer Doyle and Amelia Jones, special issue, *Signs: Journal of Women in Culture and Society* 31, no. 3 (2006): 753–83.

"Stereotypes Subverted? The Debate Continues." *International Review of African American Art* 15, no. 2 (1998): 44–52.

Stevens, Mark. "Skin Games." *New York*, February 2, 2004, 50.

Stewart, Susan. *On Longing: Narratives of the Miniature, the Gigantic, the Souvenir, the Collection*. 1984. Reprint, Durham, NC: Duke University Press, 1993.

Stilman, Anne. *Grammatically Correct: The Writer's Essential Guide to Punctuation, Spelling, Style, Usage and Grammar*. Cincinnati: Writer's Digest Books, 1997.

Storr, Robert. "A Funny Thing Happened . . ." In *Ellen Gallagher*, 29–37. Boston: Institute of Contemporary Art, 2001. Published in conjunction with the exhibition *Watery Ecstatic*, Institute of Contemporary Art, Boston, MA, October 17–December 31, 2001.

Such, David G. *Avant-Garde Jazz Musicians: Performing "Out There."* Iowa City: University of Iowa Press, 1993.

Sullivan, Dan. "Confessions by 'Colored Girls.'" *Los Angeles Times*, February 7, 1977, E1, 11.

Tanner, Laura. *Intimate Violence: Reading Rape and Torture in Twentieth-Century Fiction*. Bloomington: Indiana University Press, 1994.

Tapley, Mel. "Abiodun Oyewole's 'Comments' Answer 'For Colored Girls' Applauded." *New York Amsterdam News*, May 14, 1977, D15.

———. "Gallery Benefit Performance of 'Comments.'" *New York Amsterdam News*, November 19, 1977, D8.

Taylor, Cecil. *The World of Cecil Taylor*. Candid 8006/9006. Recorded October 12–13, 1960.

Teachout, Terry. *Pops: A Life of Louis Armstrong*. Boston: Houghton Mifflin Harcourt, 2009.

Templeton, Alice. "What's the Use? Writing Poetry in Wartime." *College Literature* 34, no. 4 (2007): 43–62.

"Theories and Methodologies: What Was African American Literature?" *PMLA* 128, no. 2 (2013): 386–408.

Thomas, Anabel. *An Illustrated Dictionary of Narrative Painting*. London: John Murray, 1994.

Toomer, Jean. *Cane*. New York: Boni and Liveright, 1923.

Towers, Robert. "Good Men Are Hard to Find." *New York Review of Books*, August 12, 1982, 35–36.

Trebay, Guy. "Ignoring Diversity, Runways Fade to White." *New York Times*, October 14, 2007.

———. "Racism on the Runway: Not an Ethnic Moment." *Village Voice*, May 9, 1995, 23–27.

Tristano, Lennie. "What's Right with the Beboppers." *Metronome*, July 1947, 14, 31.

———. "What's Wrong with the Beboppers." *Metronome*, June 1947, 16.

Turner, Patricia A. *Ceramic Uncles and Celluloid Mammies: Black Images and Their Influence on Culture*. New York: Anchor, 1994.

Ulanov, Barry. *A History of Jazz in America*. 1952. Reprint, New York: Viking, 1955.

U.S. Census Bureau. *Current Population Survey*. Educational Attainment. CPS Historical Time Series Tables. http://www.census.gov/hhes/socdemo/education/data/cps/historical/.

van de Walle, Mark. "Openings: Ellen Gallagher." *Artforum International*, February 1996, 76–77.

Vanessa Beecroft: Photographs, Films, Drawings. Exhibition catalog. Edited by Thomas Kellein. Ostfildern, Germany: Hatje Cantz, 2004.

Vatulescu, Cristina. *Police Aesthetics: Literature, Film, and the Secret Police in Soviet Times*. Stanford, CA: Stanford University Press, 2010.

Villanueva, Darío. *Theories of Literary Realism*. 1992. Rev. ed. Translated by Mihai Spariosu and Santiago García-Castañón. Albany: State University of New York Press, 1997.

Vitruvius. *On Architecture*. Ca. 30–20 BCE. Edited and translated by Frank Granger. 2 vols. Cambridge, MA: Harvard University Press, 1931.

———. *Ten Books on Architecture*. Ca. 30–20 BCE. Translated by Ingrid D. Rowland. Cambridge: Cambridge University Press, 1999.

———. *The Ten Books on Architecture*. Ca. 30–20 BCE. Translated by Morris Hicky Morgan. Cambridge, MA: Harvard University Press, 1914.

Waiting to Exhale. Directed by Forest Whitaker. 20th Century-Fox, 1995.

Walker, Alan. "Musical Criticism." *Encyclopædia Britannica Online*. http://www.britannica.com/EBchecked/topic/399158/musical-criticism.

Walker, Alice. *The Color Purple*. New York: Harcourt Brace Jovanovich, 1982.

———. "Saving the Life That Is Your Own: The Importance of Models in the Artist's Life." 1976. In *In Search of Our Mothers' Gardens: Womanist Prose*, 3–14. San Diego: Harcourt Brace Jovanovich, 1983.

Walker, Kara. "Artists: Kara Walker." Sikkema Jenkins & Co. Gallery website. http://www.sikkemajenkinsco.com/index.php?v=artist&artist=4eece69f3eb4e.

———. Biography. Sikkema Jenkins & Co. Gallery website. Archived at https://web.archive.org/web/20120101000000/http://sikkemajenkinsco.com/karawalker_bio.pdf.

———. Interview by Alexander Alberro. *Index* 1 (February 1996): 25–28. Reprinted in *Kara Walker: Upon My Many Masters—An Outline*. Exhibition brochure. With text by Gary Garrels. San Francisco: San Francisco Museum of Modern Art, 1997.

Wallace, Michele. *Black Macho and the Myth of the Superwoman*. New York: Dial, 1979.

Wallace-Sanders, Kimberly. *Mammy: A Century of Race, Gender, and Southern Memory*. Ann Arbor: University of Michigan Press, 2008.

Warner, Michael. *The Letters of the Republic: Publication and the Public Sphere in Eighteenth-Century America*. Cambridge, MA: Harvard University Press, 1990.

———. "The Mass Public and the Mass Subject." 1991. Chap. 4 in *Publics and Counterpublics*, 159–86. New York: Zone Books, 2002.

Warren, Kenneth W. *What Was African American Literature?* Cambridge, MA: Harvard University Press, 2011.

Waters, William. *Poetry's Touch: On Lyric Address.* Ithaca, NY: Cornell University Press, 2003.

Watkins, Mel. "Sexism, Racism and Black Women Writers." *New York Times Book Review*, June 15, 1986, 1, 35–37.

Watt, Ian. "The Naming of Characters in Defoe, Richardson, and Fielding." *Review of English Studies* 25, no. 100 (1949): 322–38.

Webb, Veronica. "Where Have All the Black Models Gone?" *Essence*, September 1996, 108+.

Weheliye, Alexander. *Phonographies: Grooves in Sonic Afro-Modernity.* Durham, NC: Duke University Press, 2005.

Westcott, James. "*VB54*: Black Tie vs. Black Face." *TDR* 49, no. 1 (2005): 114–18.

Wettling, George. "Lincoln Gardens." *HRS Society Rag*, December 1940, 24–26.

Whitburn, Joel. *Joel Whitburn Presents Top R&B/Hip-Hop Singles, 1942–2004.* Menomonee Falls, WI: Record Research, 2004.

White, Constance. "Black Out: What Has Happened to the Black Models?" *Ebony*, September 2008, 98–100.

Whitehead, Colson. Review of *Annotations*, by John Keene. In "Briefs," *Voice Literary Supplement*, *Village Voice*, December 5, 1995, SS8.

Wilde, Carolyn. "Painting, Expression, Abstraction." In Harrison, *Philosophy and the Visual Arts*, 29–50.

Williams, Martin. *King Oliver.* 1960. In *Kings of Jazz*, edited by Stanley Green, 241–72. South Brunswick, NJ: A. S. Barnes, 1978.

Williams, William Carlos. "An Interview with William Carlos Williams." By John W. Gerber. 1950. Edited by Emily M. Wallace. *Massachusetts Review* 14, no. 1 (1973): 130–48.

———. "This Is Just to Say." 1934. In *Selected Poems*, edited by Charles Tomlinson, 74. New York: New Directions, 1985.

Williams-Gibson, Jessica. "Controversial Public Art Project Is Discontinued." *Indianapolis Recorder*, December 16, 2011, A1+.

Wilmer, Valerie. *As Serious as Your Life: John Coltrane and Beyond.* 1977. Reprint, London: Serpent's Tail, 1992.

Wilson, Edwin. "The Black Experience: Two Approaches." *Wall Street Journal*, September 21, 1976, 24.

Wilson, Eric. "Fashion's Blind Spot." *New York Times*, August 8, 2013, Late edition, sec. E.

Wintour, Anna. "Letter from the Editor: Fashion's New Faces." *Vogue*, July 1997, 26.

Wittgenstein, Ludwig. "The Brown Book." 1934–35. In *The Blue and Brown Books: Preliminary Studies for the "Philosophical Investigations"* (1958), 2nd ed., 75–185. New York: Harper and Row, 1960.

Women Donors Network, Reflective Democracy Campaign. "Who Leads Us?" http://wholeads.us/.

"'Women of Brewster Place' Is Put to Music." Broadcast transcript. *Tell Me More*. NPR. October 18, 2007. http://www.npr.org/templates/story/story.php?storyId=15393016.

Woodmansee, Martha. *The Author, Art, and the Market: Rereading the History of Aesthetics.* New York: Columbia University Press, 1994.

Woods, Vicki. "Is Fashion Racist?" *Vogue*, July 2008, 134–41+.

Woolf, Virginia. "Mr. Bennett and Mrs. Brown." 1924. In *The Captain's Death Bed and Other Essays*, 94–119. 1950. Reprint, San Diego: Harcourt Brace Jovanovich, 1978.

Worringer, Wilhelm. *Abstraction and Empathy: A Contribution to the Psychology of Style.* 1908. Translated by Michael Bullock. 1953. Reprint, Chicago: Ivan R. Dee, 1997.

Worth, Alexi. Review of Ellen Gallagher at Mary Boone (New York). *ARTnews*, April 1996, 132.

Wright, Richard. "Blueprint for Negro Writing." *New Challenge* 11 (2, no. 2; 1937): 53–65.

Wright, Thomas. *History of Caricature and Grotesque in Literature and Art.* 1865. Introduced by Frances K. Barasch. New York: Frederick Ungar, 1968.

Younge, Gary. "Fashion Industry Scandal: The Trends That Make Beauty Skin Deep." *Guardian* (UK), November 24, 1999, 3.

Index

Page numbers in italics refer to illustrations.

Abstract art: characterized, 23–24; nonmimetic character of, 73; reflexivity of, 23

Abstraction: and abstractionism, 2, 4; in African American music, 71; African American resistance to, 4; and African Americans, 4, 9, 25–26, 27–28, 31, 56–57, 62, 67, 69; artifice in, 62–63; as atemporality, 81; danger of, in music, 72, 82, 85–86; defined, 2, 19, 192n5; as epitomized by music, 10, 70–73, 83, 85–86, 92, 105, 112, 188n22; in *E Pluribus Unum* (Wilson), 9, 188n20; as freedom, 81; and the grid, 33–34, 40, 42–43, 44–46; in jazz, 71, 72, 74–82, 86–87; in the music of Armstrong, 71, 76–83, 94; in the music of Oliver, 71, 73–76, 81, 94; vs. narrative, 85, 92, 114; in pictorial depiction, 19; and slavery 31, 57, 62; and subjective enhancement, 31–32; in visual culture, 114; in work of Beecroft, 53, 57

Abstractionism: and abstraction, 2, 4; in African American expressive culture, 9, 180, 232n99; in African American literature, 159–60; in African American music, 71; in African American theater, 173–74; and alienation effect, 3–4, 173; in *Annotations* (Keene), 149, 158–59, 160; in *Cane* (Toomer), 160; vs. characterization in fictional prose narrative, 147–48, 160; characterized, 23, 24; in "The Colonel" (Forché), 138; in *The Color Purple* (A. Walker), 159–60; critical efficacy of, 180; critical function of, 2; defined, 2–3; in *E Pluribus Unum* (Wilson), 7, 9, 63; and figuration, 63; in *From a Broken Bottle . . .* (Mackey), 160; in *Imperceptible Mutabilities . . .* (Parks), 175–80; limits of, in theater, 180, 234–35n27; in literature, 167; in "Melanctha" (Stein), 147–48; in music, 114–15; in narrative, 11, 115, 131, 172;

Abstractionism (*continued*)
and narrative disruption, 161; in non-Aristotelian theater, 3–4; in *The Owl Answers* (Kennedy), 174–75, 180; in prose, 12–13, 140; in prose fiction, 11, 167, 175, 180; in the prose poem, 138–39; and racial caricature, 25–28; and reading protocols for African American literature, 160; vs. realist aesthetics, 67; and social critique, 4, 25, 58, 62, 114–15, 140, 160, 175, 180; and social reality, 2–3; in *The Souls of Black Folk* (Du Bois), 160; in theater, 179–80; in verse poetry, 135–36; in visual art, 9–10, 58, 63–67; in visual culture, 27, 58–62, 67, 114, 131; in *The Women of Brewster Place* (Naylor), 159–60; in the work of Beecroft, 53–56, 57–58; in the work of Gallagher, 63; in the work of Rankine, 160; in the work of Simpson, 63; in the work of K. Walker, 10, 21–23, 24, 25, 57–58, 63–67, 117, 124, 131, 147–48

Abstract personhood: as emblematized by the grid, 32–34; and Franklin, 32–33; and generic perfection, 62; and rationality, 31; in representative democracy, 31. *See also* Generic perfection

Academia, U.S., and African American culture, 180

Aesthetics, Western: mimesis in, 194n12; referentiality in, 23

African American expressive culture: and abstractionism, 9, 180, 232n99; and aesthetic disinterestedness, 195n15; critical potential of, 1–2; defined, 1; music as epitome of, 10, 11, 70, 112, 144; narrative as constitutive of, 117; and polemic, 1; as political project, 1–2; and proper blackness, 2; and realist aesthetics, 2, 12; repetition in, 232n99; and U.S. academia, 180.

African American literature: abstractionism in, 159–60; critical significance of, 160; experimental prose in, 12–13;

parameters of, 160; postmodernism in, 159; realism as hegemonic in, 160

African American music: abstraction in, 71; as constitutive of black community, 96–97; development of, 94–97, 108; historical-narrative constitution of, 93–94, 97, 108–9, 110–15; as narrative: 11; and social critique, 215–16n96; social significance of, 96–97, 110–11. *See also* Jazz; Music

African Americans: and abstraction, 4, 9, 25–26, 27–28, 31, 56–57, 62, 67, 69; "negative" depictions of, 8, 9, 10, 17; "positive" depictions of, 2; and property, 31

African American theater: abstractionism in, 173–74; alienation effect in, 173–74, 233n14; and Brechtian theory, 187n10; social critique in, 173–75

Alienation effect, 7; and abstractionism, 3–4, 173; in African American theater, 173–74, 233n14; Brecht on, 3, 7, 12; vs. defamiliarization, 186n6; and social critique, 3–4; in theater, 173; in work of K. Walker, 24–25

Allegory, in *Imperceptible Mutabilities . . .* (Parks), 176, 234n20

Ambiguity: in work of Beecroft, 57–58; in work of K. Walker, 57–58

Analytical cubism, and nonillusive referentiality, 205n81

Annotations (Keene), 232n91; abstractionism in, 149, 158–59, 160; autobiography in, 229–30n80, 232n100; blackness in, 152–54, 155, 156–57, 159; concretization in, 230n86; construction of social identity in, 152–59; gender identity in, 154–55; Hejinian as influence in, 229–30n80; historicity in, 153–59, 232n100; lack of characterization in, 148–52, 159; narrative consciousness in, 149–52; narrative disruption in, 149, 229–30n80; perceptual coherence in, 150–52; pronominal reference in, 149–52,

229–30n80, 230n84; rhetorical variation in, 156–59, 232n98; semantic incoherence in, 149, 230nn82–84; sexual identity in, 154–55; social critique in, 149, 153–59; suture in, 152–53, 230–31n87

Anonymous reference: in *The Color Purple* (A. Walker), 121, 122–23, 124, 220–21n20; in *The Interesting Narrative of the Life of Olaudah Equiano*, 122, 220nn18–19; in *Narrative of the Life of Frederick Douglass*, 221n22; in *Pamela* (Richardson), 121–22, 219n15

"Apollo Vision: The Nature of the Grid" (M. Harper), 40, 69

Armory show, 58–60

Armstrong, Louis: abstraction in the music of, 71, 76–83, 94; as *auteur*, 77, 82; and jazz improvisation, 74; in King Oliver's Creole Jazz Band, 76–77; musical innovation by, 76; solo improvisation by, 76–82; "swing" in the music of, 76–77; "Weather Bird," 77

Arodin, Sidney, and Hoagy Carmichael, "Lazy River," 78, 79

Art Ensemble of Chicago: blackness in the music of, 113–15; musical influences on, 113; and C. Taylor, 113, 216n99

Artifice, in abstractionism, 62–63

Artistic form, and history, 58

Atemporality: abstraction as, 81; in jazz, 81, 83, 85; and syncopation, 83

Auerbach, Erich, on literary mimesis, 208–9n12

Auteurism, in jazz, 77, 82

"Authentic speech": in *for colored girls . . .* (Shange), 225–26n50; in postwar U.S. poetry, 225–26n50

Autobiography (Franklin), 32–33

Autobiography, in *Annotations* (Keene), 229–30n80, 232n100

Bakhtin, Mikhail, on novelistic discourse, 212n44

Bambara, Toni Cade, 159

Baraka, Amiri (LeRoi Jones): on African American music, 93–94; music as creative impetus for, 14; on C. Taylor, 97–98, 101, 104–7, 111–12, 113, 214n69

Barthes, Roland, on narrative, 222n31

Basie, William "Count," rhythm in the music of, 109–10

Beatty, Paul, 159

Bebop: influence on C. Taylor of, 107, 110, 111, 112; social significance of, 107–10

Beecroft, Vanessa, on her own artistic practice, 53–56

Beecroft, Vanessa, works of: abstraction in, 53, 57; abstractionism in, 53–56, 57–58; ambiguity in, 57–58; female objectification in, 204n69; formalism in, 53–56; human body in, 53–57; *VB35, —Show,* 48, 49, 50, 51–52, 53, 54; *VB39, U.S. Navy SEALs,* 46, 47, 48, 50; *VB46,* 55; *VB48,* 55, 56, 57–58

Benston, Kimberly: on Brechtian alienation, 233n14; on *for colored girls . . .* (Shange), 234–35n27; on modern black theater, 173–74; on *The Owl Answers* (Kennedy), 174, 175, 234–35n27

Billie Holiday and Her Orchestra, "The Man I Love," 88–91

"Black Americana" collectibles, 28–30; and racial caricature, 28

Black men, alleged negative depiction of by black women writers, 118–24, 126–31, 222n31

Blackness: in *Annotations* (Keene), 152–54, 155, 156–57, 159; as historical-narrative function, 114–15; in music, 10–11, 70, 106–7, 110, 111–12, 113–15; "proper" depiction of, in African American culture, 2

Black studies, prose fiction in, 180, 235n29

Black women writers of the 1980s: criticisms of, 117–24, 126–31, 216n1, 216–17n2, 222n31; emblematicity in works by,

Black women writers of the 1980s
(*continued*)
127–28; mimesis in works by, 123–24,
127; psychological realism in works by,
129–30, 223n36; realist aesthetics in works
by, 127–31, 222n31; referentiality in work
of, 127–28
Blankness, as characteristic of fashion
models, 50–51
Blues, in the music of C. Taylor, 98, 104–6,
111
Bois, Yves-Alain, on Mondrian, 44
Bond, Julian, on "black Americana" col-
lectibles, 30
Bop. *See* Bebop
Bowles, Juliette, on K. Walker, 17
Brecht, Bertolt: on alienation effect, 3, 7, 12;
on artistic representation, 1; on non-
Aristotelian theater, 186n5
Brechtian theory, and African American
theater, 187n10
Brown, Homer Obed, on the novel in the
literary studies curriculum, 235n29
Brown, Sterling, influence of, on Baraka
and Spellman, 215n85
Bubbel (Gallagher), 66; abstractionism in, 63
Bullitt, John M., on *Pamela* (Richardson), 121
Burns, Ken, *Jazz*, 84, 207–8n7
Butler, Octavia, 159

Camhi, Leslie, on *VB35, —Show* (Beecroft),
53
Cane (Toomer), abstractionism in, 160
Caricature, racial: and abstractionism, 25–
28; and "black Americana" collectibles,
28; in the work of K. Walker, 27
Caricature, visual, as compared to jazz
improvisation, 209n16
Carmichael, Hoagy, and Sidney Arodin,
"Lazy River," 78, 79
Central Indiana Community Foundation
(Indianapolis), 6, 8

Characterization: vs. abstractionism in
narrative fiction, 147–48, 160; lack of,
in *Annotations* (Keene), 148–52, 159; in
"Melanctha" (Stein), 143–48, 229n77;
refusal of, and social critique in African
American literature, 148. *See also* Psychic
interiority; Psychological realism
Charles, Dennis, drumming by, on "This
Nearly Was Mine" (C. Taylor), 102–4
Charlie Parker Quintet, "Klactoveesed-
stene," 110
"Chimes Blues" (King Oliver's Creole Jazz
Band), 77
"Chinatown, My Chinatown" (Louis Arm-
strong and His Orchestra), 80–81, 85
Cinema, 13; narratorial limits of, 172; non-
grammatical character of, 172, 173, 233n11;
visuality in, 166–67
Citizens Against Slave Image (Indianapo-
lis), 8
Cohn, Dorrit, on psychological realism,
222n34, 222–23n35
Collier, James Lincoln, on bebop, 107
"Colonel, The" (Forché), *136–37*; abstrac-
tionism in, 138; critical responses to,
226–27n53; figurative language vs.
literalism in, 137–38, 140, 227n55; as prose
poem, 138–39, 227n57; semantics of,
136–38
Color Purple, The (A. Walker), 117, 118,
121–24, 131; abstractionism in, 159–60;
anonymous reference in, 121, 122–23, 124,
220–21n20; consequentiality in, 128–29;
as epistolary novel, 121, 122, 220–21n20;
patriarchy in, 122–23, 221n22; realist
aesthetics in, 123–25, 159–60; and slave
narrative, 121, 220–21n20
Color Purple, The (dir. Spielberg), 117
Concretization, readerly: in *Annotations*
(Keene), 230n86; characterized, 225n49
Consciousness, narrative, in *Annotations*
(Keene), 149–52

Consequentiality: characterized, 131; in *The Color Purple* (A. Walker), 128–29; and expression, 92–94; in language, 131–32; in narrative, 92, 128–29, 131; and realist aesthetics, 128–29, 131

Constructionism and social identity, 231–32n89; in *Annotations* (Keene), 152–59

Count Basie and His Orchestra: "Jumpin' at the Woodside," 109–10; "One O'clock Jump," 109

Country between Us, The (Forché), 139

Daniels, Lee, dir., *Precious: Based on the Novel "Push" by Sapphire, 162, 163, 164, 165*; criticism of, 191–92n3; narrative disruption in, 161–67, 170, 172; visuality in, 166, 173, 191–92n3

Defamiliarization: vs. alienation effect, 186n6; Shklovsky on, 3, 186n6, 188n21

Deictics. *See* Shifters, characterized

Delany, Samuel, 159

Delville, Michel: on the prose poem, 227n57; on *Tender Buttons* (Stein), 227–28n59

Détournement, in *E Pluribus Unum* (Wilson), 187n14

DeVeaux, Scott, on bebop, 108

Devotion, Ebenezer, on representative democracy, 197n31

Diamond, Liz, staging of *Imperceptible Mutabilities . . .* (Parks) by, 177–79, 234n25

Dickinson, Emily, 139

Diegesis: in literature, 208–9n12; vs. mimesis, 208–9n12, 212–13n51

"Dinah" (Louis Armstrong and His Harlem Hot Band), 78

"Dipper Mouth Blues" (King Oliver's Creole Jazz Band), 76

Direct discourse, and literary mimesis, 208–9n12

Discipline, institutional, and normative white masculinity, 198–99n36

Disinterestedness. *See* Abstract personhood

Disinterestedness, aesthetic, and African American art, 195n15

Douglas, Aaron, silhouette drawings of, 193–94n11

Douglass, Frederick, *Narrative of the Life*, anonymous reference in, 221n22

Dramatic theater, Brecht on, 3

Du Bois, W. E. B., *The Souls of Black Folk*, abstractionism in, 160

Duchamp, Marcel, *Nude Descending a Staircase, No. 2*, 58–60, *59*

"E.B." (C. Taylor), 105, *107*

Edwards, Brent Hayes, on the relation between African American literature and African American music, 215–16n96

Ellis, Trey, on black art, 1

Ellison, Ralph, *Invisible Man*, on Armstrong, 83–84, *85*, 86

Emblematicity: characterized, 127; and stereotype, 127; in works by black women writers of the 1980s, 127–28

Empiricism. *See* Positivism

Enunciating subject, and implied author, 224n46

Epic theater. *See* Non-Aristotelian theater

Epistolary novel: *The Color Purple* (A. Walker) as, 121, 122, 220–21n20; Richardson as innovator of, 121

E Pluribus Unum (Wilson), 9, *6*; abstraction in, 9, 188n20; abstractionism in, 7, 9, 63, 188n20; controversy over, 4–9; criticism of, 63; as *détournement*, 187n14; realist aesthetics in, 8, 9

Equiano, Olaudah, *The Interesting Narrative of the Life of Olaudah Equiano*, 121, 219–20n17; anonymous reference in, 122, 220nn18–19

Estrangement. *See* Defamiliarization

Evenson, Brian, on *Annotations* (Keene), 229–30n80

"Evonce," cited in *Annotations* (Keene), 232n91

Experimentalism, literary: music as source of, 14; poetry as default mode of, 13–15; in prose, 12–13

Expression: in African American music, 11, 97; and indexical signification, 93; as inherent in music, 93–94; in jazz, 87, 91–94, 212n50; as narrative function, 92–94; and symbolic signification, 92–93

Fashion industry: generic perfection and white hegemony in, 49, 50–52, 203n61; models as "blanks" in, 50–51; and *VB35, —Show* (Beecroft), 50

Figuration, and abstractionism, 63

Figurative language: in "The Colonel" (Forché), 137–38, 140, 227n55; in poetry, 137–38; in "poetry of witness," 227n54

Film. *See* Cinema

Flatness, in the silhouette, 193–94n11

Fletcher, Geoffrey, *Precious*, 161

Forché, Carolyn: *The Country between Us*, 139; on metaphor and "poetry of witness," 227n54

Forché, Carolyn, "The Colonel," *136–37*; abstractionism in, 138; critical responses to, 226–27n53; figurative language vs. literalism in, 137–38, 140, 227n55; as prose poem, 138–39, 227n57; semantics of, 136–38

for colored girls who have considered suicide / when the rainbow is enuf (Shange), 69–70, 117–20, 121, 131, 206–7n3, 216n1; as "authentic-speech" poetry, 225–26n50; mimesis in, 126–27; performativity of, 234–35n27; realist aesthetics in, 123–27, 234–35n27; referentiality in, 126–27; social critique in, 234–35n27

Ford, Katie (Ford Models), 50–51

Ford, Tom (Gucci), and *VB35, —Show* (Beecroft), 48

Formalism: in runway fashion shows, 50–51, 54; in work of Beecroft, 53–56

Francesco di Giorgio, church designs of, *39*

Franklin, Benjamin: and abstract personhood, 32–33; *Autobiography*, 32–33

Freedom, abstraction as, 81

Freedom Time (A. Reed), 190n28

Free jazz, C. Taylor as practitioner of, 97

From a Broken Bottle Traces of Perfume Still Emanate (Mackey), 13; abstractionism in, 160

Gallagher, Ellen: *Bubbel*, 63, 66; *Host*, 63, 65

Garner, Stanton, on the phenomenology of theater, 173

Gates, Henry Louis, Jr.: on "black Americana" collectibles, 30; on *The Color Purple* (A. Walker), 220–21n20; on criticisms of K. Walker, 60

Gender identity, in *Annotations* (Keene), 154–55

Generic perfection: and abstract personhood, 62; and normative white masculinity, 36–40, 47; racial whiteness as, 50–52, 53; and racial whiteness in the fashion industry, 49; supposed, of fashion models, 50–52; and typicality, 51; in *VB35, —Show* (Beecroft), 48–49. *See also* Abstract personhood

Genette, Gérard, on literary mimesis, 208–9n12

Gershwin, George, and Ira Gershwin, "The Man I Love," 88, *89*

Glaser, Matt, on abstraction in the music of Armstrong, 71, 72, 78, 80–81, 83, 85

Goings, Kenneth, on "black Americana" collectibles, 28–30

Grammar: lack of, in cinema, 172, 173, 233n11; lack of, in visual culture, 132, 233n11. *See also* Systematicity

Grant, Damian, on literary realism, 222n33

Grid: and abstractive nullification, 42–43, 44–46; compared to jazz improvisation, 82; emblematic significance of, 33–34, 40, 198n34, 201n48; in modern and contemporary art, 43–49; suspicion of, in African American culture, 40–41; in U.S. land plotting, 41–43, 201n47

Gucci, whiteness in runway shows of, 50–51, 52, 54

Hadow, William Henry, on musical mimesis, 209n14

Hammerstein, Oscar, II, and Richard Rodgers: *South Pacific*, 98; "This Nearly Was Mine," 98–105, 99

Harper, Michael: "Apollo Vision: The Nature of the Grid," 40, 69; on the grid, 40–41, 46

Hawkins, Coleman, playing style of, 88

Hejinian, Lyn, as influence in *Annotations* (Keene), 229–30n80

Historical narrative. *See* Narrative

Historicity, in *Annotations* (Keene), 153–59, 232n100. *See also* Variation, rhetorical, in *Annotations* (Keene)

History: and artistic form, 58; in *Imperceptible Mutabilities . . .* (Parks), 177–79; in *VB48* (Beecroft), 57; in work of K. Walker, 21, 24, 25, 193n9

Hoffman, Donald D., on "innate rules of vision," 60

Holiday, Billie: vocal condition of, 93; vocal style of, 88–90, 91. *See also* Holiday, Billie, and Lester Young

Holiday, Billie, and Lester Young: musical partnership between, 71–72, 87–93; "swing" in the music of, 87, 91–92

hooks, bell, on *The Color Purple* (A. Walker), 220–21n20

Host (Gallagher), 65; abstractionism in, 63

Human body, in work of Beecroft, 53–57

Hutchinson, Earl Ofari, criticism of Black women writers by, 118, 120, 122, 126–27, 216–17nn2–3

Hypersexuality: alleged, in the work of K. Walker, 17, 27, 117; characterized, 20–21

Identity, individual vs. social, 51, 52–53

Identity politics, 231–32n89

Imagine the Sound (Mathes), 190–91n29

Imperceptible Mutabilities in the Third Kingdom (Parks): abstractionism in, 175–80; allegory in, 176, 234n20; history in, 177–79; illicit interracial sex in, 175–77; slavery in, 176–77; social critique in, 175, 177–80; stage directions in, 177; staging of, by Liz Diamond, 177–79, 234n25; temporality in, 176, 177–79

Implied author: characterized, 224n46; in "This Is Just to Say" (Williams), 135; in verse poetry, 134, 135–36

Implied reader: characterized, 135, 225nn48–49; in verse poetry, 135

Improvisation, collective: in classic jazz, 72; and musical referentiality, 72

Improvisation, jazz: compared to the modernist grid, 82; compared to visual caricature, 209n16; and Louis Armstrong, 74; and musical referentiality, 73–76

Improvisation, solo, by Louis Armstrong, 76–82

Indexical signification, and expression, 93

Indianapolis Cultural Trail, 6, 8

Ingarden, Roman, on concretization in reading, 225n49

Interesting Narrative (Equiano), 121, 219–20n17; anonymous reference in, 122, 220nn18–19

Interpersonal connection, in jazz, 86–87

Interracial sex, illicit: in *Imperceptible Mutabilities . . .* (Parks), 175–77; in *The Owl Answers* (Kennedy), 174, 175

Invisible Man (Ellison), 83–84, 85, 86

Jackson, Virginia, on the social constitution of lyric, 224n43, 225n49

Jakobson, Roman, on shifters, 226n52

James, Darius, 159

Jazz: abstraction in, 71, 72, 74–82, 85–87; atemporality in, 81, 83, 85; *auteurism* in, 77, 82; collective improvisation in, 72; communion among musicians in, 86–87; early players of, 72; expression in, 87, 91–94, 212n50; human voice as touchstone for instrumental performance in, 210–11n22; referentiality in, 72–76; social significance of, 82, 83–87

Jazz: A Film by Ken Burns, 207–8n7; on "(What Did I Do to Be So) Black and Blue" (Louis Armstrong and His Orchestra), 84

Johnson, Charles, 159

Johnson, Ken, on *VB48* (Beecroft), 57

"Jolly Nigger" mechanical bank, *26*

Jones, Gayl, 159

Jones, Jo, percussion playing by: on "Jumpin' at the Woodside" (Count Basie and His Orchestra), 109–10; on "One O'clock Jump" (Count Basie and His Orchestra), 109

Jones, LeRoi. *See* Baraka, Amiri (LeRoi Jones)

Jordan, June, on black culture and abstraction, 69

Joselit, David, on flatness in the silhouette, 193–94n11

"Jumpin' at the Woodside" (Count Basie and His Orchestra), 109–10

Keene, John, *Annotations*, 232n91; abstractionism in, 149, 158–59, 160; autobiography in, 229–30n80, 232n100; blackness in, 152–54, 155, 156–57, 159; concretization in, 230n86; construction of social identity in, 152–59; gender identity in, 154–55; Hejinian as influence in, 229–30n80; historicity

in, 153–59, 232n100; lack of characterization in, 148–52, 159; narrative consciousness in, 149–52; narrative disruption in, 149, 229–30n80; perceptual coherence in, 150–52; pronominal reference in, 149–52, 229–30n80, 230n84; rhetorical variation in, 156–59, 232n98; semantic incoherence in, 149, 230nn82–84; sexual identity in, 154–55; social critique in, 149, 153–59; suture in, 152–53, 230–31n87

Kelley, William Melvin, 159

Kennedy, Adrienne, *The Owl Answers*: abstractionism in, 174–75, 180; illicit interracial sex in, 174, 175; social critique in, 175, 234–35n27; textuality of, 234–35n27

King Oliver and His Dixie Syncopators, "Wa Wa Wa," 75

King Oliver and His Orchestra: "Chimes Blues," 77; "Sugar Blues," 75

King Oliver's Creole Jazz Band, "Dipper Mouth Blues," 76

King Oliver's Jazz Band, "Mabel's Dream," 209n15

"Klactoveesedstene" (Charlie Parker Quintet), 110

Krauss, Rosalind, on the modernist grid, 43

Land Ordinance of 1785, *41*–43; rationality of, 200–201n45

Language: consequentiality in, 131–32; systematicity of, 131–32, 172–73, 223–24n41, 233n10. *See also* Grammar; Syntax

"Lazy River" (Carmichael/Arodin), 78, *79*; performed by Louis Armstrong and His Orchestra, 78–80, 81

Leonardo da Vinci, "Vitruvian Man," 37, *38*

Liberation of Aunt Jemima, The (Saar), 28, *29*

Line break: as abstractionist mechanism, 135; as definitive of verse poetry, 133; function of, in verse poetry, 133–35, 224–25n47

Literalism: in "The Colonel" (Forché), 137–38; and realist aesthetics, 18–19; in responses to the work of K. Walker, 193–94n11

Literature: abstractionist capacity of, 167; diegesis in, 208–9n12; mimesis in, 208–9n12; narrative in, 11, 166–67, 172–73; referentiality in, 73

Looking Ahead! (C. Taylor), 98

Louis Armstrong and His Harlem Hot Band, "Dinah," 78

Louis Armstrong and His Hot Five: "Struttin' with Some Barbecue," 77; "West End Blues," 77

Louis Armstrong and His Orchestra: "Chinatown, My Chinatown," 80–81, 85; "Lazy River," 78–80, 81; "(What Did I Do to Be So) Black and Blue," 83–85, 87, 92

Lukács, Georg, on literary realism, 223n37

Lyric, social constitution of, 224n43, 225n49

"Mabel's Dream" (King Oliver's Jazz Band), 209n15

Mackey, Nathaniel, on black literary experimentalism, 13

Mackey, Nathaniel, *From a Broken Bottle Traces of Perfume Still Emanate,* 13; abstractionism in, 160

Major, Clarence, 159

Mammy, dual role of, as illustrated in *Imperceptible Mutabilities . . .* (Parks), 234n21

Manet and the Post-Impressionists (exhibition), 205n80

"Man I Love, The" (George and Ira Gershwin), 88, *89;* performed by Billie Holiday and Her Orchestra, 88–91

Marsalis, Wynton: on abstraction in jazz, 71–72, 77, 82, 85–87; on Armstrong, 71; on Holiday and Young, 71–72, 91; on Oliver, 71, 73; on the social significance of jazz, 82, 86–87

Martin, Agnes, untitled work from the portfolio *On a Clear Day, 43*

Mass culture, U.S., white predominance within, 53

Mathes, Carter, *Imagine the Sound: Experimental African American Literature after Civil Rights,* 190–91n29

McGrath, Pat, and *VB35, —Show* (Beecroft), 48

McMillan, Terry, *Waiting to Exhale,* 216–17n2

"Melanctha" (Stein): abstractionism in, 147–48; characterization in, 143–48, 229n77; mimesis in, 143, 147–48, 228n67; oxymoron in, 146–47; psychic interiority in, 143–47; psychological realism in, 147–48; and realist aesthetics, 147–48; repetition in, 140–42, 143–47, 158–59, 228n61, 229nn76–77; semantic incoherence in, 142, 228n66; and social critique, 148, 229n78; Stein on, 140; stereotype in, 143–47, 158–59, 228–29n71; syntactical disruption in, 142–43

Men of Brewster Place, The (Naylor), 218n12

"Middlebrow reception," 207–8n7

Mimesis: in classical antiquity, 209n13; vs. diegesis, 208–9n12, 212–13n51; in fictional prose narrative, 123, 129, 130; in *for colored girls . . .* (Shange), 126–27; in literature, 208–9n12; in "Melanctha" (Stein), 143, 147–48, 228n67; in music 207n6, 209nn13–14; in the music of Oliver, 73–76; and realist aesthetics, 193n10; in visual art, 73; in Western aesthetics, 194n12; in works by black women writers of the 1980s, 123–24, 127. *See also* Realist aesthetics; Referentiality; Verisimilitude

Models, fashion: as "blanks," 50–51; generic perfection of, 50–52

Modern and contemporary art: abstractionism in, 58–60; grid in, 43–49

Monaco, James, on film "grammar," 233n11

Mondrian, Piet, works of, *44, 45*; from figuration to abstraction in, 44

Monk, Thelonious, as precursor to C. Taylor, 107, 110

Morrison, Toni, 159

Moten, Fred, on black radical aesthetics, 14

Music: abstraction in, 92; abstractionism in, 114–15; abstractness of, 10, 70–73, 82, 83, 85–86, 105, 112, 188n22; autonomy of, 70, 73, 74, 75, 77, 87, 105, 207n6, 209n16; blackness in, 10–11, 70, 106–7, 110, 111–12, 113–15; as epitome of cultural blackness, 10, 11, 70, 112, 114; expression in, 11, 87, 91–94, 97, 212n50; mimesis in, 207n6, 209nn13–14; and "racial realism," 188n22; referentiality in, 72–76; as source of literary experimentalism, 14. *See also* African American music; Jazz

Musical training, among early jazz musicians, 72

Musicians, as servants, 213n61

Mutes, use of, by Oliver, 74–76, 81, 115

Narrative: vs. abstraction, 85, 92, 114; abstractionism in, 11, 115, 131, 172; African American music as, 11; characterized, 92; consequentiality in, 92, 128–29, 131; as constitutive of African American culture, 117; as constitutive of African American music, 93–94, 97, 108–9, 110–15; as constitutive of blackness, 114–15; context in the meaning of, 20–21, 117, 118–23, 131, 142, 159, 218n13, 220–21n20; curtailments on, in cinema, 172; in expression, 92–94; incorporativeness of, 85, 212n44; limits to, 222n31; in literature, 11, 166–67, 172–73; in music of Holiday and Young, 92–93; and realist aesthetics, 115, 131; social critique in, 115; and the social significance of

music, 85. *See also* Narrative disruption

Narrative, prose-fictional: abstractionism in, 11, 167, 175, 180; in the black studies curriculum, 180, 235n29; characterization vs. abstractionism in, 147–48, 160; limits of, 128–30; mimesis in, 123, 129, 130; vs. pictorial depiction, 123; and realist aesthetics, 121–22, 123–24, 222n34, 223n37; and social critique, 123; stereotype in, 123–24

Narrative, verbal: abstractionism in, 11, 131, 172; and syntax, 11–12; temporality in, 123, 166–67

Narrative disruption: and abstractionism, 161; in *Annotations* (Keene), 149, 229–30n80; in *Precious* (dir. Daniels), 161–67, 170, 172; in *Push* (Sapphire), 166–73

Narrative of the Life of Frederick Douglass, anonymous reference in, 221n22

Native Americans, and rationality, 201n48

Naylor, Gloria, *The Men of Brewster Place*, 218n12

Naylor, Gloria, *The Women of Brewster Place*, 117, 118, 120–21, 131, 217n3; abstractionism in, 159–60; realist aesthetics in, 123–25, 159–60; syntax in, 132

Neal, Larry, on black art, 1

"Negative" depictions, 19; of African Americans, 8, 9, 10, 17; of African American men, 118–24, 126–31, 222n31

Neidlinger, Buell, bass playing by, on "This Nearly Was Mine" (C. Taylor), 101, 102–4

Non-Aristotelian theater: abstractionism in, 3–4; defined, 186n5

Nude Descending a Staircase, No. 2 (Duchamp), 58–60, *59*

Objectification, female, in the work of Beecroft, 204n69

"Of What" (C. Taylor), 98, 105, 107, 112

Oliver, Joseph "King": abstraction in the music of, 71, 73–76, 81, 94; as jazz-

improvisation innovator, 72; referential mimesis in the music of, 73–76; "talking trumpet" effect in the music of, 75, 76; use of mutes by, 74–76, 81, 115; "wa-wa" effect in the music of, 75–76

Omniscient narration, and realist aesthetics, 222–23n35

On a Clear Day (portfolio by Martin), untitled work from, *43*

"One O'clock Jump" (Count Basie and His Orchestra), 109

Owl Answers, The (Kennedy): abstractionism in, 174–75, 180; illicit interracial sex in, 174, 175; social critique in, 175, 234–35n27; textuality of, 234–35n27

Oxymoron, in "Melanctha" (Stein), 146–47

Pamela (Richardson), anonymous reference in, 121–22, 219n15

Parker, Charlie: as bebop practitioner, 110; as precursor to C. Taylor, 107, 110

Parks, Suzan-Lori, *Imperceptible Mutabilities in the Third Kingdom*: abstractionism in, 175–80; allegory in, 176, 234n20; history in, 177–79; illicit interracial sex in, 175–77; slavery in, 176–77; social critique in, 175, 177–80; stage directions in, 177; staging of, by Liz Diamond, 177–79, 234n25; temporality in, 176, 177–79

Pater, Walter, on music among the arts, 70

Patriarchy, in *The Color Purple* (A. Walker), 122–23, 221n22

Perceptual coherence, in *Annotations* (Keene), 150–52

Performance, as essential to theatrical abstractionism, 180, 234–35n27

Perloff, Marjorie, on "authentic speech" in postwar U.S. poetry, 225–26n50

Pictorial depiction: abstraction in, 19; limits of, 19–21, 192n8; vs. narrative discourse, 123

Pinza, Ezio, "This Nearly Was Mine," 98, 102, 104

Plato, on diegesis vs. mimesis, 208–9n12

Poetry: characterized, 136; as default mode of literary experimentalism, 13–15; figurative language in, 137–38; and syntactic complexity, 12. *See also* Prose poem; Verse poetry

Polite, Carlene Hatcher, 159

"Port of Call" (C. Taylor), 105, 107

"Positive" depictions of African Americans, 2

Positivism: and realist aesthetics, 2; rejection of by K. Walker, 24

Possessive individualism, and property ownership, 196n26

Postmodernism, in African American literature, 159

Prada, whiteness in runway shows of, 50–51, 52, 54

Precious (Fletcher), 161

Precious: Based on the Novel "Push" by Sapphire (dir. Daniels), *162, 163, 164, 165*; criticism of, 191–92n3; narrative disruption in, 161–67, 170, 172; visuality in, 166, 173

Presenting Negro Scenes Drawn upon My Passage through the South and Reconfigured for the Benefit of Enlightened Audiences Wherever Such May Be Found, by Myself, Missus K. E. B. Walker, Colored (K. Walker), *18*, 21; abstractionism in, 10, 21–23; caricature in, 27; as "negative" depiction of African Americans, 10; realist aesthetics in, 18–19, 21, 22; reality vs. representation in, 23; verisimilitude in, 23

Pronominal reference, in *Annotations* (Keene), 149–52, 229–30n80, 230n84

Property, and African Americans, 31

Property ownership: and possessive individualism, 196n26; and subjective enhancement, 30

Prose: abstractionism in, 12–13, 140; and syntactic simplicity, 12–13. *See also* Narrative, prose-fictional; Narrative, verbal

Prose, experimental, 12; and African American literature, 12–13

Prose poem: abstractionism in, 138–39; aesthetic power of, 136; problematized, 227n57

Psychic interiority: in "Melanctha" (Stein), 143–47; and realist aesthetics, 129–30. *See also* Characterization; Psychological realism

Psychological realism: in contemporary narrative fiction, 222n34; in "Melanctha" (Stein), 147–48; and third-person narration, 222–23n35; in the work of Samuel Richardson, 218–19n14; in works by black women writers of the 1980s, 129–30, 223n36. *See also* Characterization; Psychic interiority

Push (Sapphire): criticism of, 191–92n3; narrational complexity in, 166–73; as realist novel, 167; temporality in, 167–73; worldmaking in, 173

Racial "authenticity," critiques of, 186n4. *See also* "Racial realism"; Realist aesthetics

"Racial realism": critiques of, 186n3; and music, 188n22; and visual art, 9. *See also* Racial "authenticity"; Realist aesthetics

Rankine, Claudia, abstractionism in the work of, 160

Rationality: and abstract personhood, 31; as emblematized by the grid, 33–34, 198n34, 201n48; and the Land Ordinance of 1785, 200–201n45; and Native Americans, 201n48

Razaf, Andy, Thomas (Fats) Waller, and Harry Brooks, "(What Did I Do to Be So) Black and Blue," 84–85

Rea, Paul, on "The Colonel" (Forché), 227n55

Reading protocols for African American literature: and abstractionism, 160; and realist aesthetics, 232n101

Reading subjectivity. *See* Implied reader

Realist aesthetics: vs. abstractionism, 67; in African American culture, 2, 12; in *The Color Purple* (A. Walker), 123–25, 159–60; and consequentiality, 128–29, 131; in *E Pluribus Unum* (Wilson), 8–9; in *for colored girls . . .* (Shange), 123–27, 234–35n27; hegemony of, 10, 18, 160, 193n10; and literalism, 18–19; and "Melanctha" (Stein), 147–48; and mimesis, 193n10; in narrative, 115, 131; and omniscient narration, 222–23n35; and positivism, 2; in prose fiction, 121–22, 123–24, 222n34, 223n37; psychic interiority in, 129–30; in *Push* (Sapphire), 167; and reading protocols for African American literature, 232n101; reality and representation in, 124–27, 223n38; and social critique in fictional narrative, 130; varieties of, in literature, 222n33; and verisimilitude, 2, 19, 129–30; and visual culture, 10, 58–62; in *The Women of Brewster Place* (Naylor), 123–25, 159–60; and the work of K. Walker, 18–19, 21, 22, 147–48; in works by black women writers of the 1980s, 127–31, 222n31. *See also* Mimesis; Verisimilitude

Reality vs. representation, 19, 21; in narrative, 115; in *Presenting Negro Scenes . . .* (K. Walker), 23; in realist aesthetics, 124–27, 223n38

Reed, Anthony, *Freedom Time: The Poetics and Politics of Black Experimental Writing*, 190n28

Reed, Ishmael, 159

Referentiality: in *for colored girls . . .* (Shange), 126–27; in literature, 73; in music, 72–76; in the music of Oliver, 73–76; and nonillusiveness, 205n81; in visual art, 73; in Western aesthetics, 23; in works by

black women writers of the 1980s, 127–28. *See also* Mimesis; Verisimilitude

Reflexivity, of abstract art, 23

Repetition: in black culture, 232n99; in "Melanctha" (Stein), 140–42, 143–47, 158–59, 228n61, 229nn76–77. *See also* Variation, rhetorical, in *Annotations* (Keene)

Representation vs. reality, 19, 21; in narrative, 115; in *Presenting Negro Scenes . . .* (K. Walker), 23; in realist aesthetics, 124–27, 223n38

Representative democracy: abstract personhood in, 31; Devotion on, 197n31

Richardson, Samuel: and epistolary fiction, 121; psychological realism in the fiction of, 218–19n14

Richardson, Samuel, *Pamela*, anonymous reference in, 121–22, 219n15

Rittelmann, Leesa, on Simpson, 63

Roach, Max, percussion playing by, on "Klactoveesedstene" (Charlie Parker Quintet), 110

Rodgers, Richard, and Oscar Hammerstein II: *South Pacific*, 98; "This Nearly Was Mine," 98–105, 99

Rojas, Fabio, on the humanities in the black studies curriculum, 235n29

Ross, Fran, 159

Ruddick, Lisa, on "Melanctha" (Stein), 228n61

Russell, Ross, on bebop, 109

Saar, Betye: on "black Americana" collectibles, 28; *The Liberation of Aunt Jemima*, 28, 29; on K. Walker, 17

Sapphire, *Push*: criticism of, 191–92n3; narrational complexity in, 166–73; as realist novel, 167; temporality in, 167–73; worldmaking in, 173

Saussure, Ferdinand de: on *langue* vs. *parole*, 233n10; on syntagmatic relations in language, 223–24n41

Schopenhauer, Arthur, on music, 207n6, 211n36

Schuller, Gunther, on referentiality in classic jazz, 72

Semantic incoherence: in *Annotations* (Keene), 149, 230nn82–84; in "Melanctha" (Stein), 142, 228n66

Sexual abuse: alleged depictions of, in the work of K. Walker, 17, 20, 117; characterized, 20, 192n7; in *The Color Purple* (A. Walker), 122–23, 128; in *Precious* (dir. Daniels), 162–63, 164–65, 166; in *Push* (Sapphire), 167, 170; in the work of Shange, 125

Sexual identity, in *Annotations* (Keene), 154–55

Shange, Ntozake: on realism in her work, 125–27; "With No Immediate Cause," 125

Shange, Ntozake, *for colored girls who have considered suicide / when the rainbow is enuf*, 69–70, 117–20, 121, 131, 206–7n3, 216n1; as "authentic-speech" poetry, 225–26n50; mimesis in, 126–27; performativity of, 234–35n27; realist aesthetics in, 123–27, 234–35n27; referentiality in, 126–27; social critique in, 234–35n27

Shifters, characterized, 226n52

Shklovsky, Victor, on defamiliarization, 3, 186n6, 188n21

Silhouette: flatness of, 193–94n11; verisimilitude in, 193–94n11; K. Walker on, 192n4, 193–94n11

Silverman, Kaja, on the "spoken subject" in narrative discourse, 225n48

Simpson, Lorna, *Untitled (impedimenta)*, 63, *64*

Slave narrative, and *The Color Purple* (A. Walker), 121, 220–21n20

Slavery: and abstraction, 31, 57, 62; in *Imperceptible Mutabilities . . .* (Parks), 176–77

Smith, Roberta, on *VB35, —Show* (Beecroft), 48

Smith, Sandra Wilson, on *Annotations* (Keene), 230–31n87

Snead, James A., on repetition in black culture, 232n99

Social critique: and abstractionism, 4, 25, 58, 62, 114–15, 140, 160, 180; in abstractionist prose, 175; and African American culture, 1–2; in African American music, 215–16n96; in African American theater, 173–75; in *Annotations* (Keene), 149, 153–59; in *for colored girls . . .* (Shange), 234–35n27; in *Imperceptible Mutabilities . . .* (Parks), 175, 177–80; and literary realism, 130; in "Melanctha" (Stein), 148, 229n78; in narrative, 115; in non-Aristotelian theater, 3–4; in *The Owl Answers* (Kennedy), 175, 234–35n27; and prose fiction, 123; and the refusal of characterization in African American literature, 148; in theater, 179–80

Social identity and constructionism, 231–32n89; in *Annotations* (Keene), 152–59

Social reality, and abstractionism, 2–3

Souls of Black Folk, The (Du Bois), abstractionism in, 160

Southern, Eileen, on history of African American music, 94–97

South Pacific (Rodgers and Hammerstein), 98

Spellman, A. B., on bebop, 107

Spielberg, Steven, dir., *The Color Purple*, 117

Spirit of the American Doughboy, The (Viquesney), 35

Stage directions, in *Imperceptible Mutabilities . . .* (Parks), 177

State Soldiers and Sailors Monument (Indianapolis, IN), 5, 6–7

Stein, Gertrude, "Melanctha": abstractionism in, 147–48; characterization in,

143–48, 229n77; mimesis in, 143, 147–48, 228n67; oxymoron in, 146–47; psychic interiority in, 143–47; psychological realism in, 147–48; and realist aesthetics, 147–48; repetition in, 140–42, 143–47, 158–59, 228n61, 229nn76–77; semantic incoherence in, 142, 228n66; and social critique, 148, 229n78; Stein on, 140; stereotype in, 143–47, 158–59, 228–29n71; syntactical disruption in, 142–43

Stein, Gertrude, *Tender Buttons*: compared to "This Is Just to Say" (Williams), 139; syntactical disruption in, 139–40, 227–28n59

Stein, Gertrude, *Three Lives*, 140

Stereotype: characterized, 127; and emblematicity, 127; in "Melanctha" (Stein), 143–47, 158–59, 228–29n71; in prose fiction, 123–24; suspected, in works by black women writers of the 1980s, 127–28

Stevens, Mark, on *VB39, U.S. Navy SEALs* (Beecroft), 46–47

Storr, Robert, on Gallagher, 63

"Struttin' with Some Barbecue" (Louis Armstrong and His Hot Five), 77

Study of Trees I (Mondrian), 44

Study of Trees II (Mondrian), 45

Subjective enhancement: and abstraction, 31–32; and property ownership, 30

"Subject of the statement": characterized, 224n46; in "This Is Just to Say" (Williams), 134–35, in verse poetry, 135

"Sugar Blues" (King Oliver and His Orchestra), 75

Suture, in *Annotations* (Keene), 152–53, 230–31n87

"Swing": defined, 91; in the music of Armstrong, 76–77; in the music of Holiday and Young, 87, 91–92

Symbolic signification: contingency of, 213n52; and expression, 92–93

Syncopation, and atemporality in jazz, 83

Syntactical disruption: in "Melanctha" (Stein), 142–43; in *Tender Buttons* (Stein), 139–40, 227–28n59; in verse poetry, 133–34

Syntax: and linguistic systematicity, 132, 223–24n41; and narrative, 11–12; in poetry, 12; in prose, 12–13. *See also* Syntactical disruption

Systematicity: lack of, in visual representation, 132, 233n11; of language, 131–32, 172–73, 223–24n41, 233n10. *See also* Grammar; Syntax

Tableau No. 2 / Composition No. VII (Mondrian), 45

"Talking trumpet" effect, in music of Oliver, 75, 76

Tate, Claudia, Shange interviewed by, 125

Taylor, Arthur "Montana," C. Taylor compared to, 106

Taylor, Cecil: and the Art Ensemble of Chicago, 113, 216n99; blackness in the music of, 98, 106–7, 110, 111–12, 113; "E.B.," 105, 107; *Looking Ahead!*, 98; musical influences of, 97–98, 104–6, 107, 110, 111, 112, 214n70; "Of What," 98, 105, 107, 112; on the percussional character of the piano, 214n75; "Port of Call," 105, 107; "This Nearly Was Mine," 98–105, *100, 103,* 106–7; *The World of Cecil Taylor*, 98, 105

Temporality: in *Imperceptible Mutabilities . . .* (Parks), 176, 177–79; in *Push* (Sapphire), 167–73; in verbal narrative, 123, 166–67

Ten Books on Architecture, The (Vitruvius), 36–37

Tender Buttons (Stein): compared to "This Is Just to Say" (Williams), 139; syntactical disruption in, 139–40, 227–28n59

Textuality, in *The Owl Answers* (Kennedy), 234–35n27

Theater, 13; abstractionism in, 179–80; alienation effect in, 173; performance as essential to abstractionism in, 180, 234–35n27; social critique in, 179–80; worldmaking in, 173

"This Is Just to Say" (Williams), 133, 224n43; compared to *Tender Buttons* (Stein), 139; implied author in, 135; line breaks in, 133–35, semantics of, 133–34; "subject of the statement" in, 134–35; Williams on, 224–25n47

"This Nearly Was Mine" (Rodgers and Hammerstein), 98–105, *99;* performed by Pinza, 98, 102, 104; performed by C. Taylor, 98–105, *100, 103,* 106–7

Three Lives (Stein), 140

Toomer, Jean, *Cane,* abstractionism in, 160

Transcribe! software program, 211n33

Turner, Patricia, on "black Americana" collectibles, 28, 30

Typicality, and generic perfection, 51

Untitled (impedimenta) (Simpson), *64;* abstractionism in, 63

U.S. Navy SEALs, demographic composition of, 46, 50

Variation, rhetorical, in *Annotations* (Keene), 156–59, 232n98. *See also* Repetition

VB35, —Show (Beecroft): *49, 54;* abstraction in, 53; abstractionism in, 53; and fashion industry, 50; generic perfection in, 48–49; human body in, 53; whiteness in, 50, 51–52

VB39, U.S. Navy SEALs (Beecroft), 46, *47, 48,* 50; normative white masculinity in, 46–47

VB46 (Beecroft), 55

VB48 (Beecroft), 55, *56;* abstractionism in, 57–58; ambiguity in, 57–58; history in, 57

Verisimilitude: and realist aesthetics, 2, 19, 129–30; in the silhouette, 193–94n11; in visual art, 73; in work of K. Walker, 23, 24, 25. *See also* Mimesis; Realist aesthetics; Referentiality

Verse poetry: abstractionism in, 135–36; implied author in, 134, 135–36; implied reader in, 135; line break in, 133–35, 224–25n47; "subject of the statement" in, 135; syntactical disruption in, 133–34. *See also* Poetry

Viquesney, E. M., *The Spirit of the American Doughboy*, 35

Visual art: and abstractionism, 9–10, 58, 63–67; mimesis in, 73; and "racial realism," 9; and realist aesthetics, 10; referentiality in, 73; verisimilitude in, 73

Visual culture: abstraction in, 114; abstractionism in, 27, 58–62, 67, 114, 131; nongrammatical character of, 132, 233n11; and realist interpretation, 58–62

Visuality: in cinema, 166–67; in *Precious* (dir. Daniels), 166, 173

Visual literacy, 60–62

Vitruvian Man: characterized, 36–37; as rendered by Leonardo da Vinci, 37, 38

Vitruvius, *The Ten Books on Architecture*, 36–37

Voice, human, as touchstone for instrumental jazz, 210–11n22

Waiting to Exhale (McMillan), 216–17n2; film (dir. Whitaker), 216–17n2

Walker, Alice, *The Color Purple*, 117, 118, 121–24, 131; abstractionism in, 159–60; anonymous reference in, 121, 122–23, 124, 220–21n20; consequentiality in, 128–29; as epistolary novel, 121, 122, 220–21n20; patriarchy in, 122–23, 221n22; realist aesthetics in, 123–25, 159–60; and slave narrative, 121, 220–21n20

Walker, Kara: abstractionism in the work of, 10, 21–23, 24, 25, 57–58, 63–67, 117, 124, 131, 147–48; acclaim for, 191nn1–2; alienation effect in the work of, 24–25; ambiguity in the work of, 57–58; criticism of, 17, 20, 27–28, 60, 63, 117, 118, 124, 193–94n11; history in the work of, 21, 24, 25, 193n9; realist aesthetics and the work of, 18–19, 21, 22, 147–48; rejection of positivism by, 24; on the silhouette, 192n4, 193–94n11; verisimilitude in the work of, 23, 24, 25

Walker, Kara, *Presenting Negro Scenes Drawn upon My Passage through the South and Reconfigured for the Benefit of Enlightened Audiences Wherever Such May Be Found, by Myself, Missus K. E. B. Walker, Colored*, 18, 21; abstractionism in, 10, 21–23; caricature in, 27; as "negative" depiction of African Americans, 10; realist aesthetics in, 18–19, 21, 22; reality vs. representation in, 23; verisimilitude in, 23

Wallace-Sanders, Kimberly, on the black mammy, 234n21

Warner, Michael, on abstract personhood, 31

Warren, Kenneth, on African American literature, 185n1

Waters, William, on "This Is Just to Say" (Williams), 224n43

"Wa-wa" effect, in music of Oliver, 75–76

"Wa Wa Wa" (King Oliver and His Dixie Syncopators), 75

"Weather Bird" (Armstrong), 77

"West End Blues" (Louis Armstrong and His Hot Five), 77

"(What Did I Do to Be So) Black and Blue" (Razaf, Waller, and Brooks), 84–85; performed by Louis Armstrong and His Orchestra, 83–85, 87, 92

Whitaker, Forest, dir., *Waiting to Exhale*, 216–17n2

Whitehead, Colson, on *Annotations*
(Keene), 229–30n80

White masculinity, normative:
cultural exaltation of, 34–36, 46–47; as
emblematized by the grid, 33–34, 40;
and generic perfection, 36–40, 47; and
generic subjectivity, 34–36; and insti-
tutional discipline, 198–99n36. *See also*
Whiteness

Whiteness: exaltation of, in U.S. mass
culture, 53; and generic perfection,
50–52, 53; hegemony of, in fashion
industry, 49, 50–52, 203n61; in runway
fashion shows, 50–51, 52, 54; societal
predominance of, 50–52; in *VB35, —Show*
(Beecroft), 50, 51–52. *See also* White
masculinity

Williams, William Carlos, "This Is Just to
Say," *133*, 224n43; compared to *Tender
Buttons* (Stein), 139; implied author in,
135; line breaks in, 133–35; semantics of,
133–34; "subject of the statement" in,
134–35; Williams on, 224–25n47

Wilson, Fred, *E Pluribus Unum*, 9, 6;
abstraction in, 9, 188n20; abstraction-
ism in, 7, 9, 63, 188n20; criticism of, 63;
controversy over, 4–9; as *détournement*,
187n14; realist aesthetics in, 8, 9

"With No Immediate Cause" (Shange), 125

Women of Brewster Place, The (Naylor), 117,
118, 120–21, 131, 217n3; abstractionism in,
159–60; realist aesthetics in, 123–25, 159–
60; syntax in, 132

Worldmaking: in *Push* (Sapphire), 173; in
theater, 173

World of Cecil Taylor, The (C. Taylor),
98, 105

Young, Lester: playing style of, 89–91; solo
by, on "The Man I Love" (Billie Holiday
and Her Orchestra), *90*. *See also* Holiday,
Billie, and Lester Young

About the Author

Phillip Brian Harper is Erich Maria Remarque Professor of Literature at New York University, where he teaches in the Departments of Social and Cultural Analysis and of English. He is the author of the books *Private Affairs* (also published by NYU Press), *Are We Not Men?*, and *Framing the Margins*.